# ZELDA

*I dedicate this book
to the many women of the past
who devoted their lives to the labour movement
yet remain unrecorded and unknown*

When you finally comprehend how many souls, brains, hearts have dissolved, putrescent, to pay for your name on their lips – you will be shocked, no doubt, ashamed, and even repentant, but hardly able to understand, as you flee from our liberating rage.

— *Robin Morgan*

There is no individual salvation which can be perfected, as long as there remain others who hunger or thirst or need ... You can no longer choose yourself alone, only the kind of humanity you wish to belong to.

— *Han Su Yin*

I have learned to love that Women's Movement, that face in the mirror, wearing its new, wry, patient smile; those eyes that have rained grief but can still see clearly; that body with its unashamed sags and stretch marks; that mind, with all its failings and its cowardices and its courage and its inexhaustible will to try again.

It is in my blood, and I love it, do you hear? I know in my bones that women's consciousness and our desire for freedom and the power to forge a humane society will survive.

— *Robin Morgan*

# ZELDA

*Zelda D'Aprano*

Spinifex Press Pty Ltd,
504 Queensberry Street,
North Melbourne, Vic. 3051
Australia

First published by Zelda D'Aprano, 1977
This edition published by Spinifex Press, 1995

Edited by Michelle Proctor
Typeset in 10/12 pt Times Ten by Claire Warren, Melbourne
Cover design by Lin Tobias, Melbourne
Printed in Australia by Australian Print Group, Maryborough

National Library of Australia
Cataloguing-in-Publication entry:
CIP

D'Aprano, Zelda, 1928–
    Zelda.

    New ed.
    ISBN 1 875559 30 2.

    1. D'Aprano, Zelda, 1928– . 2. Feminists – Australia –
Biography. 3. Feminism – Australia. I. Title.

305.42092

# Contents

Acknowledgements                          *vii*

Author's Note                             *viii*

Preface                                   *ix*

Zelda                                     1

Afterword                                 305

Appendices                                401

Further Acknowledgements                  407

# Acknowledgements

I FIND IT EXTREMELY DIFFICULT to express in words my gratitude to the many women who have, over the years, added to my personal development. There was a time when there were few of us and Joan Bray spent night after night with me in exhaustive dialogue. You made me think Joan, you made me seek the answers and by doing so you added to my courage, confidence and growth.

I am reluctant to acknowledge by name the many wonderful women who contributed to my being, for fear of overlooking a single one. To show gratitude for your individual contribution is impossible, yet I wish to thank you all for what you have given me.

Many thanks to Adriana Palamara, Barbara Wishart and Beata Peisker for your invaluable advice on the manuscript.

I wish to thank Selma who encouraged and inspired me into having my book republished and writing the Afterword.

Thanks also go to her family who helped with the typing and research when needed from Melbourne.

Many thanks to Jean Taylor for sending me material when requested and for your beautiful warm smile.

Thanks also to Ché Stockley, Sue Spunner and Barbara Creed, to Bon Hull for your contribution on the Health Collective, to Jan Harper for assistance with information on non-sexist children's books.

And many thanks to Ron for your support.

— Zelda D'Aprano, January 1995.

# *Author's Note*

WHEN RE-READING the preface to my book prior to this edition, it became obvious that, due to the changes which have taken place in the intervening years between 1977 – when the book was first published – and today, some of the details recorded no longer apply. Nevertheless, most of what I wrote is still relevant and necessary to this work, hence my decision to retain the preface in its original form.

This edition includes an Afterword which records in detail my experience of the Women's Liberation Movement. It expands on the information provided in the first edition and also includes new material.

I have recorded this information to ensure women's history is not lost. I urge other women to write of their experiences of the Women's Liberation Movement so that there is a continuum set up for all women in Australia.

# Preface

ON NUMEROUS OCCASIONS when addressing various groups of people on all topics associated with Women's Liberation, it was suggested that I should write a book on the experiences of my life. It never occurred to me that there was anything significant about my life to warrant recording, until the incident which happened towards the end of this book took place. This incident did not occur by chance, but was a deliberate act and this event forced me to take stock of my life and acknowledge the validity of my experiences. After giving the matter a great deal of thought, I decided that it was necessary for this book to be written.

Many women are now deeply concerned about the problems which confront women in our present day society. They wish to create a society where women will obtain total fulfilment and, to make this possible, they bring forth suggestions of methods by which they think this goal may be achieved. On frequent occasions the suggestions made are not new and have failed when attempted in the past. But because there is no record of the attempts which were made, it is impossible for women of today to evaluate or analyse these experiences in order to avoid making the same mistakes over and over again.

I have detailed several years of my involvement in the trade union and political struggle to indicate the depth of commitment and what, if any, benefits for women can be gleaned from our participation within these structures. It is also necessary, in light of all these activities, to analyse whether or not they brought about any changes in society.

My life, when looking back, seems to have covered four

phases. The initial and the longest period was the unquestioning phase, then a period of questioning with no answers. Next was the feminist phase where I was both questioning and obtaining some answers. It was only when moving into the liberationist phase that almost everything fell into place.

Working-class women very rarely write books because of our inability to write at the level required by male established literary standards. Nor are many books written about the lives of working-class women because our lives are considered to be too humdrum.

When first trying to decide whether this book should be written, I was unprepared and too afraid to expose myself to the monstrous power of our male dominated society, so I asked a young feminist writer if she would be interested in writing a novel about my life experiences. She was delighted with the prospect. However, after reading a rough draft of the manuscript, she said it was impossible for her to undertake this task. Never having endured most of my experiences, she was unable to put herself into my skin and feel my pain in order to write the novel. She suggested that I alone must write the book.

I then submitted the draft to a woman involved in the publishing field and sought her advice on obtaining the services of a ghost writer. Again I was disappointed. After reading the material, she advised me to write the book myself, as a ghost writer would, with the best intentions, refine the material. She continued to say that if I was to record the details as they were recorded in the draft, it would be unsuitable for publishers as, according to male established standards, it was impossible to combine personal experience with political experience. I gave the matter a great deal of thought but was unable to reconcile myself to the need to cut myself in two pieces.

My thinking led me to the bookshelf and I gazed at the numerous books before me. Why, why, I kept on asking myself, cannot a book record all the details of human life and involvement? There before me were books on history, economics, wars, revolutions, industrialisation, trade unions,

etc., and novels. I picked up a book on the lives of one hundred famous people and glanced through the pages. Of the hundred people featured, only seven were women. Apart from the date of birth, birthplace, places of education, military academies, etc., and the date of death, no other personal details of the men's lives were recorded. All emphasis was on their achievements, even if the achievements resulted in the destruction of human lives through war. For days on end I pondered this problem until everything became clear.

Almost all people, given the circumstances, can perform heroic deeds, however, hero-worship is a sickness of the patriarchal society. All people have strengths and weaknesses, but because men wished to preserve an untarnished image and remain immortal with this heroic image, they created history. A record only of their achievements.

Maybe Napoleon suffered from haemorrhoids and perhaps it was during a painful bout of this condition that he made the fatal mistake of deciding to invade Russia. Churchill could have suffered from continual flatulence and maybe his wife was pleased when he took himself off to his mistress so she wouldn't have to endure the advances of the oaf. Was Stalin a wife beater and did he arrange the disappearance of one of his wives? Who knows, Abraham Lincoln may have suffered great mental depression because he was impotent?

Men refused to disclose the truth of their being and created a schism in books. It was necessary for them to divide personal experiences from political experiences, denying that both were one, in order that they could remain secure in their glory. They wrote and continue to write the history books and are able to eulogize each other in glowing terms. Even the worst offenders, like Hitler, are paid the respect of being recorded for posterity.

Because there is more to life and living than is recorded in history books, the novel provided the place in literature where human experiences could be portrayed. In the anonymity of the novel men were safe and all emotions, human frailties, weaknesses, illnesses and hangups could be recorded. No man would ever recognise himself as the ogre in a novel.

Autobiography and biography almost always record the lives of "important" people (mostly men) and, again, only the good image is projected; a denial of the reality.

Over the centuries many women have achieved various forms of political, scientific and cultural gains, but they have been ignored, unrecorded or ridiculed because they didn't conform to the male-established standard of the housewife–mother role. The lives of these women differed from the established standard and this "behaviour" was not to be encouraged. Even the novel almost always portrays the housewife–mother role as being the only 'normal' role for women.

The novel became the only place in literature where women could express their pain and suffering and we too are safe in the anonymity of the novel. Although many of the details recorded in novels are based on fact, false names protect the authors from being destroyed. In order to protect themselves from exposure and retain their untarnished image, men created libel laws, and libel laws protect only those in power. Women have no power and no image, therefore we have nothing to lose.

Until women write truthfully of their personal experiences and involvement in the outside world, we will continue to be ignored and unrecorded, and generation after generation of young women deprived of this information will continue to make the same mistakes.

The male standard of literature has made respectable the recording of their total mismanagement of our world and its resulting calamities. We read of the hungry two-thirds of the world's population. We read of the distended stomachs of starving children in Biafra, of the thousands of women raped in Bangladesh, of the thousands of women and children in Vietnam whose flesh was burned from their bones through napalm bombs. But never are we permitted to read of the natural functions of women's bodies. Women in books never menstruate, nor are troubles associated with our reproductive organs ever mentioned. These aspects of women's reality are considered by men to be loathsome, "not nice" and "not

respectable". Because these standards have been established for so long, women too, when writing books, have conformed to the male rules.

I refuse to conform to the established standards by men for literature and will portray my life and experiences as they occurred. Many experiences of my life have not been detailed within these pages and, although they added to my development and understanding of what life was all about, they would, if recorded, only have increased the size of the book without contributing to the overall politics of the work.

I have written this autobiography without the assistance of a ghost writer and with all my imperfections as a writer. Should men or their power structures, now or in the future, destroy a woman because she dares to write truthfully of her experiences and involvement in society, we will know why women are absent from history.

# 1

OUR HOUSE WAS A SINGLE-FRONTED COTTAGE in the slum area of Carlton. There were no distinctive features to differentiate it from most of the small cottages in Carlton, with the long narrow passage passing the two bedrooms and the central living room leading into the kitchen. Dad erected a small room adjoining the kitchen which served as both bathroom and laundry; the old wood-burning copper providing the hot water for our baths and washing of clothes.

The old slate roof was an original part of the dwelling and constantly leaked when raining. The slates seemed to take turns in sliding out of position and in every room dishes and pots were placed in strategic positions during the winter months to receive the drip, drip, drip of the rain as it found its way through the ceiling. The house was flanked on one side by a single-storey shop which was a mixed business, and on the other side by a high timbered fenced-in yard. Within this yard stood a sturdy galvanised iron shed where hard millet brooms were stored under lock and key.

Early every morning, several men would line up at the shed to collect a broom, then set off to sweep the gutters of Carlton. These men were referred to as "susso men"; men who, because of the great unemployment at that time, were on sustenance payments and were employed to clean the gutters. Towards the end of the day, they would return to lock the brooms away until the following morning. As a very young child, I can recall their old clothes, worn boots, and the weary look on their faces.

During 1937–38, the people in the shop next door added another storey to their building, and the local council sold

the block adjacent to our house. A block of flats was erected on the site and our house was now in constant shadow, for the sunshine could no longer penetrate the side windows.

I was born in January 1928, one year before the great economic collapse, and I entered a world of uncertainty and poverty.

Poverty was reflected within our home; the worn pattern on the lino was faded through the constant wear of feet and, only on the edges or under the few odd pieces of old furniture, could the richness of the flowers be detected. It was a great day when mum scrubbed and polished the lino, and we kids would plead with her to let us get the old rags out of the bag and slide up and down the passage to make it shinier. This game kept us occupied for several hours and, while doing it, we assumed every pose from champion skaters to riders in a sleigh.

The three of us, Sara, Leon and I, slept in the one room and an unemployed distant relative slept on the couch in the living room. When Leon grew to an age when it was considered indelicate to sleep in the same room as his sisters, he was transferred to the couch in the living room.

The narrow front verandah of our home was the window to the world around us and, while gazing about, we could see the constant fights taking place outside the hotel opposite where women came to prevent their husbands from spending sustenance payments or meagre pay envelopes on alcohol. The shop next door was a focal point where people came to purchase their few needs which were usually placed on "tick";[1] the shopkeeper would be lucky if his customers were able to pay the bill at the end of the week.

When we were of pre-school age, mum would tie a cord around the iron gate to prevent us from running on to the road. The verandah then became a cage from which Leon and I peered through the iron bars at the passing parade. Several older children walked past on their way to the shop and, as they did so, they observed us peering at them, "Jew,

---

1.  Buying something on account and paying it off when possible.

2

Jew, you bloody Jew," they yelled. We were too young to know what Jews were, but the manner in which this was said made me, being two years older than Leon, aware that we were being attacked. When the children returned from the shop, mum was approaching the verandah and she heard me yell, "Jew, Jew, you're a bloody Jew."

Mum realised what must have transpired and took us into the house. She was upset by the indignities her children were forced to endure. Life was so cruel. She hadn't wanted to come to Australia.

Mum was born in Pinsk, a tiny village on the Polish-Russian border and was orphaned at the age of six. An aunt, who no longer wanted the responsibility of this unwanted child, sent her to relatives in Palestine and there she grew up to be their domestic servant. She attended school for only six months of her life and was unable to read or write; the burden of illiteracy was something she carried throughout her life and which constantly made her feel inadequate.

With the dowry provided by her uncle (little recompense for the many years of work), she married Sol in Palestine and he immediately made plans to migrate to Australia, the dowry money being used to pay the fares. Lea was averse to leaving the only relatives she had for she felt insecure and threatened, however, Sol assured her that they would remain in Australia only for three years.

The motive for Sol's desire to migrate to Australia was prompted by other considerations apart from those which could have been of benefit to his family and future. He, too, was an orphan at the age of fourteen and was left financially responsible for three younger brothers. He carried this burden for many years and hoped that, upon arriving in Australia, he could appeal to the sympathy of an aunt and uncle already living here to assist him in bringing his brothers across. He thought that Australia would provide better opportunities for the entire family and eventually they all settled here.

Five months after their arrival in Melbourne the first child Sara was born. She was followed, at two-yearly intervals,

firstly by twin boys who died within their sixth week, next by me and then by Leon, my younger brother. Lea knew she would never return to her beloved Palestine nor would she ever see her relatives again. The passing of years, nevertheless, did not destroy her passion for the old homeland which yearned in her heart.

When they arrived in Australia, Sol and Lea were practising Orthodox Jews and carried out the laws of the religion to the letter. Mum told me in later years that, when we were babies, she often placed a bible under our pillows as we slept to protect us from the devil while she ran to purchase something from the shop. However, from the time my mind records events taking place in our home, my parents had ceased being orthodox and were conducting what could be called a typical Jewish home; our meat and milk dishes were no longer separated, but we ate kosher meat.

Sol was a tradesman; a coachbuilder and wheelwright, and was extremely fortunate to have employment, even though it was a three-day working week. He worked very hard in order to keep his job and maintain his family; his work often entailed the repairing and maintenance of the Carlton and United Brewery wagons. Jobs were scarce and money was even more scarce.

Lengthy discussions on poverty and wealth never ceased in our house, and I recall a great deal being said about so many people being poor while very few were rich. I realised there was little money in our home. All the people in our vicinity had no money, and I came to understand that when adults talked about poverty and being poor, that we ourselves were poor. Clothing was provided when absolutely necessary and we always wore hand downs, except on the rare occasion when it wasn't possible to obtain a hand down and the purchase of a new garment was necessary.

When our shoes required mending we would have to miss out on school, for to possess two pairs of shoes was a rare luxury. On one occasion, after dad had for some time inserted cardboard into my shoes to delay repairs, one shoe was sent to the boot repairer while I remained home from school.

4

There was insufficient money to have both shoes completely soled, so one shoe had a small patch of leather placed over the hole. This type of repair created a large lump under the sole of the foot and remained there for several days until the shoe had worn even. However, by the time this occurred it was usual for the other shoe to have worn through.

One evening, while in bed, I awoke screaming with fright. Mum and dad raced into the bedroom, turned the light on, and there I was in a tangle of bedclothes having fallen through the centre of the bed. There was a tremendous hole in the wire base and, because there was no money to purchase a new base, dad had placed a sheet of three ply over the hole. The sheet of wood had slipped away from the hole, and thus the calamity. Even secondhand furniture was too expensive to buy.

Sara was four and a half years older than me and was not interested in playing with Leon or me, so I played with Leon who I dearly loved. He had large brown eyes and the most beautiful brown curls and I would enfold him in my arms, squeezing and kissing him until he would, after much protesting, begin to cry and appeal to mum for help.

When Leon started school, mum sought employment to subsidise the family income and, because she was totally unskilled industrially, she came to an agreement with a local eiderdown manufacturer to teach her to hand-sew eiderdowns. During the first week, she plied her needle and thread without a knot and practised the skill required for her to become proficient. At the end of the week, the boss who was an acquaintance of the family, and knew our circumstances, paid her four shillings. Mum was embarrassed and refused to take it for she had not produced anything, but he insisted that she accept the money and so she had her first pay which was spent on a pair of socks for each of the children. From then on, she worked part-time in various factories and became a skilled finisher in the clothing trade.

Mum was an excellent cook and, with the added money now being earnt, she spent what time she had in the kitchen preparing many beautiful Jewish dishes. We had very little but mum saw that we ate well, even when on many occasions

it meant buying food on "tick".

I attended Lee Street State School and soon became aware of the "susso kids". Although I didn't know why they were called susso kids, I had a vague idea that these children were even poorer than we were as, every now and again, they were asked to step out after general assembly in the school grounds and were given free school books. It was obvious by the reaction of the other children that it was very shameful to be a susso kid, for if you happened to be one of them you were looked upon as some kind of inferior being.

Many of the children attended school during the winter months in sandshoes without socks. Their feet were blue and, while knowing how fortunate I was to have socks, I felt tremendous anguish for these children for I could see they were suffering from the cold.

I now knew my family was poor, but I could not understand what "being rich" meant. On attending two film matinees where Shirley Temple was the star, I observed that the houses in these films were very big and beautiful and the people all wore magnificent clothes. Servants appeared to do all of the work and their style of living in no way resembled my life or that of the people living around me. These must be the rich people mum was always talking about, I thought. Yes, they must be rich people, but they were not cruel in the films, they were very nice and kind. Yet, I asked myself, how did they get the money to buy their beautiful homes and live as they did? It must be as mum said, I thought, they must have workers working for small wages in their factories and shops, after all, dad works so hard and we are poor, so, I reasoned, mum must be right.

As time passed and I grew older, the conversation in our home became more and more troublesome to me. Mum seemed to be arguing with everyone. She was adopting left-wing political views which continually caused arguments and words such as "working-class", "capitalist", "exploitation", "profit", "war", and "Depression" became a normal part of our vocabulary. There seemed to be no joy in the home, only arguments.

Dad, in order to escape from a home of poverty and need, was spending more evenings away playing cards. On the rare occasion he was at home, his card-playing friends called in, so there was more card playing. Maybe his continual absence was the reason mum sought outside interests.

Although mum began to reject religious dogma, her new ideology was based on the theory that communism was intent on putting into practice what the ten commandments proclaimed, the difference being that what religion only theorised, communism would put into practice. As her basic philosophy in life was, "do unto others as you would have them do unto you", it required no profound motivational or ethical shift when she gave up her religion in favour of communism. She was warm and emotional and would often cry when told of injustices perpetrated upon the poor by the powerful interests. She bristled with anger at the liberty these "beasts" were given to inflict such suffering on others. Thus her involvement with left-wing causes was a natural one and no one could restrain her from expounding her views. The only moments free from this harangue in the home were when there were no visitors.

There were always a lot of arguments between my parents over money; there always seemed to be arguments over everything. At a very young age, I recall lying in bed night after night unable to sleep because of the arguments coming from the front bedroom. I would lie there, tense and fearful. Then one evening I heard my father, with voice raised, threaten to kill us all. I was petrified and afraid to go to sleep. I heard dad get out of his bed and leave the bedroom. I listened to his footsteps as he came down the passage to the kitchen. I then heard the cutlery drawer being opened. As I heard the sound of rattling cutlery, I wanted to scream but was too overwrought to make a sound. I waited for him to come in and cut our throats. He went about preparing himself some supper which he often did when returning home late after being out playing cards. I then realised what he was doing, but I could not sleep.

The weekly ritual of bathtime was an ordeal for mum.

After chopping the wood and chips to get the fire going under the copper, she would patiently stoke the fire, waiting for the water to get hot so she could ladle it into the bath. After convincing us that we had to have a bath, heated arguments arose as to who was going to have the first, second or third bath as we were all aware that the first had a clean bath while those who followed would have piss in the bath. Mum, in her relentless patience, would finally clamp down, for to have given in would have resulted in cold water and no baths.

Mum would sometimes take us for a walk and the route taken was always the same: along Rathdowne Street, to Elgin Street, then along Lygon Street to Tilley's corner. We would gaze in the windows of the shops, admiring the vast array of beautiful goods on display, goods that we could only admire from a distance. After feasting our eyes on the unattainable, we would cross over to the other side of the road and walk home. I felt secure holding mum's hand as we walked but, of course, as there were three of us I sometimes missed out and was disappointed.

With dad being absent from home so often, I enjoyed snuggling up to mum in her bed for she was soft and warm. It was only on rare occasions that dad seemed to be happy, but at odd times he would come into our bedroom while we were in bed and sing to us. He had a fine singing voice and I would enjoy listening to the beautiful songs and respond to his feeling of well-being. When he stopped, I would plead with him to continue for these moments were very rare and the only opportunity I had to feel close to him.

Our household always seemed to have extra people in it, for my parents could not turn away the needy, resulting in what seemed to be a constant stream of unemployed men sitting down to a bowl of soup, borsch, or at least to some bread, jam and a cup of tea. These men were migrants; some of them were bachelors, others were married and hoped to earn enough money to bring their families here. They were desperately lonely men and missed their families deeply.

In retrospect, it all seems so strange: we were poor, yet both mum and dad were generous in their hospitality to others. No

person came to our home without food of some description being offered. My parents were similar to Aboriginal people: we had almost nothing but our food was shared.

Mum decided to formally join the Communist Party and discussions in our home took on further dimensions. The overseas events created great concern and mum, in her usual passionate way, wanted to know at any minute of the day what developments were taking place. Her inability to read prevented her from discussing current events or theoretical concepts in any explicit way, and she reduced all the discussion down to clichés such as "religion is the opium of the people", or "capitalists are parasites on the backs of the workers, and they cause wars".

My only escape from these serious voices was on the street with the kids, retreating into the bedroom, or playing in our poky backyard. I was accepted into Leon's peer group without any difficulty and spent many hours building pirate ships, trains and aeroplanes from fruit boxes, old chaff bags, the kitchen chairs and assorted other bits and pieces. I do not recall ever being permitted by the all-male group to be a captain of the pirate ship, train driver or pilot but, nevertheless, I joined in all the games with a great deal of earnestness and imagination and the group accepted me, even though I was a girl.

When looking back, I sometimes think that my early acceptance within this male group may have caused some of the contradictions and confusion which beset me in later years when being rejected by the adult male structures. Some of my favourite games were chuck the tin, tick tack, hidey or tiggy, and I felt quite at home with all the boys in the street. Mum became very cross on one occasion when she discovered that Leon and I had cut her broom handle off to make a tick tack set. We were most unpopular, to say the least!

When the weather prevented us from participating in outdoor activities, I would sometimes prevail upon Leon to play mothers and fathers and the one and only doll I ever possessed became the baby. We would rapidly tire of this game and

9

made several attempts to coerce the cat into lying in the pram, but these efforts were always unsuccessful. I preferred to make things for my doll and took great delight in designing and creating all types of garments out of rags and old clothes. European people come from countries where woollen blankets are a luxury possessed only by the wealthy. My parents had a huge feather eiderdown on their bed and I made my doll an eiderdown, even covering it with a white loose cover to prevent it from becoming soiled.

There was no money for toys and when dad agreed to allow Leon to buy four ball-bearing wheels to enable us to make a pushcart, there was great jubilation. With the pushcart completed, I took part in the races as both pusher and driver, and my ability was never questioned or rejected. It was great fun to line up together at the top of the incline in our street. All ready for the take-off, we waited until someone shouted, "ready, set, go", and we would race down the hill as if our lives depended on the outcome. I became an accomplished marble player; bunny hole was my speciality and I accumulated three hundred and seventy-five marbles — this was apart from the marbles given to Leon.

Our home was the meeting place for all the kids, there being nothing of any value in the house to spoil or ruin, for while we sometimes entered the homes of our friends we were forced to sit quietly, which we found restrictive and soon became bored.

We were at a friend's home when Leon first witnessed a baby being breast-fed. On leaving the house, he immediately turned to me and, in a shocked tone, asked, "did you see what that lady was doing?" I replied, "yes, all babies are fed that way." "I wasn't," he retorted. "Yes you were," I insisted. "I was not." "All right, we'll go home and ask mum". So we raced home and as usual, mum was in the kitchen. "Mum," I asked, "when Leon was a baby, did you feed him up here?" and I indicated the breasts. The only term I knew for these parts was "tits" and, in this situation, I was too embarrassed to say the word so resorted to the gesture. "Yes," said mum, "all babies eat that way." Leon was sickened. He placed his

10

hand on his stomach, bent over, and put on a gagging act. He was almost ill at this horrific enlightenment.

It is with deep feelings of remorse and guilt that I recall the disregard we had towards mum in our reluctance to interrupt our games to eat our meals. She would call us and we would pretend we didn't hear until, in her exasperation, she would come forth with two school rulers placed together and only then would we dash in. We didn't play up when dad called us, for we knew we would get a whack across the head if we dared ignore him. We would sit at the table under sufferance, hastily devour the food before us, and dash out into the street again to continue our games. It now seems such a wasted effort for mum to prepare such time-consuming dishes for us, yet she was happy to see us eating.

Sometimes Leon and I would walk to where dad worked, as we enjoyed watching him work. Dad was short and thin in stature, and the veins on his hands and lower arms swelled as he grasped the large pair of tongs to retrieve the red steel from the fire. Placing the piece of red steel on the anvil, and holding it in position, he would pound the hot steel into the required shape with a large steel hammer. Small sparks of red steel would scatter in all directions and the sharp piercing sound of steel crashing on steel was deafening. As the steel cooled off, he would poke it into the fire in order to soften the metal and again he would pound it into shape. When the right shape was attained, he plunged the metal into a trough of cold water and this process created a hissing and gurgling sound until the metal cooled off. I was always fascinated by the huge bellows and would ask dad to pull on them so that I could watch the flames grow higher among the coals. I was interested to watch the entire process which dad used and the slow methodical tradesmanship he applied until the wagon was ready for the road.

Huge and magnificent draught horses were brought to a yard near dad's work and I would watch the farrier shoeing the horses. I couldn't help feeling that this process was cruel and that the horse must suffer pain but it stood there patiently while Bill the farrier, with his back to the animal, drew the

hoof between his knees, placed the hot metal shoe against it and gently pounded the shoe into shape. A strange odour pervaded the air as the heated shoe burnt the surface of the hoof. After obtaining the correct shape and cooling the shoe in water, he proceeded to nail the shoe to the hoof.

Dad would have his card-playing friends around and pursued this pastime for what seemed interminable hours. Mum provided them with supper and fruit, but not without a price. She reasoned that with the Spanish war at its peak, she must attempt to raise urgently required financial assistance for the Spanish Relief Committee. She requested that the winner of each game place threepence in a plate. This was little recompense for the suppers provided but, after two visits on this scheme, the friends ceased to call and only resumed their visits when the free suppers were restored.

The world situation was very foreboding. Italy had attacked Abyssinia and justified this barbaric onslaught as bringing civilisation and Christianity to a pagan section of what was once part of the Roman Empire. Japan was already committing atrocities in China with the intention of conquering this vast land, and the Spanish Civil War ceased being a "civil war" when German and Italian arms were sent in to crush the people. This provision of foreign arms was also an opportunity to test new weaponry, for these powers were already preparing ahead; they had big things in store for us.

It was during this period that the building of the flats next door proceeded and I had my first puff on a cigarette. Our peer group purchased several cheap brand cigarettes and we hid amid the construction work for the great experience. What a disillusionment. I became quite ill, but was too afraid to let on to the group for fear of losing their approval. Mum did all she could to prevent us from being rejected by other children and when they returned from the fish and chip shop clasping newspaper packages of chips, mum, who vehemently disapproved of dripping, would fry chips in oil, wrap them in lunch wrap, then newspaper and give them to us to take out in the street. She loved us dearly and no effort for us was too great.

The one and only aspect of the peer group which consciously displeased me was their choice of films. When we first began to attend matinees, the violence of the serials and films terrified me. In order to escape from the cruelties and horror being screened, I would slide down in my chair or crouch down between the seats. To block out the terrifying sounds, I placed my hands over my ears. But, of course, I would not tell the group of my feelings towards these films. I later adopted the attitude that I didn't like pictures and preferred to remain home and spend my pennies on sweets. I now wonder how many males fabricated similar tales to preserve the peer group approval.

While young, I was never aware of being different to boys. My acceptance by Leon's peer group, my ability to play all of the boys' games and my ignorance of the "birds and bees", made me a young person rather than a young girl. My first encounter with the sex difference was when I was ten years old. Together with three boys, one of them Leon, we went for a walk to Princes Park. While playing there, we approached a young man about eighteen years of age who happened to be walking through the park pushing his bicycle beside him. We began to ask him for a penny and joked with him about giving us a penny each. The young man gave the boys four pennies on the condition that they were to go to the shop for ice-creams while I had to remain with him until they returned. I immediately sensed that something was wrong but felt foolish in my fears, for they were based on intuition alone, and I felt that the boys would not understand these fears, so I stood there watching them run off.

When they were out of sight, the young man undid his front trouser buttons then took hold of my hand and attempted to place it inside his trousers. I didn't know what he wanted me to do, but I sensed there was something wrong and ran off home as fast as I could. I did not breathe a word of this to mum. The boys eventually arrived home completely undisturbed and asked me why I nicked off. They said they looked but couldn't find me, so they ate my ice cream. They didn't for one moment consider that I could have been in any danger.

I told them I got tired of waiting and left for home.

At school the work seemed reasonably easy and I put little effort into it; it was something all children had to do, and I did it. On reaching the fifth grade, a new system was introduced into the school where the best pupils from the fifth, sixth, seventh and eighth grades were placed in the one room and under one teacher. This was called the special tutorial class and we were considered to be the elite of the school. For some reason or other I wasn't at all flattered or pleased by this sudden elevation. I actively disliked the teacher and the new situation for, besides having his favourites, he was unnecessarily sarcastic, and a reactionary.

I was at this early age, due to my home environment, already arguing about politics, and we immediately clashed on this ground. This was my first lesson in authority and politics, for I quickly learnt that when anyone in authority says that politics are not allowed, what they really mean is that only their politics are permitted. I was also in a position where, because I was placed among the most intelligent kids in the school, I had more competition and was forced to make an effort. I was reluctant to put time into anything unless it pleased me and playing games was preferable to doing homework.

It was during this period at school that my sister, brother and I all developed head lice (poor people's disease). Mum was nearly driven frantic in her efforts to eradicate this pest. She always prided herself on her clean home, for while the rich cling to their money, the poor cling to their cleanliness, their last vestige of dignity. She lined us up night after night, soaking our heads in kerosene, combing our hair with a fine tooth comb or using some other concoction recommended to rid our heads of this affliction. The three of us had long, thick, curly hair which made the task more difficult and we resented having to sit there patiently while mum cleaned and combed. We alleviated this suffering by insisting that we be permitted to kill the lice as she extracted them (the poor kid's amusement), but with all mum's efforts, she didn't seem to be getting anywhere. Short hair was not in vogue at the time and there was a great wailing when dad insisted on cutting our

hair. This event was nothing short of a great family tragedy, the trauma of which only abated with time.

One of the men who called into our place at regular intervals was known within the family as "fat Jack". He was repulsively obese and the front of his clothes were food-stained where his gigantic paunch protruded out beyond his chin. I always avoided him because of his uncleanliness. He lived very frugally and saved his money in the hopes of bringing his wife and children to Australia. He always called in for a free feed, and mum was eventually forced to tell him that we couldn't afford to feed him, so they reached an agreement where he purchased sufficient food for himself and mum cooked it.

One evening he was sitting on the couch in the living room and, as I ran through, he called me over. There was no one about at the time and when I approached him, he took my hand and attempted to place it against the lower part of his body. I immediately withdrew my hand and ran away. After the war, "fat Jack" had a stroke when he heard that his entire family had perished in a concentration camp in Germany and he died not long after.

I never told my parents of my two encounters with men at this early age. The conditioning of women as peacemakers and the need for us to be the conscience of the world had already permeated my psyche and, apart from not wanting to cause any trouble in the family, I valued the little freedom I had. My greatest pleasure was playing with Leon's playmates and I was desperately afraid that restrictions would be placed on me and I would be deprived of this joy. I never spoke to anyone of these incidents until thirty-three years later when, on becoming a feminist, I was surprised to learn that the majority of women had had similar experiences when very young. Why is it that the victims continue to remain silent?

There was only one girl at school I ever felt close to; her name was Miriam. Miriam's father was a gas victim of the First World War and was unable to work. There were several children in the family and they were poverty-stricken. I always admired her brilliant mind and her talent for art; a talent I

did not possess. Her books were always raggedy, with blots on the pages and the corners all curled up, but her mind was alert and able to grasp concepts. She became dux of the school and there it ended, for poverty forced her to commence work in an office. Several years later on meeting her in the street, she was the same old Miriam – dress hanging where it touched,[2] the same dishevelled hair and the same vibrant, beautiful face. She showed me a watch she had just received through the post from an anonymous admirer. Perhaps this person, like myself, was aware of what society had done to Miriam. She eventually married and had five children. Oh Miriam, how much poorer the world is by being deprived of what you could have given.

I displayed a talent towards music, so mum went to great lengths to buy a piano-accordion for me, and music lessons began at the age of eleven. I was happy playing for my own pleasure, and for the pleasure of others, however, it gradually became a chore when mum put continual pressure on me to practise. The regular need to exercise scales began to bore me, but this was essential if I was to become proficient. I knew the sacrifice made by my mother and sister who surrendered their insurance policies to enable me to get the instrument, so I felt I owed it to them to persevere.

I had long since passed the stage where it was possible to kiss and hug Leon; the incest taboo having set in. However, this was compensated for by the acquisition of a kitten. Micky was the sole creature who could accept all the affection I had, and I would hug him close and he slept on my bed. One day when I was playing out in the street, a boy ran up to me and gloatingly said that my kitten had been killed. I recall yelling at him, "You're a liar." "I am not," he retorted, "your kitten was run over by a motor car this morning." He seemed to rejoice in telling me the news but I didn't believe him. I ran like a mad thing. The front door was open and I raced down the passage to the kitchen. "Mum, mum," I called. "Jacky told

---

2.  Old expression meaning the garment was so baggy it only touched the body randomly.

me that Micky was killed. It's not true is it?" Mum looked at me with sympathy. She put her arms around me and said, "Yes, it is true." The tears welled up in my eyes. I didn't want to cry over a cat in front of mum. I felt embarrassed to display my emotions so I ran out into the yard, sat on the toilet and sobbed.

Micky had been so dear to me. He was so lovable and was the only thing I had. He was so warm and cuddly — why did he have to die? I eventually had to leave the toilet for, although it was the only place where privacy was possible, I didn't want anyone to catch me crying there. I reluctantly entered the house, with my eyes red and swollen. Mum knew and understood. "Look, Zaldala," she said, using the Jewish diminutive of my name, "we will get you another catsalla." I was given another kitten but it was never the same. This cat, like the other old tom we had, seemed to be a family cat. It wasn't just mine to love.

Despite the valiant efforts on mum's part to fatten us all, I was always a very thin child. Mum was a short, rotund woman and most Jewish women of that generation considered fat children to be healthy children. They often commented on my thinness and even asked if I was ill. I tired of these unsavoury comments on my body and often felt like poking my tongue out at them. I would have delighted in making a rude gesture, but refrained from doing so because "nice" children didn't do such things. Mum would bristle and reassure them on my sound health, for no one could say a word against her children.

My thinness was a handicap and when we went to the beach (a rare event), I would rapidly turn blue after entering the water. Mum would haul me out while I shivered and shook, wrap a towel about me, and there I sat until the heat of the sun penetrated my bones. I developed a complex about my skeletal shape and was deeply self-conscious of this for many years.

At the age of eleven, when approaching puberty, I developed a strange complaint. I had swellings of a size which covered my entire chest, the complete back of my neck or the whole area behind my knees. Unfortunately, these swellings only

appeared when I was warm in bed or sitting before the fire, so whenever mum took me to the doctor there was nothing for him to see. He could only diagnose the problem by our description of the malady and, being lodge patients (poor people's method of obtaining a cheaper medical service), he wasn't very concerned and said I was suffering from hives; the remedy being to refrain from eating eggs and oranges.

After accepting his advice for nine months, without any success, he then asked if I had my periods. I was afraid to answer his question as mum had never spoken to me of periods and I wasn't supposed to know anything about it. But being placed in this situation, I had to answer honestly and so I said "no". He then bellowed at the top of his voice, "Why didn't you tell me this before?" I was terrified of him. He prescribed some medicine which he claimed would not only stop the swellings but would bring on the periods as well. On leaving the surgery, mum wanted to know who told me about periods. I was too afraid to tell her Sara told me that girls bleed every month, so I said a girl at school told me. She didn't inquire as to what I had been told, all she said was, "Now that you know about periods, keep away from boys." This was the only advice ever given to me by my mother on the facts of life.

I still had no idea how babies came, even though I had on several occasions asked mum for information. The other members of the peer group were also ignorant, and we met together and made a pact. The first one to find out how babies came was committed to inform the group, so we all dashed off in search of this important knowledge. Leon and I approached mum and again asked for the umpteenth time, but she laughed and fobbed us off by saying, "If I answer all of your questions now, what will you have left to learn when you grow up?" This was her favourite saying when she wanted to avoid answering our questions. It was hopeless. We walked away disgusted. Bertie, a member of the group ran around excitedly to let us know he had made the great discovery and would tell us that evening.

We all met at the agreed time and were excited as we

waited for the great words of wisdom to flow from Bertie's lips. He had a very attentive audience and said, "Ladies have got a hole underneath somewhere and the man puts his dick in it." This was the sum total of his profound statement. There was stunned silence.

I said nothing and turned on my heel and headed for home. Leon came running after me. "Hey, do you believe what he said?" he asked. I pondered. "I don't know," I replied. I was busy thinking. "I don't," Leon said and guffawed. "That's mad," and he happily dismissed the great revelation. Being older than Leon, I was already asking myself questions to which I had no answers. Why are mum and dad allowed to get undressed in front of each other and sleep together while we are not permitted to undress in front of each other? Perhaps, I thought, there is something in what Bertie said.

The Communist Party was declared illegal, and Lea permitted meetings to be conducted in our home. On these occasions, we were asked to watch outside the house in case any strangers approached and, although I did not understand the serious implications of all this adult business, I did as instructed by my mother and never told the other kids what was going on in our home.

To publish or distribute communist propaganda was also illegal but there was always printed matter in our house.

I was never happy with all of this political talk within the home and it seemed incessant. I felt it further added to the already existing dissension in our home. I did not question the validity of the arguments in reference to the injustice done to the working people, for I was sensitive to the poverty all about me, but the continual arguments and serious talk distressed me.

The Second World War had commenced and dad decided to purchase a radio, a luxury previously denied — a luxury which now became a necessity to enable him to keep up with the war news. The brief broadcasts were soon found to be inadequate, so the *Herald* was purchased every evening to enlighten mum and dad on the latest events. The buying of the *Herald* proved to be a tremendous chore, for I was called

away from my games almost every night and had to sit and read all the war news to my parents.

I protested vigorously but to no avail. There was no way I could get out of it as my parents were unable to read English. One evening I decided to play it cunning and jump paragraphs in order to reduce the reading. However, dad realised there was something wrong when one moment he was hearing what Churchill was saying, then before Churchill had obviously finished, he was in the midst of the African campaign. He awoke to my ruse, severely roused at me and made me return to Churchill's speech. Mum would sit and weep at the unnecessary slaughter of beautiful young men.

The ban on the Communist Party was lifted in 1941 and mum undertook to deliver the *Workers' Voice*, the Party publication, but it was Sara who delivered the papers, and occasionally when asked to help out, I would borrow Sara's bike and take a turn.

I convinced mum to allow me to leave Lee Street school and transfer to the Brunswick Girls' School (Domestic Arts) where I thought I would be far more content. I was considered to be an outstanding pupil at this new school. However, this was not so, it was simply that the standards were lower than those I was accustomed to in the special tutorial class at Lee Street and, because this new school was a girls' school, there was more emphasis placed on sewing, cooking, and laundering — the activities required to prepare us for being efficient in our future housewife role.

Mrs Campbell, the science teacher, made several attempts to encourage me to pursue an academic career, preferably science, and suggested I should ask my parents to allow me to remain at school for this purpose. This request was unreal: I already considered myself to be a financial burden on my parents. Our home was not conducive to serious study, and I was not the slightest bit interested in pursuing an academic career.

In truth, it was impossible for me to envisage what an academic career entailed or what the final concept of being an academic could be. The only formally educated people in my

experience were our doctor and my school teachers, and it seemed as if they were from another planet; a planet on the other side. I had no choice or expectations, for my only living experience was to work and battle to survive. All I wanted to do was to reach the age where I could leave school and earn enough money to free my parents from the responsibility of providing for me.

I wanted to buy nice clothes to make me feel good and perhaps make the decisions affecting my own life. Knowing I would be going to work as soon as age permitted, I lost all interest in schooling and was absent from the merit examinations.

I left school before I turned fourteen.

# 2

LEAVING SCHOOL WAS A DELIGHT and I commenced work as a general hand in a shortbread factory around the corner from home. The need to be selective in employment never occurred to me for people only worked to obtain money to live, so one job became as good as any other when money was the only motive for working.

There was nothing streamlined about this factory; it was small and scruffy with a sweet sickly odour constantly pervading the nostrils. Apart from packing the finished products on to wooden crates in readiness for delivery, one of my tasks was to place a tiny portion of what appeared to be raspberry jam between the two sections of shortbread to act as a binder. This jam arrived in four gallon drums and I was astonished when one of the men opened a drum and revealed the contents. The jam was an anaemic green colour and on inquiring I was told that it was melon jam, the cheapest jam available. The man proceeded to pour a vast quantity of red dye into the container then gave the contents a thorough stirring to ensure complete penetration into the jam. It was only with time that I became familiar with business methods and learnt that the demand for profit justifies the means.

Now that I was working, and somewhat adept at playing the piano-accordion, young people began to gather at our home for parties and socialising. Others brought their instruments along and many a good night's entertainment ensued with dancing, singing and much merriment. No alcohol was permitted as my parents were teetotallers but, with all of the gaiety about us, we didn't need alcohol.

One of the young men who was a regular caller to our

house, asked if I would accompany him one evening to the local picture theatre. This was my first request and I was most excited when I asked mum for her permission. She was concerned, for I was still so young, but considered that, because this lad was a regular caller, I would be safe in his company. Permission was granted and I looked forward to my first date with great enthusiasm; my thoughts were constantly engaged with what I would wear. I was no longer part of Leon's peer group. This had ceased at puberty for I began to bleed, realised I was different and accepted my femaleness.

Since commencing work, my wardrobe had attained a few additions which enabled me to ponder on the necessary preparations for the big night out. The night was warm so I donned a red skirt and white blouse. After spending what must have been at least an hour before the mirror attempting to arrange my hair in a suitable style (almost impossible to do anything with a thick mop of curly hair), my preparations were completed.

I gazed at myself in the mirror and was satisfied with the results; that is as satisfied as I could be for I wasn't at all happy with the shape of my nose, an inheritance from dad which we all developed at puberty much to the chagrin of mum.

Being unaware of the dating scene and the possibility of getting a "skinner",[1] I anxiously awaited the arrival of Des. He arrived on time and I floated on air as we proceeded towards the local theatre, automatically taking the route I had always taken as a child which meant cutting through the park. I was so elated, the film was of secondary importance and when it ended we proceeded the same way home.

Des made no attempt to hold my hand and I wandered along feeling secure, happy and content in this first experience of someone wanting to be with me. We approached the park and as we proceeded through, we walked across the turf where the swings and slides were. Des grasped hold of me and, while groping and clawing at my body, he attempted to

---

1.  Being stood up – when one of the couple does not turn up for the date
    the other gets a skinner.

force his mouth upon my lips. I became alarmed and tried to fight him off, but his strength was greater than mine. He pushed me down on to the turf and, being terrified, I writhed and fought like a tiger. After several minutes of struggling, he relaxed his grip and, taking this opportunity to wriggle free, I ran home.

As I neared home, I realised that my clothes which I had taken so much delight in selecting and preparing were now in a mess. The red velvet bow from the back of my hair was missing and my hair was full of tiny pieces of turf. With pounding heart I rearranged myself so no one would detect what had occurred. Fortunately there was no one about, all were asleep when I entered the house and I was able to get myself to bed without anyone knowing. I was extremely upset and disappointed. I lay in bed and thought, why, why, why? It was terrible, terrible, and I would always hate Des and be afraid of him.

Next morning when getting ready for work, mum asked me if the evening had been enjoyable. "Oh yes," I replied, "it was a very good picture," and all communication ended there. Once again the victim remained silent.

I set off for work and on turning the corner was confronted by Des. He grabbed me by the arm as I went to dash by and attempted to apologise for his behaviour. I felt terror on sighting him. I was afraid and overwrought and pulled my arm from his grasp as I fled into the factory. Later, during the day, I was called to the phone and was astonished to hear Jan's voice. Jan was Des' sister and she insisted I call around to see her.

When the opportunity arose, I visited Jan and she explained that Des had arrived home after my refusal to speak to him and confessed to her the events and his behaviour. She went on to speak of his remorse and guilt and said he was extremely sorry for his conduct. She was much older than Des and had probably experienced similar situations, however, what she didn't know was that this was my first date, the first experience with the opposite sex. I listened to what she said but told her that I never wanted to see Des again.

Several months of working in the shortbread factory had become an extreme bore. The decision to find another job was precipitated when the army took over the factory and converted it into a hot box kitchen: a meal supply centre for military establishments.

A grocery manufacturing firm in Collingwood was my next place of employment. There I stood day after day hand filling packets with a pudding mixture. The huge metal bins contained the mixture and, with scoop in hand, I would plunge the scoop in and bring the mixture up and tip it into the packet. The flour in the mixture floated about in the air and, by the time the day's work was over, I was covered in flour. There were two different brand name boxes but the same mixture went into both. Because of the unplanned public transport system I had to change buses twice, so I walked the two miles home. The need to walk this distance, plus the nature of the job, soon sent me in search of other employment.

Sales was another job I attempted and I have never understood why saleswomen think themselves to be above the working class in status. There I was at Payne's Bon Marche, where I very quickly realised that I wasn't the type of person who could keep a perpetual smile on my face for the benefit of the customers. Nor could I pretend to be interested in refolding the goods which they continually disarrayed.

After sales, my next job was in a factory where army clothing was produced. I was seated at a button sewing machine with a number of small sections of material; these small pieces of material being fly pieces of men's shorts.

My job was to place the button over the mark on the material, hold it in position, then press the lever on the floor with my foot. The needle was supposed to stitch through the holes until the button was firmly attached to the material but, although this process seemed quite simple, for some reason or other it just didn't work. Almost every time I pressed the lever, there was a terrible grinding sound as the needle crumbled against the metal button. There was no shield on the machine and I was afraid of getting a fragment of needle

in my eyes so, to avoid this, I would hold the button and material in position, avert my face and then press the lever. Needles, like all other goods, were difficult to obtain during the war and I was embarrassed when having to continually approach the boss for another needle. When lunch-time arrived and I had what must have been a record of thirteen broken needles, I left the factory never to return.

All of these jobs were uninteresting and my only escape was in reading love stories. It was necessary for me to work in order to obtain sufficient money to live, but I felt there must be more to life than this. I found the answer in *The Oracle* and *The Miracle*, both cheap publications of romantic love stories. It was in these stories that I would lose myself, thinking that here was the "real life"; not the sort of existence I experienced at home. I fantasised myself into this world of romance, love and security and anxiously looked forward to buying these magazines weekly. I was able, through these magazines, to block out the uninteresting jobs and the home of poverty, problems and arguments.

I reached the stage where I wanted to be needed, wanted to be loved and, more than anything, to be able to give love. I went out with very few boys because my first experience was not an exception. Every boy I went out with, although not so brutal, was after the "one thing". I withdrew more and more into my own world of fantasy where it was so much more pleasant, a fantasy within the romance stories where homes were grand, there never seemed to be a lack of money, people spoke kindly to each other and everything ended up happily ever after. I was becoming a loner and didn't have any girlfriends. Life didn't seem to hold much in store for me, for what motivating force could there be in a situation like mine?

I desperately wanted to get away from it all and asked mum if I could go away for a holiday. She advised me to go to visit dad who was now stationed in a labour company at Tocumwal. All was arranged for this holiday but, on my arrival at Tocumwal, I was greeted by a friend of the family who informed me that dad had, that day, been sent to hospital

for an operation on his knee. Angelo was delegated by dad to care for me in his absence.

Angelo was a middle-aged bachelor, a man whose communism meant a way of life rather than an adopted ideology, and he certainly looked after me. The days were very long with nothing interesting to do or see and so, on one occasion, I took myself for a walk to where Angelo was working.

Several men dressed in military uniform were unloading the train and I watched as they went about their work. One young man approached and spoke to me. He was dark and handsome with a cheeky look in his eyes, and he spoke English without any trace of an accent. After talking for a few moments, I asked him his nationality, as only migrants were accepted into the labour companies. "Italian," he replied. I was surprised, "But you speak perfect English." He then explained he had been in Australia for six years. He looked at me with a twinkle in his eye and said, "You have hazel eyes, just like mine, what a coincidence." I liked him; there was something about his freshness of feature and vitality so, after talking together for a short time and explaining the circumstances of my holiday, we made arrangements to go for a bike ride on the following day.

I managed to borrow a bicycle for the occasion and we pushed our bikes at a leisurely pace through the beautiful countryside. We chatted together as we rode and were astonished at the distance covered, for we realised that time was passing rapidly and we would need to speed up the return journey. Tony was pedalling strongly when one of his tyres completely flattened. Angelo was not informed of this outing and I knew he would be very concerned if I was absent for any length of time. After walking with Tony for some distance, I excused myself and hastily returned. Angelo was worried and, after explaining the circumstances of my absence, he became quite irate and stated that under no circumstances was I to see Tony again because he was "no good".

Angelo then decided to spend more time with me and, bringing his two dogs along for company, we went for many walks. One very warm and sunny day we trudged through

the countryside for several miles and eventually sat down for a rest. I spread myself out and relaxed, only to awaken two hours later to find that my head was covered with newspaper. Angelo covered my head to protect me from the sun and there he was, sitting and waiting patiently with his dogs. He certainly was a good friend. However, another young man obtained his permission to take me to the local theatre without consulting me. I didn't want to go out with this fellow and told Angelo of my feelings, but he claimed this man to be a fine young man and said I would enjoy a pleasant evening. The pleasant evening concluded with another wrestling match. This was my first experience in learning that no man can judge another man where women are involved. I did not tell Angelo of this incident.

One of the very few jobs available to women at the time which had an aura of status was that of usherette and, on my return to Melbourne, I was excited with my good fortune in getting such a job at the Liberty Theatre. I applied a thick coating of make-up to my face (a necessary requisite), put my age up to eighteen and thought I was made when I received the increased pay envelope. Money was the only motive for working so the more pay in the envelope, the better the job.

I had stopped going out with boys at this stage so the shift work presented no problems. Again I began to question the status of this employment. Theatres in those days were not air-conditioned and the inner atmosphere became musty and stale. The staff were plunged into darkness for eight hours and subjected to the inane dialogue of C-grade films day after day and night after night for weeks on end. As if this wasn't bad enough, the management instructions forced us to wear the then fashionable spike high-heeled shoes and running up and down the stairs in the lounge and dress-circle became a nightmare.

Tony was on several days leave and called in to see me. He would wait at the theatre and accompany me home after work. Like most pre-war migrants, Tony migrated to Australia with his father, the intention being to save sufficient money

to bring the rest of the family to Australia. Once the war commenced, plans were shelved and Tony volunteered for the armed forces. He was accepted into a labour company, the non-combatant service where all volunteers who were aliens, unnaturalised or stateless citizens were placed.

When Tony returned to camp, we corresponded with each other and a romance developed. I cherished the poems he wrote and read his letters over and over again. I felt that here was a man who truly loved me and here was my opportunity for happiness and fulfilment. I genuinely believed that all a woman needed in life was a man and love. We were both young and, on each occasion when he returned to Melbourne, we were delighted to be together, however, we found it extremely difficult to control our needs for we wanted and needed each other. I kept on thinking we mustn't do anything, but it was so difficult. We longed to express our feelings without any limitations but I was afraid of my father and constantly thought of what people would say if I "got into trouble". I knew that the penalties meted out by society were very severe on women, for men could do anything, but women couldn't. I knew if our relationship was to continue I might weaken so, plucking up courage, I approached mum, explained the situation and told her I wanted to get married. Mum was very wise in the ways of life. She understood my situation and granted permission. Six weeks after my sixteenth birthday I was married.

# 3

THE WEDDING WAS A HAPPY ONE. Clothes during the war were available only with coupons and styles were very limited, so my wedding outfit consisted of a dusty pink short-length frock, a dusty pink hat and black accessories. Mum, Sara, Leon and Dave (a mutual friend who was in the forces with Tony) were the only guests and at 10.00 a.m. we met at the registry office for the service. My father and Tony's father were absent: they did not approve of the marriage. On the one hand because I was not Italian, and on the other because Tony was not Jewish.

The registry office was a bleak and austere place for a wedding, however, the "Do not spit on the floor" sign did not dampen our spirits. At the conclusion of the brief ceremony we were left at a loss, for the luncheon was to be held at midday at the Menzies Hotel. After some discussion, Tony and I decided to visit a news theatrette for an hour. On arrival at the theatre, I removed my hat and thick wartime stockings and was far more comfortable. I had only recently lost all my upper teeth (the result of poverty) and mum had paid for the denture as her wedding present to me. I was still unaccustomed to wearing the denture and refused to have any photographs taken.

The lunch was an experience for, not only was it the first time I had dined at a hotel, but the drink-waiter, not knowing we were a wedding party, recognised my youth and refused to serve me alcohol. So the bride drank orange juice (too young for grog, but not too young for sex).

Tony was granted the special eight days leave from the army for our wedding, but because there was no money for a

honeymoon we decided to go to our room; the room I had found with great difficulty. We were quite happy but, on entering our room, I was confronted with my fears; the fear of undressing in front of another person. Never before had I seen a naked body, nor had anyone seen mine. My greatest moments of anguish as a child had been when, on visiting the Carlton baths, I had to get undressed and dressed. It was a tremendous ordeal trying to manoeuvre my clothing from underneath a towel and, when other women or children stripped in my view, I would turn my face away. Now I was confronted with a husband and was painfully embarrassed. Tony understood my predicament and I did not undress in his sight for one year.

We were blissfully happy and it was agreed that I should accompany Tony back to Albury where he was stationed. I floated on a cloud; I could now kiss, hug, have sex and give all I had to give. Several days after our arrival in Albury, I developed what I now know to be cystitis but, not then knowing what the problem was, I began to cry with the pain. I had never before experienced such pain and Tony urged me to attend the doctor. I made enquiries as to the whereabouts of a local doctor and visited the next morning.

The doctor noticed the Melbourne address on the card and asked the purpose for my being in Albury. I explained the circumstances, then he questioned me about the reason for my visit. On describing my symptoms, he dismissed me with, "you most probably have VD so go back to Melbourne and see a doctor there." I was so young and timid that I just got up and walked out. Tony, on hearing the result of my visit, wanted to go and punch his head in, but I pleaded with him not to do so. I endured the pain until the condition went.

On returning to Melbourne, I called in to see a doctor and explained my reason for the visit. He made no comment about the Albury doctor but explained the nature of the complaint. Now that it had cleared, he said there was no need for treatment. Observing my tender years, he then questioned me about the possibility of children and asked if I wanted to delay childbearing. On explaining to him that I would prefer

to wait for some time, he advised me to soak a man-size handkerchief in oil and insert it into the vaginal passage. This was, in his opinion, the best form of contraception.

My rigid upbringing made any attempt to touch or penetrate my own body impossible, so I dismissed his suggestion. I approached mum for advice but she pleaded ignorance and said she didn't know what to tell me. She advised me to buy some books on the subject and see another doctor. I called on another doctor and was given a Marie Stopes Cap.[1] Again I was faced with the problem of penetrating my own body. How was I going to do this? I discussed the matter with Tony but he couldn't understand what an ordeal this would be for me. Men grow up seeing their genitals and their bodies become acceptable to them, but women are reared to hide their bodies away and it is, for some, almost impossible to accept the fact that they have genitals. This area not only becomes taboo for others, but also becomes taboo for them too. They, in reality, suffer from self-body hatred. The desperate need to protect myself from becoming pregnant forced me to insert the device. I felt while doing so that it was dirty and I never overcame my dislike of this procedure.

Accommodation was almost unprocurable during the war years and we were most fortunate to have a downstairs front room in a double-storeyed house in Carlton. I had to share the cooking facilities, one stove, with four other women; three of us between the hours of 5.00 p.m. and 6.00 p.m., and the other two (one being the landlady) from 6.00 p.m. to 7.00 p.m.

I was forced to find a job which would enable me to commence cooking at 5.00 p.m., so I started work on a part-time basis as a waitress. On one occasion, I decided to get some ironing done before preparing the evening meal and, after arranging the ironing and switching on the iron, I couldn't understand why the iron remained cold. I wondered about this then tried the light to see if it worked and it didn't. I opened the bedroom door and saw that the main switch on

---

1. The first contraceptive device invented by Marie Stopes. It was a small cap with a string attached and placed over the cervix prior to intercourse.

the passage wall was turned off. I turned it on and went ahead with the ironing. I had only ironed for five minutes when the landlady arrived home then, to my astonishment, the iron began to go cold. Once more I looked out of the door and again the main switch was off. I switched it on again and was about to go on with the ironing when the landlady ran up the passage and, without making any enquiries, called out that there was no need to have the lights burning before 5.00 p.m. I tried to tell her my lights were not burning but that I was doing some ironing before getting the tea ready, however, she insisted that she couldn't have the power on as others in the house might use the lights.

I was most upset but there was nothing I could do for we had to live somewhere. The landlady worked part-time unbeknown to her husband, held her underwear together with pieces of string and safety pins, and she owed every bookmaker in the vicinity vast sums of money.

As time went on I discovered that a waitress was a punching bag for whatever complaints people had when dining out. The tea was cold, the service slow, the meat was tough and on and on it went, while I had to smile and placate the customers. The woman manager did nothing to prevent the waitresses from being criticised when it should have been directed elsewhere and I eventually got tired of the running, waiting upon and smiling at people while they "punched" me. I was able to elude the authority of Manpower (wartime employment control) by saying I was pregnant, so they were forced to accept my resignation. I decided that learning to sew correctly would be an advantage for a woman and, although I had made my own frocks from an early age, my efforts were unsatisfactory compared with shop standards. So I started work in the alterations department of a Rockman's store thinking I would learn to sew. However, I became the messenger girl and general dog's body around the place. By the time six months had passed, all I had achieved in my quest for sewing experience was the shortening of hems. The other women employed there treated me like a child: to be seen and not heard. I was fed up with the way things had turned

out and told the forelady that I was giving notice. She said this wasn't possible because of Manpower but, not being the slightest bit perturbed, I looked her in the eye and said I was pregnant. She knew I was lying and I received word from the staff manager at head office to call in and see him.

I was ushered into his office and seated. "Now what is the problem?" he asked. I told him I was only sixteen but was a married woman and refused to accept the treatment dished out by the women in the alteration section. I noticed a slight grin appear on his face. "What exactly do you object to?" he asked. I explained the problems and went on to speak of my desire to learn sewing. He asked if perhaps I would prefer to transfer to their Carlton factory where the garments were manufactured. This pleased me, for this factory was more convenient to home and I would gain the sewing experience I sought. He went on to say that the understanding in all factories is for the most junior person to be the lunch-girl and suggested I put my age up to prevent this possibility from recurring.

We had changed our accommodation and were now living in another room where the landlady and I shared the facilities. It was during our stay here that I commenced working at Rockman's factory in Carlton and it was also at the beginning of my employment there that I became pregnant.

The first day at the factory was nerve-racking. The forelady asked if I had any sewing experience and after replying "a little," she brought over a bundle of work, a sample of the frock and departed. I closely examined the garment. It was a smock, a simple garment, and I slowly machined away, glancing continuously at the sample to make sure I was doing the right thing. We were paid piece-work rates, each garment having a price, so the more you made the more you earnt. I was delighted at the end of the week to discover I had earnt over three pounds. Thirty shillings per week was all I had earnt at the alterations department as there you were paid the award wage and being a junior made my wage very small. Tony, too, was overjoyed and we contemplated all we could do with this extra money.

It was only a matter of weeks when I became aware of my pregnancy. I now wanted to have a child but Tony was concerned and worried about the future. He was then a member of the Communist Party and was aware of the economic fluctuations, the likelihood of Depressions and what this would result in for the working people. I overcame his fears with my happiness even though it was an immature joy.

How fortunate I was in taking the staff manager's advice. Several of the women must have suspected I was younger than my stated years and continually asked subtle questions in an effort to establish my age. I was in fact the youngest person in the factory and would have again been the lunch-girl. They ceased to question me on learning of my "mother-to-be" circumstances. On several occasions, while travelling to work in the morning, a feeling of nausea would overcome me. I would alight from the bus, vomit in the gutter then continue on the next bus to work. I enjoyed being at work, perhaps it was because I knew the time was approaching when I would no longer have to go and, besides, as time went by I gradually became more experienced as a machinist. By the time I resigned, which was six weeks prior to giving birth, I was producing some of Rockman's best frocks.

The landlady discussed the disadvantages of living in her house with a baby; I understood the intention of her discussion and began searching for accommodation. I soon learnt that no one wanted a baby in their home. Every morning I got up very early, bought the *Age* newspaper and scanned the columns for a room. One morning there was a room advertised in Moonee Ponds at a very reasonable rent so, without breakfast, I hastily made off into the cold June morning.

I was cold and began to feel slightly ill. I questioned the wisdom of skipping breakfast but it was too late to worry about the situation. On arriving at the correct address, there was a queue waiting and I took my place at the tail end. No one spoke, their faces were gaunt, each person hoping they would be the lucky one. It was half an hour before my turn came around and the moment the landlady saw my condition, she immediately said "no babies thank you," and closed the

door. I was the last in the queue and just stood there looking at the closed door. It was all over so quickly. I felt numb and continued to stand there for a few moments unable to think and feeling so powerless. I had travelled all this distance for nothing; what was I going to do, I asked myself.

The time for the birth of the baby was approaching and we quickly had to get somewhere to live. I was beginning to despair and Tony tried to reassure me that all would be well. I continued to search frantically for a room and answered an advertisement for a place in Elgin Street, Carlton. The land-lady said she had no objections to children but the room she felt would not be suitable because of its size. By this stage I was prepared to accept anything, even a broom cupboard, so I followed her upstairs to the room. She had not in any way exaggerated when referring to the size of the room. I glanced at the old double bed wedged into the corner, the ancient wardrobe and the small table with two chairs, the only furniture that could possibly fit in the room in order to leave enough space for the occupants.

We had no alternative and moved in with our three cases, pots, pans, crockery and cutlery. Tony was now stationed at Royal Park and was home every evening. We were delighted when the large balcony room became available enabling us to double the size of our accommodation. We now had a large room with a fireplace and a balcony to hang the napkins when the baby was born. We had been living in the house for three weeks when one evening I was woken from my sleep with a pain; I waited. After the third pain, I woke Tony and told him the baby was coming. We both waited and on confirmation of the inevitable, we walked the several blocks to the Women's Hospital where I was admitted.

The young nurse on duty commenced taking the particulars and concluded by asking me the proposed religion for the baby. "No religion" was my reply. The nurse while writing down the particulars had her back to me, however, on hearing my reply, she spun around, "But you must give your baby a religion," this was a command as well as a plea. I explained that my husband's family were Catholics and mine were

Jewish, then asked what she would do under these circumstances. "I see," she said, and there was silence. After a lengthy, uncomplicated labour, a daughter was born, a daughter without a religion. We were overjoyed with our daughter, even though she appeared red of face and with what seemed to be large hands. She was so beautiful and we named her Leanne.

On the day of Leanne's birth, the newspaper headlines featured the death of our Prime Minister, John Curtin. Everyone could see the war was nearing its end and I felt so sad; why could he not have lived to rejoice the cessation of hostilities?

There was no post-natal attention given to public patients and I developed an extremely painful condition of the breasts. The sister in charge of the ward took it upon herself to punish women who had, in her opinion, participated in the sinful and filthy occupation of sex, by refusing to inform the doctor of my problem. Sisters often had power trips over the patients for the patients were almost powerless in those situations. After five days of suffering pain and sleeplessness, I broke down and sobbed. Taking courage, I ignored the sister and told the doctor of my pain. He was appalled when seeing the condition I was in and turned on the sister. She shrugged her shoulders and nonchalantly said it was not her fault if my breasts didn't respond to treatment and turned on her heel and marched off.

The doctor gave instructions for the milk to be expressed and fed to Leanne through a bottle. After spending eight days in hospital, I desperately wanted to return home and asked the doctor for permission to leave. Permission was granted on the condition that I continued to express the milk for another week. However, when we arrived home, we realised there were difficulties with obtaining a breast pump.

It was a Sunday and Tony and I decided to walk in opposite directions in search of a chemist shop. This was the first day on my feet since entering hospital for Leanne's birth and I walked slowly until reaching the first chemist shop, only to find it closed. I began to feel faint and was afraid I would fall

to the ground. How foolish I was, the doctor had warned me about being on my feet too much and too soon. I could not remember returning home and I collapsed on the bed. Fortunately Tony was still out and I decided not to tell him of this incident for fear of being scolded. He ultimately returned to the hospital and obtained the loan of a breast pump.

Mum was very concerned for Leanne because of my youth and insisted on calling around every day to bathe her, a practice which lasted a week for mum took ill and I resumed responsibility. I was happy with my baby.

The house was constructed in such a way that I had to run down one lot of stairs and up another to get every drop of water required. The doctor said running around too soon after childbirth would cause the loss of milk and a prolapse of the uterus in later life, but I had no choice. The milk began to decrease in quantity and all efforts to prevent this process proved to be in vain.

One of Tony's army mates was offered a house for rental in Fitzroy for the price of eighty pounds. This money was for the "key" only; a practice prevalent for the privilege of renting the property, however, in this case, there was a collection of battered old furniture included in the price. We were given the option of renting two rooms for the cost of forty pounds and with this money we could purchase some of the old furniture. We accepted the offer and moved in.

The war came to an end and I sat crying while feeding Leanne. I listened to the radio and the streets of Melbourne were packed with revellers. Crowds were thronging into the city, they were singing, laughing, kissing and crying. It was almost impossible to believe that the carnage of the past six years had come to an end. I anxiously awaited Tony's return from camp and we rejoiced together.

Living in other people's houses always created problems and, although we shared the electricity and gas bills and agreed to use two jets each on the gas stove to facilitate the cooking of meals, the landlady would, on occasions when they were dining out, place a large receptacle of water on each of her jets to prevent me from using them. I still had to

share the gas bill. Mum called in to visit one afternoon and while I was preparing the evening meal she went to the stove to give the food a stir. She saw the two large pots of slowly boiling water and became very angry when I explained the situation. The landlady was preparing to leave when mum walked into her dining room and told her that her water was well cooked. It had as much effect on her as the old Jewish expression of "giving a dead person an enema".

# 4

THE COMMUNIST PARTY DURING THE WAR YEARS developed into a large Party; it was said later that most of the recruits during that period rode into the Party on the backs of the Red Army. Tony attended his Party meetings but I was not particularly interested in what they said or did for I had, during my childhood, become over-saturated with the jargon and clichés. Occasionally something arose which prompted my interest and, with more current issues being discussed, Tony who was far less dogmatic became my mentor.

We had very little to do of an evening and we either went to bed early to listen to the radio serials or, to pass the time away, I would read my romance novels or embroider doyleys and table mats.

The Italian progressive group, Italia Libera, established regular Sunday night dances and we would, on occasions, put Leanne into her pram, walk across to Carlton and, while Leanne slept peacefully, Tony and I enjoyed the dancing. Dancing always gave me great pleasure, the rhythm of the music set my feet moving and I would dance non-stop throughout the evening, never feeling tired or exhausted.

Leon would sometimes enter a jitterbugging competition and I often became his practice partner. We danced about for what seemed hours, twisting and twirling to the best of jazz or swing.

One evening Tony and I decided to attend the local picture theatre and while preparing Leanne for our outing, the landlady, who was perhaps five years older than me, said, "you are not like a married woman." I looked at her in amazement for I did not understand what she meant or what she was

implying. As we walked towards the theatre, I kept on thinking about her comment and couldn't work out just what a married woman was supposed to be like.

Tony and I began to have differences; although very young, motherhood forced me to face and accept my responsibilities, but I felt that Tony was not facing up to his responsibilities. From time to time things needed attention like the radiator which was falling to pieces. It was winter and the radiator was in constant use, particularly when bathing Leanne, however, despite my constant pleas, Tony was going to, but never did, get around to repairing it. Eventually I became tired of asking and undertook various minor repair jobs resulting in my becoming adept in mending all types of gadgets.

Leanne was an unplanned but wanted and loved child, however, I was adamant that I did not want another child, certainly not while we were living in other people's houses. I was always afraid when going to bed, for I wanted Tony but was terrified of becoming pregnant. He convinced me that he would look after me but, to my horror, I found myself pregnant again. I was determined not to go through with it. I recalled Tony telling me of an army friend whose wife had had an abortion, so I visited her and asked if she could assist me.

Barbara offered to do what she could, but she had doubts about the doctor because she had, on a previous visit, refused his overtures. She made the appointment and accompanied me but she was right, he refused to perform the abortion. His refusal came after he examined me and I got the impression that his behaviour during the examination was a sex trip. Years later when discussing this experience with another woman who had attended this doctor, I knew my impression was correct.

Suffering from the chronic illness of poverty, I attempted to self induce an abortion by consuming a number of tablets purchased from a chemist, but when my body began to swell I ceased taking the tablets. I made further enquiries and an appointment was made with another doctor for a dilation and curettage; the polite medical term used for abortions. We obtained a loan of money from Angelo, our dear friend,

and, although I was nervous and fearful, I was determined to go through with the abortion. Tony accompanied me and waited while I had the D and C.

The D and C means D for stretching and C for scraping. The part that needs to be stretched is the tight-clenched passage between vagina and uterus called the cervix. The part that needs to be scraped is the velvet-lined cave called the uterus. The scraping part is easy, getting there is the problem.

The cervix does not suffer intrusion gladly, it must be tenderly encouraged to relax its grip and open up. To do this, a series of instruments called dilators are eased in with gentle, persuasive motions. The first dilator is very small, it is followed by successively larger dilators until the desired avenue is open to traffic. Then comes the curette, a midget metal rake designed for the sole purpose of scraping the uterine walls of foreign matter including polyps, tumours and other causes of female discomfort, apart from embryos.

All this information, of course, I have only come to know recently as, at the time of my first abortion, the entire subject of women's biology, let alone abortion, was taboo. I was completely ignorant and unaware of the experience I was to undergo when entering the doctor's surgery.

I undressed and lay on the table while the nurse went ahead with the preparations. When all was ready, a towel was placed over my face and the doctor walked in. He began to talk and ask me questions. I told him I had just turned eighteen and already had a daughter seven months old. He began to perform the abortion and with alarm I asked if he was going to give me an anaesthetic. His reply was no, he did not give anaesthetics. The towel over my face prevented me from seeing him, and he continued to talk. The pain was so severe and his voice kept on, "You must ensure that you don't conceive, you must call in to your local doctor for contraceptive advice." His voice drooled on, a deep and cultured voice, "You are far too young to be going through this." The pain continued. Did he think I was stupid? Did he think I didn't do anything? My husband was going to look after me. These were only thoughts for I said nothing.

When the abortion was completed, I lay there for a short period and, when rested, I left with Tony. He showed concern, but he would never know how I had suffered. We caught the train back to the city then a bus home. Mum who was caring for Leanne rushed to the door when we arrived home, her face full of concern. She asked if I was all right and if I was sleepy, I explained that I had had no anaesthetic. She sat down and cried, she cried for me, for she herself knew what this meant. I learnt then of the two occasions when she had experienced such abortions and she knew exactly what I had endured. Only women without money know of this experience, for the wealthy women are able to buy the best services. Despite the pain suffered, I had no regrets or guilty feelings, only a sense of great relief.

Tony was discharged from the army and now had to decide what type of work to do. He had, prior to his army years, been employed at various jobs, his last being that of a barman. He was offered a job by one of his army mates in a case factory, but we decided to give a small business venture a go. I negotiated to do outdoor machining for a clothing firm so, while Tony was away on his business, I sat at the machine while Leanne looked on from her play-pen. The business venture was a failure. Tony was not a business man, nor was he happy away from home, so discussions took place with his father concerning the possibility of the two of them going into a fruit shop together. My father-in-law was a worker and saw this opportunity as a means of breaking away from wage slavery.

We finally settled for a shop in Brunswick, and the dwelling behind the shop accommodated us all. It soon became evident that neither Tony nor I could adapt to this life. Tony had to go to market in the early mornings and, with the long day ahead of him and unable to obtain sufficient sleep, he gradually grew thinner and thinner. I resented working in the shop for nothing and insisted on being paid for my labour which displeased my father-in-law. There were many frictions for I, having known poverty, wanted the best fruit for Leanne, while the father-in-law insisted that I cut the bad section of

the "specks" away and eat the remainder. He claimed that throwing bad fruit away was throwing money away.

With the ignorance and inhibitions both Tony and I had, our sex life, like that of most young married couples, was unsatisfactory and was aggravated by our living conditions. I pleaded with Tony to sell the fruit shop but he was reluctant to make this decision, not because he didn't want to, but because of his father. He went down with pleurisy and was extremely ill. This created further difficulties, however, with constant attention and care he recovered. I was in a state of anxiety; between working in the shop, looking after Tony, caring for a child and attending to my housewife role, I too needed a rest. I desperately needed someone to talk to, a family friend who may have been able to suggest and advise Tony and me on what was best to do.

I rang an old friend who was almost old enough to be my father, was married, a member of the Communist Party and a businessman. I poured out all our troubles and cried as I spoke. His method of giving me help was to attempt to have sexual intercourse with me and, when this failed, he tried to coerce me into masturbating him. This too failed. I felt utterly betrayed, I walked away feeling as if I wanted to vomit. After several years, this man withdrew from the Communist Party and devoted his time to making money in his business interests. I never told Tony of this experience; women rarely tell their husbands such things for fear of being accused of having encouraged the incident.

There was no one but a doctor for me to take our troubles to. A woman doctor at the Women's Hospital was to interview me, however, after looking for a consultation room and finding them all occupied, we stood facing each other in the courtyard and the consultation proceeded. She questioned me extensively and I was embarrassed by the questions and the need to answer them. I broke down and cried. The details she required were so intimate and personal and never had I spoken to anyone about these matters. People walked by in the courtyard as the consultation continued. Finally the advice given was, "You need a holiday and I suggest you go away

immediately." I asked, "But what about when I return?" She resolved this problem by saying, "Do what is best for yourself."

I walked away confused, I didn't know what was best for myself and I had no money for a holiday. Again, I was frustrated by doctors advising a course of action while ignoring the capability or possibility of the patient to undertake such advice. I arrived home and told Tony of the doctor's advice. There was only one way this holiday could eventuate and that was if dad would lend me the money. Mum came to visit and I told her of our troubles, my predicament and the doctor's advice. She was deeply concerned and said, "I will talk to your father, you will go on your holiday and I will look after Leanne." Mum and dad were both delighted to care for Leanne, she was the only grandchild at the time and dad would go to great lengths to keep her amused. Grandparents can enjoy their grandchildren far more than their own children because they don't have the total responsibility for them.

Dad gave me the money for the holiday and I was very sad when leaving. Tony looked at me distraughtly; he was afraid and maybe he intuitively sensed how I felt. I was so miserable and depressed. I didn't know a soul in Sydney where I was heading for my holiday.

After I boarded the train, I sat in the compartment and cried quietly as the train took me away from Melbourne. The compartment lights were dim and I hoped that no one would know I was crying. The train went on and on, with its rhythmic beat it seemed to be saying what now, what now, what now? I eventually woke to find my head resting on the knee of the woman in the next seat. I couldn't understand how this had happened and slowly sat up, looked at the woman and asked her what had happened. She looked at me sympathetically and said, "I could see you were not well and as you fell to sleep your head slid down, so I gently placed it on my knee." I looked at her. How long did this woman sit in the one position to enable me to sleep? She must have been so uncomfortable and yet she did this for me, a complete

stranger. I was embarrassed and tried to thank her as best I could, but she nicely stopped me by saying, "Your need was greater than my discomfort." I sat there in silence and thought of the help offered me by the male communist family friend in light of the help given by this unknown woman.

I continued to feel ill and made my way to the ladies' room where I thought a wash might freshen me up and make me feel better. I gradually worsened and on the way back to the compartment felt myself fainting, so I opened the door of the nearest compartment and fell in. I came around to find the wind from an open window blowing furiously against my face and vaguely recall the stewardess being alarmed when entering the compartment. She hastily closed the window and attended to me.

When the train reached Sydney, I stepped off feeling as if I was in another world. I looked about at the strange faces going by. Could this be a new world, a new life? I felt it was impossible to escape from life. I had ceased to consider love stories as being a true reflection of life and I was so engrossed in my own misery that nothing seemed to be real. What went wrong, I kept on asking myself, Tony and I loved each other so much, what was wrong? I hailed a taxi and asked the driver to take me to a respectable place where I could get a room. He must have recognised my youth and selected a private hotel.

The room was small but clean and overlooked the backs of other buildings. The backs of buildings are never a pretty sight; all looked bleak and desolate. I felt lonely and insecure. How was I going to fill in the days? I decided to hang the few clothes in the wardrobe then buy some magazines to read, for what else was there to do? I spent my time walking the streets of Sydney and feeling guilty about Tony and Leanne. I kept on asking myself questions to which there were no answers. Is it my fault, where have I gone wrong, what has gone wrong with our marriage?

I remembered mum saying once that marriage was the same as tying two cats into a bag. On another occasion, while mum was talking with several Jewish women, one friend of

mum's said that, in her opinion, married couples should sleep in separate beds, another said that married couples should sleep in separate rooms, and mum said that married couples should sleep in separate houses. At the time of hearing this I had thought to myself, what do these old women know, my life will be different. It is difficult to know what happened during childhood to imagine that your parents were never deeply in love, and it is natural to assume that your own life will be different.

It wasn't as if Tony and I didn't try to make a go of things. We had read Van Der Veldt's book which, at the time, was considered to be the authority on sex and marriage, but there seemed to be innumerable problems. In my dejection I took myself off to the zoo. I boarded the ferry which was a new experience for I had never been on a ferry before, and the movement of the waves frightened me as I could not swim and was fearful of the sea. I wandered about the zoo, not being the slightest bit interested in the animals but it was a way of passing the time. On my return, I walked towards the jetty wondering what life was all about and began to cry. I approached the cliff and peered down. It would be so easy, one just had to walk over the edge; the rocks and sea would do the rest. The waves crashed against the rocks. If only I could, it would stop all the suffering. I didn't have the courage to do it; perhaps I wasn't desperate or sick enough to take the step. I was nineteen and this was the only time in my life that suicide was ever contemplated.

I made up my mind to return to Melbourne for I could no longer tolerate the loneliness. My holiday had lasted a week and I made the decision to have some afternoon tea in a café before organising the travel arrangements for my return. While sitting at the table drinking my tea, a woman approached and asked if she could sit at the table. She sat down and immediately struck up a conversation. She was an exuberant vital woman in her mid-forties and I welcomed the opportunity to speak with someone. The conversation led to my dreary lonely week in Sydney and, before an hour had passed, Gladys invited me to come and stay with her family, establishing the

board at thirty shillings per week. I was astonished at her invitation, "What about your husband?" I queried. "Oh Bert will be OK," Gladys replied. "He's a good old stick. You've got no worries love, you come and stay with us." It was finally agreed that I first visit their home to meet the family and then a decision about staying could be made.

I found myself outside a double-fronted brick home at Willoughby. The house seemed to be too flash for workers. I walked up to the door, rang the bell and Gladys, who was expecting me, hastily opened the door. She gaily brought me in and introduced me to the family. Bert was a tall, thin, quietly spoken man; a tram driver. Bettina, the daughter, was tall like her father but had the outgoing personality of her mother. They were warm, friendly and accepted me into their home with kindness. When several hours had passed and we had overcome our strangeness, Gladys left the room and Bert said, "You know Zelda, when Glad came home and told me she had invited a young woman to stay with us, I wasn't very happy. She's always inviting someone or other to come here and one day she's going to invite someone in and find half her house missing, although now that I have met you, I must say she's not a bad judge."

I moved in and was very content even though there was a deep ache in my heart and an inner lonesomeness. I told Glad and Bert a little of my circumstances and they in turn spoke of their previous broken marriages and their struggle with poverty. Gladys was a battler, an unskilled worker who for years had worked as a domestic, not only to assist the family finances but at times to keep the family. Bert said that it was only the sheer persistence of Gladys which made the ownership of their home possible, for he had a deep insecure Depression mentality and was fearful of purchasing a home.

I decided to get a job and remain in Sydney; I wrote to Tony of my intentions. I commenced work as a machinist again and was coming to grips with my efforts and determination to make a new start when I received a letter from Tony. He wrote of being ill with TB and said that mum was finding it impossible to cope with Leanne and intended placing her in

an institution. The fruit shop had been sold and he was now living with my family. I was shocked at the news, I was concerned for Tony's health and appalled at the idea of Leanne being placed in a "home". My escape had come to an end and I wanted to run back to Melbourne. Bert and Gladys understood the situation and we parted with sadness. I would be forever grateful for their warmth and kindness. I was grieved when learning several years later that Glad had passed away.

I returned home to find a very thin Tony; he was exceedingly pleased to see me and I was just as pleased to learn that he did not have TB, nor was mum going to put Leanne away. He had fabricated this story to bring me home for he knew me well enough to know I would return under such circumstances. We attempted to make a new start but it was so difficult when living with other people in cramped quarters. There were always others around and we had almost no privacy. Small cottages don't allow for privacy. Some years ago we had submitted an application for a Housing Commission home, but were forced to await our turn. The waiting was destroying us; how long must we wait for a home of our own? Tony regained his health but the relationship was again becoming strained.

Tony decided to leave home. At the time he was employed at his army friend's case factory and I suspected he was interested in a young woman who worked there, for her name seemed to crop up at frequent intervals. I knew there was no point in pleading with him to stay as our living conditions were deplorable and, as long as we had to live with others, they would remain so. Once again I negotiated with a firm to do outdoor work and sat at the machine in the back room to supplement the small sum of money Tony gave me. We were so confused for we were unhappy when living together and just as unhappy when separated. Tony would call in to see Leanne and was very cool towards me but, as time went on, we would look at each other then turn away when each saw the other looking. Then we reached the stage where we just looked at each other and didn't turn away. He returned home.

Dad had an old truck. At this period of time when the wealthy had difficulty obtaining new vehicles, it does not require a great deal of imagination to envisage the type of vehicle available to the poor. It was originally an eight cylinder Yellow Cab, and dad planned to retain the driver's cabin, remove the rear portion, then replace it with a utility-type body. Work got under way, but somehow or other it didn't keep up to schedule. When arrangements were made to go to St Kilda beach, Leon's mates would call around and it was all aboard. Those sitting on the rear section had to place their feet amid the workings of the undercarriage of the vehicle for, although the sides were completed and we could sit down, there was no floor. Those sitting in the driver's cabin were even less fortunate; there were no doors and only half a windscreen. When you could no longer tolerate the blast of the wind tearing at your face, Leon, while driving, would slide the windscreen across to give the passenger some respite, leaving the hand-operated windscreen wiper standing in midair. On arrival at St Kilda, the beach regulars would give us a mighty ovation and roar with delight, for it was an achievement for us to arrive at our destination. I will never forget the look on one young woman's face when accepting a lift home with us. While sitting in front of the truck with the wind blowing on her face, Leon suggested that if she wanted some fresh air she could open the ventilators down beside her legs.

For several years the Australian people had been fed propaganda about the forthcoming Australian car; "the people's car". Everyone was looking forward to this cheap car which was to be available for the workers. It was with consternation that Australia received the news that "our" cheap car the Holden would cost seven hundred pounds. This announcement was made several weeks prior to May Day and the May Day Committee approached dad for the loan of his truck for the procession. We didn't know what they intended doing with it, but on the day of the procession we climbed aboard and Leon drove to the Trades Hall, the assembly point.

A placard was attached to the front radiator which read

"Still Holden", while across the front of the bonnet was chalked, "For sale — going cheap, only 699 pounds 19 shillings and 11 pence". Two banners were placed on either side of the vehicle reading, "This is the only model a worker can afford". Leon drove the truck while we sat on the back and, as it progressed slowly along the route, the water in the radiator began to boil. On the approach to Batman Avenue, the procession stopped. Several policemen were on duty and as the procession began to move again they waved our truck on. For reasons which I do not comprehend our truck began to hop along and the spectators and policemen roared with laughter. It became embarrassing when Leon had to clutch in order to brake, for this process would bring forth a hissing spout of steam from around the radiator cap. The crowd convulsed with laughter when a smart-wit roared out, "You'd better drop your anchor mate, you're gunna sink."

Tony and I had now lived in other people's places for four years, always feeling like intruders and never knowing what just being alone together meant. I began to feel pain between periods, my stomach would distend, become hard, and the pain would last for almost twenty-four hours before the symptoms disappeared. This occurred for several months and eventually I visited the Women's Hospital. I was ushered into the consulting room where I told the doctor about the problem. He asked me my reason for not having another child. Not being prepared to go into all of the details concerning my living situation, I told him it wasn't possible under the present conditions and, besides, I didn't want another child. Leanne accompanied me on the next visit and the same doctor was in attendance. Behind him and facing me were three medical students. He asked if I had suffered the same symptoms during the previous month for which he had prescribed phenobarbs. When I told him I had, he turned to face the students and said, "It's marvellous what patients can think themselves into." He then asked if Leanne was my child and when I said yes, he asked, "Why don't you give her a sister or a brother?" I had taken as much as I could from this arrogant bastard and quietly said, "If you give me your

beautiful home in exchange for my room, and your salary in exchange for my husband's wage, then I will have another baby." The three medical students gasped while one placed her hand over her mouth as she did so. I was no longer on the defensive, I was on the offensive and I continued, "If you are incapable of diagnosing my problem then get me a doctor who can." I was very upset, I took hold of Leanne's hand and walked out of the hospital. I never went there again. I was to learn with experience that it didn't matter which hospital you went to, the same attitude prevailed. I was later to learn that the pains I suffered were ovulation pains, a condition for which little could be done.

I continually rang the Housing Commission in an effort to obtain a house; I tried to plead with them but all I got was their typical public service reply; "We understand madam, but you are on the waiting list and must take your turn. We will notify you in due course." Ex-servicemen were supposed to receive priority, yet we knew of people obtaining homes who were not ex-servicemen. It was common knowledge that to pay the "right" person fifty pounds would secure a home. He was known as "fifty pound Barry".

I could again see the writing on the wall at home; our relationship was fading once more. I became desperate and into the Housing Commission I went. Many people were sitting waiting and when my turn came I walked into the office and sat facing the clerk. "What can I do for you?" he asked. I told him I wanted to see the secretary. "You cannot see the secretary," he replied and again asked me what I wanted. "I want to see the secretary," I insisted. I was very nervous about what I was doing but desperate people know no boundaries. "You can't see the secretary as he is in conference." I looked him in the face and said that I would sit where I was until I could see the secretary. There were many people waiting but I refused to move. The clerk left the office and, after an absence of several minutes, returned and I was taken to the secretary's office.

The secretary glared at me, "What do you mean by embarrassing and humiliating my staff?" he said. I was not abashed,

"And what do you mean by humiliating the people by treating us as if we were peasants?" My back was against the wall and I fought. He then asked, "What makes you think that by behaving as you do, you will get your own way?" "Well, I'm here aren't I?" I said, and went on to tell him of our application which had been in for years and of my husband who was an ex-serviceman yet was being overlooked while others got houses. I went on to tell him of our circumstances and our desperate need for a house. He said he would look into the matter.

Several months later we received notification; a house was available for us in West Heidelberg. I broke down and wept. Mum also wept, for Heidelberg was so far away. "You will be living in the country," she cried. Tony picked up the key to the house and Sara accompanied us to see the house. We travelled out by public transport and never had I known such anxiety. Why doesn't the tram go faster? Why doesn't the bus hurry? I was convinced that the driver drove at a slower speed just because I was in a hurry.

When alighting from the bus at our street, I could not dally. I left Tony and Sara and ran over to the first commission house seeking out the right number. I became aware that our house was not on this side of the street as our number was an odd number, so I raced over to the other side and ran on until I reached the house. Our home, our house, there it was before me. I couldn't get in as Tony had the key so I ran back to the footpath and yelled for Tony and Sara to hurry. Tony opened the front door and I dashed inside. My head spun as I gazed at the walls. I wanted to fall on my knees, to kiss the floor boards, the walls and every part of the house, but all I did was cry.

At last, at last, five years of marriage and we could be together and alone for the first time. I threw my arms around Tony and we clung to each other, standing there in the middle of a bare house. We moved in just prior to Christmas, bringing our junky furniture with us. It was the best Christmas present of my life.

**5**

THE EXCITEMENT OF BEING IN OUR HOME knew no bounds.
The house was one of the earlier type commission homes: a
four-roomed solid brick maisonette, and it was two years old.
The interior needed painting, the garden needed establishing
and we discussed the priority of tasks which required attention.
There seemed to be so much to do around the place and this
gave us something on which we could work together. A motive
existed for our mutual benefit.

I turned twenty-one in January and Tony gave me a party.
It was wonderful to be able to invite friends to our home for
a party. There was singing and dancing with everyone having
a wonderful time. Our friends rejoiced with us in the attain-
ment of a home, the outcome of a long and bitter struggle.
We now laughed, kissed and hugged all over the house, with
Leanne running up to join us. Whenever she saw Tony and
me embracing, she would run up to us, arms outstretched,
and insist on joining the circle. Tony would pick her up and
we made it a threesome.

There was so much required in the way of tools and materials
to establish our home. Money was needed to buy a hose,
gardening tools, paint, and all of the other extras. Now that
Tony had to travel daily from West Heidelberg to work, this
meant a huge cut in his wages due to the high cost of transport
fares. Tony's wage was small and we were unable to purchase
what we needed. He commenced a vegetable garden and we
both laboured in an endeavour to reduce our living costs.
We purchased some young pullets with the idea of breeding
poultry and having fresh eggs, however, this venture proved to
be questionable. For months on end I would buy the weekly

supply of wheat, pollard and bran, plus eggs, and the local grocer, as well as everyone else, could not understand why our hens after being well past the laying age were barren. Not a single egg did they lay.

While travelling to the city one day, I met an old friend of the family who I knew always kept poultry and I sought her advice on egg production. After relating the problem she asked me how many hens and roosters were involved. I told her we had six hens and six roosters. She let out a mighty roar of laughter and all the passengers in the tram looked over. After collecting herself together, she leant across and whispered in my ear, "Your hens are too exhausted to lay eggs, one rooster is good enough for twenty-five hens." How was I to know the mating habits of poultry? Tony and I thought we were doing the right thing in pairing the poultry. All that can be said in defence of our ignorance is that we at least didn't make them go through a marriage ceremony.

With the weather turning cold, I was unable to work in the garden and became housebound. The winter was bleak, there was no money to afford the constant use of a radiator and we soon discovered that the open fireplace in the lounge room was incorrectly designed and most of the heat went up the chimney. The only method I could employ to keep warm after completing the household chores was to wrap myself into a blanket and sit in an old lounge chair while I embroidered. I became quite an expert at embroidery and learnt how to crochet intricate borders around the doyleys. My collection of table mats, doyleys, aprons and teacloths increased to a size which no one could use in a lifetime, but my time had to be filled in some way and this was the only way I knew.

My women neighbours were also housebound, even more so than I, for they had more children and were fully occupied attending to the thousand and one tasks that running a home requires. There was no such thing as playing tennis or indulging in the creativity of art or pottery; we didn't even possess the wherewithal for necessities let alone the funds needed for the luxury of outdoor interests. Not every woman is or can be interested in the same type of activity, and working-class

women least of all, for at no time did we when young have the environment or encouragement to develop such an appreciation. The shops were our only contact with the outside world, thus shops, shopping, and the home were all we had. The remainder of society and the world were non-existent, and this reduced our conversation when seeing each other to shopping, a visit to the doctor, why and what resulted from this visit plus whatever had taken place within the home. During the day, Leanne would play with her friends while I would just be. I had no one to talk to; you cannot communicate with walls.

The need to reach out beyond the home and to the outside world became an obsession with me. Tony was my only link with the world and I would look at the clock, knowing the time his bus would arrive at the corner and count the minutes until he came home. Sometimes I would send Leanne out to see if daddy was coming. If the bus was late, I would immediately fear that some disaster had occurred; a serious accident. I would become overwrought with anxiety.

The moment Tony entered the house, after kissing him, I would want to know all he had done during the day and the conversations he'd had, how much and what of interest had happened during work hours, but he had very little to say. I would then relate my experiences of the day, which was a résumé of all Leanne's activities and the conversations with the neighbours. One evening while giving him the latest news, I became aware of his expression, his look of disinterest, and I said, "You don't seem to be interested in what I'm saying." He attempted to let me down kindly and replied, "No love, if you want me to be honest, I'm not interested in knowing if Johnny Jones down the street has got measles or if Mrs Winter thinks she's pregnant again." I was terribly hurt and flattened, but what could I say?

Deep down inside I knew my conversation was boring, yet what else could I talk about? I was so lonely and he was all I had but what could I do with my present life-style? The life-style portrayed to all women as being normal and fulfilling. I found my husband was bored with my company. This wasn't

the way it was supposed to be. He was supposed to be my companion, my lover, my friend, my provider and all my happiness and personal fulfilment was, according to convention, to stem from Tony and Leanne; the family. Why then was this not happening? I already questioned the male provider role as experience had taught me that workers never earn sufficient wages to provide for a family, but what about the other expectations? I gradually became convinced there was something wrong with me, that I was at fault, for were not all other women content with their situations? All of the women's magazines portrayed housewives as being ever so happy and blissful, so this could only mean that there was something seriously wrong with me.

I switched from embroidery to knitting, for the finished products of knitting were more essential for use during the winter months. My hands moved and my fingers flicked the needles through the endless miles of wool. A jumper came off the finger-line within three weeks, a jumper for Leanne within one week, but I sat there feeling cold and miserable; never could I remember having felt so cold. It soon became evident that we had sufficient woollies and I could not afford to spend money required for other needs on wool. Our budget was so tight that, prior to going shopping, I would make a list of the meat, fruit, vegetables, groceries and other needs, then calculate the cost. Even the fares to and from the shopping centre had to be accounted for. There was never enough money for the lot, so the items we could do without were deleted from the list. On several occasions when the milkman called to collect money owing, I asked Leanne to remain quiet until he assumed there was no one at home and left.

There was never any money for a visit to the theatre or any such luxury. I could never work out how families managed to survive where the husband drank or gambled; Tony and I had never had these habits for they too were luxuries. If only there was a way I could earn some money at home for, if I was able to earn some money, we could then go to a show or something . . . we were so housebound.

I asked Tony to make enquiries at work to see if there was

any sort of work I could do at home. He began bringing home metal case handles which needed covering with an artificial leather in order to give them the appearance of being genuine leather. After taking Leanne to kindergarten, I sat at the kitchen table spreading the leatherette pieces before me. I would spread these pieces with glue, wait until they had become tacky, and then bind them around the metal frames. The pungent odour of the glue pervaded the entire house. Day after day I sat there alone at my work for which I received thirty shillings per week; sufficient to pay the rent and leave me with two shillings. This was a great help and we were able, through hire purchase, to buy one of the cheapest model radiograms available.

When very young, my taste in music was confined to pop but, as I grew older, my romantic inclinations predominated and I developed a preference for ballads. As time went by, Tony and I both became opera fans and we began to purchase operatic and romantic Italian records. Leanne at a very early age learnt to appreciate opera.

Because I liked people and wanted to be among them, my isolation at home during the day depressed me. There was little I could do about the situation as the local kindergarten took children for half-day sessions only and this prevented me from going out to work. Being confined to a house full of old junk, which was called furniture, did nothing to raise my spirits but what I, at that time, did not know was that a house full of new junk could not give a person fulfilment either.

An announcement was made over the radio that the price of gas and electricity was to rise. I was furious, it was already difficult to make ends meet yet prices were continually on the increase. I felt helpless and ineffectual in my anger and discussed the matter with Tony. After the discussion, I decided to try and do something about this injustice. I made up my mind to approach the women living within our block of homes and see if together we could try to do something. I had no idea of how to go about this, but plucked up the courage and went door knocking. I went from house to house and all I could do was tell the women how I felt about the price increases,

ask them how they felt, and see if they were interested in getting together to try to stop the increase spiral.

It became obvious I would have to visit more homes than those within our block for, although the women were deeply concerned with the rising prices, they were either too involved with their young families, or considered they were too power-less to be effective. Like all new housing commission estates, the families consisted of young children and all of the women were overburdened with no money and an endless struggle to survive from week to week.

Eventually there were sufficient women interested to commence a group and we began to meet at our home for discussions. We had no idea of organising methods of protest or what we could or couldn't do. We drafted letters of protest against the price increases and sent them to the government, we invited a doctor to address us on the need for a govern-ment health scheme and, in general, discussed our discontent with things as they were. After three months of meeting, I was paid a visit by two members of the local branch of the Communist Party. After some conversation and discussion about my participation within the local group of women, they asked if I would like to join the Communist Party. I briefly thought about it then said yes. As quick as a flash, they whipped out the necessary forms and within seconds I had dealt with the formalities which made me a communist. It was just like that, it was all so easy.

When Tony arrived home from work, I babbled out the news to him and was surprised at his reaction of displeasure. "Why didn't you let me join you up?" he said. "You never asked me," I replied. I was astonished at his attitude and unaware that it was a feather in the cap of any comrade who was successful in recruiting a member to the Party. I later realised he was also peeved because his male comrades had not discussed the matter of my membership with him prior to their visit.

We were both now Communist Party members and it was impossible for us to attend meetings together as Leanne could not be left at home alone. We took turns in going to the branch

meetings which meant we both attended the meetings once per month. My first meeting was an experience; it was nothing like the meetings which were held at home during my childhood years. This was a branch of approximately forty people; all of the members did not attend meetings but those of them who did were very different to the people who came to my parents' home. I observed that almost all of these people were highly educated or in business. It didn't take me long to hear their ability to express themselves in good English or to see the good clothing they wore. For some time I was too reticent and, being strictly working class, was, in the presence of these people, afraid to express myself. There appeared to be three or four workers in the branch, perhaps there were more, but they didn't attend the meetings.

The first time I gathered the courage to speak, I thought I noticed some of my women comrades look at each other. I was extremely sensitive to my lack of education and polish; I felt very inadequate as a person in their presence and thought my first impression may have been due to my own sensitivity. The branch decided to hold a class, the subject matter being, "Dialectical and Historical Materialism". I decided to attend and avidly read the prescribed reading material, however, I couldn't bloody understand what I was reading, but this did not prevent me from attending. During the discussion, I disagreed with a statement made by one of the comrades and the response was (beautifully articulated), "But surely you are not going to disagree with Karl Marx?" I was upset by her manner and tone and told her that I didn't care if it was said by Joe Stalin himself, if I didn't agree with anything I intended saying so! After having said this I felt embarrassed. The tutor, a very silent and studious comrade said, "Rightly so, we don't want 'yes' people in the Party, we need comrades to think and question." How grateful I was to him, he never knew how necessary his support was. After several years he left the Party.

As time went by I was faced with the reality of my women comrades' glances. It was not my imagination, nor was it my sensitivity. Tony arrived home after attending a meeting one

evening to inform me that Raylene had suggested he should teach me how to speak English correctly. I broke down and cried. I was devastated. Tony had never attended school in Australia. Having arrived here at fourteen years of age, he had commenced work immediately, yet I was born here, had attended school, and it was suggested that he should teach me. I was so hurt and reacted to the situation emotionally. "They're nothing but a lot of bloody snobs, bloody pubahs, they think they're better than everyone else," I cried and went on, "Who do they think they are anyway, what sort of communists are they? So I'm a worker and I don't speak bloody flash, so what? Who's communism for anyway?" I approached a woman comrade and told her of this incident in an attempt to gain her support and understanding. Her reply was, "Raylene's attitude is correct. It is vitally necessary for all communists to be articulate and speak well, why even my own mother had elocution lessons to enable her to speak correctly." I was completely crushed and thought no bloody wonder, her mother was one of the few workers on the branch and I could understand how she must have suffered.

I thought about myself. I could ignore the whole thing, but I could not ignore the awareness of my own ignorance. I knew I had never read a book, all I had read were those love stories which I now realised were a lot of bullshit and if I wanted to learn I would have to read good books. I also thought about my spoken English. My parents, being migrants, could not help us when young with our spoken English at home. Our parents always spoke in Jewish, while we always replied in English and this meant that we could only use a limited number of words which our parents understood. This curtailed the possibility of developing an extended vocabulary. Growing up on the streets of Carlton made us familiar with all the four-letter words and several others. "Shit", "piss", "bum", "dag", "bugger" were in constant use and our parents were unable to correct us for they didn't know the words to replace them with. I never heard my parents swear.

It was only when going to school that "piss" became number one, and "shit" or "poop" became number two. All swear

words were accepted by the children even though we were unaware of the true meaning of most of these expressions. There were three words which were taboo and never used. "Bastard", being one of them, was to lose its taboo in later years and, eventually, in some circumstances became a term of endearment.

Having given the matter some considerable thought, I decided I must learn things and to do this I must read books. I began by borrowing books accumulated in the extensive libraries of my comrades. They had very impressive collections, some covering almost all of their lounge room walls. I knew if I was to attempt to read a complete book, then it would be necessary to read books which young people read and understood to enable me to cope with prolonged reading. I started off with Charles Dickens, then on to Thackeray, Scott, Chekhov, Dostoyevsky and on it went. Reading replaced knitting and I became absorbed into the outside world through books.

The local branch held many good socials at the home of Dorothy and Bob. Dorothy was a warm and vital woman, giving her utmost to the Party and people. After working all day as a machinist in a clothing factory, her home was always available for meetings, socials and an extra bed when required. She and Bob were wonderful hosts and people came from all over Melbourne to the parties. I would take the accordion along and the music and fun would go on until the early hours of the morning.

Just prior to one of these socials, a woman friend told me of an acquaintance of hers who had told her that her husband demanded that she dance around their bed naked, using a fur collar as you would use a fan in a fan dance. This he found necessary for his wife to do in order to turn him on. I roared with laughter when hearing this anecdote and, after relating this to several other women at the social, I discovered a fur collar in Dorothy's wardrobe. I immediately (fully clothed of course) danced among the party-goers brushing the fur collar across my body as is done by the exotic eastern dancers depicted by Hollywood. The women who were familiar with

the story understood the reasons for the performance and enjoyed the joke, while the others wondered at the extreme mirth. Never at any time did we realise or stop to consider the feelings of the poor woman concerned and the indignity of this performance in real life. We all thought it was hilarious.

With horror, I again discovered I was pregnant. The doctor had assured me that, if used correctly, the device[1] was fool-proof, so how did it happen? It was used correctly, I was at this age and stage too wise to take chances or risks, so how did it happen? The doctor brushed me off with, "Well it's just bad luck." We had no money for an abortion and there was no alternative but to again attempt the home methods.

I lay in the bath as the water gradually ran hotter and hotter. Tony watched as I lay there almost cooking. When I could no longer tolerate the heat, he would lift me out of the water for it was too hot at this stage for him to place his hand in to remove the plug. He would dry me and carry me to bed for I was too weak to dry myself or get myself to bed. Still nothing happened. I consumed huge numbers of various pills, drank hot gin and Epsom salts, jumped from the kitchen table and still nothing happened.

I was continually weak, ill and extremely depressed. I knew now that I was not the housewife–mother type and it would kill me if I had to remain locked in the house for years to come. I thought about the poor child who would be born into such circumstances. There isn't a mother alive who, in not wanting the child, could prevent this from being visible in some way, even if it comes forth in later years with thoughts like, "I've given up the best years of my life for you." I would not say anything to the comrades about my problem. They never spoke about such matters, nor did the women discuss their women's troubles unless it was to a particular close friend.

Some of them began to question Tony and I about my illness and we always pleaded a multitude of complaints from the flu to diarrhoea. One woman sent her doctor husband to

---

1.  Dutch Cap. A large rubber cap measured to size. Covered with spermi-cide and inserted before intercourse.

visit me. She didn't come forward after his visit to offer assistance so I gathered it was sheer curiosity which prompted her interest. I couldn't lie to him and was forced to tell him of my unwanted pregnancy. He was very sympathetic but unable to help. Several days later while lying in bed, Dorothy entered the room and stood by the bed. After asking me how I felt, she said she suspected I was pregnant and placed twenty pounds on the bed. She said if the twenty pounds was insufficient she would give me as much as was needed and not to worry about paying it back. "You can worry about paying it back if and when you can afford it, but if you can't, then don't worry about it." I just lay there and didn't know what to say. In situations like those "thank you" seems so inadequate an expression. Dorothy was a worker and money did not come easily to workers yet she was the person offering the help. She was the only person in the branch I ever came close to during all my years in the Party.

I now had the money, but was again faced with the dilemma of finding a doctor to perform the abortion. I could not return to the previous doctor who did not administer general anaesthetic. I was told of a Party doctor who performed abortions under anaesthesia; he was well known among the Catholic women in his suburb for they daren't approach one of their own doctors. I went along to see him, explained my financial difficulties and told him I only had twenty pounds. He agreed to perform the abortion and, on the due date, I travelled alone to his surgery. I was surprised when all he did was insert something into my body, left me lying there for what seemed to be about twenty minutes, then removed the something and informed me that I would abort in due course.

I began to bleed during the evening but it was in bed on the following night that I began to suffer labour pains. The pains became more severe and I would let out a moan. I tried not to make too much noise as Tony had his back to me and was trying to sleep; he had to go to work in the morning. I let out another groan and writhed from side to side in attempting to relieve the pain. Tony became impatient, "What are you moaning about? All women go through this, they just don't

talk about it," he said. I continued to labour until I aborted. As the days passed, instead of recovering, I gradually became worse and was worried. I asked Tony to ring for a local doctor. A woman doctor arrived and asked me what the problem was. I could not answer truthfully so replied that I had douched myself not knowing I was pregnant and that I had aborted. She was very angry and, in disapproving tones, told me that I had introduced infection into my body. I knew who was responsible for the infection but my lips were sealed. She prescribed antibiotics and I eventually recovered. I knew that it was a comrade who, because I did not have sufficient money, put my life at risk; a risk he did not subject Catholic women to. Again, I had no feelings of regret or guilt about the abortion.

The problems within our marriage persisted so I approached a doctor on our Party branch and asked him for advice. John said it would be impossible for him to assist us as he was too close to both Tony and me, and suggested I go to another doctor whose name and address he provided. I had developed a feeling towards John which was new to me, and which I was afraid of. I could not understand this feeling, nor was I able to control it. All I knew was that while in his presence I would become tongue-tied and my only way of dealing with this was to keep away from him and avoid him whenever possible. It was sheer desperation that drove me to ask him for advice. I took his advice and went to see the doctor he recommended.

The visits to the psychiatrist were half-hourly visits and bookings were made well ahead as the services of the psychiatrists were heavily sought. I was astonished to discover the number of people needing assistance. People never make mention of their need to obtain psychiatric assistance. It took many visits to discuss our problem and I was later to learn how fortunate we were in the choice of this psychiatrist. He was a man many years older than myself and spoke to me like a father. He was extremely warm and sensitive and did all he could to explain away my many inhibitions and wrong thinking. I understood and accepted what he said, but it is

one thing to understand your own hangups, and another thing to be able to free yourself from them. My entire socialising process from birth had left me with an attitude of "ladies don't do this or that; he will think I am cheap if I suggest this or that; *ladies just don't*".

I told him of my misery and unhappiness at being in the house alone all day and spoke of thinking there must be something wrong with me because I didn't find caring for a husband and child fulfilling. He encouraged me to take up work as soon as circumstances permitted and in the meantime he sustained me. He told me I was the type of person who when facing problems would think them through and, by doing so, would never completely breakdown. To help build my confidence, he arranged for me to do an intelligence test, then was pleased to inform me that I was above average, which supported what he had already told me. He said I had sufficient intelligence to undertake whatever course of study I chose, but again my early socialisation and low expectations prevented this. He never at any stage suggested I should have another child.

I made arrangements to commence work, coinciding with the day Leanne was to attend school. Leanne already had an older playmate who was more than willing to accompany her to and from school. I took Leanne to school on the first day and when the formalities of enrolment were completed I left for work. Work was another clothing factory in Fitzroy.

The routine in this factory was the same as in any other clothing factory and I was now making women's coats. When requiring work, the machinist goes over to the cutter who has all the bundles of work ready for machining and knows which garments are required for which orders and the priorities of same. If the bundle is the same as the machinist has already been doing, then she knows which routine to take, but if this coat or frock is of a new design, then she gets the sample which has already been made by the sample hand, examines it thoroughly and proceeds slowly. By the time she has finished her first bundle she now has the routine established and the following bundles flow through her machine at a great speed.

Standing beside each machinist is a box on legs. She unravels the bundle into this box, removes the labels from the bundle and places them beside her on the machine. These labels have to be sewn into the garment during the machining process. The routine may vary with each machinist, but the method is the same. One scungy little factory in Fitzroy inserted labels in their coats which read "Paris, London, New York".

Some factories only permit sectional sewing. This means you have one woman making sleeves all day, another making fronts all day, and another doing some other limited section all day. This method is claimed by employers to be more efficient and increases production, but it is not the only advantage to the employer. It also prevents the woman from becoming an experienced all round machinist and reduces her ability to leave the job and obtain something more satisfactory. What sort of bargaining power has a woman got when all she can sew is sleeves or pockets?

The continual noise of a factory eventually becomes an unpleasant part of your life: the burring sounds of the sewing machines as each machinist presses on the pedal, the screeching sound of the cutter as it slices through the material and the hissing sound of the steam-press all add to the cacophony. The noise I found most objectionable was the radio. Music is a most individualistic choice but, with so many employees in one factory, it is impossible to please everyone so the choice of music is inflicted upon the workers by either the boss or by the majority of workers. Many people are accustomed to the constant bleat of radios in their homes and are not disturbed by it. Music is an expression of mood, and the choice you make depends on what mood you are in at a particular time, but in the factories it becomes part of the machinery and adds to the general noise. I always use my ears and find the compulsory music an infringement on my privacy and an assault on my being.

Workers should be able to make their work hours as pleasant as possible and, being socially uninhibited, I always attempted to create an easy atmosphere. This would often

cause great hilarity and, unfortunately, my loud laugh was always audible to the bosses. They would peer or glare at me but never prevented me from laughing; they knew I was a good worker and a good-humoured work-force is more likely to remain on the job.

My employer had a mistress who visited him regularly at the factory, however, having a wife and a mistress did not deter him from making attempts with every other woman. He constantly tried to increase his harem. On one occasion he arrived at the factory wearing a new tie and we all made comments about it. His mistress called in at the same time as another mate was visiting and, interrupting their conversation, she asked the boss the source of his new tie. He replied that it was a gift from his wife and, without saying a word, the mistress picked up a huge pair of scissors, lifted his tie into the air and cut it off at the neck. Not a word was said and, heads down, we continued to machine as if nothing had happened. All was silent.

It is impossible to be a prude and remain working in a factory. During all my years of working in factories, I had never heard any vulgarity although there was a very earthy sense of humour which all appreciated. Mr Whindon called at this factory at regular intervals to purchase material remnants for his stall at the market. He was very short, had a paunch and was continually pulling his trousers up. One day the boss roared out from across the factory, "Hey Abe, what gives with you? It's not that big that it keeps pushing your trousers down." Everyone in the factory laughed at Mr Whindon's embarrassment.

I eventually became bored with machining as every day seemed to be the same as the day before; the only motive for enduring the job was to earn some money with which to purchase something nice for the home. I had never known what it was like to have "nice" things in a "nice" home and already my wages had enabled the purchasing of a cheap carpet square for the lounge room and new linoleum for the kitchen.

Travelling to work and back was another hassle. The public transport system was always overburdened during peak hours

and I could never understand why the "society for the prevention of cruelty to dumb animals" never took up the cudgels. Going home was far worse, for the shops were all closed by the time I returned to Heidelberg of an evening, and I was forced to buy all the requirements at Fitzroy, place them into a string bag, then strap-hang all the way home. When removing the bag from my arm on arrival at home, my arm would tremble for an hour.

# 6

THE BEGINNING OF THE COLD WAR and McCarthyism started and a bitter and hysterical anti-communist campaign began. Many of the "Red-Army" communists began to silently disappear out of the Party and the Liberal Federal Government decided to hold a referendum to rid the country of the "red menace". Alarm was felt among all spheres of the left. This referendum, if passed, would not only make the Communist Party illegal, but would also destroy the trade unions and all opposition to Liberal Party politics.

Trade unions began to inform their members of what this anti-Red scheme entailed: it was an insidious means by which people would be prevented from voicing any criticism of the government. Trade unions, for example, would, if this referendum was passed, have to furnish the government with the names and addresses of every member. Failure to do so meant severe penalties. With people constantly moving from one address to another and, in most cases, rarely notifying the union for some time, the unions in such cases would be dealt with for not complying with the law. The trade unions would become completely ineffectual if this bill were passed.

The Communist Party threw itself into the struggle with all its might and called upon every member to make the utmost sacrifice in what seemed to be a do or die situation, and I joined the campaign. Leaflets for letter-boxing poured in by the thousands, posters for pasting up, painting of signs, and rallies to attend became a nightly feature. Night after night I went out, and mum was called in to look after Leanne when it was necessary for both Tony and me to go out. It was always recommended that two people letter-box together,

for it could be dangerous for one person to walk the streets alone at night. If this was possible to arrange I would go out with another comrade, but if this wasn't possible I would walk the streets alone.

Vast areas of Heidelberg were unsewered, undrained and had many unmade roads. The drainage from the houses was channelled into gutters running along the unmade streets and street lighting was also unheard of in those areas. On several occasions, and without company, I trudged through the darkness, slipping into the foul gutters up to my knees in dedication to make sure that not one home missed out on the leaflet. I would slip and slide in the mud and slush, but never did I burn or discard any material. I mixed buckets of starch glue for the pasting up of posters, and soon became familiar with every bus stop, every railway station and every shopping centre. I was very nearly caught while painting a sign on a local railway station and ran for my life. It was understood that, in situations like those, each person was for themselves, for it was foolish to be caught if it was at all possible to escape. By the time the referendum was over and defeated, the comrades were all exhausted but exuberant. The people of Australia had rallied to defend their freedoms, for the few freedoms we had were precious.

Tony and I had undertaken the delivery of the communist weekly, the *Guardian*, and this meant that every weekend the papers had to be delivered, a tie which was a tremendous burden. In 1952 at the beginning of the first post-war bust, people were already finding it difficult to obtain employment. The post-war world was screaming for goods, yet people were unemployed. Migrants were brought here, dumped into migrant camps and there they were left. Trouble broke out at the Bonegilla Migrant Camp; the migrants were restless, "broke" and frustrated in their need to obtain employment. Violence erupted at the camp and the demand became, "If you can't give us work, send us home." Police were rushed to the camp to quell the migrants.

With the payments on the radiogram completed, a refrigerator was the next item to be purchased. With all of my

activities and involvement, I would sometimes forget to empty the drip tray from beneath the ice chest, resulting in a flooded kitchen, and the purchase of a refrigerator became a necessity. I can recall the pleasure and status felt when the hire-purchase fridge arrived. To be able to open the fridge door and fetch yourself a cool drink was really something and we were very proud of our new possession.

I attended Party lectures and classes regularly and was now learning about economics, wages, prices, profits and the State. This was all very interesting and stimulating and I was being forced to use my mind. The women's group which had been formed had long ceased to exist for we ran out of ideas. We just didn't know what else we could do to help ourselves and it dwindled away.

I was now working full-time, running a home and participating in politics, and yet I did not feel fulfilled as a person. I had no idea why. I liked, enjoyed and needed people and our home was always a hive of activity. Comrades, friends and neighbours continually called in and we had very little time for ourselves. Being ultra-sensitive, I would be hurt easily and Tony said that the reason for my pain was that I made friends too easily, and made friends of all people. "What about you?" I asked, "you have friends too." He surprised me when saying that he treated all people with reservations. I thought seriously about this and asked myself questions. Was I naive in my attitudes, was I too trusting? It was true that I liked people but there were very few whom I considered to be close friends; was this wrong?

I did have expectations of my comrades and it didn't seem unreasonable to expect them to be honest and humane. I knew that, apart from Dorothy, the comrades were not my friends for we had very little in common except our politics.

My feelings for John grew stronger; I now recognised I was attracted to him as a man. I felt extremely guilty about this and avoided him more than ever. On very rare occasions when he spoke to me, I would on the first pretext find I had something to do in order to escape him.

There was a comrade who lived nearby who was not in

our branch. He was in an industrial branch and would sometimes drop in to visit us. Ken was a married man with a family and Tony made it quite clear by his attitude that he did not like him; on more than one occasion he was in fact rude. I spoke to Tony of this but he claimed that he did not see why he should have to be nice to him in his own home when he didn't like him. I remained silent, for what can one say in such circumstances?

I took a day off from work and called into the local shopping centre to buy something for tea. Ken too was there shopping and, after exchanging greetings, I explained I wasn't feeling very well and had decided to take the day off. He also had some business to attend to and was off from work. Later, during the day, there was a knock on the door and I was surprised to see Ken standing there. "Thought I'd call around for a cup of tea," he said. After inviting him in and making the tea, we sat at the kitchen table and talked and drank the tea. There were several tasks I wished to attend to so, when some time had lapsed, I cleared the table and proceeded to rinse the cups out at the sink. As I turned away from the sink, he grasped me in his arms.

After all these years I was now back in the same scene. As I fought, I tried to talk to him, I tried to make him understand that I wasn't interested in him and pleaded with him to release me. He was like an animal. I struggled and fought; he began to drag me towards the bedroom and I used my legs to try to prevent him dragging my body through the doorways in my attempt to escape from his grip. He was so powerful and managed to push me on to the bed. His full weight was upon me and I then began to yell, "No, no, no, can't you see what you are doing?" I broke down and then pleaded with him, but to no avail. He was beside himself with a coldness of steel. I could no longer struggle, my heart was pounding and my energy spent. I knew I had no energy left to fight him. I lay there like stone. This was my first rape. A worker, a married man and a communist. He left immediately after.

I hated him with all of my being. Why, I asked myself, why? How glibly some people brush everything aside with,

"It's all a matter of class, it's a class question." Ken, after struggling with poverty, constant job level activity and Party work for a period of twenty years, threw it all in and went into business. I was too afraid to tell Tony of this experience, I was afraid he would blame me for being friendly or, even worse, he may have thought I encouraged him. Women very rarely tell their husbands of such experiences because of the same fears.

It wasn't for many years that I learnt the reason for this rape. The feminist movement enlightened me. Tony didn't hide his dislike of Ken and Ken, who resented Tony's attitude, needed to avenge himself. What better way is there for a man to gain revenge over another man than by despoiling his property; despoiling his wife?

Italia Libera decided to send Tony to the World Peace Congress which was meeting in Vienna. I was very pleased and excited for him, however, I had some personal misgivings and internal fears. I was afraid of being left alone and to add to this fear was the possibility of Ken paying another visit. My thoughts went around and around; maybe I could borrow a gun from someone. If I could get a gun, I would kill him if he called again. I didn't know anyone with a gun.

One evening while in bed, Tony and I discussed our coming period of separation. We knew we would have several months of separation and attempted to adopt a realistic approach to this. We agreed that should either of us have a relationship with another person, we would not ask each other any questions or tell each other of the relationship. I considered there was very little risk of this occurring, so it was of little importance. The preparations for Tony's trip were all hastily attended to. He had three weeks in which to complete his arrangements and suddenly there we were, all at the port to say farewell. We stood and waved as the ship sailed away; I stood there with all of my fears and insecurities.

I continued to work and Leanne and I lived on my earnings. Dear little Leanne. I had to explain to her our need to live frugally as I earnt a very low wage because I was a woman, and now that daddy was away we would need to watch our

spending. She was concerned and took the matter seriously. One Saturday afternoon we went to a film matinee in the city and, following the pictures, we went to a Greek café for tea. We sat at a table with another young couple and waited to be served. As is the custom in Greek cafés, on the table there was a basket overflowing with bread. Leanne having sat there in silence for some time looked across at me and said, "Mummy, if I eat any of that bread, will you have to pay extra?" I laughed, "No love, the bread is included in the price." I thought the young couple sitting at the table might think I was a tightwad, so briefly explained the situation and Leanne's concern.

For the four and a half months of Tony's absence I would leave the house at seven thirty in the morning, depending on Leanne at the age of seven to make sure the house was locked when she left for school. Not only did she prepare her own lunch and school requirements, but purchased odds and ends at the local shopping centre and assisted with the housework and gardening. Children are so capable and responsible when the situation demands it but, if this was permitted to continue, what role would mothers then have?

The Party meetings were transferred to our home during Tony's absence to enable me to attend meetings. After one of the meetings I sat having supper alone as the comrades declined the invitation for supper in their desire to go home early. John had attended the meeting and as I drank the tea I thought about him and myself; was my attraction towards him because he was a doctor? No, there were other doctors but I wasn't attracted to them, so it wasn't that; it was just because he was he, and I couldn't work it out beyond that. "I hope he doesn't know," I thought, "He would think I was mad, after all, he is a doctor and I'm only a worker, what would he see in me?" I continued to think, "I am learning and I know more now than I did before, but I am still a worker. If only I'd been educated; it must be wonderful to be someone highly educated. Your job would be interesting and useful, you would know so much and people would respect you. How wonderful it would be to be happy with your job and

love going to work." Oh how deluded I was . . . Ah well, it's no use crying over spilt milk, the bloody milk was never there anyway.

At Party meetings, I listened avidly to every detail uttered by the comrades; I admired the leaders for they were so intelligent and articulate. They were, I thought, able to analyse every situation in great depth and, when called on, I attended every public meeting in order to swell the numbers. Special meetings were occasionally held for the purpose of reporting on some particular world problem and my admiration for the men on the platform knew no bounds. Never in my experience were women ever on the platform but, with all of these brilliant men available, who needed women?

At times, the trade union comrades would address meetings and report in detail on a dispute or discuss certain trends in the work situation. I listened to them and thought of their tremendous contribution to the working class and their dedication. I always thought of my own contribution and felt so insignificant. These men were great leaders, each one of them with a brilliant mind, extremely capable, and for the cause of the workers.

Our branch meeting had come to an end and, again, when asked to remain and have supper the comrades declined and departed. I went into the kitchen, put the kettle on and prepared myself some supper. There was a knock on the front door. I would be hesitant whenever there was a knock on the door and was on the alert in case it was Ken. I approached the door and asked who was there. "It's me, John." My heart pounded as I opened the door. "I changed my mind and I will have some supper." I tried to adopt a casual air and invited him into the kitchen. I continued playing the role of a worldly woman, full of confidence, but my heart was pounding. I felt ill at ease.

It was impossible to avoid him in this situation and I couldn't pretend to have something to do at this hour of night. I was forced to sit at the table with him, drink tea and make conversation. I got the impression I was prattling like a fool and I seemed to be talking about nothing. I was hoping he would

76

hurry and leave before I made a complete idiot of myself. When the tea was finished, I jumped up and asked if he would like another cup, but he declined, so I took the cups over to the sink, thinking to myself, "What else can I do?"

The kitchen was cold, so I suggested we move into the lounge where the stove had been burning all evening. The lounge was warm and I sat on the couch while he sat on a chair and we continued to talk. He came over and sat beside me and asked if the doctor he recommended had been able to assist us. "Oh yes," I emphasised, I was anxious to convince him, "He was wonderful." I felt nervous with John sitting so close, he moved closer. We looked into each other's eyes and I was in his arms. We were kissing and all the passion was released. I tried to stem the tide, "no, no," I whispered, "I couldn't, I couldn't." I was afraid. We continued to seek each other's lips, eyes, necks, and clung to each other as we moved towards the bedroom. We talked together for some time before he departed.

I lay there feeling guilty; I was an atheist with Judaeo-Christian morals. "Thou shalt not commit adultery." Not only did I feel guilt towards Tony but also towards John's wife who was away on holidays. For two days I wandered about as if in a daze, I couldn't believe it was true. The love stories I'd read in the past had influenced my thinking (unbeknown to me). I felt remorse and shame, for the love stories had emphasised what men thought of women who "make" it too easily. "He will have no respect for me, he will think I am easy and cheap." My mind went around in circles. I never, for one moment, questioned the double standards of men, for if they can have sex and affairs and we can't, then who in the hell can they do it with?

On the second evening he called in again and I was so relieved; he really does care I thought, he really does care. We talked and talked, and he understood my feelings of guilt and tension. We were then more relaxed and happy. I loved him deeply and was sure that he too was as deeply involved as I was. We made arrangements to meet at a Party social on the following Saturday evening and mum came over

to care for Leanne. I would never leave Leanne alone. Mum asked me where I was going and for sheer devilment I refused to tell her. "I don't have to tell you where I'm going, I'm no longer a child." For the first time in my life I realised I was in a situation where I didn't have to answer to anyone for what I did, where I went, or what time I came home; it was wonderful. Mum looked at me gravely, "Don't do anything wrong, Tony wouldn't like it," she advised. "How do I know what he's doing?" I asked. "He could be racing around with women left, right and centre for all I know." The affair continued until John's wife returned from holidays. We met at meetings and all was as if nothing had transpired; only the looks were there.

Ken did not put in an appearance during Tony's absence for it would have served no purpose. Tony returned and it was with mixed emotions that I greeted him. All the family wanted to hear about his travels and experiences, and asked scores of questions. Having always been interested in people's lives, the human side of people, the inside of their hearts and heads, my questions were of a different type, my questions reflected my attitude. I wanted to know if he saw, while in the Soviet Union, young people kissing or cuddling in doorways or parks. This brought forth a guffaw, "Not bloody likely, they would have to be more than keen to kiss and cuddle in five feet of snow." Everyone was highly amused at Tony's reply.

I was deeply concerned about my feelings towards Tony. I hoped he would not detect any change in me for I no longer felt I was the same person that I was prior to his departure. The affair, I felt, had made me into a woman and I was no longer the young girl; it seemed to have been a changing point in my life. Would he notice this change? Because we had married at such a young age we, in fact, almost grew up together and were close to each other despite our problems. It wasn't long before he knew about my affair, and I knew about his affair and we both laughed about it. However, with me it had gone deeper than it had in his relationship, for I was emotionally involved with John. Tony was aware of this

and remained silent; he knew that time heals all wounds.

Three months after Tony's return, I received a letter from an interstate woman friend and I was standing in the kitchen reading the letter when I suddenly became hot and thought I would faint. I could not believe the writing before my eyes. I sat on the couch and reread the section; I was not mistaken, there it was. No, it couldn't be, it just couldn't be, yet there it was. My friend wrote of how surprised she was when John, accompanied by another woman (a married professional woman who I knew), had called in to see her. They were spending a holiday together.

I thought I would die. What a fool, what a stupid fool I was to think he could possibly have cared for me. Me, just a bloody worker and he, a doctor. I wanted to throw myself on the bed and cry with anguish and humiliation. I saw myself as another conquest, but what sort of a conquest was I, a factory worker, a nothing? I was unable to speak to anyone of my torment. I suffered in silence and alone. At the time I could not see this experience for what it was: the seduction of an immature young woman by an older and more experienced man (until the feminist movement later enlightened me, for I had always considered John's actions to be those of a doctor, a professional, taking advantage of a worker). For several years John made further attempts to rekindle the affair but he never knew why he was always rebuffed.

I became frightfully bored with my jobs and would, after several months, resign only to find that staying at home was no palliative and would again return to another factory. I commenced work just three weeks prior to Christmas in a factory in Fitzroy. It was the largest factory I had ever seen and also the dirtiest. Fleas would breed undisturbed in the dust on the floor and when the machinists sat at their machines, the fleas would come to life and have a feast on our feet and ankles.

The weather became very warm and the two brothers who owned the factory decided to switch the fans on. The fans, having been unused since the previous summer, had given

the dust many months to settle, and when they were switched on the breeze they created disturbed the dust to such a degree that the factory took on the appearance of the Sahara Desert during a dust storm. The women screamed and clutched sections of garments to cover their heads until the storm abated.

When all was calm and clear, I asked if the bosses took the opportunity to clean the factory during the Christmas holidays. "You must be bloody joking," was the reply. Some of the older hands said they had never known the factory to be cleaned. I suggested to the bosses that they clean and scrub the factory during the Christmas holidays and they just laughed. "Our uncle," one boss said, "started this factory forty-eight years ago and the floor has never been scrubbed." "You should be bloody ashamed to admit it," I retorted. "You have no pride in your own workplace, you too have to work here eight hours every day. How can you tolerate this filth?" I thought they might do something about cleaning the place up but when we returned to work after the holidays, we were greeted with an extra three weeks of dirt and more fleas.

There was no alternative but to contact the union to see if we could do something about the situation, so I rang the Clothing Trades Union and spoke to one of the clerks. I detailed all of our problems and when asked for my name and address I hesitated but realised they would need to know this information to ensure I was a union member. Several days later, the bosses called me over and asked why I had complained to the union about the place. I disclaimed all knowledge of what they were talking about. "Don't give us that bull," one boss said, "Mr Bradley is a friend of ours and he told us the lot." I then knew there was no point denying their accusation so I blasted them about the fleas, no toilet paper, no receptacle for sanitary requirements in the toilets, no cleaner to sweep the floors or clean the toilets and no lunch-woman. They raved on about women pinching the toilet paper from the toilets and throwing their soiled sanitary pads up into the cisterns. "Where in the hell do you

expect the women to place their soiled napkins when you won't provide the receptacles for them," I retorted.

There is nothing refined about the life of a working-class woman, the nitty-gritty life is stark and real, a spade is called a spade and one has to accept the realities. Airy-fairy or high-falutin talk or theories are considered to be "bull" when you're on the factory floor. The argument raged between us until I walked off to my machine and began working. So, I thought, my first experience with a trade union ... Although I had always been a member, this was the first time I had approached a union for assistance and it turned out that the organiser was the friend of the boss and not of the workers who pay his wages. The bastard didn't even come to see me. What a bloody set-up, I thought and wondered what his payola was. I later learnt this set-up was not unusual among officials of the right-wing unions or among union officials where women predominated in the industry.

Several days passed, then one of the bosses approached my machine and said, "Well madam, we hope you will be satisfied now, we have put an ad in the paper for a cleaner. Does that meet with your satisfaction?"

I looked at him and said, "What about all of the other things requiring attention?"

He became very sarcastic and replied, "We will supply one roll of bum fodder (toilet paper) per week, a receptacle for sanitary napkins in the toilets, and a cleaner. Now are you satisfied?" I looked at him quizzically and said in a squeaky voice, "Yes sir."

Over a period of time, one of the bosses and I found we had similar tastes in reading matter, so we exchanged books and had many a good discussion on those books. Despite our arguments, we established a good relationship at work and many a good joke was swapped.

One of the women who worked there never knew the effect she had on me. She was a huge person in size; she weighed eighteen stone. She sat beside me as we worked and one day she commented on how pleased she was that the weather was warming up and she would soon be able to go swimming.

I looked at her astonished, "You go swimming!" I remarked. She stiffened up and said, "And why not?" "Oh, there is no reason why you shouldn't go swimming," I hastened to explain. "It's only because I am so thin I haven't been in a pair of togs for eight years." "You know your bloody trouble?" she boomed. "What?" I asked. "You're so bloody vain, you think everyone on the beach has nothing better to do than look at you; why should they look at you?" she went on before giving me a chance to say anything, "If anyone gigs at me, I just look 'em up and down and say what are you bloody looking at and that fixes them." I was hurt by what she said, but thought about it — and she was correct. Much of our self consciousness is, in fact, vanity created by the standards established by films and magazines, so, from that time on I wore bathers.

One morning I arose from bed with a slight pain in the back and by the time I arrived at work it became worse, however, seeing I was already there I decided to put up with it and put my day in. During the morning, I completed the bundle and, when attempting to rise from the chair in order to fetch another bundle of work, found that the pain had worsened to the extent that I could not stand straight. There were always piles of debris about on the floor so, stooping down, I picked up a piece of wood, used it as a walking stick and hobbled across the factory. All the staff ceased working and laughed at my gait. The bosses, who were not in view, wondered at the cause of the stoppage until I came around the corner and they too joined in the laughter.

Once again I had become pregnant - the result of another contraceptive failure: a broken condom. We now had the money for an abortion, but where could I go? Due to my previous experiences I had more knowledge and wanted the abortion performed expertly. I wanted a D and C carried out under a general anaesthetic, but where could this be obtained? After many enquiries and a great deal of running about, a doctor was recommended. He asked many questions and I was forced to tell him of my previous abortion and the resulting infection. He refused to perform the abortion explaining the

great risk of re-infection and the danger of losing my life. I was alarmed by what he said, so I called in to see a Party doctor to discuss the problem and seek his advice. He strongly urged me not to take the risk, in fact, he was adamant about it. I was not deterred, "I don't care if I do die, I will not have a baby I do not want," was all I said and walked out.

A woman knowing of my plight suggested another home method of inducing an abortion. I was to buy a female sponge from the chemist, soak it in dissolved Lifebuoy soap, then insert it into the vagina. In my desperation I was prepared to try anything and carried out her suggestion, but to no avail. I was informed of a doctor in Northcote who performed abortions so made an appointment to see him. The house was scruffy and dilapidated and I was stunned to see a policeman sitting in the waiting room. The usual examination took place and I was horrified by his reaction. "What on earth have you done to yourself?" he exclaimed. I told him of the Lifebuoy soap and sponge. "My God," he went on, "Your entire inside is inflamed from the carbolic, I wouldn't touch you with a forty-foot pole." I left his surgery in tears, "What now, what now?" I cried.

After recovering from the initial shock of the state of my body, I visited the Queen Victoria Hospital for treatment; I knew they must treat me, come what may. The woman doctor was furious on learning the cause of my condition and stated that I could be charged under the law for attempting to induce an abortion. What she said did not worry me for all I wanted was treatment, but I did tell her that no law or person would force me to have an unwanted child. She said no more and prescribed pessaries which I inserted religiously for a week. After the week's treatment, I returned to the doctor at Northcote and an appointment was made for the abortion.

The conditions under which this doctor operated were appalling. The house was dark, dirty and had a musty smell. I was asked to lie on a table in the kitchen, the instruments were being boiled in open trays on the gas stove, the nurse was not in uniform, the doctor operated in his suit and everything seemed to be grimy. The nurse applied the mask to my

face and began to spray the ether over the mask. I breathed in as deeply as possible, I so desperately wanted to sleep and have this ghastly business over and done with. For some reason the ether was slow in taking effect and I heard the nurse say, "She is resisting the anaesthetic." I thought, "If only she knew," and faded away.

I was slowly regaining consciousness when I became aware of a dreadful burning pain within my body. I moaned, "Oh the burning? It's burning, burning." The doctor spoke softly; he explained that because of the previous infection and the need to guard against re-infection, he had used large quantities of iodine. He went on to say that the iodine on the very raw carbolic-burnt tissue was the reason for the pain. I felt as if my entire body was on fire. "Please try to bear with it," he pleaded, "I know you are now free from infection and the pain will gradually ease." There was nothing I could do but suffer in silence. Dorothy was the only comrade to whom I could freely speak. My other two close women friends, Peg and Ruby, were not in the Party. These three women were the only women who sustained me. We sustained each other in times of need as only women can do. It was several years later when another woman on the branch needed an abortion that three comrades openly discussed their abortions with each other. Tony was correct: women all suffer pain but the world at large is oblivious to their suffering for they remain silent.

When I look back at this period, the contradictions which I now see just hit me in the face, and yet I never questioned them at the time. We were continually told in the Party that everything is political . . . that there is no aspect of life which is not political . . . so why was women's pain exempt from this? Why was our suffering unpolitical? Anything to do with our private lives automatically became personal and therefore was immediately discounted from being political . . . what a convenient rationalisation.

I returned to work and to the production of frocks for Woolworths, for which we were paid three shillings per frock. We were flat out trying to earn our money and resented the

fact that only three women were given the better priced garments while the rest of us were burdened with the cheap dresses. The women who were dissatisfied made a decision that the first woman to finish her bundle would ask on behalf of us all for an extra threepence per garment for the Woolworths' frocks, plus the sharing of the better priced garments. We all agreed to this and, by coincidence, I was the first to finish my bundle. I did not wake at the time, but realised later that they had all hung back and gone along slowly to ensure I would have to front the boss. I fronted the bosses and told them of the women's demands, explaining the decision taken by all of the women sewing the cheap frocks.

One of the bosses approached the machinists along the bench and asked each machinist individually if she was unsatisfied. They each in turn said "no". He didn't even bother to complete his tour; the result was obvious and, had he continued to do so, he would have found only one other malcontent, my friend and neighbour, Peg. He walked over to where I stood with a smile on his face, "I admire your principles," he said, "but they will never back you up." I was disgusted with the women; they had made a decision and didn't have the guts to back it up. They were content to let me do their dirty work then leave me high and dry.

Well, I wasn't going to back down, I stuck it out and fought for the better priced garments. I wanted to know why Coral got the men's dressing gowns which paid ten shillings per garment. Why her, and not us? The boss said that Coral refused to work unless she could earn a certain sum of money and they wanted to retain her services. What they didn't know was that Coral, because she was a punter, came to work every Monday flat broke and continually borrowed money from the bosses while, behind their backs, she held forth with her rabid anti-semitism about them being "bloody Jews". This had nothing to do with the dispute, so I made no mention of it but insisted on a better price. They said I would have to continue with the frocks at the price they were. When I refused, they told me to go home.

I took this to mean I had been given notice and told this to

the women when I returned to the machine. When the bosses heard of what I'd said, one of them approached me and said, "If you want to leave, you must give us notice."

"But you gave me notice," I replied.

"No that wasn't so," he argued.

I was so disgusted I no longer wanted to remain there and gave my notice. There was a gloom over the factory for the next two days and the women avoided looking at me. I said my goodbyes and left.

Several days after leaving the factory, Peg told me that one of the disgruntled women who had backed down from the decision was warned to speed it up if she wanted to keep her job; she had broken down and wept. My only comment was, "Serves her bloody right, I have no sympathy for these weak women."

I had no understanding why women were like this, nor any idea what was responsible for making them like this. I had never given a thought to the processes of society which socialise women into being feminine. I didn't understand that being feminine was to be passive, non-thinking, servile and manipulative. Almost all of these women were married and were put down by husbands who said things like, "You stupid bitch, you bird-brained twit, you stupid cow." That was what most of those women were accustomed to, so why should they stand up to a boss? The boss doesn't speak to them in this manner. He smiles when he asks them to do something and, what's more, they are paid for their labour which is more than they receive for their work at home.

By this stage I was fed up with work in the factories, but what else could I do? I thought I could do something better, something more useful to society, but to do this one needed to be educated and I possessed no qualifications. Home-life again became a bore, but this time I became adventurous and was determined to make an effort to seek different employment. I would try to get work where I could obtain job satisfaction; a job where I would enjoy what I was doing. I scanned the *Age* regularly looking for work; the job with that "special something". "Who knows what may turn up,"

I thought . . . and, one day, there it was . . . Dental Nurse required at Broughton Mental Hospital. "If only, if only I had the luck." I applied for the position and anxiously waited. I was duly called before the superintendent for an interview and my hopes were raised. Perhaps for once luck would be on my side. The superintendent told me they were interested in an unmarried woman because they preferred permanent staff, however, they were prepared to start me on a trial period for three months. I was unaware that I was the only applicant for the position.

I walked out of his office in a dream, I couldn't believe it; at last it had come, the chance to break out of the factories. I was so elated I flew home as if on wings and anxiously waited for Tony to come home. When he arrived, I danced about with excitement while telling him of the news. He knew how much this meant to me and rejoiced with me. He was at this time employed as a maintenance painter in another mental hospital. "Oh Tony, it will be wonderful. I will really be doing something to help people, my work will be valuable and necessary." This was very important to me.

# 7

I WAS EXCITED AS I SET OFF FOR WORK and also very nervous
of the unknown. Would I be able to learn everything? What
if it proved to be too difficult for me? No, I would try hard
to learn all there was to know and I was determined to prove
myself. This had to be it; this was my one chance and I must
succeed.

I waited for the bus, making sure I was early. At last I was
on my way to what seemed the opening of a new world. The
walk of one and a quarter miles after alighting from the bus
was no problem. The walk was through the grounds of Lister
Hospital and, at that time of year, the climate was pleasant
and the gardens were at their best.

I was overawed by the entire atmosphere of the hospital;
the noiselessness, the peaceful quiet. The only noise to be
heard was the occasional conversation of the staff as they
went about their duties. The dental surgery was clean and
newly painted, for the hospital had opened only three months
prior to my commencement and the surrounding gardens
were in the process of being established.

The dentist was an elderly man, very quiet, and, with few
words, went about teaching me my duties. I reported to the
sewing room where my measurements were taken for uni-
forms and, while waiting for them to be completed, I wore
the dentist's gowns. Working in the dental surgery isolated
me from the staff, but I would see them when they accom-
panied patients to the surgery or during lunch in the mess-
room. They were so trim in their uniforms and were in the
process of training to be nurses or were qualified psychiatric
nurses. They all seemed to be so much more intelligent than

me and I was afraid. Would I be able to absorb the knowledge necessary to be a dental nurse?

A week had passed and still the excitement possessed me as I hurried to get to work. One day I was running across the road towards the bus stop when, suddenly, I knew with horror that it was too late to stop. I turned my back to the oncoming car . . . and finished up on the road at least fifty feet from where I had stood. People seemed to come from nowhere and were hovering around. "I'll be all right, I'll be all right," I kept on saying and attempted to sit up. My thoughts were on my job. I must get to work; I'll be alright. The people insisted I must lie down and kept pushing me down as I tried to sit up. "But I'm all right, I must go to work." They forced me to lie down and a woman placed a blanket over me. The ambulance was on its way. The tears ran down my face; "I have to get to work," I thought, "they don't understand what's at stake." The ambulance arrived after some time and I asked the people to contact my husband and inform him of the accident.

I was alone in the rear of the ambulance, not knowing which hospital they were taking me to. The tears continued to flow, "I must be all right, I must, I must," I spoke to myself; "I must keep my job, I can't lose it after all this time. All these years and now this has to happen." After several hours of waiting and a sketchy examination by a doctor at the casualty department of St Vincent's Hospital, I was discharged with a certificate which read, "bruised ribs and lacerated skull". My stockings were torn, my shoes missing, and I returned home by taxi.

The hospital informed Tony I was satisfactory and would be leaving for home, so he anxiously waited. I clung to him on entering the house and he put me to bed with a hot water-bottle and tried to soothe me. On the following day my entire body was racked with pain but the local doctor, after reading the hospital certificate, stated there was very little that could be done apart from rest, warmth and a sedative.

The fear of losing my job drove me to return to work one week after the accident and, on returning, I was called to the

sewing room to collect the uniforms. I hastily ran to the sewing room, and when returning to the surgery, opened the door of the wardrobe, put on a uniform and gazed at myself in the full-length mirror. A white uniform gives one status and signifies importance and, as I turned about looking at myself, I thought, "It feels so good, I now feel as if I am someone." Working in factories and other menial-type jobs had left me with an inner feeling of nothingness but now I felt it was all over; I felt I was someone. I knew this job would give me great personal satisfaction and I was determined to make the grade. It was so much nicer to be able to say, "I'm a dental nurse," to people who asked what I did for a living than to say, "I'm a machinist in a clothing factory."

I began to suspect there was something wrong with my neck and found that holding my head up all day was a great strain. It was a tremendous relief to lie down after a day's work and take the weight of my head off my neck. I spoke of this to Tony and he would massage my neck and back in an effort to relieve the pressure. We were going to a New Year's Eve party and, by this stage, a huge lump had developed on the spine making me feel very miserable and worried.

I called in to see the local doctor but there was a locum in attendance. However, this young man was a friend and after examining my neck said, "I don't wish to alarm you Zelda, but I think you have a fractured spine." I sat down and asked him the implications of this injury and he explained that he could feel fragments of bone and only an X-ray could indicate the extent of the damage. He gave me a letter to give to the doctor in charge of the surgical unit attached to one of the mental hospitals so the X-rays could be taken. Being covered by compensation meant this was in order.

The X-rays revealed the sixth and seventh cervical vertebrae were fractured, with one large fragment wedged into the spinal column. All this trouble had occurred within five weeks of commencing work at the hospital and again the insecurity of losing this job was uppermost. However, there was no way I could avoid having the operation and it was carried out. The largest fragment was presented to me in a

bottle; "Is that all?" I said when viewing the small piece of bone in the bottle. "You don't know how bloody lucky you are," said the surgeon. "Is that all?" he mimicked as he shook his head from side to side. This was my first surgical experience and with my growing knowledge of anatomy, I soon realised just how fortunate I was and how close to being paralysed I had been.

The new job environment was wonderful; there were no pressures of production or the incessant noise of machinery and for the first time people became more important than production. Nowhere else had I found this to be so. How strange I thought, it is only after people become ill that attention is given, people only care about people after society has caused the damage.

My duties took me to two hospitals: the Broughton Hospital where I spent three days per week, and the Haven which was a retarded children's centre. After reporting for duty at Broughton Hospital, the local bus would take me to the Haven; a very pleasant ride through semi-country area. Gazing out of the dental surgery window at the Haven, I could see the beautiful Dandenong Hills. Although the patients at the Haven were considered to be children because of their mental development, their ages ranged from newly born babies to women well beyond my own age.

As dental nurse, one of my duties was to restrain and control the patients in the chair; this often meant sitting on top of the patient, holding their hands or head still, or holding a vast length of material around their body to prevent them from moving while the dentist operated. Many of the patients were twice my weight and I received many a kick on the legs. It always required a great deal of patience and strength to control them.

At first I found it almost impossible to overcome my feeling of compassion towards the patients, for I could remember only too well the agony I suffered as a child when attending the dentist. My parents were once told by a group of dental students that I was the worst child they had ever treated, and here I was . . . a dental nurse. I would avert my face when

the patient was suffering pain but, as time passed, I become accustomed to the task and was able to placate their fears.

My trial period of three months passed and I pursued the union representative in order to join the union. This union was an industrial union, embracing all the staff except the professionals and administrative personnel. Four months after joining, I attended the first general meeting held since becoming a member and discovered it was the only general meeting the union had called for a period of twenty months.

Only eight members were in attendance, three of whom were already on the executive. Although this number was insufficient to constitute a quorum, the meeting proceeded. There were two vacancies on the executive and a vote was to be taken to fill them. I got to my feet, explained my position as a new member and added that I didn't know anyone at this meeting apart from the representative from my hospital, so how could I vote under these circumstances? I pointed out that, according to the rule book, quarterly meetings were to be held and suggested we abide by the rules. This was my first meeting and I was already in a situation of confrontation.

The union had the part-time services of a secretary from another division of the federation and the members from one hospital wanted a full-time secretary and an increase in dues to pay for this. The meeting decided to defer the matter for six months to allow the executive time to research the cost involved.

I was reared from childhood to believe that the trade union movement was the only people's organisation which fought for the workers' interests, the only organisation which had the fundamental right of all people to live in dignity as its aim.

I now intended to remain in this job (the attainment of job fulfilment) and, at the age of twenty-seven, felt confident enough to participate in union activity. Apart from believing that the only method of obtaining any benefits from within our economic system lay in the united struggle by the workers, I felt that one had a responsibility to be active in a union if

you wanted to receive the benefits that accrued from this organisation.

My only experience with a trade union to date had been devastating, however, I did not envisage this as being general and was quite idealistic in my aims. I had a naive outlook due to my lack of experience and had the notion that the government as an employer would be straight down the line concerning wages and conditions. Oh I had so much to learn!

In order to understand the explosive political climate prevalent when I became involved in the trade union struggle, I must now furnish some background information.

From the time Archbishop Mannix became involved in the anti-conscription campaign during the First World War, Catholics began joining the Labor Party in greater numbers.

The ALP had a long history of factionalism and power struggles and, when there was no issue to campaign, the members tended to argue on religious lines. The "Movement" (a secret right-wing Catholic organisation) was strengthening the anti-socialist Catholic faction and Movement members themselves joined the ALP. All friends and relatives were encouraged to join and almost all Catholics were affected by the pervading pressure.

"The longstanding tendency to use church organisations as a recruiting ground for the ALP and to 'stack' branches for pre-selection and other factional purposes became exaggerated. Many young Catholic zealots who joined the ALP seemed to be motivated entirely by religion and hardly at all by grass roots politics."[1]

After the defeat of the Chifley Labor government in 1950, of the eight new members to join caucus, six were Catholics. In 1954, approximately sixty per cent of caucus members were Catholic.

The first majority Labor government in the history of the State of Victoria came to power in late 1952. Serious infighting and divisions within the ALP were concealed and Cain,

---

1. Robert Murray, *The Split: Australian Labor in the Fifties*, Longman Cheshire, Melbourne, 1970.

the state leader of the ALP, became "suspicious of intense young Catholics who seemed to have the run of 'Raheen' the Archbishop's residence, of the Movement and the influence"[2] they were having in the trade union movement.

"The sectarian atmosphere that developed in the first year of government became a chronic weakness".[3] Protestants began organising against the Catholics and it was almost impossible for men on all sides to avoid being enmeshed in the fray. Requests for land grants in Queensland, NSW and Victoria were submitted by the National Catholic Rural Movement for the purpose of establishing Italian and Dutch rural communities. "It was hoped at least in theory to have some non-catholics as well".[4] This came at a time when ex-servicemen were still waiting for soldier-settlement land. Queensland and NSW said "no", however, tremendous in-fighting within the ALP came to the surface when legislation for this grant of land was debated in the Victorian Parliament.

Industrial groups (Catholic action groups) within the trade union movement were and had been active for several years. Bitter struggles took place within the trade union movement and the Victorian Trades Hall Council (THC) was having many difficulties with the Victorian Labor Government.

Policy-wise, there was very little difference, if any, between the ALP and the Liberals and many people were becoming very cynical about the political scene. The THC and the government eventually dead-locked over the one-manned bus (driver-conductor) dispute and the THC stated "that the Victorian Branch of the Labor Party is no longer worthy of financial support or association".[5]

As far back as 1953, the Clerks' Union delegation gave strength for Catholic action activities within the ALP. At the state conference held in May of that year, almost half of the Clerks' Union delegates were members of the Movement.

---

2. Robert Murray, *The Split.*
3. ibid.
4. ibid.
5. ibid.

The industrial battle against the communists had at this stage been almost total and the industrial groups (Catholic Action) were now in control.

Many unions were deeply concerned by the situation and began recruiting support against the "establishment" policies of the Victorian Labor Party and against the desire of the industrial groups to control all unions.

Dr Evatt, the federal leader of the ALP, had already spoken of the Movement's activities and was further drawn into the struggle. Twenty-five union secretaries within Victoria attended a meeting and "with fevered unanimity decided to urge the federal executive of the ALP to immediately review the position in this state in accordance with rule (k) of the federal constitution".[6]

Press reports appeared "reflecting the mystification of many leaders of both churches and the Labor Movement and what Santamaria and the Movement were all about and about their relationship to both Catholic Action and the industrial groups".[7]

"Archbishop Mannix in an address said, 'the anti-communist industrial groups had the backing of every Catholic bishop in Australia'."[8]

"By the end of January 1955, the division and mistrust on the Victorian central executive (ALP) had hardened and believable communication between the two camps became difficult. Threats and insults increasingly became the style of discussion".[9]

The THC called on Victorian unions to support the federal executive of the Party in its withdrawal of all support and recognition of the industrial groups. There were many bitter union meetings.

"Archbishop Mannix declared a special week of prayer because of the communist threat to Australia. The possibility

---

6. Robert Murray, *The Split*.
7. ibid.
8. ibid.
9. ibid.

of a communist invasion of Australia was real he said."[10] This type of activity was symptomatic of the McCarthyist era.

After the special federal conference held in Hobart, the two rival Victorian delegations lined up to rally as much support as possible from the body of their own parties. There were two executives within the Victorian ALP, the old being the Movement, which was now deposed but refusing to go, and the other, or new executive, having the support of the Victorian Trades Hall Council (VTHC). Political infighting was at its peak and twenty-four parliamentarians were asked to declare their loyalty to the new executive.

On 19 April, in the sitting of the Victorian Parliament, Cain, the ALP premier, moved that a particular message be considered by a committee of the whole house. A division was called for and the breakaways from within their own party crossed the floor and voted with the opposition. This was the end of the Labor Government in Victoria. Eleven men crossed the floor and were eventually expelled from the ALP. Within a short space of time, seven federal parliamentarians were also expelled from the party.

Thirty-three Roman Catholic bishops of Australia issued a pastoral letter emphatically defending industrial groups.

It was within this current atmosphere that I, at the next meeting of my union, made a stand which was to lead the struggle within the union for membership control of their own organisation. I had gathered a few members to attend for I needed their support and I moved a suspension of standing orders to discuss the ALP dispute. The president informed the meeting that the union executive had already decided to support the old ALP executive – in other words, support for Catholic Action and the Movement. I was horrified, for this was done without the knowledge of the members. The meeting was very heated and arguments ensued, however, the vote was taken and the motion was carried. I then moved that our division of the union support the new executive of

---

10. Robert Murray, *The Split*.

the ALP. This again produced very heated and emotional arguments until the vote was taken and the motion was carried.

I was both excited and thrilled by the acceptance of our motion but the worst was yet to come. The fight had only begun. A member immediately jumped to his feet and gave notice of motion, the notice being that at the next general meeting he would move that the motion just carried be rescinded. During general business, I asked what progress had been made in the nurses' wage claim and was informed that it was in the course of preparation.

The union executive was, apart from one member – the president, completely controlled by Catholic Action, a group which eventually became known as the Democratic Labor Party (DLP). I will henceforth refer to these people as DLPrs.

In 1955 the union had an approximate membership of one thousand members (although there was some confusion as to whether or not they were all financial) and the result of a plebiscite indicated support for a full-time secretary.

This was the beginning of my lengthy trade union involvement. Many of the formalities were new to me but I did know some of the rules as Communist Party meetings were always conducted on formal lines. However, when there was a motion, two amendments and an addendum before the chair, I didn't know where I was; neither did the president nor any other members present. It was a case of "bull" baffling brains and somehow or other the meeting groped its way through the bog and resulted in a majority decision, otherwise there was hell to pay.

The new activity within the union was beginning to reach the members and they began to discuss with me the problems and events taking place. I did everything possible to encourage this interest, knowing that if the members took an active interest, the union would become a stronger force.

As usual, my Party activities went on, such as attending meetings and classes, letterboxing, pasting up posters, and assisting Tony with the delivering of our weekly paper. Producing goods for the Party annual fair was a time-consuming

responsibility and never, with all this activity, did I neglect the home. Friends considered me to be an extremist where cleanliness in the house was concerned for I took great pride in my housekeeping. I also knitted our jumpers and made all Leanne's frocks as well as my own. No one could say I neglected my family for outside-the-home activities.

Tony and I decided to buy a motor car but, with very little money, the only one we could purchase was an old model which spent most of its time being repaired. Paying for repairs as well as the time payments while obtaining no benefit from the vehicle was bad news, so we traded it in for another used car and remained on the same merry-go-round.

One evening while Tony and I were at a Party social, I overheard Tony ask David how he was enjoying his new job. David was an architect and he astonished me when he said that he wasn't at all pleased with his recently obtained employment. I found his reply difficult to comprehend and asked him why he was dissatisfied. "How can I be happy or get job satisfaction when I know I am designing a factory for Aspro where everything will be done inside this factory to exploit workers?"

I thought about his reply. I could not understand how academics could be dissatisfied with their work. I considered they were extremely fortunate to have had the education and the opportunities, and I felt I would have been delighted if I were in their position. Several other academics in the Party had also spoken of their dissatisfaction with their work situations and this was something I just could not comprehend.

General meetings of the union were now being conducted according to the rules and at the next quarterly meeting, in accordance with the notice given at the previous meeting, it was moved that the motion on the books regarding support of the new executive of the ALP be rescinded. Now that both sides of the political spectrum were taking more interest in the political affiliations of their union, the arguments raged and tempers flared. The DLPrs had organised the greater number and defeated the previous motion but another member immediately moved for a notice of motion. He

moved that at the next general meeting, he would move that a plebiscite of all members be taken on this issue. During general business I raised the matter of the lack of safeguards for the staff against contacting tuberculosis while taking X-rays, doing tests and giving injections as is the practice in TB sanatoria. I had become aware of the great risk, not only to myself as the dental nurse but also to the nursing staff who cleaned the patients' dentures and the laundry staff who handled the laundry. It was moved that this matter be left to the executive.

One of the tactics used by the DLPrs when they didn't want any action to be taken was to move that the matter be left to the executive. This meant instant death to action. I had for many years wondered why men developed this method of conducting meetings and it was during my involvement in this trade union that the answer became clear. It all had something to do with "constipation", for despite the constant moving of motions, nothing seemed to be happening, there was no action. Because I had very strong views about people making their own decisions on all issues which affect them, I also raised the lack of meetings at my hospital. The rules allowed for the establishment of sub-branches in each hospital but it was a real effort trying to bring this about. Mr Rogen, our union representative and executive member, said he would attend to this matter.

When commencing work at the hospital, the major causes of concern to the staff were the roster system, the shortage of staff and no pay slips with the pay cheque. The nursing staff worked a thirteen hour day, two days on, and two days off. They preferred this shift to any other, as they felt that it was essential for their own well-being and health to be away from the hospital environment as much as possible. General nursing differs greatly from psychiatric nursing, the difference being that in general nursing the nurse approaches the bed when it is necessary for her to administer to the patient but with psychiatric nursing the patients constantly approach the nurses, talk to them and request their attention. The psychiatric nurse is the daily companion of the patient and it is for

this reason that the staff preferred to work the longer day then have the two days off. The man in charge of mental health at the time was always adamant that this roster would be done away with and that a five day week would be introduced. Because of the staff shortage, overtime was being worked constantly and the method used in the accountancy section of the department resulted in all penalty rates being paid one month behind. There were no pay slips with the pay cheques and the staff were always confused, for it is impossible to remember who worked what and when. This system gave rise to a great deal of discontent.

The staff shortage on the female side was more acute than on the male side, and on the night shifts in many hospitals ward assistants were in charge of wards.

The numbers game was now being played in earnest within the union and it became obvious at the general meeting that there was going to be trouble, for the DLPrs had organised a good attendance. The federal conference of the union had decided that we support the ALP led by Dr Evatt and that our branch disaffiliate from the old executive and support the new executive in Victoria. The meeting was in an uproar and, after a great deal of argument, the president closed the debate to enable the meeting to deal with other matters. I asked the president to explain his previous remarks concerning the new state liberal government, and he said that since the new government had come to power, the union had found it difficult to arrange a meeting with the Mental Health Authority for they had become more arrogant in their attitude towards the union. I then brought up the issue of the neglect of the artisans in wage claims and pointed out that claims should be across the board for all.

I was a very quick learner and I already knew from what I'd seen on the job and learnt from the union meetings that there was nothing "straight down the line" about the government as an employer. They were no different to any other employers and the staff had to fight for every crumb.

No single person can move mountains alone and knowing the union members were dissatisfied with their work con-

ditions and the union executive, I encouraged them to attend meetings to have their say. To stand back and give workers advice on what should or shouldn't be done is easy, it is far more difficult to put your actions where your mouth is, and I was prepared to do battle. Many of the members were now feeling confident and together we created a growing interest and awareness among the membership and the union membership began to increase.

Despite the result of the plebiscite taken, arguments arose over the question of a full-time secretary and it was obvious that the DLPrs were opposed to the idea as the acting part-time secretary was one of their own supporters. They were afraid of losing this power position. We fought strongly on this issue, for it was impossible for a union to function or grow in strength without the services of a full-time secretary.

It was then moved that the meeting call for applications for the position of secretary for the branch. An amendment was then moved by a DLPr for the appointment of a part-time secretary. Their tactics were obvious. Although the union rules stated that the secretary should be elected by the members and only a member from within the federation could nominate for the position, they wanted to appoint a secretary and prevent the members from electing their own secretary. It is interesting to note that in the struggle for power, or to retain power, there are no rules that men are not prepared to brush aside, even if they themselves established the rules originally.

Discussion resumed on the issue of the ALP, so the president ruled that the decision of the federal conference was binding and our branch would have to support the new executive of the ALP. Again there was an uproar; some members were on their feet shouting and yelling. Arms were being waved threateningly and the president closed the meeting.

While walking on my way to work one morning, a motorist offered me a lift. He was one of my most bitter opponents in the union; a man holding down a senior position in the department and, at the same time, holding an official position

within the union. As we drove towards the hospital, he said that, in this opinion, temporary employees should not be in the union because if they were to get into difficulties on the job there was very little the union could do to safeguard them. I knew he was not concerned about my welfare and that this was his method of making a veiled attempt to warn me of what could possibly happen to me, particularly when so many of his mates were in power positions. I acted unconcerned but got the message loud and clear.

The executive of the union contravened the union rules and advertised in the daily press for a full-time secretary. Out of the thirteen applicants, Tony was the only union member to apply. It didn't enter my mind that I could have or should have applied, for women were not part of the paid trade union hierarchy. The executive went ahead with their wheeling and dealing and decided to appoint Mr T Andrews (ex-politician who was expelled from the Labor Party) to the position of secretary of the union. They then called a general meeting to endorse their action.

Feelings were running very high in all of the hospitals over this complete and utter disregard for the members' rights and union rules. Where this action should have been seen as the political right for union members to control their own organisation, it became, to many, a fight against Catholic church interference in their trade union. To some it was a Catholic versus all others clash, and the Catholic versus masons situation within government establishments didn't help to clarify the state of affairs. In some cases, Catholics were fighting Catholics where different political alliances were held.

Tony sent the federal president a letter explaining the entire situation concerning his application for the position of secretary and at the following general meeting, which was called to endorse the action of the executive in appointing Mr Andrews, the president read the reply telegram from the acting federal secretary to Tony's letter. He warned our branch of the union that Tony could under the rules challenge the union if they went ahead with the appointment.

We were expecting trouble at this meeting for both sides had marshalled all the support possible. The atmosphere was tense and vibrating. The executive were so confident of victory that they had Mr Andrews waiting outside the door ready to be introduced, however, arguments broke forth and emotions flared. The executive in an endeavour to justify their actions, argued that the members at a previous meeting had agreed to appoint a secretary and, in their opinion, the appointment of a secretary from outside the service would be advantageous to the members by the secretary being more able to deal with the Authority and the Public Service Board (PSB). They also felt the best man possible should be recommended. In other words, their own members were not intelligent or capable enough for the position. They argued that their action was in accord with the ruling of the Industrial Registrar but they had nothing in writing to confirm this.

After a lengthy and heated debate, the president ruled that the appointment could not be made. The entire meeting was electrified, half of the membership was on its feet, there was shouting, arms were waving in the air and punches were thrown. One member was knocked to the floor, he was a staunch ALP supporter and lost his job not long afterwards. The DLPrs continued to fight and moved an amendment that two names only be submitted for a ballot: Mr Andrews and one other, Tony's name being excluded.

Great arguments again took place but to no avail. As we left the meeting, one man dashed up to me, he was almost purple with rage. His frustration was almost beyond his control and waving his fists in my face he hissed malevolently, "You're behind all this and you'll never get away with it." I stood there petrified with shock at his violent hatred. I realised then that being a woman had saved me from public violence, for almost all male violence towards women is carried out in privacy. Further moves were made behind the scenes to appoint their man but the wheeling and dealing on this issue had failed.

I dreaded going to the union meetings for the latent and, at times, overt aggression was almost more than I could bear.

I could feel the currents seething and my body became taut with anxiety. Oh how difficult it is to be involved in right-wing unions. One would assume that in this day and age that people should have full rights when running their "own" organisations, but this is not so.

On arrival at the hospital next morning I could feel the tension all around me. I entered a small office and asked the young woman there if she felt at all confident about her exam on the previous day. Mr Malone, the hospital secretary was standing there. She said she wasn't at all confident about her exam and Mr Malone, as he moved towards the door said, "There is someone else who need not be too confident either," and left the room. He could only have been referring to me for there was no one else in the office. I felt threatened and knew my fears were justified when later, during the day, I received a phone call from someone in the know warning me that the skids were under me.

I was in a serious situation and felt insecure. I knew if I was to be sacked on any pretext the union, being what it was, would have rejoiced at my dismissal, so I paid a visit to Mr Stout, the then secretary of the Victorian Trades Hall Council. I explained my situation, and he assured me of full support if I was victimised in any way. I also let it be known on the job that if I was sacked at least twenty DLPrs on the job would go with me, for I knew enough about various individuals and what they were up to at work to blast the place wide open.

When one works within the male structures long enough, one learns to use male tactics in order to safeguard oneself.

# 8

I SUFFERED A GREAT DEAL OF STRESS because of my union activities, but there were no other means by which we could make our union strong. The thirteen-hour day shifts made attendance at union general meetings almost an impossibility, and when nurses did decide to attend it was 8.45 p.m. before they arrived. I began agitating to get a sub-branch established at my hospital to enable members to become more involved in their union.

The next general meeting decided to conduct a ballot for a full-time secretary. The members were victorious in forcing the executive to abide by the rules. An election was conducted for a returning officer and two assistants, and I found myself in the position of an assistant returning officer. The opposition must have been very slack in allowing me to win this position, or perhaps they were unconcerned because they had secured the returning officer's post.

The president continually reported to the meetings of his work within the union and I accused the remainder of the executive of riding on his back. I asked them what they were doing in each of their own hospitals, knowing full well they did very little and only one of them reported of her activities. This woman was so unfamiliar with union matters that while on the executive she once inquired at a general meeting how one goes about getting extra toilets for the staff at her hospital. She was on the executive because of her politics, not because of her trade union ability.

The ballot was under way and I was determined to make sure it was an honest ballot. This was my first experience in the position of an assistant returning officer and, to my

knowledge, this also applied to Harry the other assistant. We were called in to assist with the preparations for the ballot and, to my amazement, all the ballot papers were already initialled. We did not witness the initialling of the papers, we didn't know if the members receiving the papers were financial, nor did we know how many ballot papers were printed. Our duties consisted of counting the necessary number of ballot papers to be forwarded to each shop steward, insert them in an envelope together with a list to be signed by each member when receiving their ballot paper and that was all that was required of us.

I was most dissatisfied with this procedure and discussed my concern with Harry. He too felt uneasy and we were averse to signing our names to a statement declaring that the ballot was "fair dinkum" when we didn't know if it was. I asked him if he would be prepared to speak of his dissatisfaction with the procedure if I was to notify the executive of how I felt, and he said he would, so I immediately wrote to the executive about my concern for the ballot.

In due course, I received notification requesting my attendance at a special executive meeting. The meeting was held in a small room in the Victoria Hall. It was conducted like a court case and Harry and I were made to wait outside. Eventually we each entered alone to give evidence while the other remained outside. I was attacked for daring to imply that the returning officer was dishonest and was told in strong terms that he was a man of integrity and had conducted ballots for many years. "And now you dare to cast aspersions on the character of this honest man and citizen." The blasting came from all directions, some more vicious than others. I sat there listening. I did not consider the returning officer to be dishonest and I told them so. What I did know was that the procedure for union elections in the past had been conducted in this haphazard fashion with the office woman from another division doing at least seventy-five per cent of the work, and it was obvious that this procedure had never been questioned by the returning officer. The blasting continued, "How could you do such a thing,

and to an old man?" The emotive reasoning was revolting, particularly when coming from some of those ruthless people.

On the one hand, I was asked could I not have overcome some of these difficulties without resorting to the executive while, on the other hand, the returning officer said he was tired of me being on his back. All my concern was about the conduct of the ballot and I demanded the right to put my signature on a statement where I could say that to the best of my knowledge this ballot was conducted honestly. They hated my guts, but they were forced to conduct a new ballot. All details were attended to and both Harry and I signed the declarations willingly.

How-to-vote cards printed in three languages appeared for the first time during an election. One member claimed he received the how-to-vote cards together with a list of financial members in his hospital. The only people with access to this information were the executive. The ALP supporters then decided that they too would have to distribute how-to-vote cards.

While we were thus engaged in domestic politics, dramatic events were occurring on the international scene. The disclosures by Khrushchev of the Stalin era came as a terrible shock to the majority of communists. Obviously some of the leaders must have known what was going on over there, but the ordinary member had no idea of the suppression or suffering that was perpetrated on the Russian people. True, people did speak of the suffering they had witnessed but to convince the communists of this was the same as trying to convince Catholics of the suffering the church was and still is, condoning in South America.

I was horrified by the disclosures and wanted to know how and why it happened; what went wrong and why the Russian people had tolerated the situation? I could not understand why our Party remained silent. To whom were we being loyal? Our leaders made lengthy reports and speeches and I never questioned what they said. I was always overawed by their intelligence, ability to express themselves and their composure. I never questioned a doctor when giving a diagnosis,

and it was the same in the Party. One never questioned the experts.

Tony resigned from his job as a painter with the department; he wanted to get away from the small-town environment and went to work painting the Melbourne Cricket Ground in preparation for the Olympic Games.

Again there was trouble. Hungary exploded and Russian tanks moved in. With the Khrushchev exposures and then the Hungarian crisis, a growing disillusionment set in with left politics and more comrades were leaving the Party. This being the case, I became secretary of the local branch, a position no one coveted as it meant a lot of hard work and no status. I had already been treasurer and literature leader. Women had no difficulty in obtaining these positions in the Party because there was no power, glory or authority attached to them.

There was an elite grouping in the Communist Party, an elite that was always at the "right" gatherings, socials, parties, receptions and places. This elite was made up, in the main, of business people with money, academics, or people in power positions such as trade union leaders. The type of people in the elite may alter, but there is always an "elite". The ones on the outer were the working class.

During the Olympic Games, one of the women comrades in my branch, Jessie, was on a committee responsible for organising a welcome function to the Russian team. She was one of the "elite". The function was being held at the Royal Ballroom, and the branch booked a table. On arrival at the Royal Ballroom, Tony and I found ourselves seated at a table at the far end of the hall with a group of strangers. We went looking for the branch table and found several of our comrades seated at the table; the academics, the business people, the pseudo-elite, and several "important" Labor Party people. I noticed a number of vacant seats there and asked if Tony and I could sit there but was informed that these chairs were for some of the expected Russian athletes.

I told Jessie, who had organised the table, that had I known we would be sitting with strangers we would never have

attended. She shrugged her shoulders and said, "No one is keeping you here, you can go," and turned on her heel and flounced off. This was the attitude of the elite to the workers, even if the worker happened to be the secretary of the local branch.

Although many genuine comrades gave their time and energy to causes such as the Peace Movement and Aboriginal issues, these organisations received priority from elitist middle-class "do-gooders" in the Party. The greatest problem faced by middle-class left-wingers was to find an outlet for their energies. Women in the main were affected in this way because men have many organisations which they control, but the women were at a loose end.

The Party constantly stressed the need for comrades to be involved in local organisations and, feeling guilty because I had played no part in local activities, I joined the Local Progress Association. This involved me in more meetings and a lot of talk which led to nothing apart from conducting an annual fair: an event which took me out every night for a week to raise funds. The chairman was a detective and he continuously ridiculed the secretary even though they were of the same religion and politics.

As time went by, the roads were made, street lighting was provided and the obvious needs were attended to, so people gradually lost interest in the organisation and it fell apart. I never did know what happened to the money raised at the fair.

At the general meeting of the union, in December 1956, and again in March 1957, the question of affiliation to the ALP was raised. I went to great lengths to explain the need for the union to be affiliated and stressed the need for workers to have a political party where they could bring pressure to bear, otherwise how could politicians take heed of our demands and needs? The motion was carried and now the union would affiliate with the ALP. This campaign had proceeded for almost two years and yet there was more trouble in the offing.

Notice of motion was moved that we disaffiliate from the ALP but this was defeated for lack of a two-thirds majority

needed according to the rules of the union, and again there was shouting and screaming with tempers raging.

I had reached the stage where I trembled every time I went to a meeting. The DLP supporters were now organising in earnest and were bringing migrant members along to the meetings. These migrants were brought there, not because they wanted them to take an active interest in union affairs, but they were to be used for expedient political purposes. These migrants were totally unaware of the ineffectiveness of the union at the time.

Early in 1958 Michael Cody, the DLP candidate, was elected full-time secretary to the union. He was a young man who prior to obtaining this position was employed as a clerk in a general hospital and, being a member of the federation, was eligible to stand for the position. He proved to be most incompetent and it was said that he practised speech-making in front of the mirror.

Union meetings are very impersonal and extremely serious and, when there was nothing of a controversial nature being thrashed out, Mr Cody supplied us with the necessary entertainment to prevent the members from becoming bored to death.

Whenever he addressed the members, he always adopted a particular pose and had three points to make. There never seemed to be one point or two points but always three points. There were two methods employed to illustrate his three points. He would, as he was speaking, raise his hand and with one finger in the air say, "And the first point I want to make is," and on he would go adding another finger as each new point arose until he had three fingers pointing at the ceiling and his speech was over. The other method was similar but instead of using numbers, he used the alphabet; a, b, c and he never went beyond c.

Whenever he commenced his tableau, we would give each other the nod and quietly mutter, "Here it comes," and once we had established whether he was on the numbers or the alphabet, we would accompany him saying point two and then point three or point b and then point c.

Roger, who joined the department and worked at Broughton hospital, suggested the union should produce monthly bulletins to notify the members of what the executive had been doing. Roger was a communist and prior to working in the hospital had learnt the necessary union tactics from his experience within a militant trade union. His ability to assess the situation and move amendments when needed was always a source of wonderment to me. When the occasion arose and he out-manoeuvred the opposition, I would always think to myself, how marvellous, I would never have thought of that.

When thinking back, I now realise that most of the men in their union struggles tried to out-manoeuvre one another and, while I did on several occasions play the numbers game, I was more concerned with the need to win people's minds and thus became absorbed with the content of the debate. My absorption with the debate prevented me from using tactical ploys.

When I rose to my feet to support Roger's suggestion of regular bulletins being distributed to the membership, the migrants began to scream and shout, "Get back to Siberia, you bloody commo." I waited for them to simmer down and proceeded. I then asked if the executive had discussed the recent price increase in gas, electricity and fares and, if so, what they intended doing about it. Their reply was that, as yet, they had not met.

I knew the migrants who were brought to the meetings would soon learn what was going on and it was just a matter of time. I did not underestimate their intelligence and knew they would learn but, in the meantime, I had to tolerate their abuse. The only method to expose the executive was to continually move for action, then question the executive at the following meeting as to what had been done.

A member moved a lengthy worded motion expressing dissatisfaction with the wages of all employees within our department. In speaking for the motion, I stressed the need to send a copy of the protest to the Public Service Board, the state government and the press. During general business, I moved that sick bays be provided for staff in the hospitals,

as there were no facilities for staff who became ill while on duty.

At the next general meeting, I asked about the protest motion and the reply was read. They had done nothing about the price rises. The president, and the only ALP supporter on the executive, reported that the secretary was not putting him in the picture about what was going on in the union. He felt, as president of the union, that he should be fully aware of what was happening within the organisation and continued to say that, in his opinion, the members were entitled to know what was happening in their own organisation. During discussion I supported the remarks of the president and asked why the executive was adopting this secretive attitude and what were they doing which needed to be kept from the members' knowledge. The question was not answered, but it was pointed out that, according to the rules, the secretary was appointed for life. This brought forth great shouts from the members, however, the rules were now being altered to ensure that the secretary's position was to come up for re-election at given periods.

Meg, a close friend and neighbour who also worked in a mental hospital, accompanied me to the next union meeting. I rose to ask a question concerning the minutes of the previous meeting and the migrant men started again, "Shut up you rotten commo, sit down, get back to Siberia." I was most upset but stood my ground and waited. I felt a sharp pain sear through my body and thought it must have had something to do with the contraceptive ring I had had inserted during lunch hour that day. I grasped the back of the seat in front of me and waited for the shouting to cease. When all was quiet, I asked if the proposed eight hour shift would apply to all of the nursing staff. The president replied that this shift was being considered for all mental hospitals by the Authority.

During discussion, I pointed out that whenever members of the executive spoke, it was always to refer to people working in conditions worse than our own. For some reason, only known to themselves, they never looked at the people working under better conditions. I went on to point out that when

they had run out of people in Australia working under worse conditions, they might try comparing our conditions to those in India. Again it was necessary to stress the fact that the Authority was always pleading a shortage of funds and the need for our union to apply pressure on the federal government to provide more money for hospitals.

As I spoke I began to tremble and made an effort to control it. During general business, I moved that the union do away with the wage differential which existed between women doing the same work. A single woman (permanent) would receive a higher salary than a married woman (temporary), the reason being that a permanent single woman had to pay superannuation. Married women were not only discriminated against by being refused permanent staff positions, but they were also paid a lower salary. As I spoke to the motion I again began to tremble. I made an effort to control the trembling but found my voice too was trembling, so I had to stop speaking for several seconds until I was sufficiently composed to continue. After being told the policy of the union "was equal pay for equal work among the sexes", I again pointed out that people of the same sex were not getting equal pay for equal work.

The motion was carried but nothing was done about it. I rose to my feet and brought up the issue of the male staff who were not receiving the uniforms they were entitled to. The executive said they would deal with the matter.

On the way home I was feeling very ill and Meg, looking at me, said, "I don't know how you stand up to it, all those migrants screaming at you and you keep on going."

For some time past I had suffered from severe stomach pains and after attending this meeting and feeling so ill from its effects, I paid a visit to the hospital. Several X-rays and tests resulted in me being treated for ulcers. The time had come for a cessation to all my after work activities and I retired for a period of three months. It was beautiful to be able to go to work then come home and remain home, no meetings, no hassles and no anxiety.

With hindsight, I now ask myself what motivated me to

keep on battling. I always attended the union meetings with trepidation when anything controversial was at stake, so why did I continue with the struggle when knowing that it took me several days to recover from the tension and strain? Did I in any way gain ego satisfaction from this involvement? I always felt exhilarated when gaining a victory over the DLPrs, but was this victory alone sufficient and was this an end in itself? No, I genuinely felt I was doing the right thing by the workers, for the staff of the hospital, and it was always with this in mind that I pursued any campaign.

Another factor concerning my union involvement may have stemmed from the fact that marriage and motherhood had not suppressed my vitality and personality. I had to be alive . . . to live meant participation and participation meant struggle, for, without this, what else is there? What better motive can there be for living than knowing you have contributed to making this earth a better place?

The president of the union was retiring from the service and our Public Service Board representative stated, in a speech of gratitude and farewell, that the union had previously slumped to a low ebb. He went on to say that the Public Service Board had been concerned about the state of the union and felt something needed to be done to re-establish the union, however, now the union had the respect of the board and this was due to the services of the president and executive. The men on the executive continued to eulogise one another and I sat there thinking of a joke I'd heard about a parson who was walking down a country lane and admired a beautiful farm. On approaching the farmer he said, "With the help of God you have a beautiful farm," and the farmer replied, "You should have seen this farm when God had it on his own." I remembered the union when these same men had it on their own.

During the meeting an executive member suggested the union should call on the Trades Hall Council for support in our dispute with the Public Service Board over salaries. I pointed out that apart from a few letters and delegations we had done nothing to support ourselves and that we, the

members, had to fight our own fight. The Trades Hall Council is approached only after a union is faced with a complete deadlock or when a union has done all it can possibly do on its own, and I was opposed to the right-wing policy of getting others to do the fighting for you. Roger asked if the executive had considered lunch-time meetings, and they replied this had been done on some occasions, but in fact this was very rare.

I was being criticised by members of the executive for not standing for office within the union. It was said that I was ready to criticise but was not prepared to get on to the executive and work. I did not wish to hold office for I knew I would be in a situation of continual confrontation with the other executive members because of their attitudes and do-nothing policy. I also lacked the self confidence which I thought was necessary to lead a union but, first and foremost, I was reluctant to separate myself from the workers by accepting a position of authority.

Many members from various hospitals pressed me to stand for election for the executive so, to allay any further criticism, I stood knowing I would never be permitted to get there. I was defeated in the ballot of June 1959. During July 1959 the executive passed a resolution calling on the federal government to double all social service payments when the 1959–60 budget was brought in. They also supported the ACTU policy for increased social service benefits. This was the first time the executive had made a stand of this nature without having been forced to do so by the membership; however, no action was taken around these demands.

I was elected to attend the state conference of the union and was very interested to see what took place at these conferences. The conference dealt with the usual departmental problems but no dynamic events took place. I found that parking the car within reasonable distance of the conference room was an impossibility, so I parked it in a restricted zone with the intention of moving it at intervals. I completely forgot about the car and later realised I would get a ticket. On mentioning this to several present, they suggested I should

request the union to pay the fine but I rejected this as, in my opinion, the members' money was not there to pay for what was my forgetfulness.

The conference delegates decided to have a counter lunch at a nearby hotel and, never having experienced a counter lunch, I was to learn the ways of the hotel world. After glancing at the menu board and ordering my meal, I was asked what I wanted to drink. There was great laughter all around when I replied "white tea". I sat there thinking, "what's funny about that?" until I was enlightened. "You don't drink tea at a hotel while having a counter lunch. Serving food is only another means of getting you into the hotel so you will drink the grog," I was told.

The conference concluded and the underlying factor of all our problems was the lack of finance. The Authority was hamstrung in all directions because of the lack of finance.

When I first commenced work at the hospital most of the wards had what were called airing courts around them. These airing courts were iron paling fences around the wards to enable the patients to sit or walk around in enclosed areas without fear of wandering away or being knocked down by cars. As time went by, drugs were being developed and prescribed for the patients which subdued them to the extent that the fences were no longer necessary. Only the receiving wards and wards for extremely disturbed patients retained the airing courts.

In whatever circumstances I had previously worked, I found all people would greet one another; that is, until I worked in the hospital. People do not usually greet strangers, but it is natural to assume that people working together will acknowledge one another. I now learnt that this was not always the case. After working some years in the hospitals, the matron did not acknowledge my greetings when passing, nor did the woman doctor at the Haven, so I learnt with great difficulty to ignore the presence of two women, both of whom were in positions of power.

It was early 1960 and I moved at the union meeting that, "the union strongly condemns the proposed increases in tram

and train fares and the increase in the price of gas and hospital fees." The motion continued, "we see this move as a direct lowering of our living standards and a cut in our already dwindling wages due to the constant increase in the price of commodities. We as a union of hospital employees demand that the railways retain the Sunday services in order that the citizens of Victoria may visit their relatives in distant hospitals, and to enable employees who depend on train services to get to work."

The old dentist was now retiring and I was worried about the new dentist coming. When commencing this job, my ignorance of dental nursing and the duties it entailed left me in a position of non-questioning but, as time went by, I became acutely aware that the dentist was not carrying out his functions as he should. I did not see one filling performed and, although I had now been employed as a dental nurse for six years, I could not mix a filling. All my great ideals about job satisfaction and helping people had gone, but there was nothing I could do about the situation for no one had the right to criticise a professional; it was considered unethical to do so. The nursing staff would, on various occasions, vent their anger on me for the misdeeds of the dentist and all I could say was, "I am only the nurse, take your complaints elsewhere." I felt very strongly for the patients but there was nothing I could do; so much for the job satisfaction I so desperately sought.

I was very worried about the new dentist for I couldn't do the job I was being paid for and how was I going to tell him? There was no way out of the situation, I would have to tell him the truth, but I knew this would have to be done discreetly for professional people are very loyal to one another and they are a law unto themselves.

The new dentist arrived, he was a young man and very enthusiastic. I very gently explained that, although I had been employed for six years, I had never been taught how to mix a filling but hoped he would understand without me having to say any more. He was very understanding and went to a great deal of trouble to teach me all that I needed to know.

A special general meeting of the union was called to discuss a petition from one of the suburban hospitals. I was staggered to find out the nature of the petition and from where it had come. It was calling for a motion of no confidence in the executive of the union and was initiated from the hospital where the migrant men worked who had for so long heckled me. On arrival at the Trades Hall these men were very agitated and hovered around me as they spoke of the ineffectiveness of the executive. If it wasn't changed, they said, they would no longer remain in the union. I pleaded with them to remain in the union and fight to make the union a strong organisation, for nothing could be gained if they resigned.

After some very heated discussion over their grievance, the decision was, "that the executive stands censured for not giving this matter adequate attention, but that it continue in office until the next election."

I was again defeated for office during the election of 1960, however, I became the shop steward for the female staff at my hospital and now had to devote time not only to recruiting members to the union, but also to dealing with the problems brought to me.[1] The continual agitation eventually led to the establishment of a sub-branch in the hospital and this meant more meetings; however, the members would now be able to air their grievances on the job and participate in making their own decisions.

I was very impressed by the treatment given to the patients by the new dentist and, as I acquired the necessary skills of a dental nurse, I became aware that the treatment was equal to the best treatment obtainable for the highest payment. This man gave of his learning to all the patients, irrespective of how mentally disturbed they were. He was a man who came from a middle-class background, had a private school education, and his attitude was one of warmth and care for people. I

---

1. Shop stewards had to enrol new members which wasn't always easy. They also had to take up the members' grievances with those higher up. Being shop steward made you "the union" in the eyes of members so you often copped the flack from the members. There was no prestige.

decided to tell him of my union activities for I thought that, even if he did not agree with what I was doing, he would eventually know of my union involvement because the staff would, at times, come to the surgery if they had a problem to discuss. It was better for me to be honest rather than risk the possibility of another person relating distortions and untruths.

At the general meeting of September 1960, a woman member asked the secretary for the union policy on the cost of living adjustments, equal pay and the shorter working week. The secretary's reply was that all of these points would be discussed by the executive, which in reality meant that these issues would rest in the archives . . . the usual tactics.

I moved that a copy of the following motion be sent to the federal government – Mr Menzies, Mr Calwell – and that a copy of the replies be sent to every shop steward. "That this branch of the union vigorously demands the immediate withdrawal of the proposed amendments to the Crimes Act. As unionists, we see the proposed amendments as a direct threat to our organisation and we consider that our members must at all times have the freedom of speech to campaign for better living standards without fear of being considered saboteurs." The president suggested that it go to the executive. The same old tactics. If the DLPrs had the numbers at the meetings, everything which required some sort of action was left to the executive, meaning instant death to the proposed action.

Our hospital sub-branch was a militant branch and we dealt with all of our problems without resorting to the executive. We held regular meetings in the hospital mess-room and the members were involved in their own organisation. Because the union was an industrial union, nurses and tradesmen were in it together. This situation displeased some of the sisters to such a degree that when I approached a young trainee nurse to join the union, she informed me that the sister in charge of her ward had advised her against joining the union as "we," she claimed, "are professionals, so why should 'we' be in an organisation with 'tradesmen'?"

I knew this feeling was prevalent among some of the sisters so, on entering the mess-room during the lunch-break, I

approached the table where some of the sisters were seated; the sister in question being among them. "Oh sister," I said to the particular woman, "I believe you are discouraging trainee nurses from joining the union because you don't think nurses should be in the same organisation as tradesmen." All the other sisters tuned in. The sister said this was so and she felt this way because she considered nurses to be professionals. I asked her how a nurse could be a professional after completing a three year apprenticeship, when a tradesman took four years to complete an apprenticeship. All was silent. I made it quite clear that all the staff working at the hospital were there because we needed the money, and it was necessary for us all to realise this and support one another.

The rule of divide and conquer is nowhere stronger than in a hospital. Every ward has but a few staff, and nearly every member of that staff is of a different classification to the other. There is a ward assistant, first year trainee nurse, second year trainee nurse, third year trainee nurse, qualified nurse, and then the big-wig; the sister. A complete pyramid. Each classification is divided from the other, with fraternisation being frowned upon. Not even at lunch would the classifications mix together. The perfect method of dividing human beings from one another. Even in the psychiatric hospital where they do all the studying of psychology and the need for people to relate together, the attitudes of doctors, matrons and nurses remains the most inhumane when the question of authority is challenged. The power structure is at its best.

As shop steward for the female staff, I was always being approached by women in distress. They came and poured out their stories of intimidation, humiliation and sheer degradation. I was appalled at the continual incidents that were a byword in the hospital. Not all of the sisters were like this, but the majority were.

Early one morning I answered a knock on the surgery door to find a woman standing there. Mavis was a ward assistant, a woman about thirty-eight years of age. She was visibly upset and I asked her in and sat her down. She was trembling as she told me of her experience. She had been ill for a week with

what is commonly termed "women's troubles" and her doctor had asked if she'd wanted all of the details on her certificate, or preferred some other reason. Mavis preferred not to tell them of her private problems so the doctor wrote "suffering from fatigue" on the certificate. On returning to work, she entered the matron's office and handed her the certificate. The matron sat as she read then burst forth with facetious laughter. She called the deputy matrons into her office and, while she continued to laugh, said, "This woman," pointing at Mavis as she spoke, "has had a week off because she was suffering from fatigue." When the matron laughed all must laugh and the deputy matrons joined in the chorus of laughter.

The matron continued, "Have you ever heard anything like it, a week off from work with fatigue?" the laughter went on. Mavis felt as if she was encircled by a pack of hyenas, she felt so humiliated and degraded. She was close to tears but her determination to prevent these ladies from having their satisfaction steeled her. When the matron had completed her game, she dismissed Mavis like casting away a dead rat. I had no understanding of what made women like the matron behave in such a manner and all I could say was, "What a pack of rotten bitches." I offered Mavis a cup of tea but she had to return to work; she called in knowing I would support and sustain her.

On many occasions when women approached me over this type of problem, I would encourage them to either accompany me or leave it to the sub-branch officials to take the matter further, but they always declined and refused to take action. If the situation became too unbearable for them, they would resign from the job.

One of the major factors causing the serious shortage of female staff was, beyond any doubt, the attitude of senior staff towards those below them. In later years I learnt that all power structures have been created by men and when women, by the grace of men, occasionally obtain a position of power they feel the need to prove themselves capable of carrying out this authority which often makes them more ruthless than the men.

I awoke one morning to find I was menstruating and, not feeling the best, I decided to absent myself from work and remain in bed. As I lay there thinking of all the dental appointments and what an inconvenience my absence would be to the patients and dentist, I eventually changed my mind. By this stage it was too late for breakfast and I dashed off in order to get to the hospital on time. We had coffee-making facilities at the surgery but, because I couldn't be bothered going to the trouble of getting myself something to eat and drink, I hastened to the mess-room to have a quick coffee and some toast.

The hospital secretary was walking through the mess-room when he observed me sitting there. He asked me to report to his office and I hastily gulped the remainder of the toast and coffee and did as requested. There was no point in denying my guilt or lying so, when entering his office, I told him I knew I shouldn't have been there, but went on to explain the entire circumstances which had led to my transgression, plus the fact that I was too lazy to go to the trouble of making breakfast in the surgery. (If I had made it there he would never have known.) He laughed at my sheer honesty but, having called me in to chastise me, he told me never to do it again.

The Australian Dental Association was establishing a course of night lectures to enable nurses to obtain qualifications and the dentist asked if I was interested in attending. I was delighted with this news and, after all enquiries were made, the department agreed to pay the ten pounds fee and I formally enrolled. I felt secure in the thought that I would at last possess some sort of qualification which would enable me at all times to obtain employment.

The local sub-branch of the union met regularly and we were constantly confronted with problems arising in the hospital. The most humorous incident at any of our meetings happened one evening when the artisan shop steward, in all seriousness, rose to his feet and moved a motion that locks be placed on all drawers in the engineer shop. In support of his motion, he went on to say he was sick and tired of every

Dick, Tom and Harry playing around in his drawers. The members present began to snigger and, misunderstanding the reason for their mirth, he glared at the members and addressed a question at them, "How would you like everyone playing around in your drawers and taking your tools?" The members roared with laughter but, undaunted, he continued to explain that because the department refused to provide all the tools necessary to carry out the tasks required around the hospital, he had brought some of his own tools from home and objected to anyone else coming in and having access to his tools. By this stage, the members were convulsed and it wasn't until he simmered down that he realised the reason for so much mirth.

I was now attending the night lectures for dental nurses and became aware that there were only two women, including myself, who were of an older age. All the other women were very young. A woman friend told me of her sister who had been a dental nurse and when she became older found that no dentist would employ her. I pondered over this and realised these qualifications were useless because the majority of dentists employed untrained junior girls to cut costs. I wasn't deeply concerned as it didn't affect me and I never for one moment thought that I would be in a situation of desperately needing employment. Oh, if only one could see into the future!

I enjoyed learning and, in my eagerness to learn, I would return to the hospital and discuss the lecture of the previous night with the dentist. He always went into lengthy explanations and answered all my questions.

We had a very successful social club at the hospital and many pleasant functions were held. Work situations can at times be similar to a marriage situation where people share their problems but never their joys and for this reason I encouraged the staff to attend these functions.

Most of the big-wigs on the administration and medical staff attended the socials. On one occasion, I was sitting at a large table with my back to the wall and,when asked for a dance, I found it impossible to approach the dance floor

without disturbing all of the people sitting on either side of me. I was reluctant to disturb people so I stood on my chair, stepped across the table to the chair on the other side and so on to the floor. All eyes boggled at my unorthodox method of dealing with the situation for, although I always dressed with good taste and preserved my dignity, I never was a lady.

# 9

AT THE GENERAL MEETING OF THE UNION mid-1961, I objected
to the salary increase which was only for sisters in charge and
up. This was a splitting move by the board and was an attempt
to buy off one section of the nursing staff at the expense of
the other. The fat cats getting fatter. I maintained that the
union should have stuck to the original claim and fought for
it. However, I realised that it was now too late to reverse the
decision so I moved for a claim to be prepared for all of the
lower-paid workers and that all hospitals have meetings to
support the claims.

We were horrified to learn that the federal conference had
in their wisdom decided to disaffiliate us from the Australian
Council of Trade Unions, the governing trade union organi-
sation of blue-collar workers in Australia.

The Broughton Hospital (my hospital) sub-branch called a
meeting and moved the following resolution: "That this sub-
branch requests a special meeting to consider disciplinary
action against the federal delegates of our branch of the union
and we condemn the secretary for not giving the sub-branches
sufficient time to present agenda items for the federal confer-
ence. We support the president and other executive members
who supported our affiliation with the ACTU." We hurriedly
got a petition signed by thirty-six members in our hospital
showing, in effect, how our members felt about the issue.

Things were going on in the union executive which gave
rise to a lot of talk but the members were never told of events
taking place. There were little snippets being relayed here and
there which made suspicions rise. One interstate delegate to
the federal conference told me that, in his opinion, the DLPrs

were getting ready to slide Cody out of his position as secretary. He had become an embarrassment to them because of his inefficiency and incompetence.

During late 1961, heated arguments arose at the general meeting over our disaffiliation from the ACTU and it was pointed out that we were the only union in Australia to disaffiliate from the ACTU.

Somehow or other the union ended up without a secretary — he had vanished from the scene. It appeared that his own mob did get rid of him and rumour had it that they obtained a good position for him with Shell Petrol as part of the deal to keep him quiet. We were told nothing with regard to his disappearance and the executive appointed the president to act as secretary until the next election. The meeting was asked to endorse their action.

More arguments arose about our disaffiliation from the ACTU and I moved that the federal body which was hanging on to our affiliation fees should pay them into the ACTU within two weeks or, failing this, that it must return this money to our branch. This action would have to suffice until the plebiscite was taken.

From the very first petition against atom bomb tests distributed in Australia, I decided to set myself a target of several hundred names and keep at it until the desired number had been collected. Time and time again I would go door knocking, and alone if necessary, but this procedure was too slow as I would have to repeat myself over and over at each house. I found it easier to visit the local shopping centre of a Saturday morning and approach a group of people, explain the purpose of the petition, then obtain several signatures at once.

Week after week I would be distributing leaflets on every injustice ranging from increased prices and inflation to world peace, or in support of a particular strike relating to the Vietnam War. In fact there were leaflets on everything and I often wondered if people read them.

I was the best *Guardian* (communist weekly) seller on the branch. This honour carried no status, of course, for it was a task that almost every comrade loathed, including myself. It

was only my dedication and devotion which compelled me to knock at people's doors and ask them to purchase a copy. This was my Sunday morning job and there I would be on the following Sunday knocking again on their doors to see if they would like to buy the paper on a regular basis. Once a sale was established, another comrade would have to take over the round as Tony and I had as many customers as we could cope with. I was convinced, with the passing of years, that many of our customers took the paper not because they were particularly interested but because of the friendship which had developed between us. This was confirmed when on one occasion I was too ill to deliver the papers and Leanne rang our customers and asked them to call in for their copies. They all had cars but not one called in.

Roger and I prepared a lengthy statement which we moved at the union meeting. We called for publicity in the press and the statement, after pointing out the problems existing in the hospitals, called on the federal government to increase the allocation of money to state governments for psychiatric hospitals and to continue paying social services to patients while in these hospitals. All the hospitals had ceased to be called mental hospitals and were now officially known as psychiatric hospitals.

Attention of members was drawn to the fact that the previous meeting held by the union was unconstitutional, as Rule 29 had not been observed. After some discussion, questions were asked concerning Rule 29, and I asked from where and when did the amendment to Rule 29 come. As usual, the wheelers and dealers had pushed this amendment through in 1960. The membership was totally unaware of this so it was then moved that this change to the rule be made invalid because the members were not notified of the proposed change beforehand.

Discussion then took place about retirement from the job at sixty years of age, and I urged that this matter be given serious consideration for so many men in the department died before retiring, and very few who did retire enjoyed a long retirement. I felt very strongly about this issue.

At the general meeting of February 1963, it was decided to donate twenty pounds to the equal pay committee and for the union to contact them and invite a speaker to visit every hospital during lunch hours to address the members on the equal pay question. These meetings never took place.

By this time, the Communist Party was split down the centre. The ordinary members of the Party were completely unaware of the problems until they read about the rift between Russia and China in the capitalist daily press. There had obviously been tremendous infighting around the leadership but this was not apparent until the complete split. No ordinary member got to the basic cause or reason for the difference. From either side, all one got was abuse and explanations of why the other side was wrong. Total confusion reigned among the members and the lack of any in-depth information or discussion created a great bitterness, resulting in the comrades turning against each other.

It wasn't until nine years after the split that I read an article in an English magazine which explained the basic ideological differences between China and Russia and I, at last, had a glimpse of what it was all about.

I was not at all sorry to see the back of comrade Ted Mill. He was always on the platform, the one who spoke at and down to the members. He was aloof, cold and calculating and was never seen anywhere unless he was telling others what had to be done. He was busy making lots of money for himself, by being one of the legal profession, while he continually spoke at meetings about the revolutionary working class.

I always went away from these meetings feeling as if there was something wrong with me, for where I worked the workers were not revolutionary and listening to Ted Mill made you feel as if it was your fault that this was not so. He gave the impression that if you were doing your job as a communist the workers would "naturally" rise to arms. In time I came to learn that men like this were in fact carried away by their own rhetoric, egotism and bullshit.

At the Party trade union activists' meetings, I never spoke once. How could I? What I was doing was insignificant com-

pared to all of the wonderful things men were doing. No one ever spoke of work being done in the right-wing unions. The great wonders being achieved by the male comrades in industries covered by left-wing unions made me feel that my contribution to the working-class struggle was infinitesimal. I listened to their experiences for they knew so much and I had so much to learn. I would come away from these meetings thinking there was something wrong with my efforts or something wrong with me, fullstop. I was damned if I knew how, why, or where I was wrong but my own experiences just didn't fit into the scene that these great men talked about. After the departure of Ted Mill, there was no further talk about the revolutionary working class but the same brilliant achievements by men were trotted forward continuously. I would, on occasions, attend all day or even weekend meetings and would come home exhausted and suffering from a severe headache, caused by excessive concentration. I would never relax or switch off while someone was speaking for fear of missing out on something which was necessary for me to learn. I always considered I had much to learn but never felt I had anything to contribute.

How strange it all seems when thinking over the past. The people who worked with me at the hospital and my trade union colleagues would never have believed that I sat at the communist trade union meetings or Party conferences and said nothing. What they didn't know was that when attending these meetings I felt too ignorant, too inadequate and it was almost as if I were a non-being. I always had plenty to say at my trade union meetings and I fought with all I had when I considered the cause to be just, yet when among the "learned" men of the Party all my confidence disappeared.

Only women involved in men's organisations could understand my feelings at that time for now, when I look back, I realise that many of these men were unthinking, superficial fools, but they delivered their contributions with confidence and arrogance. It wasn't until I became a liberationist that I learnt what confidence building was all about and the effect "leaders" have on people and the vast difference between

leaders and giving leadership.

The union now had a new secretary, a member of the ALP, and, after trying to establish some sort of order with the records in the office, he reported to the general meeting that the office records were in a total mess and they would have to be dispensed with. We would have to start from scratch.

When it was discovered that the federal executive of the union was attempting to alter the rules to prevent the branches from making their own decisions, we resisted all its attempts by instructing our federal delegates to oppose this skull-duggery. Comments I made at this meeting in opposition to what the federal executive was attempting were conveyed back to it, and I received a telegram from the secretary of another branch threatening me with action for the statements made.At our next general meeting I informed the members of the telegram and its contents and the meeting decided that all correspondence from that branch be rejected without reply.

Roger moved that the federal council initiate a campaign to win a fifty per cent increase in margins for hospital workers and I moved that we commence an immediate campaign for four weeks annual leave.

Oh Glory Be! I had now been elected to the position of federal delegate. I reported my attendance at the federal conference to our general meeting and, among other items reported, I informed the meeting that 1964 was to be equal pay year and that it would be conducted by the ACTU. All branches were asked to send delegates to Canberra to support the campaign. I then asked our secretary for the names of our federation delegates to the ACTU conference. The secretary didn't know who our delegates were but Mr Morgan, a member of our executive, rose and said there were seven delegates from the federation and he named them. All of the seven were DLPrs including himself. The members were staggered; we had no idea he had attended the ACTU conference. When asked why he was so secretive about it, he said he had never been asked to give a report on the ACTU conference. How could the membership ask him to report when they didn't even know he was a delegate?

The union meeting of late 1963, decided that every hospital was to stop work on a given time and date. The members were then to congregate in the hospital grounds for two hours in the morning and again during the afternoon in protest against the eight hour roster. This stop-work was to take effect in seven days, unless the executive in the meantime reached a satisfactory agreement with the Authority. The executive could not reach any agreement with the Authority and the stop-work meetings in the grounds were held.

For an industry or service where stoppages were almost unheard of, the tension was terrible. There were people who were terrified of stopping, they spoke of being dismissed and were afraid of losing their long-service leave. The women, in the main having been conditioned from birth to always serve unquestioningly, spoke of the impossibility of leaving the patients and every conceivable excuse was trotted out.

The three sub-branch officials of our hospital were under tremendous pressure and it was impossible not to feel all the tension about us. We were continuously harassed with stories of so and so said he or she wasn't going to stop for anyone.

It was decided to leave a skeleton staff in all wards and those on duty during the morning would stop work in the afternoon to attend the meeting. The meeting took place in the grounds and, as shop steward for the female nursing staff, I took my turn in addressing the meeting. This was my first experience in a strike situation and, despite my nervousness and knocking knees, I knew the most important outcome of this meeting was to create unity and strength among the staff. If we were to remain united and strong, nothing would defeat us. During the afternoon, the second meeting was held with the staff swapping over, and all the staff were able to participate without the patients being unattended.

This was the first stop-work action at Broughton Hospital. The trade union movement considered 1964 to be equal pay year and our secretary asked all sub-branches to hold meetings within their hospitals on the issue of equal pay. He told members that the Public Service Board had the power to grant equal pay but refused to do so. There was no action taken on this

issue because women would have been the only beneficiaries.

Our claim for a salary increase was rejected outright so the executive recommended action. This decision taken by our ultra-conservative executive was a tremendous step forward and was only made possible by the secretary who was responding to the members' discontent. All overtime was to cease, ward assistants were to stop performing tasks they were unqualified for, and no patients were to work at the laundry or industrial therapy.

University students were employed at the hospital during their vacation and, in my capacity as shop steward, I approached the women students and sought their support during the dispute. I pointed out to the young student assisting with occupational therapy that, while this job was only a means of obtaining some money during her vacation, it was our very livelihood and requested she give the matter her serious consideration.

The hospital secretary called me into his office and wanted to know what authority I had to threaten the students employed there. After discussing the matter with him, it became evident that the student had related my conversation to the head therapist and she in turn had distorted all the facts when reporting me to the secretary.

A patient attending the dental surgery for treatment said that the sister in charge of her ward had advised the patients to work in the ward and that by doing so they would be assisting the staff during this dispute. I explained that this was not so and was again called to the secretary's office. "It has been reported to me," he said, "that you have been interfering with the treatment and orders of the nursing staff to their patients." I explained what had transpired giving the secretary all of the details and I told him that, as union representative, I considered it was my duty to inform the patient about the situation, for I had every right to tell the patient the truth. However, I pointed out that I had no power to prevent the sister concerned from ordering the patients to work. The sister in question eventually became a matron.

During all periods when negotiations were being conducted

I, together with the other two shop stewards, took turns in addressing the staff during the lunch-breaks in the mess-room. There were three meal rosters and we each dealt with one meal roster. This enabled the staff to keep abreast of what was transpiring.

Eventually the work bans were called off. The union weakened and presented a claim for one section of the staff only. This sectional acceptance in pay disputes adopted by the union always caused a split in the ranks of the staff, sometimes between the nursing staff or the nurses on one side and the artisans on the other.

I have now recorded some of the most pertinent struggles within the union over a period of ten years to indicate the depth of involvement required of a militant woman by militant male standards. Although there were many other issues dealt with, I think it unnecessary to detail those events or the campaigns over the following five years. It should be noted that dental nurses, and there were only five dental nurses within the department in Victoria, received no benefits whenever the nurses or artisans obtained a salary increase. Dental nurses, hairdressers and chiropodists were in separate classifications and required separate wage claims.

I had passed my dental nurses' examination and was very excited knowing that I was capable of doing so and had a certificate indicating my qualifications. At one stage I was the only qualified dental nurse within the department but was receiving the low wage because I was a married woman. I made application to receive a wage increase and it was then that the board discovered the anomaly which existed. This eventuated in the wage discrimination between married and single women being abolished. After all the years of bringing this injustice before the union, it was my own case which led to this problem being solved.

# 10

DURING THE PAST TEN YEARS, Leanne had grown from a child into a young woman. How well I recall the excitement and pleasure she felt when her calisthenics concerts were approaching.

We encouraged her to participate in local activities and for several years she attended the local Methodist church calisthenic group, an involvement which culminated annually in a concert which Tony and I always attended. We gained tremendous pleasure from seeing her delight as, together with the other children, she performed in the gay-coloured costumes. I took special care when sewing the various costumes each year, for I knew the joy she experienced and the importance of this evening.

She also attended a local children's drama group established by another church for we never at any time imposed our atheism on Leanne. She attended religious instruction at school as we considered there were numerous religions in the world and, as an individual, she should be free to select a religion of her choosing if ever she desired to do so. With her grandmother Lea always speaking Jewish, Leanne grew up understanding Jewish but was unable to speak the language. Tony always spoke in English and so she never learnt to speak or understand Italian.

We had by this time almost renewed all our furniture and we now had a "nice" home. The garden was established, the garage was built . . . and we had the whole suburban bit.

How strange it all seems when looking back . . . The left-wing slogan of those times was "The workers are entitled to the fruits of their labour", and the capitalists were more than

pleased with this slogan for they too wanted the workers to purchase the fruits of their labour. No one questioned consumerism, ecology or pollution. No one knew about such things and everyone was flat out buying, buying, buying. Oh how simple it all was, and as we were buying up, the cash registers tinkled with profits. Despite all this obsession with materialism, I didn't know of anyone who was content, for material possessions cannot make people happy they only, in moderation, make life more comfortable.

The ownership of our old car enabled us to break out of the housebound situation and we would on occasions enjoy a good night out at the theatre. We did not indulge Leanne with material things but would take her to the ballet, to concerts and to see many overseas artists when they performed in Melbourne.

Tony had for some time discussed with me his feeling of discontent in his job situation. Since leaving his job as a maintenance painter he, like all building workers, needed to travel all over Melbourne to obtain employment. I understood his feelings and encouraged him to take up something different. "What can I do at my age?" he asked. "Why not take up studying and do something with your head?" I suggested, and continued to encourage him. "You have a good mind and you could do something better." Tony wasn't convinced. He had never been to school in Australia and was now thirty-four years old. He said he was too old to commence studying. "Oh rubbish," I retorted. At times I was very blunt, a trait which often hurt people when this was the last thing I intended. "Look, I am working, Leanne is getting older and will within the next few years be earning some money, so there is nothing to stop you from studying." Tony began to think of the possibility of studying and, after making several enquiries, he decided to give it a go. In 1958 he commenced a course to obtain his leaving certificate.

Over the years I had become worn with the fear of pregnancy. Every month, because of my lack of faith in contraceptives, I became anxious and wondered if my period would arrive. It seemed to be like a recurring disease; the anxiety,

fear and apprehension as I waited. I had been advised about the insertion of a ring and found this at least seemed to work. There was a continual unpleasant seepage from my body and, at times, a slight bleeding but this was preferable to having an unwanted child. The ring had to be removed annually and, after a break of one month, it was necessary to have a new ring inserted.

The day had arrived for the ring to be inserted and the local doctor made the appointment to coincide with my lunch hour. This was done to prevent any loss of time from work. I always dreaded this experience and on arrival at the surgery I found two patients still waiting. I looked at my watch and estimated the time; it will all be over in half an hour, I thought. I waited ten minutes . . . then quarter of an hour. I entered and lay on the table. My legs were in the stirrups and all was ready. Five minutes and it will be over.

The doctor commenced the insertion. Just a few minutes and it will be over. "Relax," he said, "It is much easier for you if you relax." It usually took three or four sharp stabbing pains to complete the insertion. I groaned and counted, that was one, another was coming, I held my breath, that was two. I braced myself for what I hoped would be the last pain, clenched my fists and waited, again it was over. Oh, there was to be one more. I ground my teeth together while bringing my hand to my mouth to stop myself from moaning, and that was it. I lay there trembling for a few minutes while the nurse cleared away the instruments.

It was time to return to work, I had very little time left and would have to hurry. I returned to work all smiles. It was impossible to speak of my suffering; women are not allowed to speak of this type of pain because it would place an unpleasantness on something which is supposedly for pleasure only. So I smiled and smiled.

The workday proceeded as usual, with running about here and there in the surgery. After arriving home and attending to the tasks necessary, I remembered there was a union meeting on that evening, so I called in and picked up Meg to accompany me to the meeting.

The year was drawing to a close and Tony obtained his leaving certificate. This achievement gave him the confidence to continue with his education. In 1960, there was great jubilation in our home when the matriculation results were published and Tony had passed. We were excited about his prospects and he was now faced with the decision of selecting the preferred subjects to enable him to undertake a part-time Arts course at Melbourne University. Who would ever have dreamt that we were going to have a university graduate in the family? The entire situation seemed unreal to me and, in reality, this is what it eventually proved to be.

Our car was a gutless wonder which kept us in continual poverty as well as suspense from one day to the next. Will it break down today was the question forever in our minds?

Tony enrolled to do two subjects at the university and this meant attending lectures four nights per week. Reliable transport was required, so we decided to go the whole hog and purchase a new car on hire purchase. Having paid off the two previous cars in Tony's name, I asked if he would have any objections to this car being in my name and he had none.

There was a desperate shortage of teachers at the time and Tony was fortunate to obtain a position as a teacher on the understanding that he continue to study. He was employed as a teacher by day and, with the purchase of the new car, was able to attend university. As a first year qualified teacher, Tony earnt a lower wage than he had as a painter but this didn't create any hardship because I was working.

Our home was the type of home where people always called in, so Tony took himself off to the bungalow where he could study without any interruptions or diversions, and we kept up the hire-purchase payments on the car.

One evening, for the want of something better to do, I was reading Leanne's leaving-standard notes on Modern History when I said, "I could do this." Leanne looked up from her studies and replied, "Of course you could. Why don't you have a try? You could do it easily."

I enrolled to sit for Modern History in the leaving year exams. For three weeks prior to the exam I read Leanne's

notes thoroughly and arrived at the Exhibition Buildings. Among the heads of the hundreds of young people milling about, I was pleased to see other people closer to my own age. Here I was, after all these years, sitting for a school examination and, although there was nothing at stake, it was important to me to know if I could pass. I was very nervous when reading the examination paper and observed that many of the students were already writing, so I thought, "bugger it, here goes," and off I went. I now had my dental nurses' certificate and leaving subject. I couldn't believe it. I felt good inside when knowing of my pass in both areas. It is all very well for teachers at school to encourage young people to continue with their education but, as you grow older, there is a nagging fear within that maybe even if you had had the opportunity, you may not have had the ability.

I was now having trouble whenever I had a ring inserted. Within a few weeks it would come away and the doctor said my body would continue to reject the rings. I commenced taking the pill only to find I was bleeding at frequent intervals. The doctors called this spotting and I was desperate for I could no longer tolerate the fear of pregnancy.

After making some enquiries, I made an appointment to see a doctor who performed tubal ligations. He discussed the finality of this operation and its seriousness with me, but I assured him when telling him of my experiences that I had beyond all doubt made up my mind there would be no more children. This was my last and only hope. I also told him of the slight prolapse of the uterus brought about by being on my feet for too long and too soon after Leanne's birth. He said this could be corrected. When he was informed of Tony's consent for the operation, arrangements were made.

I went into hospital and it was an experience I never regretted. It was a much greater operation in those days compared to the modern techniques available to women today and, because women did not speak of such things, all had to be hush-hush. Even the whereabouts of the hospital was a secret. Eighteen years of fear and anxiety were now over and I felt as if a tremendous burden had been lifted from my shoulders.

It took one year before the fear of pregnancy left me.

Apart from going to work, taking an active part in my trade union and politics and looking after the home, I had all of a woman's troubles to contend with. How fortunate men were, for this world concerns itself with men's pain. If men are ill, this means man hours lost from work and decreased profits. But the reality of a woman's biology is denied and women are afraid to complain for fear of losing their jobs and so no one cares. And we continue to smile and smile.

While at home I was always thinking. While doing the ironing, sewing or housework, my mind was always active. Tony would often say, "I can hear your brain ticking, what are you thinking about now?" I would laugh, for how correct he was, and then I would tell him of my thoughts. On several occasions he said, "You are a difficult woman to live with. You set such high standards." I wasn't to learn until many years later that he felt it was necessary for him to live by my standards in order to obtain my respect. This was obviously a strain, for no person can maintain a living situation where they must conform to other people's standards.

It was 1962; Tony was teaching and in his second year at university. Leanne was also studying. I read Leanne's notes from the previous year on British History and again decided to enrol for the subject. I passed this examination and realised that my previous year's effort was not a fluke. I really could do it. If I wanted to obtain my leaving certificate, I would have to get three subjects during the following year so I decided to think about it.

Now that we possessed a new car we were able to take the risk of long trips, and for the first time we ventured on holidays. Lack of finance prevented us from staying in hotels or motels, but we loaded the tiny car with camping equipment and even travelled as far north as Sydney. We always took one of Leanne's friends to accompany her and many a pleasant holiday was spent seeing something of our beautiful country.

Since Tony's trip overseas it was agreed that I should have an overseas trip, but it became a standing joke in the family when my trip fund was always depleted for something required

139

in the home. We now not only possessed a "nice" home of furniture, but we also had a hot water service installed and had just purchased a fully automatic washing machine. My overseas trip was only a dream.

Having married at an early age, I knew little of the realities of life for I went direct from my parents' home into marriage. Little did I know about relationships among men and women or what life was all about and, like the vast majority of married women, I was smug. Although I rarely said anything derogatory about another woman, I was uninterested in women's company for I considered their conversations revolving around husbands, children and home to be trivial and uninteresting. I was out into the workaday world and was more interested in men's conversation. Men represented society and the world, while women "only" represented kids and the kitchen.

Despite my lack of understanding as to why women were in this position and why their conversation was so limited, I was always sympathetic to women and supportive of them in times of need. Maybe my empathy towards their suffering stemmed from my own constant feeling of inner lonesomeness, a lonesomeness which is difficult to define and impossible to eradicate.

What could I say to a woman who confided her desperate need for affection and explained how she tolerated her husband's hopeless attempts at sexual intercourse because it was only on those occasions he would bother to display any affection towards her? The drunkenness, the lack of affection, the thoughtlessness, the complete disregard, the unwanted children; the problems were unending and, not knowing any of the answers, all I could offer were sympathy and support.

Except for two families, all of our immediate neighbours were of the working class and they all battled along to give their families the best possible according to their standards and circumstances. The women were extremely strong and, with the continual shortage of money and family problems, they almost all went out to work to supplement the family income. The only women unable to do this were prevented

from doing so by the number of pregnancies and children. These women went without a new frock or a pair of shoes for years on end and all the money was spent on the children or on payments for a car for the husband. These cars were very rarely used to ease the burden of the women and very rarely used to take the family for an outing.

I decided to have a go at obtaining the school leaving certificate and this meant being out two nights per week. English was a compulsory subject and I chose Needlework and Commercial Principles as the other two subjects. I wasn't at all worried about Needlework after having spent so many years in the trade, nor was I worried about Commercial Principles, but I was very worried about English. Grammar had never been a good subject of mine at school and, although I had always passed, I could still remember the difficulty I had in trying to understand all the garbage about subject, object, predicate, participles etc. etc. Leanne did all she could to encourage me but I wasn't at all confident. I attended night school regularly and when the time came for the examinations, I was still worried about my English.

It was almost impossible to believe that I passed the three exams. I now had my leaving certificate but was not interested in proceeding with further studies. It had been essential for me to prove my worth to myself but I had no need to prove it to anyone else. I now knew that I could choose to do a university course if I wanted to and this was all that mattered.

Tony missed out on passing Philosophy. When discussing his failure with his university tutor who was a priest, the tutor said that Tony had two handicaps: the first because he was an adult and the second because he was Italian and Italian people are very practical.

We had a very heated discussion on this subject when Tony arrived home and told me his tutor's comments. I was also an adult and practical and I argued that if philosophy was unrelated and divorced from life or reality, then it was a lot of bullshit. The following year, Tony repeated the subject and in answer to my question concerning what he had written, he said he didn't have a clue for all he did was rave on about a

lot of nothing. He passed the subject.

Leanne was now at teachers' college and well on the way to establishing a career; the heartfelt ambition of most industrial workers for their children. How easy it is for "enlightened" teachers who, never knowing the complete alienation and destruction experienced within the industry, talk about the need for education to be education rather than the present preparation for the system and boss. The working-class victims of this system cannot fall back on daddy to place them into the family business at a later age, and it is only the people who have no alternatives who are in a position to decide what's best for their children within the present economic system. After all, we are living in a society where money and status go hand in hand, so is it any wonder that workers want their children to get some of the cream?

Over the twenty-one years of my marriage, I had felt love, happiness, unhappiness, hatred, restrictions, freedom, elation, depression, indifference, glee, misery and a great deal of physical pain. But the one thing I had always had was security. I am not referring to financial security but the security of knowing there was always someone there. Tony and I had for some years been drifting apart. We were good friends and were close to each other but we had given each other all there was to give and there didn't seem to be anything left. Like so many married people, we just remained together, until early in 1965 when I returned home from work to find a note ... Tony had gone.

I was distraught and afraid; apart from the few months when I had gone to Sydney and when he was away overseas, I had never been alone. Now I was alone. I kept asking myself how was I going to cope? How was I going to manage being all alone? I was hurt and devastated. Leanne had just commenced teaching and I turned to her for solace.

Next morning on arrival at work, I tried to think of a doctor on the staff who was approachable. I hadn't slept all evening and knew I couldn't keep going if I didn't get some sleep that night. There was only one doctor suitable, so I rang and asked if I could see him. He told me to come over to his

office immediately. This doctor had been the victim of a Nazi concentration camp and, by Hollywood standards, he was most unattractive yet he became a very beautiful person to me. I told him I was very upset and requested some sleeping tablets and began to cry. He asked what the problem was but I was reluctant to tell him and he then explained that he could not prescribe medication without knowing what the problem was. I told him of the situation and he exclaimed, "Oh is that all," and then proceeded to tell me of his own previous marriages.

After telling me his story, he said, "You know, it's just like parting with a dining room table which has been standing in your dining room for twenty or more years." I laughed at his analogy. He was wonderful and was doing what he could to make me feel better. He was a warm and humane person, a quality which was rare among the doctors who came to study psychiatry at the hospital.

Tony had now completed seven years of study and was well on the way to obtaining a university degree.

143

# 11

THE NEIGHBOURS WERE ALL SHOCKED when they learnt of our marriage break-up for we were considered to be one of the happiest couples in the street. It is surprising how little people know of what goes on in the hearts and heads of other people.

I was unaware of the deeper reasons responsible for our break-up, but what I did know was that, compared to women, men are more able to walk out of a marriage situation. Although children and lack of money are the main factors which tie women to a marriage, our crippling emotional dependency, a neurosis created during childhood by the nuclear family unit, leaves us with a feeling of incompleteness for we feel that we are not full people unless we have a man. In our society, having a man means reaching fulfilment.

I knew our marriage had long ceased to be a vital relationship, but I thought that respect and concern for each other was sufficient to hold us together. Although free from the burden of young children, I was a victim of emotional dependency and insecurity and I was very miserable.

Now, when thinking back, I can even laugh, for Tony, after having been gone for several weeks, called in to pay us a visit. He wasn't in the house for more than ten minutes when he complained of his aching piles. He opened the cupboard, took out the ultraviolet lamp, placed it on the table, positioned his backside, then proceeded to bake his aching piles. I was still seen as his wife, for no man would ever admit to suffering from piles, let alone stand there baking them before a woman he was attempting to woo. This scene could only have taken place before a wife, for the games we play prior to trapping

144

each other soon disappear when certainty is established. We then relax with all of our infirmities.

Now that I was alone, I wondered where I could go for pleasure and entertainment for, although I continued to visit our married friends, I knew I would have to expand my horizons and re-enter the world outside.

Ballroom dancing seemed to be a reasonable way to meet people and, on making several enquiries, I discovered there were only two dances where people of an older age group congregated. This was it. I decided to give it a go. I needed some new clothes and got under way with the sewing. I designed my own gowns and they were always exotic creations. I would now have to look my best for, in our competitive society, the only area of competition open to women was with other women in order to get a man and then hang on to him.

I was all ready and off I went to the Masonic hall. On arriving at my destination, I sought the ladies' room. There were numbers of women adding another smear of powder to their noses, giving their hair another touch and doing all they could with what they had. I combed up a loose curl and added another hairpin to my wig. Oh yes! Wigs and all, and I pre-set them into elaborate coiffures to enhance my sophisticated air. I entered the hall and just stood there as is customary and within moments I was asked for a dance. It took only seconds to realise that this fellow was a lousy dancer but I had to endure the torture. The next dance was certainly an improvement for this bloke could really dance and it was a joy to be able to dance correctly.

The following week I was back there again, and I noticed that most of the men who were present the previous week were also there. As time went by, I became aware that, despite a few exceptions, the same men attended these dances week after week even though they almost always accompanied women home. The same situation existed at Leggets, the other ballroom.

On several occasions after being asked if I would accept the offer of being escorted home, when they heard that I had my own car, they immediately lost interest in the deal. They

didn't even feign interest by asking me to supper. I quickly summed up the situation. They hoped to escort the woman home, get what they wanted, then drop her. Their continual attendance at the ballroom indicated their lack of interest in the women they had previously escorted home.

Over a period of time, I did accept several invitations to supper only to find myself embroiled in more wrestling matches. I couldn't believe at my age that I would still have to endure this indignity. I was convinced that some of the worst offenders were married, for I deduced that they were determined to make the grade because they didn't know when they would again be free. Some were so violent and aggressive they would have attempted rape if I had slackened my resistance for one moment.

I began to understand a little more about life and what transpired out in the world and felt deeply sorry for the women going to these dances. I watched them in the ladies' room and it was evident by their appearance that they had spent hours at the hairdresser's, ironed their frocks and then of course there was the diligent application of the face make-up. Hours of work and time had gone into their preparation, but for what?

I knew what women wanted, for I was a woman and knew how they felt. I knew these women were in the main seeking companionship, affection and warmth. They were lonely women, but what were they getting? I also knew what the vast majority of men at these dances were after. What a set-up!

When my marriage broke up I decided I would never marry or ever live with a man again. I wasn't quite sure whether familiarity bred contempt or bred no attempt but, from the observation of marriages all about me, there wasn't one where I envied the woman. What I did desire was a permanent relationship but no living together. I thought this type of relationship would have a greater chance of success, and it was at this time that I met up with Barry.

Barry and I had attended the same school as children and we had many a laugh talking about our old school teachers and experiences, but you can't talk about your old school-

146

time experiences forever. Although he didn't live with his mother, she clung to him and apart from being a hypochondriac, I eventually came to realise he was also clinging to her. This was his means of escaping from any form of commitment to a woman. He suggested that we go interstate for our holidays and, after all the arrangements were finalised, he declined because of mum.

I returned to the dances only to get out of the house and, one evening after having made the decision to remain at home, I changed my mind and started on my preparations. I knew I should get out of the house and it was 9.30 p.m. when I approached the dance hall. There I was, exotic gown, wig, the long drop earrings, the whole works. After parking the car I walked towards the hall and was almost there when I raised my foot to step into the footpath and tripped over. Down I went. It was so inelegant being sprawled across the footpath. I felt extremely embarrassed and looked around to see if anyone was about, but fortunately there was no one in sight. After getting myself together, I examined the damage. My stockings were torn, my hands were grazed and I felt like nothing on earth. There was a hotel nearby and I hastily entered to purchase another pair of stockings and repair the damage. All was well again and it was now 10.00 p.m.

People were dispersing from the floor and Gloria, a dance friend, was standing aside as I approached her. Beryl too, walked from across the floor and, after greetings were exchanged, she laughed and said, "Well there's no doubt about them." We looked at her questioningly and waiting for her to continue. "That bloke I just danced with was a new Australian and while we were dancing, he said I know what you need to make you happy, you come with me to my room and you can have a little drink and I will make you happy." She told him she wasn't thirsty and didn't need his form of happiness. I said that the majority of men who came to the dance were either very mean, married, or one night killers. They couldn't understand my reasons for saying this, until I drew their attention to the permanent clientele who always took a different woman home almost every week. They were stunned by the obvious truth.

147

Gloria seemed to be suffering from the blues and complained about the condition of her hair. She wasn't being asked for dances and commented on my beautiful hair. I immediately enlightened her on my wig and explained how men judged us purely on our external appearance and they roared with laughter at the subterfuge.

The music commenced and I was on the floor. My partner began a rave about what he would do if he won a lottery; not just the ordinary Tatts, but a huge lottery. He was very dramatic and his voice became melodious. Before I knew where I was, we were on an ocean liner together, touring the world. One moment we were in Honolulu, then we were in San Francisco, then in Mexico, and it was a fantastic trip. He was treating me to every luxury and kindness. We were walking through Athens, then through Rome and by the time the dance was over, I was almost seasick. I thanked him and walked away. Christ, I thought, after all I went through before getting here and I have to go and strike a Walter Mitty.[1] I returned to my friends, told them of my world tour, and left them in peals of laughter as I departed for home. One Walter Mitty for the night was quite sufficient.

I began to suffer more pain. This time it was across the lower part of my back and every morning when I woke up the pain was excruciating. "Christ, my kidneys have had it." – this was my own diagnosis. Again I approached a doctor at work and after explaining the symptoms, he advised me to see a gynaecologist. I made the appointment but was convinced the problem had nothing to do with my reproductive organs. How wrong I was for thinking that the tubal ligation had put an end to my troubles. The tubal ligation did away with the problem of pregnancy but there were other problems.

There I was at the clinic and Leanne was waiting to take me home. This time I had a curette and diathermy treatment on the cervix to eradicate an erosion. Again I was suffering

---

1.  *The Secret Life of Walter Mitty* is a film in which a character called Walter Mitty fantasises himself into the roles of talented, learned, heroic and handsome men and acts out these fantasies.

because I was a woman. The clinic where this treatment was performed was owned by many doctors and dentists within the immense building. When asking for a pan while coming out of the anaesthetic, the young untrained assistant told me they didn't have any. When I woke sufficiently to be mobile, I was draped into a man's dressing gown and escorted through numbers of people to the toilet used by all women on the floor at the rear of the building. I was given a cup of coffee and biscuits and then I paid fifteen dollars before leaving for home.

It wasn't until I reached home and had fully recovered from the anaesthetic that I realised I hadn't received a receipt for the fifteen dollars nor had I obtained a medical certificate for work. I rang them on the phone and was told I was ineligible for a refund from medical benefits insurance because I had not remained overnight. This clinic did not cater for overnight patients, but they said they would furnish a receipt if the taxation department queried the entry. The receptionist said that the doctor would issue a certificate for that day only. I almost told her to tell him to stick his certificate. I rang my local doctor and was forced to pay another fee.

I struck up a relationship with a man who I had known for several years and, because it was important to me to have an honest relationship, I told him of my attitude towards marriage or living with a man. He was a confirmed bachelor and was delighted with the set-up; that is, until he was put to the test. I could read his mind saying, "Wacko, all sex and no responsibility."

On the odd occasion, he would make some comment about current affairs in the world and, although I disagreed with his politics, I remained silent. I was determined not to let my politics interfere with the relationship, so he was able to voice his opinion while I remained silent.

He eventually realised my silence was intentional for he had known me long enough and this began to worry him. He asked me why I remained silent instead of voicing my opinions, and I told him of my reluctance to cause arguments; how I felt that there was no possibility of me convincing him

nor would he be able to alter my opinions, so there was no point in creating conflicts which would only result in both of us being upset.

He was not satisfied with my reply and continued to point out that it was bad for me to remain silent when disagreeing with him but I said, "If I am not complaining, why should you?" He ceased to press the matter but was disgruntled.

After some months had passed, I noticed a gradual change in his attitude until one evening he said, "I have something serious I want to discuss with you. I want to give you some advice." I wondered what it could be. "Zelda," he began, "you are the type of woman who should get married and you must never tell a man that you will never marry or live with him." I was stunned. "But you don't want to get married," was all I could say. "I'm not talking for myself," he explained, "I'm talking about any man you go out with." I failed to understand what he was getting at. "I don't want to hurt anyone, and I prefer to be honest right from the beginning." "You don't understand," he continued, "listen to what I am saying and take it seriously because it is for your own benefit," and he repeated, "You must never tell any man you will never marry or live with him." It then dawned on me. "What you are trying to tell me is that a man always wants to feel that the woman is so crazy about him that she can't live without him, and it is he who rejects her." "That's right," he said. That was the end of that affair.

I couldn't understand why men would prefer women to be dishonest when honesty seemed to me to be the only basis on which to establish a relationship. I was confused and all I could think was, "What bloody egos men have."

# 12

gruesome father. Nobody was too keen after Hortense had DI. After those few lectures on T, ...blic examination and on the stages of dying lectures, they would, "What is wrong ...hich it was named?" "I would feel mentally if I were given a paper after this. This is second ...it a doctor standard, this was a doctor, so I gave its name, new known."

See than went on the anatomy, ...and she took to help them from the freezers, ...on't doubt the, ...they were so many tissue hanging under the skin to ...the knee, and the band...

THE NEED TO WORK UNTIL I WAS SIXTY had long ago become part of my reality, and all the years of fighting with the children at the Haven was beginning to tire me. A rumour was circulating at the hospital that the department might create a new position in one of the hospitals for a chiropodist, so I decided to undertake a course in chiropody, hoping that I would be in the box seat when the position became available. I enrolled to do the course which meant attending the college two nights per week for two years.

I resigned from the position as union shop steward for I knew it would be impossible to apply myself to the course and do justice to the members as shop steward.

The first series of lectures were on physiology, and the doctor giving the lectures considered that if we weren't able to keep up with him or grasp what he was saying, we shouldn't be doing the course. The blackboard was very small and he wrote rapidly as he raved on. The medical terms were unfamiliar to us and we struggled to copy his notes, taking care to spell the long words correctly. By the time we were half way through, he was already rubbing the board clean so he could rave on again. We had no hope and, by the time the lecture was drawing to a close, I was in hysterics. I could see the funny side of it, however, several students were distressed and after another lecture or two they withdrew from the course.

Within eight lectures, we had covered the circulatory system, respiratory system, nervous system, renal system, digestive system and the blood supply. There seemed to be thousands of words such as systole, diastole systemic, neural mechanisms, vaso-motor, pneumataxic centre, ADP plus PC = ATD plus

creotone, Father Homozygous DD Father Heterozygous DD. After sitting for the exam, I took the examination paper to the assistant nursing lecturer at work. When he looked through it he exclaimed, "I would fail dismally if I were given a paper like this. This is second year medical standard." His wife was a doctor so I guess he would have known.

We then went on to anatomy, and this took in everything from the knee down, I didn't realise there were so many finicky things under the skin between the knee and the tip of the toes. Again the scores of mystifying terms. I drew up a chart with the muscle layers; where they started, where they finished, the blood supply, nerves etc. and found that studying from this chart increased my ability to remember all of the details. Several students made copies of these charts.

Never having possessed the talent for drawing was a handicap, for when it came to sketching feet and entering details for note taking, I immediately had to draw toe-nails for, without the toe-nails, my sketches did not indicate whether you were glancing at the dorsal or plantar surfaces; that is, the top or bottom of the feet. Fortunately I wasn't expected to pass on my artistic ability and managed to obtain an honours pass in anatomy.

I completed the chiropody course and qualified, only to wait in vain for the job. The department never created another position for a chiropodist. Nevertheless, I enjoyed learning and knowledge gained is never wasted.

Now that my marriage was broken, I was eligible for permanency within the department but they rejected my application. I made enquiries with our Public Service Board (PSB) representative and he said that this was the first rejection in his experience as board representative, for the board always accepted all applications unless the person concerned had a criminal record. Where did that place me?

I wrote to the PSB asking the reasons for their refusal and they replied that I was unsuitable for permanency. I was not deterred by their reply and again wrote pointing out that apart from my dental nurse's qualifications, I had my school leaving standard certificate and asked what else I required to

make me suitable for permanency. Their reply was that I was eligible to apply for any position advertised in the government gazette, but they did not state what I should do to become "suitable". I informed the secretary of the union about this matter, but he was unconcerned. The board representative was also unconcerned. Although it had been reported in years gone by that the Public Service Board was concerned about the low state of the union, they weren't prepared to give a woman who had helped strengthen the union, permanency within the service.

I began to ponder about my role in the trade union struggle at the hospital. A sub-branch meeting was to be held at my hospital and one of the nurses asked if I would bring up a certain matter for discussion at the meeting. I suggested she should come along and raise the matter herself and offered my support, but she didn't attend. On the following morning, she wanted to know if the issue had been discussed. I pointed out that it was up to her and that she should have attended in order to raise the matter, but she said, "Jack wanted to go to the drive-in, so I went with him." Jack was the husband and a nurse in another hospital.

During the years of my work within the union, I didn't see any people who weren't already socially conscious become so, nor did I see people who had a social consciousness develop a social conscience. I didn't see anyone become aware of their personal or political (same thing) oppression. On the contrary, it seemed that as long as someone else was prepared to do battle, they would be left to do it. The members were now more interested in their union, but to the vast majority it never became part of their conscience or lives. They saw it basically as an organisation that was there to look after their wages and conditions and, so long as the money was coming in and they were able to buy material goods, then this was all that mattered. Materialism was the god. Like most people, they were deluded into believing that there should be no "politics" in the union, when the very essence of our living experience is political, and the very structure of the trade union movement itself is political.

Most of the position seekers in the union were either do-gooders or of the right-wing and the union afforded them the opportunity to obtain ego satisfaction while for the right-wing it also meant control of a power base. It was only the constant struggle by the members which forced the leaders into action.

I thought about the nurses who were nursing people who were the victims of society; victims who almost always returned to the hospitals after being continually battered by society. Yet they were completely unaware of the connection between society and sanity, or of the need to change society to prevent people from being battered.

Psychiatry is not a definite science and every odd bod and sod among the medical profession working in a psychiatric hospital is let loose on the patients. The nursing staff, even if they wanted to, are unable to interfere with the doctors' treatment of patients; like all workers, they only work under instructions of those in power or those holding power. It is a well-known fact among medicos that psychiatry attracts the "pure culture" of the medical profession: those who passed their exams because they memorised sufficient knowledge to do so but, left to their own devices, are unable to diagnose or treat patients as they should be treated; those who are unable to use their hands for the purpose of surgery; and those who wish to earn a quick buck between the hours of nine to five. Psychiatrists, like skin specialists, cannot guarantee a cure so most of them work on the premise of "keep your patients happy" and keep them coming back! Very few psychiatrists question society and the effects of society on people, they treat people not society.

A very middle-class doctor at my hospital set me on the road to thinking about society and sanity and the connection between the two. He may never know the contribution he made to my development. When asked what he thought about group therapy being conducted in the hospital, he said that group therapy was very worthwhile but claimed it didn't go far enough. In his opinion, all people in society should be able to discuss their problems with each other in order to do

154

away with whatever is causing the problems. China, he said, had introduced a method of getting the people below to become involved in their own decision making; decisions which affected their everyday lives. He believed the results would be interesting to observe in years to come. He pointed out that China was the only country ever to carry out this vast and important experiment.

I began to do a lot of thinking about women. I found through my observations of the women at work and the women living around me in the commission area that, although they were concerned with rising prices and the lack of money, they spoke far more about their personal misery and pain than they did about the lack of money. At work, the women would complain about the injustices meted out to them on the job and, when they knew I could be trusted, they complained of the misery in their personal lives. I could not understand why they would never take any action to extricate themselves from these situations, on the job or in their personal lives. Men too, when they knew I could be trusted, confided their personal problems to me.

Many women were desperately unhappy. Some would become involved with other men only to find that these affairs eventually led to more unhappiness. Some would take it out on their children, others would just cry and complain about having "bad nerves" while others would throw the entire responsibility for their misery on to their husbands. What almost all of these women did was obtain tablets from their doctors to kill the pain. Phenobarbs, Sod. Amytal and in recent years Valium is the panacea prescribed by doctors for removing the "housewives' syndrome" and "bad nerves". Many women prefer to take these tablets rather than examine their own pain, for the need to analyse one's own pain can be extremely devastating, particularly when the need arises to confront one's own illusions.

I was confused and began to question the narrowness of the trade union movement, its impersonal attitude towards people and its lack of concern. It seemed to me that there

155

was more to life and living than wages and conditions, but I had no answers.

From the time the new dentist commenced working at the hospital, I began to obtain job satisfaction. There was a tremendous backlog of work, however, the time arrived when some of the patients became "dentally fit". It gave me a great sense of fulfilment when noting DF on their card and knowing that these people had healthy mouths.

After several years, I ceased feeling pleasure when the patients were dentally fit, for I began to realise that despite the fact that their mouths were healthy, they were very sick people. And again, like the trade unions, it seemed as if we were only dealing with another fragmented section of the human when so many other things were wrong. I couldn't work through this problem and I was unable to understand why our society seemed to be all skew-whiff when it came to people.

I was becoming impatient with the children at the Haven and was finding it more difficult to cope with the hassles and struggles of controlling them in the dental chair. This became a tremendous burden and I dreaded the two days per week in attendance there. The situation was untenable both for the patients and myself, but I didn't know how to solve this problem for I had to work and what else could I do?

By chance, I happened to be talking with a woman at a Party social evening when she mentioned that a position was available in the office of the Sausage Workers' Union. She had been offered the job but was satisfied with her present employment so, when I told her of my predicament, she suggested I contact them to see if the position was still available. I pondered over this possibility before deciding, for this was a big step to take. I had now been employed for fifteen years in the hospital and although they wouldn't make me permanent, I knew they would never sack me. I felt secure, and leaving this job meant going from a position where I was qualified, to working in an office for which I had little skill or training. I could type at thirty words per minute, which was far from satisfactory but this was typing alone, I had no training in

156

setting out letters, and nor did I have any confidence. I spent many sleepless nights before deciding to take the step.

I rang the Sausage Workers' Union office, had an interview, and was all set to commence work early in January 1969.

I handed in my notice at the hospital and it was with nostalgia that I said goodbye to the many friends made there. I was surprised when some of them said I was lucky to be leaving the place. I was sorry to be leaving the dentist, a man I had worked with for nine years and whom I had come to respect for his warmth, humanity and sense of humour.

I had for fifteen years contributed to every collection taken up in the hospital and had attended every social and farewell, yet I was to establish a record; a record that will never be surpassed at Broughton Hospital. After fifteen years service, I received no farewell. I considered this to be an honour, for it proved to me that I had, as a unionist, done my job well. It also demonstrated that the men in power did not practise hypocrisy, as they did not make a speech of regret at my departure. I have respect for people who stick to their principles, even though I may oppose them and fight them to the end. With these men I could have no illusions; I knew where I stood.

Over the years of struggle within the union, I saw the growth of this organisation from a membership of one thousand members to an organisation of over four thousand members. This wasn't too bad when taking into consideration that many people came and went from the job and the entire establishment employed approximately five thousand. I saw the union develop from a narrow clique which locked out all membership participation to an organisation where the members pressured, urged and demanded.

Politically, I saw the union move from being completely right-wing to a position of support for a middle-of-the-road Labor Party policy.Who knows how long this position will endure for, as soon as the DLP political party decides that it is time to control the unions once again, these same right-wingers will move in. There is great scope for political intrigue within the trade union structures, for they are power bases.

They will, as is usual, have to create another anti-communist wave of hysteria, and they are experts in this field for, while they rave on about anti-communism, they divert people's attention away from seeking their own solutions to the many problems confronting them in their everyday lives.

It wasn't until I became a feminist that I was able to examine my union struggle as a woman, and this was a new aspect to me. In all of my campaigning I never saw myself as a woman. I didn't consider my pain, my problems, or the pain or problems of other women, as being political or something which could be altered.

I never once at a trade union meeting brought up the question of child care centres or pre-school facilities, even though I had these problems when Leanne was young. No men ever brought this matter up either, and now I wonder if men see children as their responsibility at all, for surely responsibility by men towards children is more than bringing home a pay envelope?

My confusion about the narrowness of trade unions only cleared when becoming a liberationist, for it was only then that I understood that all men's structures only allow for superficial thinking. One only hears what men think in the narrow confines of the particular structure. I wanted to know how people felt and no male structure reflects feelings. I didn't at any stage during all of these years get to know the inner heart or head of any of the women or men involved in my trade union and nor did they get to know me. Yet we vigorously fought each other on male political terms. Maybe, if the truth was known, we were suffering from similar inner pain, a similar inner lonesomeness and the same lack of personal fulfilment.

# 13

always the bus top and I would question the amount being spent on administration, and how much explanation was needed to be described thoroughly.

The Sudden views and financial statement and many of the statements which with continual disputes, it was difficult to have any information as to what ended upon? several people in the heat of their differences. The problems were common for, and it often became necessary to ask through it the group did not have a head over their own views, which was always a problem. Tolerance was

I WAS NOW WORKING in the office of the Sausage Workers' Union and I felt as if a new life was opening up for me. I would be meeting more people, doing new things and no longer would I have to hide the fact that I was a communist. Never had I done anything to be ashamed of; for I saw being a communist as a way of life, a life dedicated to changing society in order to improve the life of people. However, this was not the way all people saw communists, and I was forced to remain silent about my membership in order to keep a job and survive. But now it would be different, and what a relief, for it was not within my nature to be secretive.

I applied myself to the job with all of my being, for I was now working for a cause, and trade unions were part of the struggle for the working-class cause.

Geo Seeton, the secretary of the Sausage Workers' Union, was a member of the state committee of the Communist Party, one of the great men I had often listened to and admired. Now that I was working among these men I would be able to learn from their knowledge and experience.

There was an office staff of four: Joan, Fred and I were communists and Betty, although being uninvolved politically, was a labor supporter. I sat at the desk behind the reception window, attended to all enquiries, received union dues, attended to the antiquated switchboard, answered all queries relating to wages, awards, sick pay, long service leave, casual rates and numerous other problems. It took some nous getting acquainted with the different wage rates, and I would have to calculate how much holiday pay for given periods and what the members were entitled to. The organisers were

159

always out on the job and I attended to these problems. The staff patiently explained what needed to be done and I quickly learnt.

The industry was an "itinerant industry"; seasonal and fraught with continual disputes. It was nothing to have six disputes in one day and at various places, plus the possibility of four strikes. The pressures were tremendous and at times it was necessary to ring through to the shop delegates in all of the factories, a task which was always a problem. Telegrams and phone calls were almost a daily feature of the system and the switchboard very rarely functioned as it should have. I rang the Post Master General (PMG)[1] to send technicians to repair the antique until the time came, when after several suggestions of installing a new switchboard went unheeded, they ceased calling. The stage was reached when I couldn't switch calls through to the various officials, and I would either have to run to their office to tell them of the incoming call, or yell at the top of my voice to let them know of the calls. Trying to keep communications open was an ordeal in itself.

The working conditions in this union office were appalling and of all the offices in the complex, the window of one office, that of Geo the secretary, was the only window which could be opened. The others were double-glassed to prevent the traffic noise from penetrating and the only air entering the maze of offices was through the door leading from the corridor in the old Trades Hall building. There was no air-conditioning, no fans and no running water. The only part of the floor to be swept was the section visible without moving the chairs. I would cease working three-quarters of an hour before knock-off time on Fridays and clean up around me.

It was unbearable to come into the office of a Monday morning to be greeted by dust and dirt. The staff and organisers thought my cleaning effort was a great joke and, in good-hearted fun, they would say, "Here goes Sadie the cleaning lady. You're not working in a hospital now." In time they

---

1. Today known as Australia Post. Australia Post and Telecom were combined and called the Post Master General.

became accustomed to my cleaning and ceased laughing.

The office staff were hard workers and very conscientious. Whenever overseas guests or "important" people were visiting the Trades Hall, we were expected to do the catering and, just prior to my commencement at this office, the women, although attending to all of the catering, were not permitted to attend the functions. I always went along to these functions and, eventually, we insisted that women working in the office of the host unions should give us a hand with the catering. On two occasions when we were overburdened with work, we even managed to convince the officials of the host unions to do their own catering but, needless to say, they got the women in their offices to do it.

The staff in our office were working under the greatest difficulties of any union staff in the Trades Hall. We got out monthly bulletins to all of the members and a journal every two months. We did not have a collating machine, folding machine or any of the modern machines available. The only time I had morning or afternoon tea was when one of the other women would forgo hers in order to relieve me from the switchboard and enquiry window. I drank my tea while working. I would never have done this in industry but, like the other staff, we felt that working here was for a cause and so it didn't seem important.

I realised very early in the piece that there was discontent among the staff over the lack of modern equipment and the conditions in the place so I suggested we draw up a list of our grievances and present them to Geo. "Oh no, you can't do that," they said. I couldn't understand why, so I then suggested that we write out a list of grievances, sign it, then hand it to the executive to discuss. Again I was told this could not be done. "Why?" I asked, "My trade union experience has taught me that when workers want something they have to ask for it, and if the answer is no, then they have to fight for it." "It's different here," was the reply. "Why?" I asked. "It just is." I couldn't understand the set up and continued, "It seems that we are in a boss–worker situation, so what is different about it?" "No, it is not a boss–worker situation,"

said Joan my comrade. "Well what is it?" I asked. There was no reply and I continued, "It appears to be worse than a boss–worker situation because we don't seem to have anyone to complain to." Fred explained that in order to get anything we would have to lobby each official to try and get them on side. I said no more, for these people had worked here far longer than I and they should know what the score was. But, as a unionist of the struggle, I thought the set up was bloody awful . . . we would never have tolerated this at the hospital. I found it difficult as a communist to grasp and accept this situation but remained silent. I couldn't help thinking, "If only the staff at the hospital could see this great union fighter now."

The sausage industry was a predominantly male industry and women had entered the industry during the Second World War when male labour was unobtainable. The conditions under which these people laboured were hard and only the disadvantaged workers and migrants sought employment in this field. A temperature of approximately ten degrees was maintained in the workplace to prevent the sausages from going off, and the women were rugged up beneath their white uniforms in order to keep themselves warm. The men worked at a furious pace and one noticed the absence of grey hair on the line, for men as they grew older could not keep up with the established quota.

When union meetings or shop delegates meetings were held at the Trades Hall, the members would call in and many a good yarn and repartee was exchanged. Their down-to-earth humour, their ability to relate anecdotes was always a great source of pleasure. It was at these moments that I wished I possessed the skill to capture these experiences in print, for modern technology and the owners of industry now prevent people from talking while working and much of this old Australiana is fading away.

It was January and the weather was very hot, so I decided to call into the pub opposite the Trades Hall after work and have a cool drink. I entered the back bar of the hotel, bought myself a drink and joined in with a group of trade union

officials who I knew. After a couple of drinks, I left for home.

At work next morning, I mentioned that I had called into the pub the night before for a drink. "Who did you go with?" asked Betty. "No one," I replied. "Why?" Betty shrugged her shoulders and walked out of the office. I wondered about her question and attitude.

Several nights later, I again called into the hotel and then I noticed that I was the only woman there. I didn't feel out of place or uncomfortable for I considered myself to be conversant in matters pertaining to trade unions, but I did wonder why there were no other women in the hotel. I began to call into the hotel regularly and decided to invite other women so I could enjoy women's company. It wasn't long before women became regular customers of the John Curtin Hotel.

One evening when at the hotel, my boss Geo called in. He very rarely spoke to the office staff and I was surprised when he approached me and said, "A bloke I know asked me when I was going to knock you off, and I told him that I had no intention of trying and do you know why?" My immediate thought was, "Christ, who'd want you?" but all I said was "Why?" "Because I respect you," he replied, then moved off to talk with some men. I thought, how strange, he obviously can't respect a woman he has sex with. His values were all up the spout.

Geo was a man with tremendous ability and it did not take long to become aware of this. However, the tragedy was that he grew up in poverty, never had the opportunities, and eventually became the secretary of the Sausage Workers' Union. Because of his ability, he was never challenged. He was articulate and alert and, as time went by, with his power unchecked and unchallenged, he became a power unto himself. No one could threaten him.

I did not understand all these complex side-effects of power – and power unchecked – at the time, for I had no idea of how power corrupts. This lesson I was yet to learn. Workers do not read books on power structures, hierarchies, pyramids and pecking orders and we have to learn through bitter experience.

I decided to attend the Left Action Conference which was to be held in Sydney during the Easter period, and was looking forward to this event. Before the conference started and preliminaries were being attended to, I became aware that all the people assembled on the stage were men; there wasn't a single woman seated there although at least one-third of the people at the conference were women. Before the conference got under way, I approached the microphone and raised objections to the all-male panel on the stage and demanded woman representation. This was accepted and immediately attended to. The conference was underway and, after agreeing that each person may only speak once per session and for no longer than three minutes, it became a competition as to who could capture the microphone. I sat and took note of each speaker, male or female, and began to number them.

Albert Banger, the revolutionary of all revolutionaries, stood up and wanted to speak for a second time within the session. When this was refused, one of his henchmen moved that he be permitted to speak for a second time. The conference rejected this motion and we were all entertained by an amusing spectacle; Albert Banger with head held high stalked out of the conference and his entire retinue followed him. The scene was like a segment out of a Yankee film where the sheik walks out and his advisers and harem all follow in his wake.

The first evening was set aside for socialising and I took this opportunity to approach several women and, one after another, I asked if they intended speaking at the conference. Every reply I got was "no". The reasons given were, "Oh I couldn't", "I wouldn't know what to say", "Oh no, I would make a fool of myself". This was the general attitude of the replies. I began to think, why, why? Why are women so afraid? All the men who approached the microphone did so with confidence, even if their contribution was a lot of nonsense, yet the women were too afraid.

After sitting there for two days, I noted that twenty-seven men had spoken while only four women had done so. I told

the conference what I had done and told them of the figures taken. Why, I asked, were women afraid to speak their views at such a conference? When the session was over, a middle-aged woman comrade whom I had known for many years, came over and said, "You were right in asking these questions. The reason I ceased speaking is because my husband told me that, whenever I speak anywhere, I embarrass him." I just shook my head, I didn't know the answers, yet I knew that so much was wrong.

The sausage industry was being used as a test case for equal pay and the union was gearing itself for the case to be heard before the Arbitration Commission. Geo began going to meetings and would arrive back at the office with thousands of leaflets. He instructed me to organise leaflet hand-outs in the city after working hours. These hand-outs were to be done in our own time.

Most women working in the Trades Hall were uninterested in the equal pay campaign for they were privileged and already received equal pay. I rang the various unions and felt I was doing well when I received the offer of assistance from five or six women. All of these women were left-wing and worked in the offices of the militant unions.

At this particular time, handing out leaflets in the City of Melbourne was illegal, and we would constantly have to watch out for the cops. I found that women were reluctant to leaflet after work and arranged several lunch-time distributions. Again the numbers dropped until I went out alone. There were so many leaflets and my reluctance to waste any printed matter sent me out on the streets time and time again during my lunch hour. I would watch out for the cops then go back to work and eat my sandwiches while working.

There was great optimism felt about the forthcoming case but, just in case it failed, Geo and one other organiser said there would be big trouble if equal pay was refused. They spoke of big things happening if the case failed. The time of the case hearing was upon us and women from the sausage factories were brought into the court to support their claim.

I was asked to go along with them and together we marched up and down the street in front of the court building, holding our placards and chanting slogans.

On entering the court I immediately felt the oppressiveness of the atmosphere. People only spoke in whispers as they do at funerals and eventually we ceased talking for it is impossible to relate in such an atmosphere. The door opened at the rear of the court and in walked the judges. All male judges. Everyone stood to attention until the judges were seated and then the proceedings began. All the seats in front of the bench were occupied by men, the "fors" and "againsts".

The case presented was not equal pay for equal work; but for doing away with the differential in salaries, the claim being that the twenty-five per cent difference in salaries was discrimination on the grounds of sex. The evidence given by Bob Hawke, the ACTU advocate of the time, was irrefutable. The women sat there day after day as if mute, while the men presented evidence for and against our worth. It was humiliating to have to sit there and not say anything about our own worth. I found the need to sit there silent almost beyond my control and was incensed with the entire set up.

I was advised that to ask for a raise in salary after working in an office for six months was the established routine adopted in offices, and now that I had been employed for over six months, I told Betty and Fred of my intentions to ask for a salary increase. I was surprised by their reaction. Betty shrugged her shoulders and in a haughty voice said, "please yourself" and walked out. Fred turned to me, "I would have second thoughts about asking for a raise if I were you." I asked why, and told him of the advice received. He muttered, "Well it's up to you," and proceeded with his work. I went ahead and wrote a small note to the executive of the union requesting an increase in salary.

Two weeks later, I had occasion to enter Joan and Betty's office to addressograph some envelopes and, while working, Joan, my comrade and workmate, turned to me and, in a disapproving voice, asked me why I thought I deserved an

increase in pay. It was the tone of her voice which staggered me, for I immediately knew she did not approve. I told her of the advice I had received. "But you knew the wage you were getting when you came to work here." I thought I was imagining things, this was not only my workmate, but also my comrade. I told her that all workers know the wage they are going to get when they start a job, but that doesn't stop them from asking for more. "As a matter of fact," I continued, "they even go on strike to get more." I was very upset. Betty then in a facetious tone asked, "What makes you think you should be getting the same wage as us?" I explained that I didn't ask for the wage they were getting and all I asked for was an increase. "Well," said Betty, again adopting the tone of voice, "If you think you can do my job you're welcome to it," By this stage I knew exactly where I stood with my workmates and said, "I have never claimed that I could do your job, but neither could you do mine." As I left the office, I told them I wasn't aware that they were paying my wages.

I was stunned and amazed. I thought about all of my union struggles to obtain better wages for the workers in the hospital, and how pleased I was when they received an increase, and here my workmates (one being a communist) were opposed to my receiving an increase when I was the lowest paid worker in the office. I sat down at my desk, turned around to Fred and knowing full well where he stood, I said, "I will never be a clerk. I am an industrial worker and a trade unionist." He knew what I was on about for he remained silent. It was obvious that they had been approached to see if they considered me to be worthy of the increase and, knowing their attitude, I was not at all surprised when my request was refused.

The divide and conquer rule which pervades our society, and which was the going thing at the hospital, was just as strong in this communist-led trade union office. I remained silent and nothing was ever said again. It was many years later when I learnt that in order to have status one has to rise above others and, in order to obtain or maintain this status, it is essential to have someone to peck. I was the object to peck in this situation.

The equal pay case decision came down. Everyone was shocked, for it had nothing to do with the evidence or case presented. It was a replica of the decision brought down in NSW which gave equal pay for equal work. This decision meant that every union would have to establish an individual case of proof in every classification of work performed. To the women in the sausage industry, the result meant an extra three per cent of women obtained equal pay and, as nine per cent were already getting equal pay, this meant a total of twelve per cent of women in the industry would now obtain wage justice.

I still went to an occasional dance and preferred to go with a woman friend so we could have a chat over supper. I was getting fed up with the artificial scene and the sizing up and down of the women by men. The boring conversations such as, "who do you barrack for in the footy?" left me cold and I began to freak men out with my conversation.

One evening when I was wearing my wig, a man told me how beautiful my hair was and my immediate desire was to lift the wig from my head and say, "would you like to take it home with you?" The only reason I refrained from doing so was that I didn't want him to have a heart attack on the floor.

Leanne accompanied me to the dance on several occasions. One night, in order to make conversation, a very suave character asked what my hobbies were. After telling him I read quite a lot he asked what my choice of books was. His lower jaw nearly hit the floor when I replied, "Dostoyevsky, Shakespeare, and Karl Marx." "Why do you look shocked?" I asked, "Don't you think intelligent women go dancing? I happen to enjoy dancing." Leanne and I enjoyed the laugh together. We had great fun in being mother and daughter, cousins or sisters, and we changed our relationship whenever we wanted to have a lark.

On another evening while dancing with a fellow, he mentioned God during the conversation, so I told him I didn't believe in God and that I am an atheist. He was shocked by my forthrightness and spent the rest of the night dancing with

me and trying to make me see the light. He spent the latter part of the evening over supper trying to convince me to go to bed with him. Somehow or other, his belief in the Lord didn't prevent him from participating in that "sinful" occupation. However, when he finally had to accept the fact that there was nothing doing, he then regretted telling me of his marital situation. He thought he may have stood a chance by lying about his wife and children. He obviously believed in a good religion which allowed all of this hanky panky. So much for religion.

Yes, I had by this stage learnt that there was no difference between men; it did not matter whether they were communist, Catholic, Moslem, liberal, black, white or brindle for when it came to women and bed they were all the same, there were very few exceptions.

All was silent from the unions about the question of equal pay and all that was said about "big things" happening in the sausage industry if the equal pay case failed didn't come to fruition.

The Victorian Employed Women's Organisation Council (VEWOC), an organisation made up of representatives of unions with female members, came to life once more. This committee only put in an appearance prior to an election and was used as a propaganda vehicle for the ALP, using equal pay as the football. Something to kick about at election time. Dianne Ronberg, the then secretary of the Insurance Staff Federation, was on the committee and, knowing of my interest in the equal pay question, invited me to attend the next meeting of VEWOC I arrived on time and we waited for the other representatives to arrive, but alas, they didn't front, so Dianne and I had an informal discussion on the nature of the meeting to take place. The idea which had come from the men was to have a lunch-time meeting in the city square and that five male speakers, possibly one of them a politician, were to speak. Both Dianne and I were unhappy about this arrangement. People do not have sufficient time during lunch hour to listen to five speakers and we were, in principle, opposed

to the idea of all male speakers. We were also aware that the question of equal pay was only being used by these men to further their own ends, and we questioned their motives.

After having a chat about all of these aspects, we both agreed that something more than just talking was needed to draw attention to the pay injustice meted out to women and more positive action was required. We began to fantasise women chaining themselves up like the suffragettes did and jokingly asked ourselves where women could chain themselves to make their protest effective.

I began to think seriously of the chaining-up idea, then decided I would be prepared to chain myself to the Commonwealth Building as part of the VEWOC demonstration. Little did I realise the effect this event would have in changing the entire course of my life. I felt that the commonwealth government should set the example by giving equal pay to women in government employment and, after assuring Dianne that I was serious in my intent, she became excited and undertook to contact Don McSwan, the elderly secretary of the Garment Workers' Union. He had played a main role in establishing VEWOC but he was shocked by the suggestion. He didn't think the chain-up was necessary or wise, so I decided to do it as an individual but requested moral support from other women.

The day of the meeting at the city square had arrived – 21 October 1969. I had already spent several lunch hours distributing leaflets advertising the meeting and again I went with several other women and distributed leaflets. After the leaflet hand-out, I made my way to the city square and the number of speakers had been reduced to two women. It was almost impossible to hear them because of the traffic noise and, although the press, radio and television had been notified of the meeting, they were not present. However, when they were told to be at the Commonwealth Building at 2 p.m., they all turned up.

I had planned the entire strategy for the event. The door system had to be examined in order to determine how much chain would be required then, having done this, I asked the

late Jim Donogan, the then secretary of the Painters' and Dockers' Union, if he could get me some chain. I explained the purpose for which the chain was needed and Jim said he would be glad to oblige, but on the condition that I refrained from revealing the source from which it was obtained. I agreed for I had already priced chain and it was very expensive. I simply purchased the locks.

I felt strongly about the need for women to begin fighting their own battles. The placards were all ready for the event and I refrained from eating or drinking for several hours prior to the chain-up as it would be embarrassing to find that I needed to go to the toilet while still in the chains. Following the meeting at the city square, several of the women accompanied me to the Commonwealth Building where, within seconds, I was chained across the doors. The other women walked up and down with the placards which called upon the government to grant women equal pay.

I did not know how long I would be there; I was very nervous but it had to be done and I was prepared for anything. A Justice of the Peace was already lined up in case of arrest. The press, radio and TV arrived and it was on. They asked why I was protesting in this manner and what I hoped to gain from this demonstration. I explained that I was protesting against the injustice done to women over the right to equal pay and, when asked how I felt about being the only woman prepared to do this, I told them that today it was me, tomorrow there would be two, then four women, and it would go on until all women were demanding their rights. They asked ridiculous questions like, "Do you now feel like Mrs Pankhurst?" and such, but I made light of these inane questions. I explained why the Commonwealth Building was selected and they then asked where I got the chain from. It was a very heavy chain and with a smile I stated that it was donated by an all-male union, which was not a lie, but refused to name the union.

The entire building became a mass of faces at the windows when they learnt of what was taking place. I had given the keys from the locks to another woman and, after some time

had passed, she went off to purchase some sandwiches. It was during her absence that the commonwealth police arrived and ordered me to unlock myself. I refused to do so. They again told me to unlock myself and again I said I did not have the keys, which in fact was true. The building warden stepped forward and read a meaningless script to me. The police then cut the chain with a pair of bolt cutters. I was amazed how easily the bolt cutters snipped through the thick chain, it was as if they were cutting paper.

I returned to work and ate my sandwiches on the way. I trembled for several hours after my ordeal and gradually regained my calm. The press, radio and TV featured the event, however, the press distorted what was said during the interview. I was convinced that genteel meetings at the city square would never achieve anything. Women would have to fight for what they wanted.

The next day, Sharon, a young woman who worked in the office of the Drink Workers' Union, called in at our office and eagerly displayed her support. She was most anxious to participate in any similar action which might be held in the future. I received a phone call from Alva Giekie, a woman congratulating me on my courage and requesting to be brought in on any further chain-ups. She also had a friend who might come along, so we arranged to meet to discuss the issue.

Alva was very enthusiastic to get into action and we decided to chain ourselves across the doors of the Arbitration Court, the institution which refused to grant women equal pay for work of equal value. Alva's friend, Thelma Solomon, was a willing participant but they were both schoolteachers and it was difficult for them to take time off from school for a demonstration. There was a dispute pending within the teaching service, and a stop-work of teachers was possible. We decided to wait for the outcome. Meanwhile, I went and examined the door system at the Arbitration Court to determine how much chain was required, and where the chain would have to go. I made various enquiries in my search for chain and was able to obtain some from the Builders' Labourers' Union. I purchased more locks and all was set to

go if the teachers went on strike.

Alva was so keen that she suggested we carry out the chain-up strike or no strike, but I realised there would be media publicity and both Alva and Thelma would be in strife. Alva having had no previous experience of the media, thought if we asked them to refrain from photographing her and Thelma, that all would be well. I explained that this wasn't possible and they could not risk such action. The teachers' strike was planned for the Friday, but it would not be known until the Thursday evening's negotiations if the strike was on or off, so we had to wait for the late news Thursday night before we could act. I listened to the late news and negotiations had broken down so the strike was on.

We had discussed the need for several women to come along with placards and give us moral support, and I undertook the responsibility of getting this support. The next morning I went to work earlier than necessary, for I did not consider that I could do as I liked while working for the union. I was "Mary Ann" in the children's page of the union journal, and did almost all of this page at home where I could apply myself without interruption. I never asked for payment from the union, so a little time in return still put the union in my debt.

My early arrival at the Trades Hall gave me the opportunity of calling in to Jerry, the secretary of the Drink Workers' Union and my comrade, and I told him about young Sharon and her eagerness to lend support. I asked if she would be able to take one hour off in order to give us some badly needed moral support. Jerry stood there stuttering and stammering, "Oh," he said, "She couldn't possibly go along; after all my union is a right-wing union you know. If the members saw her there they would want to know what she was doing there." He continued to stutter and stammer. "Forget it," I said and walked away. I then rang the Steelworkers' Union, another left-wing union, and spoke to one of the organisers about getting some support from a woman. He advised me to ring back and ask Lennie McMichael, the secretary of the union. Lennie was also a comrade and when I rang and explained

the situation, he said he would not let a woman go for this purpose. When I asked for his reasons for refusing, he stated they did not work this way. I tried to explain about the teachers' strike and why it had to be a last minute decision, but he said, "The answer is still no." There was no one else I could ask for only two of the women comrades had made an approach of support for my stand but didn't indicate any interest in activities of this nature.

Alva, Thelma and I chained ourselves across the doors of the Arbitration Court on 31 October 1969 without any support from other women. The media was present and again there were photos and interviews. I suggested that we must not be provoked for it was important to preserve our sense of humour in such situations. There was just sufficient chain to allow the door to open slightly, and people had to bend down and crawl in sideways to enter the building. This was so undignified for the "important" people and one commissioner told a union official in the building that he was lucky I didn't know who he was or I may have wrapped the chain around his neck.

Again the questions from the media concerning the demonstration and, eventually, we were paid a visit by several commonwealth policemen, one being the policeman who had cut my chains on the previous occasion. The three of us were asked to undo the locks and leave the building, but we refused to do so. We were again asked and again we refused, until the building warden arrived and we were cut loose. We were lined up like naughty children to stand before the warden as he read his text for the day from his book of legal jargon. His voice trembled as he read.

The experienced chain-cutting cop approached me and said that this was the second occasion on which I had acted in this manner, and he warned me that serious action would be taken against me if I behaved in this manner again. I asked if this only applied to commonwealth buildings, knowing his jurisdiction full well, and he replied yes. "Oh well, there are plenty of state government buildings," was my reply. We then caught a taxi and I returned to work.

Alva was very eager to get women involved in action. She suggested that we ask the trade unions to notify and encourage their women members to participate in a march through the streets of Melbourne in support of equal pay. Knowing what the trade unions were like and how conservative they were, I tried to convince her that the unions wouldn't even consider our correspondence, let alone rally their members for this cause. I felt we would need to form an organisation of our own and do far more organising ourselves before the women of Melbourne would take to the streets. Alva was impatient and in her enthusiasm and ignorance of the trade union movement, she was determined that this march would be successful.

We wrote to the trade unions and requested the support of their women members. On the due date, Alva and I, carrying the many prepared placards, stood at the corner of Swanston and Lonsdale Streets and waited for the women to arrive. Needless to say, we stood there waiting alone! We were embarrassed and pleased that only one representative of the media arrived.

We then got down to the seriousness of forming an organisation of women who would be prepared to be militant in the cause of women.

# 14

CLAUDIA, WHO WAS BY THIS STAGE an established woman journalist, wrote a feature article in the *Herald* about a diamond party. Wealthy women paid fifty dollars per ticket to attend this party and they wore their diamonds. The money raised was for the Queen Victoria Hospital and I thought a further article explaining where the money had come from to pay for the diamonds would be appropriate for the women's page in the union journal. I brought the article into work and discussed it with Joan and Betty.

Joan's son was very artistic and he drew a cartoon of two women stripped of their foundation garments and clothes but decked out in their diamonds. The reason for this cartoon was that these women, when stripped of their clothing which is produced by the working class, are reduced to the appearance of all people when naked. Their diamonds did nothing for them.

When all the material was ready for publication, I called Geo aside as he was running through to his office, showed him the *Herald* article and photo of the wealthy women then our article and cartoon. He became very upset when he recognised two of the women in the photograph, one of them as being the wife of the owner of a large sausage works. He then commenced to defend them.

I was surprised by his attitude and, in defence of our article, I told him that the workers in their sausage factory had paid for the diamonds of these two women. "No they didn't, no they didn't," he insisted. He was extremely agitated. I didn't know how to handle the situation so remained silent. He walked out of the office.

I could not understand why he had reacted as he did: he was so obviously disturbed by our article and cartoon. Later, during the day, while pondering this incident, it all became clear. Geo was a close friend of the owners of that sausage works and it would seem that he could have been placed in an embarrassing situation. It could be assumed that he was concerned in case his friends should be offended, however, he did not prevent the article or cartoon from being published.

The Party called a meeting of member trade unionists and Geo spoke for one and a quarter hours on the topic of workers' control. After listening to his lengthy report, questions and discussion took place and I rose to my feet. This was the first time I had ever spoken at a trade union cadres meeting, and I told them of the treatment received at the hands of the two comrade union secretaries when I sought moral support for the chain-up at the Arbitration Court. I told them of the circumstances which led to the last-minute decision and the refusal by these two comrades to assist. I explained how the two women accompanying me had never before been in any kind of demonstration and the courage they displayed in doing so, and how the three of us were alone in this struggle. I was greeted with deathly silence and the men went on to discuss more "important" matters.

Christmas was approaching and while I was having a drink with some of the various union officials at the John Curtin, they spoke of the parties, outings and gifts they were giving to their staff members. Geo entered the pub while Roy, a union assistant secretary was speaking of these matters. I gave Roy a nudge and a wink and said "Listen to this!" "Hey Geo," I called, "what are you giving your staff for Christmas?" He turned his head, "You can all get stuffed," was all he said. I jokingly said to Roy, "See, that's what we are getting for Christmas: a stuffing."

Joan and two of our officials went off for their holidays and, on the second last working day, Betty who had placed some beer in the fridge prevailed upon Geo to have a drink with us. He said he was too busy and had to go somewhere, but Betty persisted until he reluctantly agreed. She opened a

bottle in the organisers' office and called me in. Fred was nowhere in sight. It was a strange gathering, Betty, Geo and I. I didn't like the taste of beer but accepted the drink because of the festive season.

Geo held the floor non-stop until, after ten minutes or so, an organiser arrived and he was then able to ignore us and converse with the organiser. He had made his token gesture to his staff. These few minutes were the longest period he had spent with his staff in almost the year of my employment.

The next day was the final day of work, for the Trades Hall was closed between the Christmas and New Year. This break gave us a few days of freedom. I had taken very little sick time off during the year and although some unions gave their staff shopping time, we did not receive this privilege. Our only gift was permission to knock-off at midday on this last day of work.

During the morning, the president and one organiser thanked us for assisting them during the year and for the work we had done. This was not on behalf of the union, but as individual men. The organiser even gave us a little gift which surprised us, but no one else put in an appearance. Geo didn't even bother to ring through.

Betty, Fred and I, like three dogs with the mange, closed up the office and went over to the pub. We had a few drinks together, gave each other a kiss and best wishes for the new year and departed.

I arrived home flattened, never had I seen staff treated like this. There is nothing worse than being ignored. When I arrived home, Leanne and Mark, a young comrade, were there and I told them of my feelings, and how disgusted I was at being treated in this manner, especially when Geo is a comrade. "I feel like writing and telling him just what I think." "Why don't you?" Mark asked. I didn't know where Geo lived as he didn't have the phone on. He didn't want to be disturbed by his membership after hours. Mark suggested I obtain Geo's address elsewhere. This I did and then sat down to write.

*Dear Geo,*

*I am writing this letter from one communist to another, and I wouldn't be writing it if you weren't a communist. I am writing this letter because of your attitude towards the staff in your office. We would be the hardest worked staff of any union office in the Trades Hall, yet you do not recognise our contribution, you are completely unaware of what we do.*

*Yesterday, after Betty insisted, you condescendingly had a drink with us, but after suffering our presence for several minutes you hastily escaped.*

*I recognise your ability and you don't have to bullshit me into seeing it, all I ask is that you recognise our ability.*

*I didn't know what snobbery was until I came to work for a communist in this union. The dentist I worked with for nine years was a public school boy and he ate his meals with the staff, but you have no time for the workers, while you find plenty of time to dine with the Joneses and Withers [two sausage factory owners].*

*You were unable to acknowledge our efforts or even wish us a happy New Year. You once said you respected me. I don't want respect, I want recognition. Because of the way you treat the staff, most of the officials treat us in the same manner, it is up to you to set the example of how we should be treated. I take this opportunity of wishing you and your family a very happy New Year.*

The above letter is not word perfect as the duplicate was eventually sent to a Party member in Sydney. However, the content of this letter will forever remain imprinted in my consciousness. Never would I cease to feel the repercussions of this document.

I gave the letter to Mark to read. His only comment was, "You should have written it in stronger terms. Why didn't you tell him to get stuffed, like he told you at the pub?" I couldn't do that, I was only interested in letting him know how I felt.

If Geo had been on the phone I would have rung him and told him, or if the Trades Hall hadn't closed down I would

have told him to his face, but these avenues were closed to me so I had no alternative but to write. The letter was posted. The Christmas and New Year were over and we were back at work. In several days it would be one year since I had started work in this office. Time moved on very quickly. Geo was his usual self and he in no way indicated his feelings about the letter. I assumed that he had probably read it, thought what a lot of rubbish and thrown it out.

Michael Berrigan, a journalist with the *Sunday Observer*, rang and requested an interview with me on the equal pay question, so I arranged to have the interview with him over a counter lunch on 15 January. John Hurst, a journalist from the *Australian* also interviewed me and John's article appeared in the *Australian* on 14 January.

The day of the fifteenth had arrived. Little did I know what a traumatic day this would be, a day which was to alter the very foundations of my life. The two organisers were still away on holidays and I had the lunch appointment. I decided to discuss the result of the equal pay case and what effect the result had had on the sausage industry.

Geo rang the office and spoke to the president and I indicated to the president my desire to talk to Geo when they had finished their conversation. Their conversation having ended, I asked Geo if he had time to tell me of the final effect of the equal pay case in our industry and any other relevant details and explained the reasons for needing this information. He went into great detail and spoke of how women in the industry had equal pay during the war, but the successive liberal governments had filched this away. He went on and I made notes of all the details, until I had what was a good example of the failure of the court decision to implement equal pay. I thanked him for this information.

Michael Berrigan was a very gentle and kind person and I enjoyed the interview. I also mentioned the meeting that Alva, Thelma and I were calling to initiate an organisation of women to campaign for women's rights, and he made notes of all the particulars of this meeting and said he would publish this information.

The type of women's organisation we envisaged was a militant organisation, for we recognised that women were not going to achieve anything unless they were prepared to fight. We had passed the stage of caring about a "lady-like" image because women had for too long been polite and lady-like and were still being ignored.

The union executive was meeting in Geo's office, and if any urgent messages had to be delivered I would knock on the door, wait until I was told to enter and then deliver the message.

There I was, waiting to be summoned after my knock and when someone called, "Come in." I entered to deliver the message. Geo was on his feet, waving his arms around. There was immediate silence and he remained in this pose for several seconds until I left the office. He was obviously very agitated and emotional about something. At 4.30 p.m. the executive meeting was over and I was asked to go into the office of the assistant secretary. Bob asked me to take a seat and, after sitting down, he told me he had been instructed by the executive to advise me that my services were no longer required from that day. They were paying me a week's pay in lieu.

I became all hot and began to cry. "It was the letter wasn't it?" I said. Bob made all kinds of excuses; he was in a difficult position. "You can say you resigned if you wish," he advised. I continued to cry; I couldn't believe it, it just wasn't possible. This was the first time I had ever been sacked from a job, and it was a communist who had sacked me. "No, I won't say I resigned, I will tell all what he has done to me, my comrade." I was so distraught and couldn't stop crying. I asked for a copy of their reasons for sacking me in writing, and Bob said he would post it to me. I told the staff of my dismissal and why. There was dead silence. I had told no one of the letter before, as I had considered it to be a private letter from one communist to another, but now that Geo had made his private letter union business, there was no longer any need for me to treat it as a private matter. They were silent as I collected my few things together and went over to the pub. I sat there crying. The trade union officials were all shocked when they

heard about my dismissal, but all remained silent.

I went home completely shattered and wretched. I sobbed and sobbed. It was impossible for me to sleep. I thought I would go mad. It seemed that all of my life was spent fighting injustice. I had participated in every cause and in every campaign, I had done all that was humanly possible to do to alleviate the suffering of others, and now a communist had sacked me for daring to criticise him.

I went along to the Party and told them what had happened. They listened, but were silent. I couldn't believe it; a communist doing this to another communist and the Party remained silent. I thought of all of the differences and arguments I had had with bosses over the years in the factories. The disputes with the two secretaries in the hospital, the fact that the state government wouldn't make me permanent, but they never sacked me, yet a communist did because I criticised him. How could this happen? The Party always emphasised the need for criticism and self-criticism, yet this is what happened when criticism was put into practice.

My head span round and round with all of the "whys". I was in a terrible predicament. I had the house up for sale and wanted to move closer to the city. I had assumed that I would be working in the union office until I retired. I wanted to be near mum who was now getting old and I could foresee a time when to run a car would be financially impossible. Now I was without a job and the house was up for sale.

For several nights there was no sleep. Like most women, there were other periods in my life of sleeplessness because of men. Yes, the tears, the misery, the heartache. Why? Why? Why? But this was different. All my life my ideals, my thoughts and attitudes, everything that was me was bound up in the struggle against injustice and man's inhumanity to man. What I did not understand then was man's inhumanity to women. All of the ideals I had cherished, where were they? If a communist in a capitalist country would deprive another communist from a livelihood, what would this type of communist have done to me if he was in power and omnipotent? All the communists remained silent. It was only then that I

understood what had happened in Russia. To my knowledge, only one comrade had tackled Geo and told him what he thought of him.

Another woman comrade, a woman without a man (the most vulnerable people), told me she had had a similar experience and had taken to drink after the incident. She was ultimately proven to be correct but it was too late. With me, the continual sleeplessness was taking its toll. My mind would not switch off. Over and over I churned and I would break into sobs. I rang a doctor friend and prevailed upon him to call in. I explained the matter was urgent. He had left-wing politics and was very sympathetic when hearing of my experience. "Zelda," he said, "You must always mistrust leaders, after all, what motivated them to seek power?" He prescribed some sleeping tablets and, after a few nights of sleep, I was able to cope with the situation.

I wrote a letter to the executive of the Sausage Workers' Union pointing out that members of the union have the right to defend themselves when charged by the union, however, they had decided to act upon a private letter and had deprived me of any right to defend myself. There was no reply. I further wrote to the committee of management of the union (the governing body) informing them that, under the circumstances, I was no longer interested in working in their office, but pointed out the terrible working conditions they expected their staff to endure. As an active and fighting unionist over a period of many years, I had fought to provide workers with good conditions; conditions that they themselves expected and yet they deprived their staff of. I strongly suspect that the committee never saw my letter.

I was unable to go to my union for help as the Clerks' Union is a right-wing union which is interested in holding power for political purposes only. They would have been interested in making political capital out of my situation by attacking a left-wing union, but clerks are always being sacked and they are unconcerned. I had no support – the situation of all women. During this crisis only one comrade sustained me and, naturally, this comrade was a woman, Kathy.

I had a few weeks holiday pay to keep the wolves from the door and was in no state as yet to seek employment, but I let it be known around the unions that I was seeking a job.

The Party called another meeting of trade union activists to continue the discussion on workers' control which had commenced prior to Christmas. Geo was sitting out in front and again was talking about workers' control. After he had proceeded for approximately fifteen minutes, Mark stood up, interrupted him, and said, "I cannot go on listening any longer to Geo talking about workers' control when he sacks a woman from his office for criticising him. What sort of workers' control are we on about?" There was dead silence. The atmosphere was thick and no one said anything. I sat in silence and was terribly embarrassed. Never had I experienced anything like this in the Party, for they were always "nice" and polite, and didn't do what Mark had just done. Nobody seemed to know what to do, comrades began to mumble, stutter and stammer.

I didn't know what to do and yet I felt I should do something, so I rose to my feet. I didn't know what I was saying but I had to say something. After several minutes I began to cry and sat down. The leaders said they would discuss the matter so the meeting would be able to continue as planned. Mark had forced the Party to do something about my experience. I sat through the entire meeting, but all I could recall of what transpired was, as I was leaving, an elderly woman approached me and said "Zelda, if you talk to them nicely and gently, you can always get what you want. It all depends on the way you go about it." I shuddered and said nothing.

Several nights later, I entered the John Curtin and was called aside by Kevin. Kevin was a very quietly spoken comrade. He told me that he was having a drink with another comrade when Geo had walked in earlier in the evening. Geo was drunk and said that he was going to get the Party to investigate the men I went to bed with, and also that I was fucking with Bob, the assistant secretary of the Sausage Workers' Union. I sat down. I felt ill. "Hasn't that man done me enough harm?" I asked, "He deprived me of my livelihood, and now

he is attempting to degrade and smear my personal life."
Kevin explained how he and the other comrade were both
sickened by what Geo had said, for they knew he was lying.
They also knew his reason for doing this was because I brought
the entire issue out in the open and didn't hide behind the
resignation ploy. Together with this, was his resentment
because the Party was forced to take up the issue. I let the
Party know that if I heard one more word about my personal
life from Geo's mouth, I would have him in the courts.

The Party established a committee to investigate my dis-
missal. I was unaware of who was on this committee, but had
to wait to find out.

The Boilermakers' and Blacksmiths' Union required a
woman in their office to relieve their staff who were due for
holidays, and this gave me six weeks work. I took the position
hoping that something would turn up in the meantime. This
union and the Steelworkers' Union were housed in two houses
adjoining each other and the back fence dividing the two
houses was removed to allow for easier car parking. I parked
my car in a car park only one block away from the office and
I enjoyed the quietness of this union office. What a difference
there was between this office and the Sausage Workers' office.

Bronwyn, who worked beside me, asked where I parked
my car and, after telling her of the car park, she offered me
the use of her car space at the rear of the building. She was
fearful of parking out the back because the organisers were
driving in and out and she was afraid of having her new car
dented. "But if your car is old and you don't mind taking the
risk, then you are welcome to use my car space." I was happy
about her offer, but was reluctant to cause any trouble. She
insisted there would be no trouble as she had an allotted space.
I began to park the car at the rear of the office, however, if I
knew there was to be a meeting and many people were expect-
ed to attend, I parked the car down the street. I often gave
Cora a lift home. Cora worked in the Steelworkers' office
and was at times glad to be dropped off on the way home.

One morning as I approached the rear of the office through
the back lane, my comrade Lennie was approaching from

the other end of the lane. My little Volkswagen slid into the back of the building before he was able to manoeuvre his Holden in. I had been at work for fifteen minutes, when the secretary of the Boilermakers' Union came into the office and said, "Zelda, I have been asked to give you a message from Lennie McMichael which I will do, but I have no comment to make! He told me to tell you that a couple of nights ago the Steelworkers' Union council decided that no staff members are permitted to park their cars at the back of the building." "Fair enough," I said, and didn't bother to explain that Bronwyn, who was now on leave, had given me her parking spot. I had learnt to remain silent, for only men have the power to make decisions.

Two nights later Cora asked for a lift home and, as she headed for the rear door, I called and pointed at the front door. "This way," I said. She wanted to know why the car was back at the car park and I told her of the message. "That's news to me, I haven't heard of any council decision about that." Cora made investigations the next day and discovered that Lennie had lied. The council had made no such decision. Heather (who worked in their office and said she was not the slightest bit interested in the Vietnam War because it didn't affect her as she had daughters) was still parking her car out the back. Again, I had been dealt with by a comrade. I had no more illusions about the type of people my comrades were.

Most left-wing men in power positions are more vulnerable because of their politics, and have to do the right thing by the workers or they will be thrown out of their positions, but when it comes to the personal, that's different. It is no wonder that all men claim the personal is not political . . . this enables them to get away with almost anything.

My personal life continued to be smeared and I heard statements from here and there about what was said.

A woman comrade, not knowing the circumstances of my dismissal from the Sausage Workers' Union, was offered the position and interviewed for the job. Geo told her that I was a hot pants and had to go for, not only had I tried to entice every member of the executive, but after failing to make the

grade with him, I wrote a personal letter to him which fell into his wife's hands. The woman comrade felt ill in the stomach when he uttered these words for, although she didn't know me closely as a person, she knew enough about me to disbelieve these allegations. She did not take the job.

How easy it is to besmirch women, to defile them and get away with it because this is not political. Several people even went so far as to tell me that there must have been something in my letter to Geo which may have led his wife into thinking there could have been an affair. How fortunate I was to have kept a duplicate copy of this letter. My women's intuition must have made me do this for never before had I kept a copy of a personal letter. Geo had made the letter union business, so I made the duplicate available to several people for perusal.

Nothing was taking place in my personal life for I was no longer a masochist, and I now avoided suffering, pain and disappointment. The few relationships I did have ended in disaster, and the tears and depression which followed were not worth it. I dare say I could have maintained a relationship if I was prepared to play all of the female games, but I never was a good actress when it came to human relationships and was unable to play-act, cheat, manipulate, be dishonest or crush my inner spirit. No man was worth hanging on to if the price I had to pay was the destruction of myself. I had learnt that the combination of my mind, spirit and personality was a constant dynamic force, and to suppress any one part of me was sufficient to destroy me. I now understood why Tony said I was a difficult woman to live with. Unfortunately, I didn't understand myself until I became a liberationist and then I understood why the few affairs I had were so painful.

Work and the need for employment began to worry me. I was prepared to go and work in various industries where women were employed and write of these experiences if anyone was interested in publishing them. I contacted Michael Berrigan and asked him if the *Sunday Observer* would be interested, and he said he would make enquiries and let me know. I told him of my dismissal following his interview and

187

he was very understanding and said, "Don't lose your ideals, it is idealists who change the world." I, at this stage, didn't know the difference between having ideals and being an idealist. After a week or so, Michael rang and said they were interested in my scheme and to go ahead with it. I was to take note of the firms, the addresses, and supply this information together with the articles written. I did this and worked in a small meat company, a factory where electrical fuses were assembled, a knitting mill, and also as a cleaner in a hospital.

The conditions were terrible and the wages were even worse. One of the numerous details I reported was that the machines in the knitting mill were no longer in benches where women could talk to each other. They were now in separate units, with each unit being just too far away to enable the women to converse. The unit in front was placed just far enough ahead for the same reason and each woman faced the back of the woman in front. This method of desking is now used in all offices. The replica of the school room, the school being the training ground for all people to cease communicating with each other. There is nothing more alienating than looking at the back of a person's head, for our faces were made for greeting; this is now done away with and people are no longer human but part of a machine. Almost all of the women in these industries were migrants and they disliked their jobs but were unable to obtain better positions because of their lack of skills and lack of English. Like all working-class women, they worked to educate their children and pay off the house.

The experience of going back into productive industry made me acutely aware of the non-status of the people who produce. In the factory where fuses were made, I was very quickly informed that I was sitting at the wrong table in the canteen at lunch-time. These tables were for the office staff and I observed that the office staff had stainless steel-legged tables and chairs, sugar basins, salt and pepper shakers and ash trays. The producers had wooden-legged tables and garden-type benches to sit on, and no sugar basins, salt and pepper shakers or ash trays. I butted my cigarettes on the floor.

The producers – the factory workers – make everything, but the overheaders have the status. All of the non-productive people have status. What a sick world, for where would we be but for the workers who produce all of our material wealth. Again — status can only be achieved at the expense of other people.

The articles were completed, all reduced in size and all featured together with photographs in the centre double page. I was again out of work, and nothing was heard of the Party committee set up to investigate my dismissal.

# 15

THE MEETING CALLED by Alva, Thelma and me took place on 2 March 1970. Fourteen women arrived and we sat around and spoke to one another of the need to do something about our own situation in society, and of our expectations of a women's organisation. We were, in fact, feeling our way as, apart from Alva, Thelma, myself and one other woman, all of the women were strangers. Three young lefty women arrived and adopted the cynical and patronising attitude of "Christ you're bloody ignorant," and proceeded, with what they considered to be very subtle methods, to teach us what's what.

Bon Hull offered to have the second meeting at her home and she placed an advertisement in her local paper inviting all women to attend. She envisaged great numbers of women flocking to the meeting and hired one hundred chairs to accommodate the crowd.

John Sorell in his interview with Bon stated in the *Herald*, 16 March 1970, "I've seen this sort of organisation before. They generally peter out after some enthusiasm at the start. And the reason they peter out? The apathy of women themselves. They realize they've never had it so good." We gathered at Bon's place and, much to her dismay, only eleven women attended. Bon, who was aware of the tremendous suffering endured by women, could not understand why they didn't attend.

Ben Hills, a reporter for the *Age* came along to the meeting but was refused permission to attend. Next morning he reported that he had, on previous occasions, been prevented from attending functions because he wasn't wearing a tie or when the press were barred, "but last night was the order of

the boot to end them all. I was shown the exit for wearing trousers."[1]

At the second meeting, there were several women who came along for the first time and some who were missing from the previous meeting. When contacting the women who did not attend the second meeting, two women said it was too left and the lefties said it was too weak. One of these left-wing women reappeared two years later but only for a short period. The meetings continued with different women coming and going, but a hard core were sticking to it and fighting through.

The women immediately began doing things. Letters were being sent to firms which discriminated against women in advertising for staff, letters were sent to sponsors of TV programs who were using sexist advertising, and a petition was circulated on the abortion issue. We agreed on The Women's Action Committee (WAC) for the name of our organisation and drafted a list of demands which we adopted as policy. We refused to have a constitution, and whenever suggestions were made for the need of a structure based on male-type organisations, such as an executive, president, secretary, etc., several women were adamant in their opposition. I was particularly vocal on the matter. My experience had taught me that these type structures lead to power positions and, once you have positions of power, you have people fighting each other to obtain the power, glory and status that is created by these positions.

From the very beginning, I felt that it is not a question of whether it is woman or man, it is the position which corrupts and, once people obtain power, they seek to stay there and in doing so they must inevitably go bad. I had learnt this lesson the hard way and shuddered at the thought of women becoming like men in their scramble for power.

The WAC decided to have a tram ride and pay seventy-five per cent of the fare to draw attention to the wage injustice. Equal pay was refused but we were expected to pay the

---

1. "Emancipation is for Ladies Only", *Age*, 17 March 1970.

full price for all goods and services. I undertook to see Charlie O'Dea the secretary of the Public Transport Workers' Union. Charlie was a Marxist Leninist and another "revolutionary" of all "revolutionaries". I was to see him and tell him what we intended doing. We wanted him to chat up the conductors or conductresses so they wouldn't mistake our intentions. We had no differences with these workers and did not wish to embarrass or alienate them.

I bumped into Charlie at a reception held at the Trades Hall and told him what we intended doing. He was flabbergasted. "This is a very serious thing to do. Do you know what you are doing? You should give this matter some serious consideration." He went on and on. I told him we had discussed the matter in complete seriousness and would go ahead with it, and I asked if he would chat the staff up to avoid embarrassment. He began to mutter and stammer, "Oh this is a very serious matter," and turned on his heel. He very rapidly beat a hasty retreat as he continued to mutter. I gazed at his retreating back. This was the man who went to jail as a hero.

There was no doubt whatsoever, women would have to do their own fighting. Within our new organisation we placed no compulsion on women to participate in any action which, for reasons of their own, they couldn't bring themselves to do. Women are in all types of personal situations and relationships and, understanding this, we did not put any expectations on each other. Nor were we made to feel any sense of guilt because we were unable to participate. Our organisation embraced all women who were prepared to act, and action meant writing letters to newspapers, firms or any undertaking, no matter how militant or gentle.

The press were distorting all information in reference to the women's struggle, so Bon and I wrote, on average, one letter a week to the press. It soon became apparent that they ceased publishing letters with our signatures, so we began to write letters under false names. What else could we do when men have total control over the media?

Bon rang one evening and was elated because of a wonderful letter in the *Herald*. "We have another supporter Zelda, isn't is great." I asked her to hold the phone while I looked excitedly through the pages seeking the noted epistle and behold — there it was. As soon as I began to read it I recognised it. I had written the damn thing under a false name and we roared with laughter. Even though we were disappointed at being unable to cherish the thought of one extra woman supporting us, we were greatly amused by the incident.

Four of us boarded a tram and refused to pay the full fare. Representatives from the media accompanied us on the two tram rides and took notes and photographs. Again we were in the press. The Tramways Board threatened action against us to retrieve the money owing, but nothing was ever done. What a wonderful chance that would have been to expose the wage injustice meted out to women.

The WAC drew up a policy for it was necessary to enlighten women with our demands. The policy was as follows:

### Economic Equality

(a) One rate of pay for the job performed. That is a basic salary for all adult workers, plus increments for qualifications and experience etc. necessary;

(b) Equal opportunity in employment;

(c) Credit given to women should be under the same conditions as men. No male guarantor should be required;

(d) Maternity leave of one year with no loss of seniority or superannuation. Maternity allowance equal to the woman's full salary for six weeks (as recommended by the ILO);

(e) Child care, kindergarten and child minding facilities should be increased;

(f) Part-time work should be made available for women who require it;

(g) Retraining centres should be set up for women returning to the work-force after rearing children.

### Social Equality

(a) Women should not be used or considered as sex symbols e.g. in advertisements, bathing, beauty queen competitions, employment etc.;

(b) All business and political organisations, state functions and public places should be open to women;

(c) The attitude of society to women's role, and so called "feminine behaviour", must be changed to allow women to develop their full potential.

### Equal Education

(a) No distinction should be made between girls and boys (Primary school);

(b) No distinction should be made between courses for girls and boys (Secondary school);

(c) Girls to be made aware of the longevity of their working lives;

(d) Girls to be encouraged to undertake apprenticeships in all suitable trades.

### Abortion Law Reform

(a) Abortion should be available at low cost to all women after consultation with their doctor;

(b) A substantial increase in family planning facilities. Partly-used suburban Baby Health Centres should be used for this purpose;

(c) Liberal sex education should be provided for children.

The Women's Action Committee does not have any political affiliations. It is a pressure group working for the equality of women.

As individuals, all members have the right to belong to any political organisation of their choosing.

No one could accuse the WAC of being a communist front as the communist women were noticeable by their absence. The more I thought about the women in the Party, the more they seemed to resemble a nice group of Christian ladies.

They did good work, respectable things like typing, doing something about the local kindergarten, preparing suppers for all of the functions, and making goods for the annual fair. Like all women they never discussed their innermost heartache, their sex life, their exploitation in the home or their personal oppression. The men made all the decisions, just like they do in all structures, and the women followed, doing their bit to assist the men in their cause.

I attended a Party meeting and counted the women present. Of the nineteen women in attendance, twelve were knitting or crocheting while the meeting took place. There is nothing wrong with knitting or crocheting, both are wonderful skills, but only one of those industrious women spoke and, having three minutes to make her contribution, she sat down after two minutes. I just couldn't understand what was preventing these women from using their minds. No one could convince me that women did not possess minds necessary to pave the way to a better world, but what was it that stopped these women from developing?

The Women's Action Committee was being asked to provide speakers for schools, church groups, women's committees and mixed groups. None of us in the committee had speaking experience, nor did we have the confidence to do it. I undertook this task and was petrified. I began to do research into everything from subjects girls were taught in schools, to the number of abortions performed annually in Australia. My time was taken up with writing all my speeches, for I had to read them in full as I was too terrified to do otherwise.

I had to write a different speech for almost every occasion as the meetings were made up of various ages and interests. At first my voice would tremble and it was sheer bravado which kept me going, however, after several months I gained sufficient confidence and knowledge to get by. My greatest worry initially was not the speech, as I knew what I was talking about, but the fear of questions. I overcame this fear more easily than anticipated, for I was not on an ego trip, and if I didn't know the answer to a question or problem, I said so. There was no point in pretending to know all the

answers or evade the questions by using tactical ploys.

In retrospect, I can now understand why women and the majority of men lack confidence in themselves, for all structures are run by leaders and it is in the leaders' interest to maintain power by preventing the people below from using their own initiative for self development. Any development from below could eventually threaten those in power.

I typed numerous copies of the many speeches on all of the various topics and distributed them to the women on our committee. I encouraged them to write speeches of their own and use my notes only as a guide. They could use the researched material to free them from the need to duplicate research, but it was essential for them to create and develop their own personalities and speech technique.

Bon was the next woman to accept a speaking engagement and appeared on a platform among several competent and articulate men. She was so nervous that she was unable to read her notes, however, she must have impressed at least one young man because, as soon as the meeting was over, he dashed up to her, introduced himself as being a reporter from the *Sun* newspaper and was delighted with her contribution to the evening. "I've never heard anything like it," he said. "What you said was terrific, but they'll never print that," and they didn't.

One evening I was driving to visit a friend and, while stationary at a stop light, a drunken driver ploughed into the rear of my car and smashed me into the vehicle in front. The impact crushed my little Volkswagen at both ends and I received a whiplash injury to my neck which aggravated the old spinal injury. Just following this accident, I commenced employment in an office on a four week trial basis.

There were many hassles during the four week period for, apart from contacting lawyers about the accident, I was forced to seek and obtain specialist treatment for my neck. The only other employee was a young woman who had started with the firm two weeks before I did and she assumed all the authority of teaching me what to do, even though her instructions contradicted those of the boss' wife. She would sit there silent

when the wife of the boss told me I had erred in my work, and it was beneath my dignity to say, "she told me to do it this way." Once again I realised I would never make a clerk – I wasn't that type of person; yet what else could I do?

The WAC decided to protest at the Miss Teenage Quest being held at the Dallas Brooks Hall. There we were with our banners draped from the balcony, protesting against the exploitation of women's bodies for charitable purposes. We were approached by the newspaper reporters and again it was essential for one of us to speak on behalf of our movement. I was afraid to project myself now because of my employment situation, but someone had to do it, and I not only had the confidence but also the least to lose. Our women all had the courage, but they still lacked confidence.

When we left the hall, we decided to have supper at a pizza place in Carlton. After supper, I was the first to wander out. As I stood waiting for the other women, a car slowly drove along the gutter and came to a halt. The driver tried to attract my attention as Thelma approached. I grabbed hold of her arm and said in a voice loud enough for the fellow to hear, "I saw him first and he's mine." Thelma took up the challenge and said, "But you had the last one." Alva by this time was in the group and she started, "You two have both had your turn, what about me!" And there we were, all arguing over who was going to have the bloke. We argued over who would go first, second and third and the fellow got such a shock, he drove off like a rocket while we doubled up with laughter.

The *Age* newspaper next morning featured our demonstration and referred to me as the leader of the Women's Action Committee. When I arrived at work, I could sense the veiled politeness. The four weeks trial had come to an end.

I met an old friend, who was at the time active in the Steelworkers' Union, and I asked him if he thought there was a chance of getting a job in their office. He advised me to ask John Quartercent, the new secretary. John had just taken over from Lennie who had risen to greater heights and was now in Sydney. I went to see John and asked if I could get a job in his office. He said I couldn't be employed there, the

reason being that every woman in their office had to be a complete allrounder. He claimed that each woman there had to be able to take over from any other woman who might be away ill or on holidays. I knew that all of the women in their offices were not stenographers and that this was an excuse.

I had known John for many years; I had seen him rise from an apprentice to a tradesman. I had seen him go on from a worker and a communist to a trip to Russia with his wife for many months, and then on to rapid promotion within the ranks of his union. The trade union movement offers very rapid promotion for men who learn to say the right things at the right time. John told me there was a good job going at Mindrill at Preston, the wage was forty-eight dollars per week, it was good money he said. I just looked at him. Yes, a woman's role was to serve continually at the lowest level. I said nothing and walked out of his office.

I was interviewed by Norm Galagher for a job in the office of the Unskilled Building Workers' Union. I sensed all along that their only interest in me was because I had exposed a Communist Party union official. This crowd called themselves Marxist-Leninists and followed the China-line. Their interest in me proved to be superficial only, for I never got the job. None of the great lefties were prepared to take the risk of employing me. I was too hot to handle for they could not be sure that I would play along according to their rules. I could no longer be trusted to follow any line, or be faithful to any male cause. All male structures demand complete loyalty from people within their ambit and a woman's place is not to question why.

One of the officials of the Unskilled Building Workers' Union was a Marxist-Leninist between the hours of nine to five, and a practising Catholic after work hours. After his death, his wife received the sum of forty-four thousand dollars. Four thousand dollars which was collected from the workers and the union, and the other forty thousand from a source which would make a story of its own. The union officials were aware of the double life of this official, but he never rocked the boat. They went to a great deal of trouble

to assist his good Catholic wife and children, but would not give me a job. So much for the left male politics. Like all of the others, to retain their power positions they would embrace the devil, so long as the devil did not rock their boat. Yes, the same infighting existed among the China-line supporters for power and the occasional free trip to China; the same old scene.

I saw an organiser from the Drink Workers' Union and told him I was considering getting a job in a pub. "Take some advice from me," he suggested. "If you do get a job, don't let Jerry know." I didn't ask him why. By this stage I didn't have to ask questions. Jerry was one of the union secretaries I had criticised at the Party trade union cadres meeting.

I wrote to the Twenty-seven Unions (the break-away from the Trades Hall Council) and offered my services to this militant group for the purpose of organising women in the factories. I explained I had no income and would require a wage, but was prepared to work for a low wage. I did not then realise that offering my services for a low wage was typical of how women downgrade their own abilities. I did not see or understand this set up, and was only concerned with offering my services for the cause. They didn't even reply; they had much more important matters to attend to.

While talking to two union officials at the pub one evening, Harry, the president of a union told the other official that, had I been a man, I would have been a trade union secretary long ago.

Later, during the evening, I broke down and cried. Here I was among so many men, some whose intelligence and ability was so much less than mine and they were holding down important positions while I was unable to find anywhere within the trade union movement to give of my ability. I knew what I was capable of doing and what I had to give, but what I didn't understand was why they didn't want me.

At this stage I was confused and didn't understand what structures were all about. I knew from experience that these men fought like hell to retain their positions and they certainly wouldn't step aside to allow a woman to take their place.

While working in the Sausage Workers' Union office, I had observed the structure in practice. In some unions the organisers had one dollar per week deducted from their pay packet for propaganda purposes at election time. This money was pooled when the election was due to pay for the publishing of material in support of their re-election. Photos and all are displayed. If you happen to be an individual member seeking a position within this machine, then you have no hope because, whether you are male or female, if you are not in with the ruling clique, you will never make it. Should any other candidate or group of candidates have a vast amount of election material then they must be suspect, for where did they obtain the money to pay for this material?

Almost all men in full-time union positions see their position as an end in itself; a lifetime career. It is marvellous to see what lengths men will go to to gain promotion within the ranks of the trade union movement. The back-stabbing and the wheeling and dealing is similar to that which takes place in the public service or among the higher echelons of private enterprise.

I had seen men join the Communist Party, obtain positions as organisers in unions then leave the Party after having established themselves. Others joined the Labor Party, obtained a union position, then moved on to Parliament, a good stepping stone.

One young man went from one union to another, and in each union he was a full-time official until he eventually became the federal assistant secretary in the third union. He had never worked in any of the industries covered by these unions. Yes, I had seen the lot.

Derry Moran, a journalist for the *Herald*, interviewed several of the women from the WAC for a serious article about our organisation. He was the first journalist to display a mature attitude to the new Women's Movement. The press had been giving us a very rough time with their misrepresentation, untruths, scoffing and sneering. We had to endure personal embarrassment when being misreported, but we knew we

would have to put up with this, for how else could women in the community get to know we were in existence? We knew the time would come when attitudes would have to change but, in the meantime, we had to cop the shit. I went on radio on several occasions and was offered an hour of sexual gratification by the radio announcer of the program, if and when I had an hour to spare. I never did have an hour to spare.

In desperation, I went along to an agency for employment. Mr Dunlop got in touch with a firm and an appointment with the prospective employer was arranged. I found myself face to face with a woman, the owner of the firm. She was a stout elderly woman, well dressed, and her silver hair was stiff with hairdresser's lacquer. She sat very straight-backed in her chair and asked all of the usual questions. An agreement was reached for me to start work in a week's time as the end of the financial year intervened. Three days prior to commencing work, I went down with the flu and became delirious. The doctor was called and antibiotic injections were plunged into me. The following evening, I was feeling a little better and opened the front door to collect my delivered *Herald*. Back in bed I began to read the newspaper and there it was, the article by Derry Moran, together with a photograph of me on the chains at the Commonwealth Building.

I began to grin as I read the article and, as I read further, I began to laugh. I could imagine my prospective employer sitting in a stiff-backed chair at home reading this article. I could see her face turn white, then as she read further her face turning crimson, then as she reached the end, her face being purple. I laughed uproariously.

There was a knock on the front door and I opened up to let the doctor in. He followed me into the bedroom and I was still laughing. "You must have been told a good joke," he commented as I climbed into bed. I showed him the article and briefly told him how my imagination had run riot about my prospective employer. He too became infected with my humour, and laughed with me. "You've got a good sense of humour for one who is unemployed."

Next morning Mr Dunlop rang from the agency. He

mumbled and beat around the bush until I could no longer bear it and decided to relieve him of his pain. "I know what you are trying to tell me, you are trying to tell me that Mrs Cork no longer wants my services, is that right?" "Well, yes, that is so, but she wishes you to know that she assists in charity and plays her part in helping where she can." It was obvious her charity disappeared when depriving me of a livelihood, but he continued to say that I should have told him who I was. "Well now that you know who I am, could you place me in employment?" He went on to say that, under the circumstances, he would have to tell any prospective employer who I was. Fat chance there was for me to be able to get a job under those terms. If a woman wouldn't employ me, what hope would I have of a man agreeing to employ me. He never did get me a job.

I began to realise I was in serious difficulty and that, to a degree, I'd unknowingly martyred myself for the cause of women. It wasn't so bad for academic women as a certain amount of dissension is tolerated in academic spheres but, for women in industry, there is always the fear employers have of engaging a trouble-maker and I certainly had a record. What sort of a woman would chain herself to the Commonwealth Building?

I received a phone call from an acquaintance who had rejected a position as a medical representative with Scherrings, the vast overseas pharmaceutical company. He declined the offer because more than fifty per cent of the business was in selling their contraceptive pill, and he was expected to go to Sydney to attend a course of lectures on the hormonal and procreative functions of women. The salary was ninety dollars per week plus a car, and he thought that being a woman with dental nursing and chiropody training I would be more suitable for the position. I rang the firm for an appointment but was informed that they didn't employ female representatives This firm believed that women were only good for taking the pill . . . not selling it.

I rang to make enquiries about a chiropodist's position and was told the salary was forty-two dollars per week plus a

202

bonus. I was disgusted to learn that patients were treated on piece-work rates.

The secretary of the Parcel-packing Union asked me to call in and see him. I wondered what he wanted to see me about and was most curious. This industry had vast numbers of women and my mind speculated on the possibilities. I called in and he told me he was interested in starting a campaign for equal pay within one of the large factories. This factory employed several hundred women, and he wanted someone to work there to assist from below. This man was several years younger than me and had already been in an official position for some years, and now here he was, a secretary of a union; but not one official in this union was a woman. All he was offering me was the chance of doing his shit work in the factory. He was a member of the Labor Party and very ambitious.

I was very worried about finding a job and, one evening while at the John Curtin, one of the heads of the Australian Trade Union movement approached and wished to discuss a matter with me. I waited for him to open up, but he was reluctant to discuss the matter in the hotel and suggested we go to his office. I was intrigued and felt sure this matter must concern the new Women's Movement.

When we entered his office he wanted to cuddle. I was annoyed. "Oh come off it Richard, I thought you wanted to discuss something important." I soon realised what the score was and made it quite clear there would be nothing doing. I insisted on being told where the toilet was. He kept on making a pest of himself until I showed my anger, so he indicated where the toilet was. I returned to make my farewell and he was on the phone. I immediately summed up the situation. He was speaking to a woman in a most degrading manner and I could hear her giggling through the receiver. I was revolted by the scene. When finishing the conversation he turned to me and said, "I would only have to snap my fingers," and he did so as he spoke, "to have that girl come here, even at this time of night." "I'm sure you would, but I'm one woman who won't come when you snap your fingers," and with that I

made for the door. He followed as I walked out and said in a most depraved way, "You are a weak shit." I continued to walk and was on my way down the stairs. I could hear as he called out from the top of the stairs. "You are a rotten shit, that's all you are, a weak rotten shit." I came out on to the street and turned towards home. I felt ill, here I was without a job and all they offer me is a fuck!

A few of the women from the WAC were visiting Sybil's home on an informal visit and I told them of my experience with this trade union leader. "What else can you expect from these 'important' men, they have to be arrogant in order to get there," said Jane, and she went on to talk of a friend of hers who was secretary to a famous politician. This secretary was cleaning up his desk when she came upon a list of names on a piece of paper. She at first thought it may have been a guest list for a function but, on closer inspection, became revolted. The paper was toilet paper and it read, "Bett, Mary, Shirley, big tits one, big tits two, big tits three, blonde pro one, pro two, pro three, big teeth, New Zealander, Chinese one, Jewish one . . ." and on it went. It also included his wife's name. The secretary realised this was a list of conquests, hastily written among men to see who had "knocked off" the most women. Some competition.

Barbara then told us of the Liberal Prime Minister who was drunk at a diplomatic function. He staggered up to the wife of a diplomat from one of the emerging African nations, put his arm around her and said, "How about coming to bed with me, I've always wanted to try out a bit of black velvet." The woman immediately reported the incident to her husband. They left the reception and had their flag removed from outside the building. A great deal of behind-the-scenes talking was done to prevent a breach of diplomatic relations.

We realised there was no difference between men of any politics or religion. Pat told us of a woman whose husband was a die-hard liberal supporter and bank manager. He raped his wife on her first night home from hospital after undergoing a hysterectomy and needless to say she finished up back in hospital and eventually divorced him. "Can't you see the

slimy bastard," said Marion, "fawning over the women as they came into the bank? Good morning Mrs Jones, and how are you on this fine morning?"

I roared with laughter and they all looked at me. "Oh, it's all right, I haven't gone crazy, not yet anyway. It's just my imagination running riot. I was just picturing all these bastards in a few years time. All their secretaries, wives and girl-friends will be watching them like hawks. They may not be in a position to say anything, but they might just start writing down their experiences in books. These blokes will all become paranoid, can't you see them eyeing their secretaries and trying to read their thoughts? They will be thinking, I wonder if she's one of them?" We went on from one ludicrous scene to another until we were tired from laughter.

The Women's Action Committee was five months old when, late one Saturday afternoon, I picked up the phone to hear Bon's voice saying, "Oh Zelda, I hope you won't be ashamed of me." "Why should I be ashamed of you?" I asked. "I was arrested this morning and I've just arrived home from Russell Street Police Headquarters," she replied. "What on earth for?" I gasped and she proceeded to relate the events.

Bon, after gazing in the windows of several shoe shops, wended her way through the various city arcades towards McGills in order to do a survey on the number of male maga-zines involved with out-of-the-home activities as compared with female magazines of the same nature. She reached the General Post Office, and was about to cross the road, when she realised that a young man was speaking through a mega-phone from the steps leading to the post office. It was almost impossible to discern what he was talking about for the traffic noise almost drowned the voice emanating from the instru-ment but, after several minutes of standing in the background, it became obvious that an anti-Vietnam War conscription meeting was taking place. Bon stood in the background beside another elderly woman and they began to converse and observe the proceedings. Within minutes a brawl broke out and the woman beside Bon said, "You can always count on drunks to start a brawl." "They're not drunks lady," a voice

said, "they are plain-clothed cops."

The fighting became vicious and the crowd surged around and on to the road. Bon, who had intended going to the races following her magazine survey, got caught up in the crush and was only able to extricate herself after losing her hat. She was appalled by the violence and when she saw a policeman punching a young woman in the breast in order to force her into a police car, she lost control and, pointing at a man opposite her, yelled, "Stop him, stop him, is this South Africa?"

As she called out in her anxiety she was, without realising it, hitting the roof of a vehicle stationed in front of her. She was not even aware that the vehicle was a police car nor did she know that the man she was appealing to for help was a policeman.

Bon was arrested and charged with offensive language and resisting arrest. The barrister told her not to be concerned for, in his opinion, the charge of resisting arrest would be dropped, although he thought a ten dollar fine might be imposed for offensive language in order to justify the charges being laid. The barrister was stunned when the magistrate fined her fifty dollars on each count or a month's jail on each of the charges if she defaulted. He immediately advised her to appeal against the judgement, for he was a distinguished man in legal circles and did not take kindly to what was an obvious judicial blunder on the part of the magistrate. No judge, he assured her, would permit this travesty of justice to go through.

Several of the women attended the county court for the appeal hearing and, despite the evidence which was irrefutable and the obvious perjury on the part of the police, the judge upheld the magistrate's decision. The barrister was shocked and white of face and said that the decision was political. He was severely shaken and I realised this was his first experience of political railroading. Bon told him she had no intention of paying the fine and would go to jail. She explained that had she been guilty of the charges she would have faced up to the consequences, but she was entirely free of guilt concerning the numerous swear words the police had accused her of using — nor did she resist arrest. Never would

she pay the fines. "You are a very courageous woman," was all he could say. Jan, who came from a religious middle-class background, sobbed when the judge gave his verdict. I placed my arms about her when leaving the court and tried to console her. "I am not crying for Bon, I am crying for my country. Justice was on trial today and justice was defeated. Anyone could see that Bon was telling the truth. Where are we heading?" she sobbed.

Time passed and, although the period had elapsed for Bon to pay the fines, the police made no attempt to apprehend her. After some thought, Bon decided to present herself to the local police station at 11.00 a.m. on 11 November — Armistice Day.

Jan and I went to the police station. Our dear Bon looked tense and strained. We embraced and, as she was taken away, Jan and I gazed at the departing vehicle with heavy hearts and tears in our eyes. We were later informed of the "special" man who interrogated her for three quarters of an hour in order to pressure her into paying the fines. He attempted every ploy and trick in the book, but was unable to break her spirit. She was, after the interrogation, taken to Fairlea Women's Prison.

Bon was the first Victorian woman to enter prison because of the Vietnam War and had been, just two to three years prior to becoming involved in the Women's Movement, a Liberal Party voter.

The strength and courage of women was becoming more and more apparent to me. We had no one on our side, no political parties, no governments, no armies, no police, no trade unions and no religions. All we had were ourselves — women, and we had our backs to the wall for there was nowhere we could go. We were forced by sheer need to combine with each other for what we wanted and the only way forward was the possible unity of sisterhood among women.

I was informed that one of the unions was looking for an organiser so I wrote in for the job, explaining in detail my experience of the trade union movement. I eventually received a letter stating that I was not eligible for the position as the

rules of the union required a member only. A week later I heard on the grapevine that a bloke I knew got the position. This fellow had far less experience than me in the trade union struggle and was not in the industry. They worked him into the industry for a month and then he became an organiser. It was an insult to my intelligence to be treated in this manner. All the trade unions wheeled and dealed, but all of the wheeling and dealing was for the promotional positions for men.

Meanwhile I became disgusted with the long wait for the Party to deal with the matter of my dismissal. I couldn't help thinking that if they wait this long for everything, when the "revolution" is ready to start they will be watching it on TV. I sent my resignation into the Party and when I told Kathy of this, she asked me to give the investigation committee a chance. She said they may do the job and if you give up now you will never know, so I withdrew my resignation and waited.

I was extremely busy with all of the correspondence and organisational matters of the WAC and we were doing so much. Our meetings were informal and we had a different chairperson for every meeting. The only way women could learn to chair meetings was to be put into the chair and, although this sometimes created problems, we were prepared to cope with these situations rather than adopt male methods.

I now rarely attended my local branch meetings of the Party. They bored me to death. There were very few in the branch, for the business people and academics had gone. There were no more worries about how people spoke English, but the procedure of the meetings gave me the horrors. Everything was so formal; apologies, correspondence, then the reading of the agenda items, then general discussion. The whole catastrophe!

Nothing was ever discussed in depth. Ten minutes would be given to report on the problems in the Middle East or Africa; ten minutes to a strike situation or some other dispute; and ten minutes to peace. This went on until all the problems of the world were solved, which was usually between 10.00–10.30 p.m.

It was a complete and utter waste of time going to these meetings for I had too much to do and could not afford to

waste time listening to a lot of superficial generalities which were completely unrelated and were never questioned in depth.

Six months after my dismissal from the union, the Party committee finally got around to investigating the matter, an example of Party dynamism. I was stunned by the choice of comrades on the committee. Not one of them was a worker from the job. One was a union official, and the other two worked for union bureaucrats, one being Fred who still depended on Geo for his crust. What a bloody set-up. I had no alternative but to go along with it.

The greatest stumbling block was that I could not tell this committee the complete truth as to why I was sacked. I had since discovered the truth but, if I was to tell the comrades of this, they would have either asked me to divulge the source of this information, which I was not prepared to do, or they would have dismissed the evidence as gossip and unbefitting for a comrade to repeat. I had been told from two different sources that Geo's wife had received the letter. She, unbeknown to Geo, had kept the letter, run around to various members of the executive who she barely knew and demanded that I must go.

She had given the letter to Geo three days later and I had to go. That was the story of the great union leader, but they still insist that the personal is not political. I remained silent about this information and relied on the superficial reasons for the dismissal. All I could say was that I had sent Geo a letter and I enlightened them on its contents.

No other comrades from the union were called in but, even if they had been, how can a structure pull an idol from his pedestal when it was responsible for putting him there in the first place? Geo was the only person interviewed.

I was duly informed that the document of the findings was ready and called into the Party room to pick it up. I was glad I was sitting down when reading it. I was horrified at what they had done to me. I said nothing, folded up the document and took it to Kathy to read. She sat reading the document and waved her head from side to side. She couldn't believe it and re-read parts of it while I looked on in silence. When she

finished we looked at each other. "What now?" I asked. She continued to shake her head, "I cannot tell you what to do now, not now."

I went home and wrote out my resignation from the Communist Party. I wrote with all the depth of my feeling, for never could I belong to any Party which puts expediency before truth. I addressed it to the state committee, but they never saw it, for I was later to learn that two of the male leaders, in their wisdom, had decided to treat the matter as confidential. My growth in childhood, my twenty-one years membership, the university of my life — what a way to learn. This was only a closing of one stage in my life for a new stage was already opening up.

I thought seriously about the many years of my membership in the Party and asked myself if the Party had given me anything. Taking the overall scene, the Party did make a tremendous contribution to my life and being. If people learn through experience, then the Party had through my experience of it educated me; this was my university.

Working-class people, because of their socialisation and situation, do not use their thinking capacity and, by joining the Party at a young age, I was forced to use my mind. In order to learn I read books on economics, philosophy and history. Attending classes made me think, even though, like all institutionalised learning, the thinking and reading was only on prescribed subjects and books. Together with the use of my mind came organisation, and I learnt how to apply myself to detail and developed the ability to organise.

Had I not worked for a communist in the Sausage Workers' Union, I may have remained an idealist, however, the experience gained by the attitude of the communists working in that office, plus the brutal dismissal by the leader, forced me again to think of further dimensions in life.

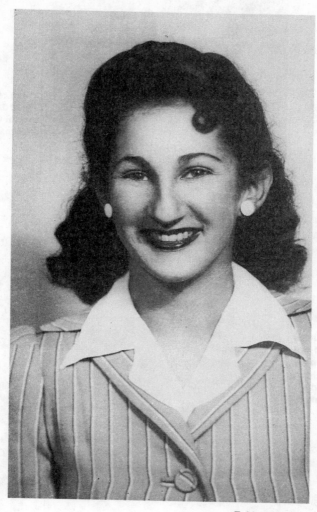

**Zelda age 15.
Featuring
make—up
befitting an
usherette
of the times**

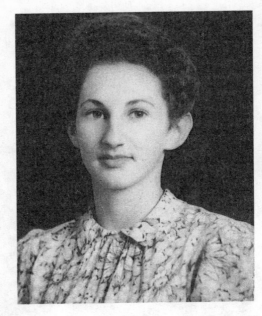

At the tender age of 16, several weeks after marriage.

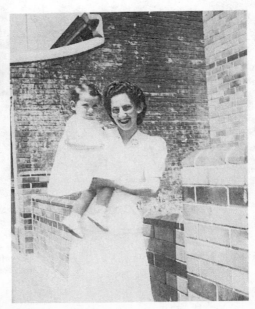

About 18 years of age with baby daughter, somewhere in Carlton.

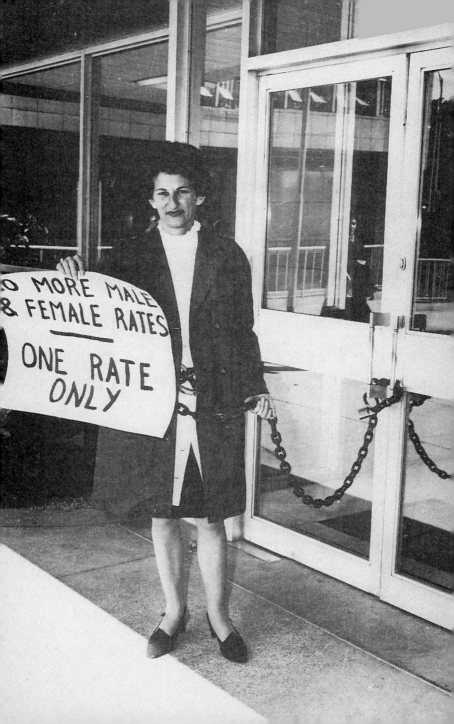

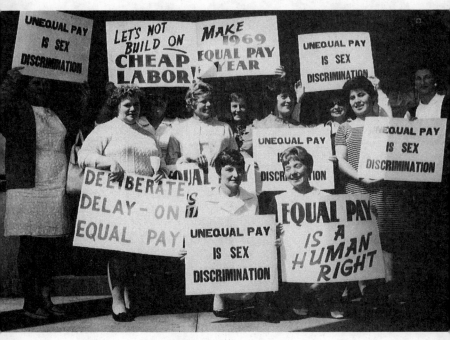

Women
workers
involved in
1969 equal
pay case.

**Women
demonstrating
at Miss
Teenage
Quest 1970.**
*(The Age)*

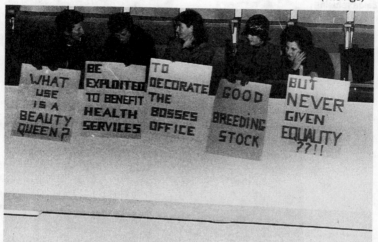

**Bonnie and Zelda refusing to pay full fare on tram.**
*(The Herald)*

**Thelma
Solomon
fights with a
man at
the Miss
Teenage
Quest 1971.
He had
attempted
taking her
banner.**
*(The Age)*

# 16

THE WILLINGNESS OF THE PARTY ITSELF to sacrifice me in order to save the integrity of a corrupt leader forced me again to think of further dimensions. My developing feminism assisted me with examining all-male structures. I thought of the wheeling and dealing that went on in the Party when free overseas trips were available. The ordinary members never knew of these trips and the decisions were always made up above. Only men of "importance" obtained these trips, some even getting two or more bites at the cherry. Very few women ever struck it, and those who did had, in the main, already accepted male values or had to put up a bitter fight to get there.

The Communist Party is not alone in its attitude, for it is no different to any other political party, nor is it different to any other hierarchy. All hierarchies function the same way. The struggle that goes on in all churches as to who gets the wealthy parish is a similar example, for a wealthy parish means more cash from weddings, christenings and funerals. All-male structures use women to mix the concrete and build the buildings; it is the men who decide the design of the building and when it will be ready — and then they take control of it. It was only when I became a liberationist that I began to understand why all of my trade union struggles of the past, together with the struggles of all people in trade unions, had not brought about any changes; not only within the structures of society, but within people themselves. If trade unions were able to raise people's consciousness to the stage where they developed social consciences, we would have had a wonderful society long ago.

I now knew that the personal is political and all human suffering, whether it be at work, in the home, in human relationships or through lack of money, can only be tackled in totality. To attempt to solve one dimension of problems is to fragment humans and this will achieve nothing because the person is one being, and all these problems are interrelated and interconnected.

I was notified by the estate agent that he had a buyer for my house. I had already selected the flat I wanted to buy in Carlton and now I could go ahead and finalise the arrangements. However, being unemployed was a worry, for what could I say when going to my bank for a loan? How could I overcome this problem? I knew very few business people, so I approached one of my ex-comrades, a man I had known for many years and asked if he would be prepared, if asked, to say I was working for him for "x" amount of dollars. He refused to do this.

There was a woman I had met on one occasion whose husband was in business. She was a member of the Labor Party and a very strong woman. I didn't know whether to approach her or not, for it seemed a bit of a cheek asking a person for this sort of favour when you have only met them once. I had no alternative. I was desperate and called in to see her and told her of my problem. She was only too willing to help and all was arranged. Bonnie, a foundation member of the WAC and a woman I had only known for four or five months, offered to lend me all she had. How wonderful women are.

The agent said I would have no problem in obtaining the loan from the bank as the sum required was so little. Two thousand five hundred dollars would adequately cover the deficiency to buy the flat which was valued at eleven thousand four hundred dollars.

I had transferred my account from the National Bank, to the Commonwealth Bank opposite the Trades Hall for convenience and, when discussing the loan with the manager, I told him of the two insurance policies I had, hoping this would

be in my favour. He grasped on the insurance policies as a means of avoiding the granting of the loan and suggested I go to the insurance company for a loan.

I was worried and went directly from the bank to the AMP Society and took the lift to the appropriate floor for house loans. This was my first visit to this monstrous building and what a monstrosity it was. A huge lump of concrete. A young man came forward at the enquiry desk and, after explaining that I had two policies with the company and was after a loan to purchase a flat, he went and conferred with an older man then returned and told me they do not grant housing loans to women.

I thought I was hearing things. He repeated that they do not give loans to women for the purpose of buying houses. I wanted to scream and shout. I was beside myself and began trembling with anger and frustration. I had heard about this sort of thing but never thought it would happen to me. I controlled myself as I spoke.

"Do you mean to tell me that you take money from women, but we cannot get a loan?" The young man realised he had trouble on his hands and called upon the older man for assistance. I became so emotional I could feel the tears coming to my eyes. I kept thinking I mustn't cry, I mustn't cry. I tackled this older man while desperately holding on to my calm. "What do you mean by taking the money from women then refusing to give us loans?" He tried to explain that a woman may incur a debt then get married. "So, and what if she does?" I asked. He went on to say she may become pregnant. "So what if she does?" I asked, and my voice was like steel. "Who would pay the debt back?" he asked. Then I let go, "And who's going to pay the bloody policy payments she has undertaken if she marries and gets pregnant? That doesn't stop you from signing up women for policies does it?" By this stage I was trembling all over.

I told him I belonged to an organisation of women who were fighting this type of discrimination and I promised that this would only be the beginning not the end of it. The man became alarmed and assured me that all insurance companies

have an agreed policy towards loans to women. "Well we'll see about that, I can promise you," I said and left. As I went down in the lift I told several women there of my experience and how our money must have paid for the building for if we cannot obtain loans for housing and men can, then it must be our money which paid for the building.

I went home and immediately wrote of my experience to the late Isobel Carter, the women's editor of the *Herald*. She researched the matter of loans to women for housing and published her findings in the *Herald*.

I told the WAC of the experience and we immediately started a campaign on all of the banks. I eventually received the loan from the Bank of NSW. In all of the replies received from banks concerning housing loans for women, the Bank of NSW was the only bank which, at that time, stated in writing that if a woman met all of the necessary requirements then a guarantor was not required. With all of the documentation for selling the house and purchasing of the flat finalised, I contemplated getting a job as a housekeeper in a private home. I thought I would let my flat, for I was stone broke, and the rent from the flat would cover the payments while I would be able to save a little money from my housekeeping wage.

I answered several advertisements for housekeeper jobs and at first thought I was imagining things when the prospective employers made certain statements. I gradually realised there was no imagination involved, only stark reality. Every one of these men wanted the housekeeper to provide her body, as well as her labour. What a bloody racket.

This was another experience in my life; another reality to face – I knew there would be women desperate enough to obtain a roof over their head and would comply with the employer's wish for, after all, hadn't they experienced the same situation in marriage?

How strange life is: when growing up in Carlton it was a slum area, an area where only the poor lived, but now the academics and jetsetters were moving in and the area had become the place to own a town house. They were no longer

214

slums. What a joke. I had lived the full circle, from Carlton the slum area, to the brick home in housing commission suburbia and back to Carlton. As far as I was concerned, it was the same old Carlton but now I loved it. I now had my flat — all I needed was a job.

# 17

AFTER THE MANY UNSUCCESSFUL ATTEMPTS to obtain employment, I finally commenced work as a mail sorter with the Post Master General (PMG). Women working within this department were to receive equal pay in January 1972 and this suited me fine. To become a qualified mail officer it was necessary to attend a special school and, while waiting until there were sufficient people to form a class, I worked on the floor. I was designated to what is known as the inland section and, for several weeks, was employed doing the most menial tasks.

Here I was back in a factory environment and, although the constant noise of the machinery was irritating, it was good to be back among the working class. They were my people and, although I was well aware of how easily they are divided and can turn on one another, I loved their earthy humour, their practical approach to life, and together we shared our experiences. I had known all of the hardships workers endure; lack of money, no house to live in, insecurity in job situations, unwanted pregnancies and the rest.

The work I performed was extremely monotonous, but this was compensated for by the attitude adopted by the management, who permitted people to communicate with each other. The management recognised that the nature of the job was soul-destroying so, as long as we kept our hands moving, there was no objection to the workers talking. Only a government department could accept the needs of human beings in this manner, for the competition in private enterprise totally destroys all aspects of human social relationships in the drive for super-profits.

The school had commenced and the purpose of this class was to learn fifteen hundred place names within Victoria and their postal areas, as well as other departmental necessities. This type of learning was different to any learning I had previously participated in. This learning was sheer learning for learning's sake and a good memory was required, for it was essential to remember names and locations. What a marathon task. Many of the names sounded the same or very similar and, to overcome the difficulty of remembering them, I did what others had done; invented little stories around place names to imprint the names on my mind. The results were very humorous. "Mr Meredith had a Tatong around his Wandong," was an example of the type of story invented. The people attending the class were adults, many of them migrants, and we were all anxious to pass the exam, for we each needed the job. We were all nervous. I was fortunate to have the confidence of knowing I could learn from my previous experience, but I felt very sorry for the other people who had left school many years before and had no confidence in themselves.

The tension when the class first got under way was terrible and, for the first couple of days, all was silent as the cards flicked into the boxes. All one could hear was the tap, tap, tap, as the cards hit the rear of the boxes. I was the first to complete the suburbs and, whenever possible, I would assist the others. Sitting closest to the testing boxes enabled me to whisper the answer to a plea for help. Although I knew this was cheating and not initially helping the person, I knew that when they had overcome the first few days of tension, they would no longer need this assistance. It only took that help at the beginning for people to gain a little confidence and, as the days went by, only a few required further encouragement; then all of the class rallied around them. A wonderful feeling of togetherness developed within the group, and this closeness remained with almost all the people throughout their employment at the mail exchange.

I was extremely aware of my tenuous situation in this job, and realised I would have to tread very carefully for some

time in order to establish myself in the job. It is said that truth is stranger than fiction, and who would ever have thought when the commonwealth police were cutting me from the chains, that I would be working for the commonwealth government.

I was aware that I was trapped, for my attitude and the years of service to people in non-profit government employment had made it impossible for me to work for private enterprise. I could no longer work where I knew my being was only calculated in terms of profit and I fully understood the many young people who dropped out instead of selling their bodies to a profiteer. This was my dilemma.

After a period of almost four months employment, the *Sunday Observer* published an article and again featured the photo of myself handing the tram conductor seventy-five per cent of the fare. I arrived at work waiting and wondering what the consequence would be, but gradually grew calmer as only one workmate made a comment. I had no illusions and was aware that my bosses would now know who I was, but nothing was said.

One evening while visiting the John Curtin Hotel, Jim, who was a trade union official and a friend of many years, enquired as to the type and nature of work I performed, and I proceeded to explain.

"I stand by a conveyor belt and, as the mail-bags come down one after another, I grab hold of the bag, cut the string which is tied around the neck of the bag and tip the contents on to the belt. I then press a button which moves the belt and takes the mail down to where women sort it into various bags and chutes."

"What do you do then?" he asked.

I began again. "I stand by a conveyor belt and as the mail-bags come down . . ." I repeated what had already been said. "Wait a minute, wait a minute," he said. "You've already told me about that. What else do you do?" So I began to repeat the same story.

"For Christ's sake, I want to know what else you bloody do!" I explained that on this team and roster I would continue this task all day every day for the two weeks and, in

fact, I had been doing this job for several weeks.

"Jesus bloody Christ," was his comment. "You shouldn't be doing that sort of work, not with your brains." I asked what he suggested I should do for a living. "Christ you should be able to get something more interesting than that." But he could not suggest an alternative. "You've got your leaving certificate, why don't you study on and go to university?" he asked.

I told him that many workers I knew had gone to university and, having done so, had found their niche in society. They no longer felt like nobodies and were enjoying their new-found status. As far as I was concerned, I was prepared to use what I had where I was among the workers, for I wasn't interested in the status bullshit, I knew I was a person and didn't need a university degree to tell me I was intelligent. However, I still had illusions about the trade unions and thought they needed intelligent people.

I told Jim about Merril who was a young woman university graduate. She was so excited when she obtained the job she desired yet I observed her gradual disillusionment over a period of time. She gave all of her mind to this job (a research assignment), which demanded this commitment, only to eventually realise that what she was doing was almost useless.

How fortunate I was in my job, I knew what was expected of me and this was all I gave. No more seeking job satisfaction and no more disillusionment. I appreciated the work I was doing. Whenever the opportunity arose, which was often when doing this monotonous work, my mind traversed the confines of machines and mail to concern itself with the tasks and problems which the Women's Movement was faced with.

The job suited me not only because it required the minutest amount of what I had to give but because it enabled me to possess my own mind while giving me an income on which to live. Together with this was the nature of the industry. The staff were on fortnightly rosters, and, with the continual change of people and tasks, it was possible to become acquainted with various types of people. One very rarely got bored, for all people have their distinct personalities and,

while one person can converse about serious topics, another may have a wonderful sense of humour. And so the constant change of workmates always created a spontaneity in conversation.

This was the best job I ever had, for I was on the lowest level where there was no competition. I no longer needed to prove myself and people could communicate with each other. I knew that for the vast majority of people in our society there is no such thing as job satisfaction. I was, for the first time in my life, content at work.

The Women's Action Committee, after being established for a year, had approximately fifteen committed regulars, with other women coming and going. When we initially formed the organisation, we were totally unaware of what the overseas Women's Liberation groups were on about. However, Kathy Gleeson, who was manager of the International Bookshop, obtained *The Second Year Notes from Women's Liberation* from America, and this publication was our first introduction to Women's Liberation theory. The material in this magazine exploded our minds, for we then became aware that there were other women who felt as we did. With the avid reading and discussion taking place, we knew we were liberationists by the time our organisation was one year old.

I, at first, did not realise that men would react so violently towards our movement, and thought that the men from the left would soon come to understand the justice of our cause. I even envisaged the left men giving us support in our struggle. How wrong I was. It soon became evident that I was going to have to make a stand and, knowing the decision would place me in another situation of confrontation with them, I was reluctant to do so. Not because I was reluctant to confront men in their politics, for I had already dug my toes in there; but I realised that fighting men over women's politics was another issue and that, by doing so, I would be destroying what little possibility remained of my having a good personal relationship with a man. Was there a man who could understand and appreciate what I was doing? This was most unlikely.

The occasion arose one evening at one of the Women's Action Committee meetings where I knew in all my conscience that I had to make this stand and, in doing so, knew what the consequence would be. I must have been very upset, for I cannot recall what incident occurred to force me to take the stand but, when I went to bed that evening, I cried and cried. I did not regret the stand taken, for I had to live with my own conscience but I was aware of the price I would have to pay.

My entire life now was committed to the women's cause; there could be nothing else and there was no turning back. I tried to make it easier by telling myself that my previous relationships were ratshit anyway and I wasn't losing anything. But even though this was true, it was devastating to face what life I had left knowing there would no longer be anything in the emotional area for me. One may carry on continually hoping, and hope alone can be sufficient to carry you through, but I had destroyed what little hope I had, and ahead lay bleakness.

What a long distance I had travelled. From love yarns and the total female acceptance of emotional dependence to this. I now knew I was entirely alone and only our small group of women could sustain me. I thought maybe the time would come when I would be sufficiently intact and able to be a complete person within myself. Only time would tell.

Working-class women like myself always assume that women who attend university, or who are academics, are very self-confident and articulate women. I was to learn that this was not so.

Early in 1971, a group of women students at the University of Melbourne formed their own liberation group and extended an invitation to the Women's Action Committee to attend one of their meetings. Thelma, Alva and I went along, and we sat and listened to their discussion. All women who formed groups in the early years of the Movement always found themselves confronted with the argument that men should be allowed to attend the meetings, and this was the topic under discussion.

One young woman said she was aware that, although this was only their third meeting, she was already expressing herself more freely. Another said she was afraid to express her ideas in front of men for fear of making a fool of herself. And so it went on. I then realised these young women were no different from me – we all had the same problems. This was further confirmed when the Women's Action Committee decided to participate in May Day.

That year was our first involvement with May Day and, like all of our actions, there was no obligation on the women to participate. The May Day committee refused to permit us to have a speaker on the platform, so we decided to be in the march, but have a stump of our own at the bank of the Yarra River.

I was responsible for organising women speakers for our own platform and found it almost impossible to arrange – all the women I approached were horrified when asked. Many of the women were either students or academics, yet they lacked the confidence to speak publicly. One woman, who was a tutor at a university, said she would fall over and faint. When I said, "But you are a tutor," she replied "Yes, but that's different to public speaking." She, in time, did speak in public and did an excellent job of it but, at this stage, she wasn't ready for it.

I kept on ringing and pleading with women until Leonie Campbell, under duress, agreed to speak. I convinced her to do what I intended doing, writing what I had to say in longhand and reading it out, word for word. I was too nervous to do anything else.

The march was over and there we were at the Yarra bank. Alma Morton carried the apparatus from her car and set the chair beside the railing near the path. She had the makeshift microphone and speaker ready and we were all set to go.

Several of our women stood around and I climbed on to the chair in readiness. I had been attending the Yarra bank rallies since early childhood but never in my wildest dreams did I ever imagine myself on the stump. But here I was and I had to speak. I unravelled my pieces of paper and started. I

can't recall what I said or wrote but, being inexperienced, my speech didn't take more than five minutes and I stood by as Leonie stepped on to the chair.

By this stage women were beginning to drift over towards us, and we were pleased to see their interest. Unfortunately, Leonie too had written only a short speech and the two of us had completed what we had to say within fifteen minutes. The women standing by wanted more and the gathering was growing. I tried to urge other women to say a few words, but they couldn't. "Get up and read yours out again," they suggested. I had terrible visions of Leonie and I jumping on and off the chair in turn. The entire incident is hilarious now, but it was an ordeal at the time.

I climbed on to the chair and was reading my speech out for the second time when a brawl started among the body of people gathered at the main platform. People were screaming and shouting and the police were flying in with all of their might. The entire place was pandemonium. Two policemen were each holding the legs of a young man and were dragging him along the footpath towards their van. His head was bouncing and knocking on the path and his face was covered in blood. Jenny, who had after a great deal of consideration agreed to attend the march, went hysterical at the sight of this brutality. She began to screech at the policemen and I could see her being dragged away too unless she could be controlled. We managed to calm her but never would she forget this incident.

We were appalled at the violence of the police and no longer wished to continue with the platform. We all felt ill.

I continued to visit the John Curtin and argued with the trade union leaders on every topic, particularly on issues relating to women. On many occasions I took a severe battering but always came back for more. I dished it out but also had to take it. I put up with their sneers, insults, scoffing and all the rest but knew that, in time, like all men in the structures, they would be forced to move.

Night after night I would listen to their conversations of what had occurred in this dispute or that dispute, what had

happened in this factory or that factory but, whenever I started to approach the very problem under discussion from another aspect, the woman's angle, I was always ridiculed as being on my hobby-horse again.

They would continually tell me women were hopeless when it came to industrial problems, and how women wouldn't learn or lacked the guts to take action. When I tried to explain the reasons for this fear that women have in making decisions and taking action within the work-force, these knowledge-able men switched off. They wouldn't even listen. "Here she goes again," was the attitude they adopted. At times I would arrive home disgusted and think, "What a bloody fool I am for even trying," but someone had to batter them until all women got going. On several occasions they upset me to the point where I went home ill. It was just as if I was back in the struggle within the right-wing trade union while working at the hospital, but this time I was fighting for women.

As time went by, I even managed to sell these same men copies of our Women's Liberation newspapers and publica-tions. I am quite sure they did me a favour when purchasing these papers, for they were not convinced. The John Curtin became the first hotel in Melbourne to have Women's Liber-ation posters on the walls.

The Women's Action Committee decided it was time to take more positive action on the abortion question. It was almost a year since we had organised the petition in support of abortion law reform, and we now decided to use the ideas of sisters in other lands. We obtained the poster of an obviously pregnant man's body, and superimposed the head of our state premier, Henry Bolte, on the body. We had thousands of these posters printed calling for abortion law reform.

Several of the women who had cars volunteered to drive women around to stick up the posters and, there they were, pasting the posters up all over the city shops and walls. These women had never before carried out such tasks and, although they were made aware of the risks involved, they were not deterred.

The people of Melbourne arose to find their city plastered with these posters. By coincidence it happened to be the Premier's birthday and the evening *Herald* featured the poster in its Black and White column as a birthday greeting to the Premier of the state.

The women in our committee decided to have a Consciousness Raising group. We had read that our sisters in America were doing this and decided to give it a try. It was an experience never to be forgotten. On the very first night when the women began to talk of their personal experiences, two women spoke of masturbation and recounted incidents during their childhood. I had never in my life heard women talk of such things and my mind boggled. The sex manuals I had read only wrote of male masturbation and never mentioned female masturbation. The only reference to female masturbation I had heard was from Tony, and all he knew about the subject was what men usually prattle about: the old myth of carrots and candles. I listened to the conversation, looked at these women, and couldn't imagine them using carrots and candles.

It was only when we got to discussing female sexuality, our anatomy and our feelings, that I learnt about clitoral orgasm. Then I understood what the women were talking about when they spoke of masturbation. The carrots-and-candles story was certainly a male-created myth.

We were gradually overcoming our self-body shame and self-hatred, and I was beginning to understand more about life and myself. We spoke of our childhood, our feelings towards parents and sisters and brothers, of our experience with men, our marriages, our lack of confidence, our feelings of inadequacy and our general non-being. What a revelation! For the first time in our lives, women were able to understand each others' hearts and heads. One elderly woman remarked that she never thought it possible for women to interrelate with each other free from judgement, condemnation and bitchiness. We discovered with time that those of us who were in this initial group all had an extremely warm and close feeling towards each other – the result of Consciousness Raising.

I was introduced to Jamie, a man who was a worker and, although active in his trade union, held no official position. His only claim to fame was that of shop steward and he was free of any ambition or the need to "make it" in the male world. Through conversation it became obvious that he and his wife were separated; his wife having returned with the children to her family overseas. I met him on several occasions at parties and a relationship developed. This relationship was not to last for very long, as he had previously arranged to work interstate for six months. He went off as scheduled and we began corresponding – a correspondence which brought us closer together. I was very disappointed, when the time had almost arrived for his return, to receive a letter from him stating that his wife wanted a reconciliation. She wished to return with the children. The children were young and I understood the tremendous burden this woman had. I wrote to him conveying my best wishes and hoped that all would be well for their future life together.

The Catholic church was becoming concerned at the audacity of women fighting for the right to have abortions and retaliated with the establishment of an organisation called The Human Life Research Foundation. The president of the Victorian branch of this organisation, Dr Billings, was reported in the *Herald* as saying, "Life is being devalued by pre-marital sex, drug taking, homosexuality, easy divorce and abortion."[1] Although all these issues were promulgated, abortion was the only issue which they actively took up. The reason for this is obvious. The other issues would have interfered with the pleasures of men.

This organisation called its first public meeting at the Melbourne Town Hall and we were pleased to see that, despite the buses provided to bring people from outlying towns such as Ballarat, their main support came from old people, priests, nuns and school children. The Town Hall was far from being full.

---

1.   "Drugs, Sex Devalue Life", *Herald*, 19 May 1971.

We stood on the steps handing out our leaflets to all the women as they entered, and there was Pauline. There was no doubt that she had seen me but chose to ignore my presence. I knew she must have been embarrassed on seeing me, and I made no attempt to approach her. Pauline was a practising Catholic, married, and a mother of four children. Of the hundreds of people at the meeting, I alone would have known the skeleton in her cupboard. She had had two abortions prior to getting married and justified her abortions by saying they were circumstantial. She was opposed to other women having abortions.

Catholic women are no different to other women, for we all do the same things in our bedrooms. The only difference is that some Catholic women have guilt feelings which they often carry throughout life. Some of them attempt to atone for their guilt by working ardently for their men's causes in order to seek absolution from their sins.

The left-wing feminist women in Sydney organised a discussion on women's issues and invited all interested women to attend. I was interested to hear the views of these women and, together with several other women, I boarded the train for Sydney.

The railway conductor entered the carriage and, as he approached me for my ticket, he hesitated, stood still and stared at me. "Don't I know you?" he asked. "I can't ever recall having seen you before," I replied, and he continued checking the tickets with a puzzled look on his face. Some time later he returned to the carriage, stood before me and said as he pointed his finger, "I know you. I've seen your picture in the papers. You're the man-hater." We all roared with laughter.

Among other matters raised at this gathering, some women wanted to know what possibilities existed for a national women's conference to be held in Melbourne to coincide with the ACTU conference. It was suggested that this given time would be appropriate to discuss the problems of women in the work-force and women in the trade unions. On returning to Melbourne, I put this proposal to our committee. The

women felt that a conference of this nature could influence the ACTU conference to take into account the needs of women. We felt that we had the necessary confidence and ability to organise a conference, and so we got under way. This was our first national conference and the first national Women's Liberation conference. Prior to this there had been a left-wing women's conference, but the Women's Action Committee had not been notified about it.

Since the inception of the WAC, I had been fortunate to obtain five hours sleep per night and, as usual, when something of importance was to take place, my period arrived. It coincided with the conference. As always with conferences there were many organisational problems and, right from the commencement, I felt ill. It was more than I could bear when some young women objected to having to pay a registration fee of two dollars (one dollar for students and pensioners). Some objected to the charge of fifty cents which covered the cost of a copy of all papers presented. Some even demanded to know what we intended doing with the "great profits".

We didn't even bother telling them that three women were financially carrying the entire conference. We put this money up without even knowing if we would get any of it back.

I felt so ill I just wanted to die. When one of the young Sydney "sisters" accused us of leaking names of early enrollers for the conference to the capitalist press I just went home to bed and cried. To some of our interstate "sisters", there wasn't one positive aspect to the conference. Although it was based on the theme of Women in the Workforce and Women in the Trade Unions, some women wanted the right to speak on whatever topic they wanted. They also criticised the presentation of papers.

Despite all of the problems, the ACTU was forced into recognising the existence of women in the work-force, and women realised the desperate struggle ahead in forcing the unions to recognise the need to fight for equal pay as well as all our other demands.

Experience has shown that conferences have a limited role in the women's fight, for their size is alienating and prevents

all the women attending from participating. Many women seek and need conferences where women present papers, not for the purpose of reiterating what is already known, but for the purpose of introducing new ideas. Other women require speak-outs where all women can participate. We had to develop new methods of communication in order to accommodate the needs of all women. The tendency now is for a combination of both the presentation of papers, then breaking up into smaller groups for total participation.

Our first pro-abortion demonstration was planned for 20 November 1971. There we were, gathering at the city square and wondering how many women would be brave enough to take to the streets of Melbourne in support of the abortion issue.

A great deal of publicity had been featured in the press about the graft and corruption within the Victorian Police Force. This corruption was due to the laws of the state which made abortion illegal. However, people were no longer shocked when hearing of such corruption, and the laws remained on the statute books. The word abortion was known and understood by all, but was still a "closet" term and experience. Here we were on this Saturday morning waiting for and expecting women to march through the city in support of the right of women to obtain abortions.

Five hundred women gathered. We were elated as we took off on this historic event. The bystanders were no doubt shocked by our guts – or lack of shame – but we were encouraged by the few women who were game enough to indicate their support. The *Herald* that evening published the following sentence in one of the inside pages:

"Dozens of barefoot women took part in an abortion law reform march in the city today." This was the sum total published in our media on this historic event.

# 18

ALL OF THE LEFT-WING MALE TRADE UNIONISTS decided to bury their political hatchets and come together for an all-day seminar on workers' control. They were seeking sponsors for the seminar and I was asked to add my name to the list of sponsors. I told the fellow who solicited my support that they could all go and get stuffed.

Only one left male trade union official had shown genuine interest in the women's conference on trade unions and not one other had even requested a copy of the papers to become familiar with what women wanted from the trade unions. What could women hope to gain by attending a male seminar of this nature?

I knew why I was asked to lend my name to the list of sponsors. Some of the male left now looked on me as a leader of the Women's Movement and, to give credence to their seminar as far as women were concerned, it was necessary to obtain patronage from a woman. I refused to be used by men or to lend any support where women would obtain only token recognition.

At a later date a leaflet was distributed advertising the seminar and a woman's name appeared on the list of sponsors. When next I saw Mark I said, "I see you have your women for the sponsorship." His reply was, "Well, we had to get some woman."

I had no intention of going to the seminar, for I had learnt through experience that men do not consider women's contributions seriously and I was not prepared to talk to the male wall.

In retrospect, one can only smile at the irony of previous

predicaments for, on the day of the seminar, I was again menstruating and feeling like nothing on earth. The phone rang at midday and Sandra was on the other end. She urged me to come into the seminar. During the morning session only one man had mentioned women, and this was just a fleeting remark. I told her how ill I felt, but she continued to plead.

"Come in just for an hour and then you can return home. If you don't say something about women we won't even get a mention." I tried to tell her that men don't listen when we speak but she persisted. I very unwillingly got dressed and went in.

The seminar resumed and Jack Tuesday, who was to become the flying filmstar, was first to report. He at least made sense but the others who followed used the same old clichés I had heard on a thousand and one previous occasions, and they said nothing. When I got to my feet I asked these men what their reaction would be if our government brought enough Asian people to Australia to make up one-third of the work-force and if this one-third of the work-force were prepared to work for low wages. I pointed out that the trade union movement would conduct the most massive strike program all over the country to combat this threat of cheap labour to our living standards. "But," I said, "we already have one-third of our work-force doing cheap labour, and yet you great militants do nothing because the people concerned are women."

I went on to suggest that, where possible, women and children should be encouraged to accompany husbands and fathers to stop-work meetings, for it wasn't just the men who were affected during strikes. The entire family needed to be involved in the struggle. I had so much that needed to be said on women and the trade unions, but my three minutes were up and I had to sit down. It's acceptable for women to listen to one man after another all day, but it's an endurance test for men to even listen to one woman for three minutes. After listening to several other men beat their lips together, I got up and went home.

The only comment heard about my contribution was, "She

bloody well walked in, didn't pay her buck, said her piece and then went home." I wasn't aware that I was supposed to pay but, after hearing this, I made sure that the dollar was paid and wanted the intellectual giant who'd made this comment to be made aware of my payment.

Two weeks after the seminar, Sandra rang me again. "I have an apology to make to you, Zelda." I couldn't understand why she needed to apologise to me. She continued, "I feel responsible for talking you into attending the seminar, and while you were talking there I observed the men and they weren't even listening. I got so annoyed with them, but lacked the courage to get stuck into them."

I laughed. "Don't let that worry you, Sandra. I've been doing that for years and that's why I no longer bother. When women fighters are in larger numbers and our movement is stronger, then men will have to listen to us."

Although the majority of people working at the mail exchange had passed their examinations for the necessary qualifications to be mail officers, a system prevailed that placed people with seniority on to what is called qualified rosters, while others were on unqualified rosters. The difference was that the qualified rosters entailed more sorting, while the unqualified rosters, in the main, covered the labouring tasks. Women, because they were not eligible for permanency until equal pay became a reality, were hamstrung, as the men, knowing that equal pay would become a reality during January 1972, raced in madly and were placed on the qualified rosters. This meant the women were unqualified and left to do labouring work. Of approximately three hundred and eighty women employed, no more than twenty were on the qualified roster. To do away with this scheme, and share the good jobs with the bad, would have upset the applecart for the men so, until some of the men dropped dead, retired or resigned, the women had little chance of getting on to the qualified rosters.

Working various shifts enabled me to accept numerous speaking engagements and there I would be addressing a group either at a university, a kindergarten mothers' group

or a group of high school students. After speaking to these groups on many and varied topics associated with Women's Liberation, I would return to work and carry out my job, whether it was folding empty mail-bags, tipping contents from the bags or dragging and stacking mail-bags. I was always amused by the difference, and always thought, "I wonder what those students or women would say if they saw me doing this?"

On one occasion when I was wandering through the grounds of La Trobe University in search of Glenn College, I observed the beautiful garden surroundings. I sat in Glenn College in a comfortable lounge chair and noticed the carpeted floor. What a crazy world we live in. In all my years at work, never had I seen workers enjoy such work-conditions. Yet these young people, who are in the main the sons and daughters of the wealthy and middle class, were enjoying the benefits of these conditions when they hadn't as yet done any work in the community to contribute towards this grandeur. I returned to work, looked at my fellow workers who contribute towards the education of the elite (fourteen per cent of workers' children attend university), gazed around at our work conditions, stared at the hideousness of the Spencer Street railway lines from the window and thought, what a bloody difference.

I needed so much time to think, and this job gave me that time. My hands worked and my brain thought. I was no longer the frustrated intellectual but a thinking worker, a thinking woman.

One evening, after addressing a group of educated people in a private home, a woman approached me and asked where I lectured. I told her I spoke to people whenever I was invited to do so, but she said, "I don't mean that. Where do you lecture during the day?" I then realised what she was getting at, for she assumed that I was a lecturer at some institute of learning. After explaining that I was not an academic but worked at the mail exchange as a sorter, she was most surprised and said, "But you know your subject so thoroughly."

People always consider that persons with intelligence must

either have positions of power or be academics. It is never accepted that intelligent people can be workers. Workers are considered to be stupid, for if they had brains, then they would be ambitious and would rise in status, even if this status didn't bring in a greater salary.

How hollow the word status is. It is interesting to observe sales people and office workers. Almost all of these people, because of their conditioning, assume they are not members of the working class.

There we would be on the tram during lunch hour: me in my scruffy-looking blue uniform provided by the department which covered my old working-clothes, and they in their expensive clothing — the uniform expected of workers in shops and offices. Yet this costly uniform is not provided by the boss, nor is dry-cleaning compensated for. In fact, these expensive clothes are not even a taxation deduction. I would smile to myself as I observed them and thought my thoughts. I was sure that, even apart from the difference in the uniforms, my wage packet would, in most cases, be more than theirs. I had no illusions; status does not pay the rent, it is only a means of dividing people from each other.

I travelled great distances to attend gatherings and meetings and, in answer to a question put to me one evening, explained that our few women who were undertaking this work, not only paid their own expenses but also contributed the funds to enable our organisation to function.

More and more feminist literature was becoming available and I would pore through one book after another. One couldn't read these books like one reads a novel; every aspect had to be thought through. "Is that correct? If so, why? If it isn't, why not?" I had learnt not to accept the written word at face value, but only if the stated concept fitted in with my life experience and reality. No more would I blindly accept anything, and every book had to be analysed in depth before I was satisfied.

People knew I was a shift worker and the phone would commence ringing at 7.00 a.m. and continue through until 12.30 a.m. Calls came in from interstate, from women in

distress, from women seeking abortions, from men who anxiously wanted to solve their marital problems. Together with these calls were the numerous calls necessary for organisation. On many occasions I would sit for an hour and a half in an attempt to assist a woman. Both Bon and I were becoming desperate with the phone problem. It reached the point where I was unable to eat a meal, have a shower or even pay a visit to the toilet.

Although I had grown up learning to swear, there were certain four-letter words that were definitely taboo. I had never thought about swear words seriously, for it was socially determined what could be said and what couldn't. "Bastard" was a word that I never used when young, but the continual use of the word within society had eventually destroyed its offensiveness. When some of the younger women began to attend our meetings, they would, on occasions, use the two taboo four-letter words and, when they did, I would freak within myself. Eventually, some of we older women asked the younger women why they found it necessary to use such language. The young women put a question to us, "Do you know what a 'cunt' or a 'fuck' means?" We all knew what these words meant. The younger women explained that all women know what these words represent but, because men have for so long been using these words for swearing, they have become non-usable for "ladies". They went on further: "If women were to use these words in the correct context, they would soon lose their value as swearing terms. For example, a heading on the front of the Melbourne *Truth* once read, 'Woman Has Ten Lovers In One Night.' Now, would you," they asked, "consider these ten men to have been lovers?" We knew the ten men certainly were not lovers of this woman. "It would have been better," they said, "to have written 'Woman Has Ten Fuckers in One Night'." That's all they were giving. They certainly were not giving this woman love, or sex.

Yes, I thought, a fuck is precisely just what it means; there can be no glossing over this term. It has a definite meaning

all of its own. I realised that even to call it sex is misleading. Sex should embrace far more than just a fuck.

The young women went on to discuss the word "cunt". Again I freaked. "Cunt," they said, "is a part of our body, a normal part of our body. Because of their hatred of women, men use this normal part of our body, our genitals, as the worst possible means of insulting another man. How could any man who likes women use this word towards someone they cannot stand? If we," they went on to explain, "overcome our self-body hatred and consider our own bodies to be normal, healthy and beautiful, then the word 'cunt' to us would be a beautiful part of our body. So it all depends on our own attitudes."

I thought about this discussion very seriously; what they said was correct, but how can you learn to say these words when for so many years you have pretended not to hear them? I decided that I must overcome my own inhibitions and wrong thinking in regard to these words, so I began to say them to myself when alone. If I said them often enough I would get accustomed to hearing myself say them, and this would eventually break down my attitudes. It was a tremendous step for me when I first used the word "fuck" when conversing with some friends. "I've made it," I thought. The first time is the most difficult, and it is the same when revealing to others the abortions, the rapes or other experiences we have buried away in our minds and hearts. Once you verbalise them, it then becomes easier.

It was during the second year of the Movement that women began to pour in. It was both vital for the Movement and essential for the health of Bon and myself to obtain a Women's Liberation centre. The visit of Germaine Greer to her home town added further impetus, and the need for a centre where women could make contact became critical. We needed the Women's Liberation Movement in the phone book, not only for organisational purposes but because we had become a reality within society.

During March 1972, the women obtained a centre in the

city of Melbourne and we called it "the women's centre". We were now officially known as the Women's Liberation Movement and appeared under this title in the phone book. Consciousness Raising groups began to flourish all over Melbourne so the few of us from the Women's Action Committee decided there was no longer any need for us to retain our committee and we disbanded. We were all actively engaged in the Women's Liberation Movement and joined in with our local groups.

I was asked to address a group of male prisoners at Pentridge Prison and was pleased to learn that a prisoner had suggested the invitation. The invitation was extended as an experiment through the education section of the prison and, not knowing what to expect, I was pleasantly surprised with the high level of questions and discussion which followed the talk.

Seven of the prisoners in the group were illiterate; not because they were mentally incapable but because of their personal circumstances. Despite this, the level of discussion was higher than I had experienced with other male groups.

It seemed incongruous to speak about Women's Liberation to a group of incarcerated men, so I chose to speak on the nuclear family and the effects of this institution on all the members within this unit. The prisoners were certainly able to identify with the subject matter and, as I left the prison and proceeded on my way to work, I couldn't help but think of the continual destruction of human beings that is brought about by our society.

# 19

I BEGAN TO VISIT THE JOHN CURTIN regularly on Friday nights, not because of the great entertainment value, but because it was essential for my own health and well-being to escape from the phone, which brought pressures and problems. This was my only escape, for I seldom went out, and there was no time to be worried about my private life. I enjoyed the company at work, the mental stimulation of the women in the movement and people in general.

One evening, two acquaintances called in to visit; a wife and husband. They had been drinking with a few friends and, although it was already late, they decided to call in for a chat. After some time had passed and they made no attempt to leave, I was forced to say I must get some sleep in order to get to work in the morning. They ignored my plea, and the husband continued to talk, so in desperation I suggested they sleep in the spare room for the night. They accepted the offer and I fell into my bed exhausted.

I awoke to my body being pulled about. The husband was in my bed and the fight was on. This man was not a communist – just a man. I fought like a tiger and wanted to scream, but how could I? His wife was very young, this was her second marriage, she had no relatives in Australia and she clung to him. I knew that if I screamed and the wife came in, all that she clung to would be destroyed. She was clinging to a monster, yet I could not be the one to make her see this. I was forced to endure the scene. For what? Yes, great judges in all their male wisdom talk a lot of shit when judging rape cases. They do not concede the right for women to own their own bodies under all circumstances. To have your body violated

is something women know only too well. One has to have
suffered this indignity to know what it is like, and there are
very few women who have escaped rape. They choose not to
talk about it for, although they are the victims, they are the
ones that feel the shame. Most rapes take place in the marriage
bed. Yet how many men will admit to having raped a woman?
They refuse to accept the fact that they oppress women and
are rapists. As long as a woman has to be talked into having
sex, then it is rape.

One evening while addressing a group of one hundred and
fifty women, not one woman in the group disagreed when I
said that there are very few women who have never known
rape. Why then, do they remain silent? We should be scream-
ing it from the roof-tops. And yet we are told that the personal
is not political. How can there be so much suffering without
it being political? Every experience of life is political.

I understood the reason for this rape. Firstly I was Zelda,
the "great Women's Libber"; secondly, he knew enough
about me to know I would not destroy another woman; and
thirdly, he wanted to degrade me because I was a strong
woman. I never spoke of my rapes. I was like all women who
suffer and remain silent. We are expected to remain silent
about our suffering.

We meet many people during a lifetime, but we seldom
get to know them deep down inside. What do we really know
about them? Are we reluctant to know people in depth for
fear that their experiences may make us feel uncomfortable?

One evening, while entertaining several people, I entered
the kitchen to make some coffee and was followed out by a
young woman who I had just met that evening. There was
something she wanted to tell me, something she had never
spoken of before, not even to her mother or her husband.
She began to cry and I embraced her, for it was obvious she
required not only support but understanding. Her crying
ceased and, as she moved away from me, she looked into my
face and told me all. When she was thirteen years old, and
while menstruating, she was raped by six men. She broke
into sobs. "I will hate them for as long as I live."

239

I put my arms about her and she rested her head on my shoulder. She continued to sob as she spoke. "They are probably all respectable married men now, standing on guard over their wives and daughters."

"After this happened," she continued, "I got a terrible itch down there. Do you think this could have caused some damage?" All these years this beautiful young woman had been carrying this terrible fear and tragedy around in her head and heart. How many other women were doing likewise?

Through the Consciousness Raising group I had learnt why men rape women. Not only did I learn to understand the reason for my first rape, and why he did not return while Tony was overseas, but the reasons why men commit rape. Monogamy, the nuclear family and society created and perpetuated this crime.

Jamie returned from interstate. He called in to see if the cassette player he had sent was satisfactory. I felt his reason for calling was an excuse and that he considered it necessary to explain the circumstances of his coming family reunion. He was going to bring his family to Melbourne and they intended settling here. We only had to look at each other to know we still cared but we continued making conversation in order to prevent a lull, for we both knew what would happen if the conversation stopped. The conversation ceased, and all logic was swept away by emotion . . .

We both knew it could only go on for a brief time, but I was prepared to accept what little happiness there was in the situation. I would go off to work and arrive home to find Jamie curled up reading one of my Women's Liberation books. We would go to bed and, although I had already read the book, we would read together and discuss the details. His mind boggled. He was a man who had seen a reasonable amount of life and, like most men, he thought he knew all there was to know. The difference between Jamie and so many other men was that his mind wasn't set. He wasn't a super-egotist. He was prepared to read, think about his own experiences and discuss new ideas.

All men, because of their early conditioning, have egos,

but a few, a very few, have small egos, and they have no need to prove themselves. They are not interested in competing with other men, and Jamie was such a man. These men are considered to be failures in our present society.

I had thought there was no hope of my ever again having a beautiful relationship but now I realised that, if women like myself were ever going to relate to men, then it could only be to men who did not possess super-egos.

I did not neglect my activities and, when I returned from a meeting, Jamie would ask question after question about the evening. He was enthusiastic and fully supported the need to change society.

For hours on end we discussed everything about life, conditioning, love, sexism, children, families, sex, exploitation of people by people; everything was thrown into the melting pot. Jamie accompanied me on two of our demonstrations, and even took the Women's Liberation papers to sell to passers-by. He felt the need to do something to help change society and, although he was almost always the shop steward on the job – a demanding role with no prestige – compared to what I was doing, he considered his contribution to be infinitesimal.

When discussing children, he began to realise where and how he had been wrong in his attitudes towards his children and was now determined to rectify the situation when the family returned.

The first week had gone by, then the second. I knew the time must come. Jamie decided it was impossible for his family to settle in Melbourne for we were too involved to make living here with his family a success. The third week was nearly over when, on arriving home from work, I asked him if he had obtained employment. He had, and it was inter-state. He was leaving in the morning.

I knew it had to come and did not attempt to interfere or discourage him. I had known from the beginning that it would be brief.

It was a very warm evening and we lay on the bed and watched Germaine Greer and the Reverend Alan Wallace debate the issue of women in society. I began to cry and Jamie

tried to console me. He asked me not to cry and I told him that I was not crying for myself but for all humanity who was suffering. I lost control, and pointed to the reverend on TV and said, "It is men like that creature who have created religions and all of the rotten morals which they themselves can't live by. They have imprisoned people into the institutions of their creation, and then they bleat about sinning." I began to sob, "They cause all of the suffering." Jamie embraced me and we remained close together.

Next morning we moved about like two silent automatons. There was nothing we could say to each other. Jamie began to cry and we clung to each other as we sobbed. I could no longer endure the situation. I ran out of the flat and drove off to work.

I had no illusions about life. I knew that nothing is permanent. I knew that it is impossible to contract human emotions and this is why marriage in most cases is such a failure. I knew that, even if Jamie had been unattached, the time would have come when all could have faded, but it is hard to accept the break when all is so beautiful. Maybe it is better, I thought, to break when it is still beautiful because you then have wonderful memories. The alternative is that the relationship almost always becomes destructive and the woman usually gets hurt.

In our competitive society people are reared to compete with one another. Women, because they have been conditioned to the housewife–mother role and are locked out from positions in the "outside" world, are confined to the restrictiveness of "get your man and home". Hanging on to your man becomes a lifetime task. This situation creates competition among women at the personal level and turns women against women. It was during a Consciousness Raising session when we discussed, "Have we competed with other women over men?" that I became aware of how subtle the indoctrination really is. Each of us present claimed that we had never competed in this manner until we delved into why we wore make-up, wore wigs, continually changed clothing, or went to great lengths to make ourselves attractive. We were forced to ask

ourselves who decides what attractiveness or beauty is, who establishes the standards of beauty, and whether women of other lands who wear no make-up are beautiful. We all finished up realising that we had, in fact, been competing all our lives with other women over men.

Women employed in offices and shops are expected to dress well and wear bright make-up of the right amount. This situation creates problems among women, particularly among women of differing ages. During periods of unemployment, the older woman realises that her youth is gone and feels threatened by the stream of young women who are employed to add the sex object image to the already decorative quali- fication of women in these jobs. In the factories, women are paid for the work they produce and at the mail exchange there was very little competition among the women. The vast majority of the women working there wore very little make-up, wore ordinary clothing and were there because they needed the money. They had no airs about status or delusions of grandeur.

I was being pressured by the women at work to stand for a position which was vacant on the union sub-branch. There were only a few months outstanding before elections were due to be held and the union had decided to make this brief period in office an appointed position. How could I explain to the women that I was no longer interested in being a shit worker for men? I now knew that women's needs and demands are considered by men in the unions to be unimportant and I was too tired and worn out to blaze a trail for women within this union.

I thought the matter over and decided to apply for the position. I would put the union to the test and see if they were prepared to cop me. I wrote my application and needed a nominator and seconder to sign the document. I approached two women and, after confirming their financial standing within the union, asked if they would be the signatories. They agreed, and I insisted that they read the application before signing.

During the following week, I was called into the super-

visor's office and asked to take a seat. I had no idea what this summons meant, for I had committed no misdemeanor. I was flabbergasted when the supervisor said I had been reported for taking a petition around on the job and requesting people to sign it. I couldn't imagine what sort of a petition I was supposed to have trotted around the office, and asked what the petition was about. He replied that he wasn't free to say and that, although nothing had been reported on paper (officially), all reports had to be investigated. I was appalled to think that someone could fabricate this type of tale and couldn't understand why anyone would want to say such a thing. I asked if it was possible for the reporter (informer) to be called into the office so I could ask for more details but he said this was not necessary.

I pointed out that I was being accused of committing a misdemeanor when in fact I was innocent and that I was being deprived the opportunity to prove my innocence. I then began to laugh. "Maybe," I said, "the informer was annoyed because he thought I was taking up a petition for free love and was put out because I didn't ask him to sign it." He appreciated the joke. All of a sudden it dawned on me. I woke to what had happened and mentioned the union application and the need to obtain a nominator and seconder. I then knew I had real enemies at work. What a warped mind the boss who reported me must have had for, if he was efficient in his job, the two women would have readily told him what they had signed. I later discovered that he thought the petition was in support of abortions for women.

I was unsuccessful for the position on the union sub-branch. I was glad, not only because I didn't want the position, but also because I then knew where I stood with my great union leaders. Once again I was amazed at their fear of me.

When shifts permitted, I attended the quarterly union general meetings but that was all. Like all union meetings I had ever attended, these followed the same pattern. Every meeting seemed to be an opportunity for the leaders to tell us "peasants" what they had done for us over the past three months. Lengthy ego-tripping reports would consume almost

all of the meeting time until the final few minutes of general business were reached. By this stage almost all of the members in attendance were bored to death and sitting there like stunned goslings. They were glad to see the end of the meeting and would then dash over to the John Curtin to awaken from their stupor. This general meeting was the sum total of the participation of the members in what was supposed to be their own organisation.

This union was like all unions: rigid laws of debate were adhered to. Many a time I witnessed a man get to his feet, start to talk, but then the president would raise his gavel, "Are you speaking for or against the motion?" The man would attempt to explain, only to be interrupted. Again the gavel was pounded. "Are you speaking for or against the motion?" the president roared. "I will sit you down, as two speakers have already spoken for the motion and we now need two against, so if you're not speaking against the motion sit down." The man would sit down in confusion. Oh how many times had I witnessed this scene over the years? The alienation of people at work, within their unions, and in all the structures governing our lives is complete. I often thought, when witnessing the mindless situation workers are forced into, that if it was at all possible to train horses to do the work humans do in society then people would be placed into cans for dogs' meat.

A union secretary told me of a tragic situation concerning a de-facto wife whose partner was killed when the West Gate Bridge collapsed. The worker had written a will when only a lad and, although he had lived together with this woman for seventeen years and had purchased a house, she was left homeless when his father, the beneficiary, claimed the house. Although entitled to workers' compensation, she was prevented by law from taking legal action over the bridge disaster.

On hearing of this incident, I moved a motion at my union meeting that the union research officer do a thorough research of the Commonwealth Employment Act to determine if there was any discrimination between entitlements for legal wives as against de-facto wives in regard to compensation or

superannuation payments on the death of an employee. I argued that the role of a union is not to sit in judgement on the moral values or standards of members, but was to see that justice is done to people and their partners. It was interesting to note that not one member opposed the motion. This again illustrated how conservative and behind the times the unions are. Unions, like all structures, are so out of touch with the feelings and thoughts of the people that they in fact become fossilised in their activities. What may have been progressive way back in the time when unions first became established is no longer valid for today.

The result of the research revealed that there were positive discriminations and, with the Labor Party coming into power in late 1972, the union research officer obtained a position as an advisor to the Prime Minister. It was gratifying to learn that all discrimination between legal wives and de-facto wives was removed from within the Commonwealth Employment Act. Many of our laws are full of this discrimination which makes a mockery of marriage being a free choice.

The narrowness of the trade union movement irked me greatly. Conservation and ecology were now issues with several unions but basically the attitudes were just as in centuries gone by. The union leaders, like all leaders, reminded me of a group of Neros; all playing their fiddles while the value of human life was disintegrating around them. It is correct to say that the majority of people living in affluent industrial western countries are not starving, for lack of food is the problem mainly of the third world countries. But people in our wealthy country are consuming more and more alcohol and Valium is the most prescribed drug in Australia. The quality of life is what our problem is; the breakdown of human relationships and alienation.

It would seem that the capitalists are only interested in workers during working hours because their labour makes possible the profits gleaned. Even though some unions force industry to provide good conditions, the workers pay for it through higher prices being charged for the commodities produced and purchased. Trade unions in the main are only

concerned with workers during working hours, for they too obtain money through dues for membership. Unions are forced to give something in return for this money: wages and conditions. Governments also make money through taxation from the workers during working hours. It is only recently with the Labor Government in power that funds have been allocated to services which are provided for people. But who cares about Aborigines, women, pensioners or the unemployed?

Han Suyin, in her book, *A Many Splendoured Thing*, wrote, "Politics are passing things, but pain and hunger and poverty like the proverbial brook go on forever."[1]

Poverty and hunger still remain with us in Australia but for the majority of people this is not a problem. However, everyone feels pain, the affluent and the poor. I am not referring to physical pain, which doctors treat, but to the pain which stems from the heart and head. Head and heart pain is considered to be personal and not political; thus these problems are left entirely unattended except for professionals like psychiatrists who cash in on these matters.

Trade unions with their narrow insights think that people only require good wages and conditions. Most unions don't even put up a struggle for good conditions, and think about money as their only objective. What they are in fact doing is selling the workers for what they think is a fair price. What a commodity!

People, as total beings, are important. In our present society sufficient money to live on is essential, but there is far more to living than having sufficient food and obtaining material goods. Trade union leaders, when selling us for the right price, must face the fact that they are assisting in taking away our human dignity. It is necessary to create a society where trading in human flesh no longer exists.

As the Women's Movement became more vocal, more widespread, and an accepted reality, I noticed a marked change in

---

1. Han Suyin, *A Many Splendoured Thing*, Penguin, Australia, 1959.

the attitude of some of the union leaders. They admired my courage, consistency and guts, but I was no threat to them, their wives were safely ensconced in the home. Occasionally they would tell me of a dispute in an industry where they were able to get the women to make a stand and, by doing so, were successful in obtaining their demands. They would tell me of incidents where they were responsible for gaining a victory for some women, but never were women to be developed or employed as organisers in their structures. One woman who was employed within an industry for two years was informed that she required at least eight years experience before she would be suitable to be employed as an organiser. The same union had three male organisers who were suspected of never having worked within the industry. This union had a predominantly female membership.

I always appreciated the reports of women taking action because this was an indication of the changing attitudes of women. It became obvious that this reflection of change was only filtering through the militant unions, where women were a minority in the industry. The unions covering the bulk of the women in the work-force, the clerks, shop assistants, clothing and textile workers, were non-militant unions and discouraged raising the consciousness of their members through participation or action.

My activities and involvement in the Women's Movement created a new and strange situation in my personal relationships with men. Apart from the general curiosity about the "sort of person I was under the skin," some men, having grasped the fundamentals of what we were aiming to achieve, supported our stand and went to great lengths to impress me with this.

One man I began keeping company with was a very genuine person. He was a worker, free from ambition and self-seeking, and did what he could within his male union to support the women's cause. I began to notice he was always keen to tell me what problems and disputes he had on his job, and also the pros and cons of what took place at his union's meetings but, whenever I would begin to talk about

what was happening in the women's struggle, he would switch off mentally. He would delight in telling me of some issues where he was able to strike a blow for the women's cause, and then immediately switch off.

One evening we arranged to meet and have a meal after a Women's Liberation meeting. The meeting was very productive and it was with a feeling of elation that I met him. I told him the meeting was terrific but my elation went unobserved. He didn't ask what had transpired, so I remained silent while he went on about all he had done since our last meeting. After an hour had passed, I thought I would have another go for I was interested to test him out. Again I said, "Gee, it was a wonderful meeting," and immediately I saw his switched-off look. I knew he wouldn't understand if I attempted to discuss my feelings, and the relationship came to an end.

He alone was not guilty of this for, apart from two men, all the men I knew who agreed with the women's cause were the same – they were only interested in telling you what they had done, were doing, or what they were thinking. The very sadness of this situation was that I enjoyed being told of the incidents and events taking place, not only within the feminist cause, but also within the trade union movement. However, it became frustrating when I felt I may have had something valuable to contribute and they made it obvious that I had nothing to say which could add to anything. Once again it is only they who are doing important things.

Most of them come to life when finding themselves among young feminists, for it is then that they play the role of the great non-sexist. Oh, how they try to impress and ingratiate themselves and, sadly at times, they are even successful in hoodwinking the young. Maybe this is why they wouldn't employ me. I knew them too well and for too long. They also knew I was unimpressed with their bullshit. They couldn't put it over me.

The time may come when some of our younger women may obtain positions within the trade union structures. I repeat "young" because the sexism of the trade union leaders will only be fed by youth. If an older woman attempts to make

the grade, she will have all of my support and sympathy, for the struggle she will have to endure will be soul-destroying.

I only hope that when women do eventually penetrate the bastions of the trade union hierarchy, they do not turn their backs on the women who fought to make their acceptance into those ranks possible. Will women then pound the gavel and say, "Sit down or I'll sit you down"?

# 20

I THINK I MUST HAVE BEEN THE FIRST WOMAN employed by the mail exchange to menstruate; that is, officially. I read in a trade union journal that Japanese women receive one day off per month (physiological leave) without pay so I decided that when I next needed to take time off while menstruating, I would state "physiological reasons" on my absentee form. When the time arrived, I stated this reason and was confronted by one of the male clerks. He was a married man with two children and he said that my stated reason was insufficient. I took the form from him and told him I was menstruating. As I wrote this on the form, he blushed, looked most embarrassed, took the form and hurried off. I was greatly amused. Good heavens – anyone would have thought I'd said I had syphilis.

In all my working years, I had never before told an employer that I was away from work because of my period. I always made other excuses. On one occasion in the "ladies" room at work, a young woman entered with her absentee form in hand and asked the women present for suggestions for her previous day's absence. The women began to suggest toothache, earache, stomach upset, backache, sinus, etc. etc. On and on it went, but the woman had used all these excuses before and asked for something original.

How ironic this set-up was, for all of these make-believe excuses were recorded on their personal files and were used against the women when they applied for permanency.

Another woman reached the stage where she was tired of lying about her body and used "indisposed" as the reason for her absenteeism. She was approached and asked for further

explanation and, having heard of my experience, she wrote "menstruating". That made two normal women at the mail exchange.

All people are aware that it is normal and natural for women to menstruate yet our male-dominated society continues to persecute women because of our bodily functions. Due to minimal skills, many women are afraid of losing their jobs and, although hernias, haemorrhoids, and bad hearts are accepted for male absenteeism, women are afraid to take time off when suffering from severe uterine cramps or excessive bleeding. Our male industrialised society requires women in the work-force. It is high time that industry and the trade unions stopped punishing women for being women and gave us at least one day off per month on full pay.

The only statistics available on "man-hours" lost to the work-force are those on strikes, heart conditions and alcoholism. I would state that, apart from caring for sick children and the occasional day off to attend to some important business matter, seventy per cent of time lost from work by women through illness would be due to their reproductive organs. It is not possible to calculate the "woman-hours" lost to the work-force because women lie about their condition. Maybe if the truth was known, business interests would press for more research into women's health to prevent the precious loss of labour and profits.

When commencing work at the mail exchange I decided it wasn't necessary to travel to work by car and add to the pollution, so I began to travel by public transport. Financially, it was just as expensive travelling by public transport as it was to park the car all day near work. However, apart from the inconvenience of having to change trams and take three quarters of an hour to travel three miles, being a woman was the deciding factor which made me return to car travel.

When working on the late shift, I became annoyed and scared when waiting alone in Swanston Street for a tram. On several occasions I purchased a packet of hot cooked chips, and stood there eating the chips to make it obvious that I wasn't soliciting. I felt more at ease when other people were

also waiting. When alighting from the tram, I was always aware of any male footsteps behind me until I reached home.

One evening when racing out from work, the tram had already departed. I decided to walk to Swanston Street and, as I went along Bourke Street, I saw a man walking towards me. He turned up a lane and disappeared but, when I reached the lane, there he was exposing himself. I hurried along with a sick feeling in my stomach and I could hear him calling after me. From then on I travelled to work by car.

I always wore old clothes to work, usually slacks, but on one occasion I was going to a party after work and decided to wear a full-length dress. Before changing into my work uniform, I walked across the floor to clock my card. The men all noticed me and began to whistle. They ceased whistling and rose to their feet cheering and clapping their hands. The place had stopped work to give me an ovation in my gown. I continued to walk through as if they weren't there but, besides being embarrassed, which is unusual for me, I also began to laugh. There were several women working in a section there but they were unable to see me because the men on their feet blocked the view. As I turned the corner of the machine and became visible to the women they too began to laugh at the crazy situation. I approached the women, stood beside them and we laughed together. I was working in a different section before knock-off time, so I changed back into my dress and returned to my machine for the last few minutes of the workday. Again some men started carrying on. One of the men became disgusted with their childish behaviour and roared out, "What's wrong with you fellows, haven't you ever seen a woman dressed before?"

I received a lot of good-humoured teasing and had my own methods of retaliating. Many of the men would have a go at me and, apart from one incident, this was always done in fun. I would wait, if necessary, for the opportunity to get my own back and I very rarely missed out. Sometimes I retorted immediately and, other times, I would wait for the right moment.

It was with great surprise one day that I looked through the union journal and discovered that the ACTU had called

a conference of women workers. One of our women was present at this conference. We had no knowledge of this conference, nor did anyone at work know that she had attended. It was obvious that she was selected to attend by the all-male executive, and we were not even made aware of all the particulars which came out of this conference. All we got was this one column in the journal.

Following the brief report on the women workers' conference was an article I had written on the problems facing women who, due to a shortage of labour, were recruited into employment fields which had in the past been male industries only.

Men within these industries felt resentment towards women for intruding into what they saw as "their" domain; "their" industry. Together with this was the great resentment towards women receiving equal pay. Women entering these industries were allotted all the light and unpleasant tasks requiring manual dexterity and for which they received a lower salary. These tasks, over a period of time, became established and accepted as women's jobs.

With the advent of equal pay in January 1972, the majority of men, including some in authority, demanded that women share the heavy physical tasks while at the same time the men were averse to sharing the obnoxious "women's jobs". Equal work by women should also have meant equal work by men but, while men argued that women should do their share of the heavy lifting etc., the men refused to relinquish their clerical, pencil and paper jobs. After discussing certain matters in this article pertaining to our industry, I pointed out that because our industry lent itself to automation, it was to protect men's jobs that the union insisted on equal pay as a condition for employment of women in the industry. I went on to argue that the criterion should not be equal pay for equal work, but equal pay for work of equal value. It was essential for both men and women to value one another's labour and not to see the other as a threat within the industry. It was for the benefit of us all to work together in our common interests. Several women made favourable comments on the

article, but not one of my male co-workers said a word.

Although my article was introduced by stating that I had been a member of the union for some years, it also went on to say that I was an advocate of women's rights and a great fighter for better conditions for female employment. How strange that, despite this great wrap-up, I was not informed of the ACTU conference on women workers.

I was continually being asked to stand for the position of union representative for the women, but I refused to be used as a messenger-girl for a drunken male shop steward. Having a position which carries no authority to deal with the many problems raised, only creates a situation where the woman concerned gets all the kicks when the shop steward has failed to do his job. I had been a punching bag for men for too long, and was too wise to fall into that trap again.

A very staunch Labor supporter asked me why I didn't stand for a position on the union executive. I looked at him. "Do you really think they would let me get there?" I asked. "No," he replied, and laughed. "The bosses are scared of you, the union is scared of you, and the workers are scared of you. You are too militant and fair dinkum." I wasn't scared of the bosses or the union and knew that if I had wanted to or had the ambition to become the union representative, I could have got there.

Workers are not stupid people. They can judge if a person is genuinely concerned for their interests and I knew from experience that I could have gained their support. However, what energy I had left was given to the women's cause because, no matter how much workers suffer, women workers are always worse off. We have double the oppression, firstly because we are women and secondly because we are workers. Those were my priorities.

There was only one overseer at work who I disliked. All the staff disliked him. He was a woman-hater and that made him worse as far as I was concerned. The occasion arose when an extra person was required to work out in the yard and I was sent off to report to this overseer. He accompanied me to a trolley standing in the centre of the yard and went on to

explain that, as the trucks entered the yard, the drivers would deposit parcel bags on to the trolley. When all the trucks had called, it was my duty to wheel the trolley over to a particular chute and toss the bags from the trolley down the chute.

I managed to wheel the trolley down to the chute as it was downhill and, after giving the trolley a shove, it rode down easily. The chute itself was a hole in the wall almost five feet from the ground. The bags were extremely heavy and were stacked so high that I couldn't even lift them off, let alone throw them into the chute.

I just stood there and roared with laughter for I had no intention of even trying. The rules stated that two people must lift a bag together. I could see the overseer looking at me, and I knew well what the bastard was up to. I very nearly gave him the thumb-up sign but thought better of it. I just kept on laughing. One of the truck drivers who was walking past and saw me laughing asked me what the joke was and, when I told him, he walked over and helped me toss the bags down the chute.

Several weeks later, I was seated together with two other women on a letter machine which was under the control of the same overseer. On seeing me sitting there, he walked along the machine until he was standing in front of me, and he began a tirade against women. He said the worst thing the department had ever done was to bring women into the mail exchange and give them equal pay; "they don't deserve it." I tried to point out that the department had to employ women because they were unable to get men, but he continued to rave on. The two women sitting beside me smiled at him. When slaves are frightened, they almost always smile at their master thinking that, by doing so, he may slacken his strength on the whip. I realised there was nothing to be gained by trying to discuss the matter with him, as he was a maniac, so I left the machine and made my way to the toilet.

I realised that women were, in some instances, worse off than black people, for one of the overseers made a disparaging comment concerning colour to an Indian woman and was forced to apologise. Racism is not permitted, but sexism is.

We had no power to report an overseer for degrading and humiliating us because we were women. What would have happened if the same overseer had stopped in front of three black people and said, "The worst thing the department ever did was to employ black people in the mail exchange?"

I found most of the men on the job were easy to get on with. Some were witty and, with some, I could have very interesting and controversial discussions. However, there were men who were very opposed to what I was doing; not that they understood what I was doing, or why, but they were such superegotists that they considered they knew everything about everything, including Women's Liberation. I avoided talking to these men and, in the main, they avoided talking to me.

Numerous women were having affairs with men at work. There were single women with married men, single men with married women, and married men with married women. The whole scene. The funny part is that, like most married people who are continually having affairs, if you ask them what they think of marriage they usually say they wouldn't like to be single; that is, they don't mind marriage, as long as they can have a bit on the side. So much for the marriage vows and contract.

It was not surprising that some men offered me their "services". I was aware of the way some of them thought and, although they didn't say so, it was obvious that they were thinking one of two things; "All she needs is a good fuck," or "I wonder what she's like in bed?" One man at work assured me that he would satisfy me if I would allow him one and a half hours. He believed in the adage, it pays to advertise. Another, after being rejected, wanted to know if I was frigid, and I assured him that he would never have the opportunity to find out. Another very seriously told me that if at any time I wanted "something", he was ready to oblige. I looked this fellow in the eye very seriously and told him that I would remember his offer but there were already seventy-one men on the list. As I walked away from him I said that I would notify him when his turn came. I was highly amused and thought, "The egotistical bastards, they all think they have

257

something special to offer; what is so special about their individual penis? Anyone would think by their offers that they had a diamond-studded 'special'." All these men were married, yet this did not deter them. I was, by now, well aware of what men thought, but what they didn't know or face up to was that almost all women get this type of offer from men. They are not, as individuals, offering anything unusual or special when they offer us a loan of their penis. It is for this reason that women use the marriage contract; an institution created by men.

Women are placed in a position where it is necessary for them to contract themselves through marriage in order to receive commitment and money. On the other hand, women who are prostitutes make men pay for each act of intercourse. The only difference between the two options is that one is by contract, while the other operates on piece-work rates.

One day, while working with three men on a sorting rack, I was asked my opinion on the previous night's press statement concerning an increase in the price of cigarettes and alcohol. I adopted a very gloomy countenance and said it looked as if I would have to give up drinking and smoking, and just stick to sex. The three men were astonished and their eyes almost popped out of their heads. It was impossible for me to stay serious, and I laughed.

During November 1972 the equal pay issue was again before the Arbitration Court. Almost sixty years of asking, begging and pleading, and women were still cheap labour.

Sylvie Shaw, with the assistance of Bon Hull, Alva Geikie and Libby Brook, had produced a document entitled, "Women in Employment". Much of this research was used when the Women's Liberation Movement decided to seek leave to place a submission in support of equal pay before the courts.

Again the same women assisted Sylvie in her research. The submission presented came in two parts; one in support of equal pay and the other seeking an equal minimum wage for women. Our submission ended with these words:

"The Women's Liberation Movement believes in equality for women in all spheres of society. In the employment field we believe that women have the following basic rights:
1. The right to work.
2. The right to equal job opportunity.
3. The right to equal pay for work of equal value.
4. We feel that discrimination based on sex is a fundamental denial of justice to half the Australian population."

At the end of the hearing the court adjourned and, while all women waited pensively for the results, the Labor Government gained power. Twenty-three years of Liberal Government had given women nothing. We waited anxiously.

The new Labor Government immediately responded to the women's growing demand for equal pay and intervened in the case. The case was re-opened and the new government supported the claim for equal pay.

The bench brought down a decision granting women equal pay for equal work, but rejected our claim for an equal minimum wage with men. Although the result was a breakthrough, there were tremendous difficulties facing women in attempting to gain wage justice. How, for example, can the work of a typist (no male typists) be evaluated? Would it be just to compare the work of a typist to that of a tradesman when seeking work value comparisons for the purpose of claiming wage justice?

By rejecting our claim for an equal minimum wage, we were aware that further anomalies would develop within the wage structures, so we again sought leave to place a submission before the Arbitration Commission when it resumed, to hear the case for an increase to the male minimum wage, plus an increase to the national wage.

I was selected to present the submission and, after several discussions, the submission was prepared. It wasn't a very lengthy document, for what could we say at this type of case apart from pointing out the anomalies that would be created by an increase in the male minimum wage in reference to equal pay for women? I was given time off from work without

259

pay in order to present the submission from the Women's Movement to the Arbitration Court. I was the only worker in attendance at the court, the only woman to place a submission to the court, and the only person to do this at my own expense.

I didn't know when I would be called on to present the submission so I was forced to sit there and listen. I hoped it would not go on for too long as the longer I sat there the more wages I lost; a situation that no man in the court had to worry about. They were all well paid for their attendance. I sat there listening to the advocate from the ACTU going on hour after hour about the industrial situation of the country, the world monetary system and world inflation etc. My mind would wander off every now and then and, at times, I wondered if the judges could fully understand what he was saying in the realm of economics, for they were experts in law; how much did they know about the complexities of economics?

Because I was interested in people as people, and not in their bloody positions of power, my imagination began to make me smile. I looked at one man on the bench and thought he would be the clumsy type who squashed your tit with his elbow every time he moved. Another, I thought, would be a strictly in-the-dark type man. Another was a real charmer – the older Stuart Wagstaff type, dressed immaculately, with his shirt cuffs showing just the right amount, and shining cuff-links. You could just imagine him holding a cigarette in one hand and saying, "When only the best will do," and with the other hand patting the bum of his blonde secretary. Another would be the type who would have to stop the proceedings, put the light on and examine the "how-to-do-it" manual to see what had to be done next. Finally came the chief. I could see him as the real Anglo-Saxon; stiff upper lip and all that sort of thing, saying in a very Oxford accent, "Oh, I say, old chap, that's not the sort of thing a Britisher would do with his wife." At this stage I had my head down and was laughing to myself.

I was back in the scene. The advocate continued on and on; all around the world and from heaven to hell, all because workers wanted more money. The next day was the same and

260

again my mind began to wander. Christ, I thought, I'm better off dragging mail-bags at work than having to listen to this drivel day after day. How can they stand it? What terrible institutions men have created for themselves. The only reason they put up with it is because they get well paid, and with the pay goes the power they gain over others. And, of course, one cannot overlook the status bullshit which goes with high wages and power. What it is to sell one's soul for an ego trip!

There was a great deal said about poverty and about the difficulty in assessing poverty and needs. Being a typical Aussie, I thought, Jesus, if you had ever suffered poverty like I had, it would not be difficult to assess. I could remember the time when I had to delete items from my weekly shopping list because of the lack of money, and had to sit through the coldness of winter because the use of a radiator would have increased our electricity bills. Here I was listening to a lot of men, who had never known what it's like to be poor, discussing poverty and needs. What a lot of utter crap. And men claim they have the solutions. Not if they have created institutions like this one, I thought.

The entire setting and atmosphere of the court reminded me of the games I played as a child. The male peer group would pretend they were on a pirate ship, a train, or flying an aeroplane but, whatever the game was, there was an earnestness about each player seriously adapting to the role that had to be played. In the court room the men were still playing games; they had never grown out of it. To them the red indians were the workers, the born losers. Children swap around and share the cowboy and red indian roles but in this game the players are the same, but they never swap sides. All male institutions seem to be replicas of the cowboys and indians complex. The men never grow up, only the rules of the game change: they cease exchanging sides because the games are now real. How sad for us all.

I was very tense and nervous despite my moments of humour and, as I sat there in the intimidating atmosphere, I found I needed to visit the toilet more than usual. Nervous tension often creates this situation in people and I was no

different. I was furious when, in this new building, I was directed to the fourth floor and to the rear of the building to use the female staff toilet. It didn't seem possible that a toilet for women was overlooked when designing this building and I made further enquiries. I was informed that a toilet did exist for women on the first floor but it was only for the use of "special" women, and not for any woman attending the court.

On each occasion when I had to go, I got more and more mad. The entire proceedings of the case, plus the continual need to run to the fourth floor were making me seethe. What gave these great men before me the power to treat people like myself with such contempt?

By the time I had to present the submission, I could not address them as "Your Honour". I did not honour them and I didn't see why I should. I could no longer play their games. To me they were just a group of men who had taken the power side of the game for themselves, never swapping over with the "indians". Being an "indian" prevented me from feeling any respect for the masters of their role. To me they were just men. If they thought they were superior to me, that was no concern of mine. If they thought their position of power entitled them to respect, then again that was no concern of mine. I certainly played no part in creating their power positions so why should I respect them? I considered myself to be as important as them and the work I was doing for a living to be as useful, if not more useful, than their contribution to society. I rose to present my submission which, through sheer necessity and gut reaction, had become lengthier than the original previously prepared. What follows has been copied from the transcript of the submission:

"Ms D'Aprano: We support the ACTU claim for $11.50 per week to increase the total wage. This would benefit the lower wage earner, particularly the vast majority of women who are employed in the lower paid jobs. We see percentage increases to salaries as favouring the higher income groups only and increasing the gap between male and female earnings as well as disadvantaging women performing the lower status

jobs. We further support the ACTU claim for regular adjustments to salaries to offset increases in prices.

Much has been said here about the difficulties in assessing a minimum wage, the relative concept of poverty, and who can assess needs. It appears that the persons directly affected are not speaking for themselves, and here I would like to make an analogy; for example, being a woman I am directly affected by the lack of toilet facilities for women in this building and the need for women to take a lift to the fourth floor, traverse two corridors to the rear of the building and use the toilet facilities provided for female staff; men have the privilege of using the press facilities on the ground floor. In other words, until one is personally affected, all concepts seem remote.

Professor Henderson's poverty line research is slightly outdated. Dr Halliday's thesis has been questioned by Mr Madden who seeks confirmation of publication.

There is not one person in the body of this Commission who is forced to exist on or below the present minimum wage. However, this need not be. After raising my personal level above the poverty line for a period of nineteen years, I returned to working at four different industries for a period of time to again familiarise myself with poverty standards, viz. the electrical trade, the textile industry, the meat industry and as a wardsmaid in a hospital. It was a very enlightening experience. My take-home pay was $31, $34, $39 and $32.

Although three years have elapsed since working in these industries, and wages have increased, they fall far short of what I personally consider necessary to provide for my personal needs – in our opinion these salaries are below the poverty line.

In assessing my personal immediate needs in monetary terms – and I did so last night – I would require a minimum salary of $71.50, and this is less than I am receiving, so people may not argue that one adjusts one's standards of living to one's salary. This $71.50 for my personal needs in my opinion was the minimum that I could live on, thus it would be unreasonable and unjust for me to assume that women could live on any less, unless they were enduring some type of poverty.

We as individuals can assess what we require as minimum. We can all do this personally, then why should we require others to survive on less? To set wages according to need is all very well as long as this method applies to all people regardless of sex, and takes into consideration our own personal standards and needs, otherwise it is a matter of: don't do what I do, do what I tell you to do.

We feel that the recent decisions brought down by this Commission show inconsistencies, and I quote:

1. This means that award rates for all work should be considered without regard to the sex of the employee.

In the same judgement you dismissed outright a minimum wage for women, and again I quote:

2. We reject that argument because the male minimum wage in our award takes account of the family considerations we have mentioned.

You claim that family considerations are an essential characteristic of the male minimum wage, in other words, the male is the bread-winner and solely responsible for family consideration, despite evidence which indicated the number of married women working, in other words, dual bread-winners, other males single, and the growing number of families where a woman is the sole provider. To have made the decision in quote 1 and followed it with quote 2 creates a contradiction.

Exhibit J22 distributed at today's hearing lists approximately 100 classifications for over-20 awards, mostly male awards paying less than the minimum wage, thus the granting of equal pay for work of equal value within these industries would become invalidated within these classifications because the males would be paid the minimum wage and not the award specified; while women would receive only the male award rate, therefore an increase in the male minimum wage will further extend the gap between male and female salaries; in other words, the women on low salaries will be penalised further.

We feel that if women are not granted an equal minimum of $65.00 with men, the award rate which is set without regard to sex will increase; however, the resulting wage may still be

less than the minimum rate, thus the Commission has not provided equal pay but only a pay rise for women. We consider this discrimination on the grounds of sex.

In conclusion:

1. We support the ACTU claim for $11.50 to increase the total wage, and support regular adjustment to salaries;

2. We suggest that the Commission indicate in its decision that it still has an open mind to a further claim for an equal minimum rate, and the establishment of all rates, whether award rates or the minimum wage, without regard to sex. Thank you."

I presented the submission without once referring to the commissioners as Your Honour. I had been well educated in the university of life about leaders and their importance. I only hoped that women would see through the institutions men had created. Unfortunately I knew there would be women who, having accepted male values, would be only too delighted to fit into the cowboy and indian games. How sad.

Following my submission I asked leave of the court, explaining that I was on leave without pay. Leave was granted. Never again would I agree to go there, for I could not play their games any longer. Life was too grim, and there was too much human unhappiness and misery to be dealt with to be playing games. Anyone can read a submission. I had more important matters to attend to. Experience once more had shown that when the "indians" revolt, the cowboys give way. After all the years of campaigning for equal pay, it was only when women themselves began to fight that equal pay became possible, and yet pay justice for all women has still to be resolved.

# 21

CHRISTMAS WAS APPROACHING and several women, including myself, volunteered when called upon to work in the "ship" section. This experience taught me never to volunteer for anything in a job situation again. However, we were stuck with it and had to make the best of it. The regulars did most of the skilled work while we, in the main, did the labouring.

One of the women wished to attend a pre-Christmas party so I changed shifts to enable her to enjoy herself. By taking over her shift, I was forced into doing her job and for eight hours I dragged bags one after another to a raised platform. Each bag was lifted and the contents were emptied on to the platform. After sorting the large packages into various bins, the remaining assortment was conveyed by a moving belt to another group of sorters. All day long three of us toiled at this task while the majority of regulars sat and sorted.

With only half an hour to go before knock-off time, I was exhausted and unable to do any more work. My back was aching and almost every muscle in my body was numb. I leant against the platform in a state of stupor. Two supervisors approached and I told them I was done in and couldn't possibly do any more work. I told them how pleased I was to be returning to my own shift on the following day. "Besides," I went on, "I would refuse to do this job continuously because it would interfere with my sex life." The supervisors were stunned but, on recovering from their initial shock, we laughed together.

One of the other prize jobs I was instructed to do was stand by a platform and as the bags fell from the chute I had to remove them and stack them on the floor. The bags were

heavy and felt as if they were packed with rocks. It took all my strength to drag them from the platform and drop them at my feet. When there was no further room to move and I was almost surrounded by bags, I switched the conveyor belt off and called for help. Another middle-aged woman was sent to assist me and we heaved the bags together.

I was very annoyed by the system operating in this section and glanced over at a man working nearby. "Hey Joe," I called, and almost went on to say, what happens here should a woman be suffering from a prolapsed uterus? However, thinking he may not understand me, I instead said, "What happens here if a woman gets a fallen womb?" His immediate reply was, "Don't worry love, we'll help her look for it."

I met Jan through the Women's Liberation Movement. She was an employee in a commonwealth government department and the nature of her job took her outdoors. She had many problems and, moving from an industrial town in the state of NSW to Melbourne would have alleviated most of her troubles. She had a serious kidney condition and was advised by her doctor to seek indoor employment, her marriage was on the rocks, and she had a daughter with learning problems at school. She came to Melbourne for a brief holiday and I took the opportunity to introduce her to the federal secretary of her union, in the hope that he could assist her in some way. Jan had played an active part in the union for eight years and had, like me, embarrassed the officials on numerous occasions. They, like so many union officials, were like vacillating blobs of jelly.

The federal offices at one stage had huge posters on the wall of Mao, Che Guavara and Karl Marx but, since moving into a carpeted suite, all signs of the "revolutionary greats" had disappeared. I never found out whether they were relegated to the cupboard or to the dust bins. Jan told Geof Tiler of her situation and how necessary it was for her to live in Melbourne. A few discreet phone calls were made and all was arranged. She was bubbling over with excitement and extremely relieved to know that her troubles would be over.

She was to put in for a transfer and wait.

Jan returned to NSW and, together with her husband, they put the house up for sale and she waited on news for the transfer date. The house was sold and she was, after several weeks, informed by word of mouth that no vacancy existed for her within the previously agreed section nor would there ever be. She was offered two alternative choices.

Jan was one of several children of a drover. Her early years were spent on the track and her schooling was sporadic. Her only job experience had been in factory-type jobs and she did not have the confidence to tackle administrative work. Arithmetic and clerical work were beyond her ambit and she did not possess the necessary aplomb which usually accompanied this type of employment. She was an industrial worker in manner and outlook and was afraid to accept a position of this nature. She would in fact have been like a duck out of water.

She was alarmed about her situation and contacted me about her plight. I was staggered when receiving the news and learning that her house had been sold. I hastened in to see Geof Tiler and asked him what was going on. Before he committed himself, he asked if Jan was a member of the Communist Party. I couldn't see the relevance of this question and wondered why he wanted to know. I told him that she was an unfinancial member and was at the time reconsidering her membership in the Party for she had many misgivings about it. He said that, in view of her Party membership, there was nothing he could do for her. No wonder his posters had disappeared.

Jan, in her desperation and against my advice, brought the matter into the open by reporting the details of her predicament to her local Trades and Labour Council. She was the union delegate to the council but the men on the council would not intervene on her behalf. It was, they said, a private matter of her own union. The right-wing, the left-wing and the centre were unanimous in this decision. Despite the bitter political differences between these men, they were united on this issue. Jan was a woman and, seeing it was "only" a woman

at stake, the matter was considered to be unimportant. This was Jan's reward for years of devoted service to the union movement and to her male comrades.

It is interesting to note the difference in attitudes adopted towards salaries between the unions and those in the hierarchies. Full-time officials in the few militant left-wing unions almost always obtain a salary relative to the earnings of the majority of workers represented within the industry, but this is not the practice in right-wing or centre of the road unions. Most unions discourage member participation and the officials award themselves pay increases without endorsement by the total membership. Some officials have their salaries pegged to classifications way above the people they represent within government services and this is why the "fat cats" are always supported when they seek an increase.

The Amalgamated Metal Workers' Union (AMWU) with a national membership of 166,000 (1976 figures) is the most powerful union in Australia. Their Victorian state membership is 58,000. The federal secretary of this union receives $190 gross per week and a state secretary obtains $181 gross per week. All monies received by the officials for attendance at wages boards, trade committees and the apprenticeship commission is returned to the union. Apart from receiving the use of a car, which is essential for their organising, there are no perks.

How different the situation is when the majority of union members are women. The press reported that Mr D Joiner was elected unopposed to the position of Hospital Employees Federation (HEF) secretary and that as the Victorian state secretary and national secretary he had become one of the highest paid union officials in Australia. What an ironical set-up. This federation had a national membership of approximately 60,000 and a Victorian state membership of approximately 20,000. Even if his salary was halved to represent each of the positions, this man would still be receiving far more than his counterparts in the AMWU. Having been a member of the HEF for so many years, I well knew that the

responsibilities of these positions within the union did not warrant such extravagant payment and, if they did, then both positions would be far too great for one man to handle. No union official should gain a rise in salary unless the wage sought is put before all the members to vote on the issue through a plebiscite. The only other suitable method to avoid a plebiscite is to make the salaries of officials relative to a classification covering the earnings of the broadest number of members within the union.

Unions with a majority of women members almost always become the most vulnerable to right-wing political intrigue. During the early seventies, the largest retail stores in Australia reached an agreement with the clerks' and shop assistants' unions for compulsory unionism. The stores deducted the union dues from the salaries and paid them into the union. This "I pee in your pocket and you pee in mine" agreement served the political interests of both the unions involved and the big stores. Apart from placing millions of dollars into the funds of these unions, it also gave strength to the right-wing union's voting power at the ACTU conference. This move was engineered to build opposition to Bob Hawke the president of the ACTU and to gain more strength on the executive.

The Women's Action Committee wrote to the ACTU concerning the great number of women affected by this intrigue but we received no reply.

The time had long since arrived for all union meetings to be held on the job and at regular intervals. Melbourne, like all growing cities, was spreading to an extent that made it almost impossible for women to travel home, attend to the family's needs and then travel again, for anything up to twenty-five miles, to attend a union meeting. Meetings conducted during extended lunch-hour breaks would have been the most practical method of involving the people in their "own" organisation and would have assisted in overcoming the alienation in at least this area. People given the opportunity to make some of the decisions affecting their own lives could have been encouraged to take a greater interest in society. This participation would have been one

method of assisting people in developing self confidence. The union executive and office bearers would then have functioned as co-ordinators and initiators rather than bureaucrats and demagogues.

I once heard a Catholic academic say that Catholicism and communism had one basic thing in common; they were both concerned about the future. This may be so, but the hierarchical structures governing both the church and communist parties only lead to disillusionment and despair. Neither the Catholic church nor communist parties (all brands) demand their adherents be humane or live by humane principles. Allegiance to the structure is all that is required and, even though leading males within these structure often deviate, no one kicks them out – that is, unless they do something which can no longer be covered up. For the ordinary people, that is the membership or flock, unquestioning loyalty to the leaders or cardinals and bishops etc., is all that is needed. If you hold a Party card, can spout a few left-wing clichés and give finance to the Party, you are a communist. If you believe in God, donate money to the church and support its politics, then you are a good Catholic. These structures have no rules apart from allegiance and anything goes, for they do not concern themselves with the behaviour of their adherents outside of the narrow confines of their own politics. They do not believe that the personal is political.

I recall a man and woman who worked with me over a great number of years. They were practising Catholics, attended church every Sunday and were avid campaigners for DLP politics within the union. After relating together for almost a period of ten years, the man left his wife and moved in with this woman. Another ten years or more went by and his wife conveniently died. An advertisement appeared in the press to his dear departed wife and, within three weeks, the mistress was exhibiting a magnificent engagement ring. She was very proud of this possession and hasty plans were made for the wedding. By this stage the woman was fifty-six years old and was determined to become an "honest" woman. At this period

271

of time, the public service would not accept married women as permanent officers and, rather than live in "sin" for another four years and retire from work with superannuation payments for life, she decided to resign from the job and get married immediately. Oh, how desperate women become.

A great farewell was organised and, even though the staff were well aware of the set-up, the speeches made at the function were nauseating. I almost expected someone to say, "And I hope all their troubles will be little ones." I got the giggles when one of the fellows sitting opposite kept on repeating, "What a lot of bullshit! I've never heard so much bullshit in all my life." Old Scotty made us all laugh when saying, "Well, what she loses in super, she'll pick up in child-endowment." After the wedding, she brought the photos to work and showed them around, proud of the fact that her cousin, the priest, had officiated at the wedding.

It would appear that to be religious or to belong to any political party is easy . . . all you have to do is keep on barracking for the team, just like you do in football. All religions, all political parties and even football were devised by men. All that women have to do within these structures is keep on serving, serving and serving.

One evening, while discussing with Joan and Norma the situation of left-wing women of our generation, we discovered that almost all of the left-wing men had, over the years, either made it in the trade unions, had given away politics and made it in business or management, had obtained promotion in government employment and were no longer involved, had kicked on through studying and were now establishment academics or had just dropped out of the scene. We found very few to be workers at the lowest level and still politically active, particularly if they had been involved in right-wing unions.

When thinking of the vast number of women we knew, only three had made it. The three women concerned were totally male-identified and had very little sympathy for women. They were all academics. One had a senior position

in the education field and ruled with all the might of an autocrat. Another, although successful in the male academic sphere, found it necessary to continue blonding her hair in order to prolong the sex object image and the other appeared to be quite self-satisfied for she had made it. The remainder of left-wing women became good housewives and drifted away into oblivion. Who wants middle-aged women around anyway? They would much rather have the young women circulating around them. During our discussion, it also became apparent that very few women of our generation had devoted their time to trade unions even though the vast majority were employed outside the home.

I observed and analysed the men who were making it in our society; the managers of firms, the academics, the trade union officials and men in power positions within the public service. All of these men were on paid salaries and had power and status. They may have complained of how overworked they were, but never did they willingly relinquish their positions to rejoin the ranks of the workers below.

I was now a liberationist and understood why I never would fit into a trade union hierarchy. I could never separate the human being into different parts. Although I had functioned within the narrow confines of the trade union while working at the hospital, I was a member and not an official and was therefore able to concern myself with the total person. I now have a far greater understanding about what the total person is and what people require in order to live fulfilled lives but I did, in my own unenlightened way, endeavour to assist people in all ways. In order to fit into a trade union hierarchy, I would have had to overlook the human being, the person, and concern myself with the product only. As a trade union official, I would have had to think of a product that I was selling at a price and, apart from the price, the only other consideration would be the wrapping. Somehow or other, and although I didn't fully understand it, the personal was always political to me and people were my concern. Wages and conditions (price and wrapping) were only one aspect to be dealt with. I felt that all people as individuals should have

the right to determine what they did with their own bodies.

Now I could see that in our present society it was compulsory for people to sell their bodies to the bosses for forty hours per week. Many were prepared to sell their bodies to bosses for more than forty hours per week (overtime), but no men were permitted the right to sell their bodies to a boss for twenty hours a week.

Part-time work in some industries has been accepted for women, but part-time work for men is almost unheard of. People have no right or control over their bodies when it comes to hours of work, conscription, abortion, who the foreman is, what takes place at work, what they produce at work, how they produce it, or where the profits go. Our bodies are owned by capitalists, the state, the church and, for women, there is also the added ownership of our bodies by men.

Now that I was better able to understand myself, I realised why men in power positions didn't want me around. I was a threat to them. Not only would my presence have embarrassed them but I was also considered in their eyes to be naive. To have some sort of human principles and to expect some sort of basic honesty was being foolish or at least idealistic. I may have even rocked their boat for I now understood that I, in fact, differentiated between allegiance to a cause and allegiance to a structure. I would by my very presence have witnessed, apart from other things, their continual sexism; a situation which *could* have made them feel ill at ease.

During the recent bitter struggles taking place within the Builders' Labourers' Union, an up-and-coming Victorian official in an attack on the NSW branch said, while addressing a union meeting, "Them and their talk about homosexuals and sexism. I like fucking on top and that's where I'm going to stay."

I knew that the time would come when the heavy work expected of the women at the mail exchange would be too much for me to cope with. The Labor Government, in response to the women's demands, had done away with all sex discrimination in employment within the services and this enabled

me to apply for the position of a senior mail officer. This position entailed more clerical work and I saw this possibility as my only hope. Another woman and I were the first women to seek this position in Melbourne. The reaction of most of the men was what could be expected. When seeing women enter a domain which had previously been exclusively theirs, they would scurry to apply for promotion. Because seniority takes priority in government positions, I knew I would rarely get the opportunity to work in this capacity.

At one stage I even pondered the possibility of applying for a supervisor's position. I had the necessary qualifications to do this but, as always, when the employment situation begins to tighten, meaningful jobs must be made available for the children of the wealthy who fail to gain entry into the universities. This came about due to the upgrading of the educational qualifications to Higher School Certificate. These tactics also prevented the workers below from obtaining promotion to higher levels. How can workers employed on shift work undertake the intensive high pressure study in order to get promotion? I do not recall the union opposing these changes even though I drew their attention to this matter.

When observing the supervisors at work, I realised that, even given the opportunity, I could not function in this role. Some of the supervisors were very active on the job, but many spent a great deal of their time walking around and watching the workers. They rarely spoke to the workers as this type of fraternisation is frowned upon and is seen as undermining discipline. I could not live without people for not only did I like people but I needed them. It was impossible for me to ignore their presence. I worked to live – and did not live to work. Had I sought this position, one of my duties would have been to remove women who may have been resting in the "ladies" room. I too was a woman and knew what it was like to suffer from the numerous female disorders. I too knew what it was like to feel weary. True I, a woman, could have advised them to return to work in a nice manner; it's the same sort of pill, the only difference being that I would

have been putting a sugar coating on it.

It was impossible for me to fit into any of the male-created structures, whether it be in the trade unions or anywhere else. I was a liberationist and could not play any of the cowboy and indian games. Any woman who thought she could alter the rules of the game was deluding herself. The rules were laid down when men first developed the competitive society and can only be done away with when our society is completely altered. Women who gain positions within the power structures only do so by the grace of men, for men in the higher echelons of the structures do all of the selecting. In private enterprise, these women almost always become as brutalised as the men and hospital matrons, in the main, are no exception. There are, however, some women in the institutions of learning, various government departments and the media who are endeavouring to introduce positive content into their work. These women often encounter tremendous opposition from within their hierarchies but they battle on despite the obstacles and frustrations. Some give up altogether.

Numerous young men of today suffer from a feeling of desperation. They have become disenchanted with all of the present structures and the means adopted to overcome this situation is to create new structures. We have a spate of new religious sects and a multitude of small political groups where each and every person involved wants to be "king". Their egocentricity, their arrogance and their "sounder" ignorance[1] rapidly lead to a falling apart and the inevitable increase in more groups or total disillusionment.

All men are sexist in our present society and to think that this may not, or should not, be is a pipe-dream. Some men, because of the persistency of women's struggles, are being forced to re-examine their own values in light of their own personal misery and the ever-increasing futility of their lives. These men are slowly becoming aware of the crippling institutions and structures but are finding that the way out of this

---

1. Profound ignorance spoken with great confidence.

dilemma is quite difficult because they cannot relate to each other as people.

I never was oblivious to men's suffering but, after the millennia of male rule and the world almost reaching a state of self-annihilation, I no longer consider that men have the solutions to the problems. They persistently deal with the symptoms and never tackle the cause. The Women's Liberation Movement is creating a new analysis which, not only enables us to recognise the cause, but also makes possible the solutions. A healthy society can never be established as long as sexism survives for as long as more than half the world's population is oppressed there can never be people's liberation. Women are now fighting, pressing and urging for liberation, but we alone cannot change the world. Men also have a responsibility towards humankind and hopefully they will join with us before it is too late.

The Amalgamated Metal Workers' Union (AMWU) is one union where some moves are being made. This union conducts schooling for their many shop stewards and the topics undertaken for discussion cover a wide range. Apart from the many sessions involved with the functioning of trade unions, sessions are held on economics, multinational corporations, workers' control, women's liberation and zero population growth. Female as well as male shop stewards attend these schools and, by doing so, gain the opportunity to discuss the very situations which affect their entire lives. At the present time, this union is the only union within the state of Victoria attempting to broaden the knowledge of the workers within their industry by introducing the "personal" into the struggle. This is only a beginning for they need to do a great deal more in order to promote this type of discussion and interrelation among the workers in the factories. The AMWU has very few women members and these activities only further expose the non-activity of unions which are predominantly female in membership. The newly established Working Women's Centre may be able to change this situation in the future. It is hoped that this centre, if it continues to flourish, will not be used by the unions as a means of

avoiding the responsibility of developing their own women organisers.

Oh what a different person I was! I had long ceased wearing wigs or make-up and had stopped shaving the hair from my body. It was, at first, difficult for me to accept the hair on my legs but I eventually became accustomed to accepting my body as it was. I even reached the stage where I thought that women with bald legs looked similar to dressed poultry. I overcame most of my self-body hatred and was able to glance in the mirror, accept myself for who I was and no longer try to fit into any other image. How wonderful it was to be free of all fears; no more fear of age, no more fear of wrinkles or grey hair and no further competing with other women. I was free and it was a wonderful feeling.

My sense of humour began to develop from the time my marriage broke up and, as a liberationist, I had ceased seeking male approval. I was no longer worried about embarrassing a man. There was no one to say, "Don't carry on like that, you embarrass me." It was only now that I could say and do whatever I liked for I belonged to myself and it was fun.

After attending a meeting one evening, several women decided to have supper at the Genevieve restaurant in Carlton. When supper was over and we were attempting to say good-bye to each other on the pavement, a man approached and insisted on engaging me in conversation. I was extremely brusque but he refused to take the hint and continued talking non-stop. He was beginning to rile me and I was just going to tell him to piss off when he asked me where I worked. I immediately adopted a dramatic pose and, with one hand on my hip, I raised my other hand to my mouth, took a pro-tracted draw on my cigarette, blew the smoke out slowly and said in true Mae West tradition, "Well, as a matter of fact honey, this is my beat right here." His response was stunning; he was dumbfounded and, as he stood there gaping, Molly and I walked towards the car, laughing till we cried. "What if he does live in Carlton as he said he did?" asked Molly and continued, "You might bump into him at your local shopping

centre." I shrugged my shoulders, "If that should happen, I will do the same thing and say, I have changed my beat honey."

I had, after all these years, reached a stage in my personal life where I felt that I was as total and intact as any woman could be in our society. My experiences had not made me bitter or abrasive; compassion and warmth were, and always would remain, part of my psyche. I did not envy men their great masculine image for, despite this facade, most of them were in fact only empty shells, and what woman could possibly wish that upon herself?

I had overcome the most insidious form of male approval-seeking for I no longer sought institutionalised recognition. All forms of recognition can only be obtained on male terms, whether it be in personal or other areas, for men have established all of the standards. Male approval-seeking must not be confused with efficiency, for any job which is worth doing is worth doing well and any task I undertook to perform gave me great satisfaction when knowing I had achieved what I had set out to do.

I no longer felt the need to be dependent on a man. I was a person in my own right and didn't feel any lack of identity because I didn't possess a man of my own. I was content to go out with my women friends and couple-friends. I no longer needed to depend upon another person for my heart and head, nor did I want to be responsible for another person's heart or head. I no longer wanted to own or possess a man and nor did I in turn want anyone to possess or own me.

I found there were three situations affecting people who wished to live alone; loneliness, lonesomeness and aloneness and each situation was distinctly different. I never suffered from loneliness for I had the movement women and many friends. At times I felt a deep inner lonesomeness and this is an inherent part of our being. No other person can fill this need and most people have, on occasions, felt this inner lonesomeness even when living with a partner. This feeling produces a need to be close to someone, to feel their strength and be sustained by it. Unfortunately, men only see this need

in women as a sexual need. How wrong they are, for it is at these times that women want to be accepted as people and not as sex objects.

Aloneness became a necessity for me. My work situation of being surrounded by hundreds of people and noisy machines, together with my continual attendance at meetings, gatherings and lengthy discussions with friends, gave me little time to gather my thoughts. After having discussions until the early hours of the morning with numerous women, my mind would be racing at top level. I needed to be alone, for there was always so much to be thought through. There was always so much reading to catch up with and so much writing to be done. Being alone gave me the opportunity to recharge my batteries and get myself together; a time of refreshment for something else.

I needed people and needed the women in the movement; this was a human need and not a neurotic dependency situation. I needed to communicate with people, to laugh with people, to share their being and experiences with them, but never again would I want to own another human being. No one had the right to the ownership of another person, whether it be their heart, mind or body, whether it be for eight seconds or eight hours and this also applied to one's children.

I now knew that all women suffer. Some more, some less, but it was essential for women to grow and strengthen the Women's Movement. Many young women were now taking part and asserting themselves as people. They were battling it out in political parties, in the churches, in the community, in their workplaces and, hardest of all, in their personal lives.

Some of the older women who had in their lady-like way campaigned over the years to raise the status of women, felt resentment towards the militant women from the liberation movement. They felt we were not giving them true recognition for their efforts over the many years. This was not the case, for we recognised that, apart from having a conservative and reactionary liberal government to contend with for twenty-

three years, women in the community were unprepared to battle for themselves. However, conditions change, and the time had arrived when women were prepared to adopt more militant action for we knew that if we were going to achieve our demands we would have to fight for them.

Women now wish to improve the lives of all women and will not have this struggle contained by some senior positions being made available to privileged women. All women must benefit from our efforts. The new wave feminist "extremism" inspired other women's organisations and lent impetus to their activities, resulting in several women being appointed to positions within male power structures. I was always amused when reading press statements made by some of these women. "No, I don't go along with Women's Liberation. I have never been discriminated against by men." Do these women really think that men at this given time in history changed their attitudes due to an act of God?

I knew that the time would come when ladies participating in various women's organisations would draw the curtain down over the "ugly and extremist" beginnings of the new wave feminist struggles. International Women's Year was drawing closer and one could have even been deluded by the press into believing that men were giving us recognition for one year out of the goodness of their hearts. I had no doubt that many women would attempt to block out the "ratbag" element who strove so valiantly against great odds to establish the recognition of women as people. Without this recognition, I seriously doubt if the United Nations would have condescendingly granted one whole year to more than half the world's population.

Many people are confused by the more radical stand taken by the Women's Liberation Movement and question why we are continually critical of left-wing men. It is necessary to emphasise that almost all of these men are no different to right-wing men where women are concerned; they have all been conditioned under a patriarchal capitalist society where money buys all, where double standards prevail and where women are sex objects and/or mothers.

The great differences which exist are among women themselves. Women in the Liberal Party were prepared to attend special meetings for women and be addressed by a man. Most women of the left would no longer tolerate that scene. They would tear their men to ribbons if they were foolish enough to even suggest this type of meeting. In the main, left-wing women now decide what has to be done, how to do it and when to do it.

The values of left-wing women differ from most other women for we seek financial independence to enable us to have free and committed, equal and loving relationships with men. We refuse to exchange our bodies in return for the price of survival, or material and emotional security; and this is why we have great problems with men.

Although most men harbour a deep resentment for being responsible for the family, they, at the same time, think that the stability a wife and family offers, the catering to their comforts and the availability of sex will cease if women own their own bodies. This double bind is often responsible for the violence of men towards their wives and children, for where else can a man vent his feelings when the hatred of his job and his frustrations become too much for him? Most men never question the institution of marriage and the nuclear family; this is something they have grown to accept as "normal" and "natural".

It is tragic that women also regard this situation as being normal, for they too have been conditioned into seeking the "right" man; a man who must be a "good" provider, a man with enough money to pay adequately for her services. Most women who engage in paid employment outside of the home only see their wage as a supplement to their husband's earnings for they still consider him to be the provider.

Industry will inevitably accept women into the ranks of management if this will, in return, lead to more profits. This move will in no way threaten the power of the males in business or in their personal lives, because they will continue exploiting human beings, will still be oppressive and sexist

and will continue buying women just as they have always done, whether it be in or out of marriage.

For those women active in the trade unions, it is fatal to be caught up in the political wheeling and dealing of men in their struggle for power. To be caught up in this type of struggle will result in women being set against each other. We need to judge men on our politics not theirs. We need to continually put forward our demands and thereby unify all women around our needs. Only then can we judge the male leaders on how they react to our issues. This does not mean that we cease to struggle for wages and conditions, on the contrary, we will be adding further dimensions of human needs to the overall quality of our lives. The trade unions need to be humanised and one important factor is to do away with all discrimination in all laws between the rights of legal and de-facto wives (de-facto husbands).

Above all, women are to be encouraged to adopt a realistic attitude to the present situation in society. They need to be able to realise that the child-bearing period of their lives is very brief and that taking their place in paid employment carries responsibilities as well as rights. We need to create a situation where both men and women can take an active role and responsibility towards paid employment (trade union involvement), while also equally sharing the domestic work, the nurturing of children, the sick and the aged.

To make this possible would require a drastic reduction in working hours for both men and women and would require a dramatic change in the thinking of men. These changes would also result in doing away with the male-provider role and free men from the wage-slave system which binds them to their jobs and masters. The nurturing of human life would assist in the overall humanising of men for it is almost impossible to violate, rape or destroy life when so much of one's self has gone into creating it. Child-rearing does not allow for ego-tripping for there is no status attached to washing stinking napkins or cooking meals, but the process of nurturing can

be very rewarding and is a vitally essential task for all people to experience.

Until we can alter the exploitative sexist attitudes of men, trade unions will never accept the needs of women, Aborigines, or pensioners and it then becomes impossible to force the capitalists to meet the needs of people.

Women must be given time off on full pay when suffering from problems specific to women and, with greatly reduced working hours, men and women would be able to attend family planning clinics to obtain contraceptive advice. Time off on full pay should be granted to all women and men undergoing medical operations, sterilisation operations and for women when having abortions.

Our capitalist society is unconcerned about human beings and our needs. We are constantly being told that we have to compete with overseas industry in order to obtain markets. To hell with your competition. People the world over are sick and tired of being set against each other while the owners of industry reap the benefits as they lead us into economic calamity. People of all lands feel the same fatigue and the same pain and women everywhere are becoming disenchanted and exasperated with the total egotistic mismanagement and competition of the male world. The anger of women is greater because we are the greatest victims.

It is up to the trade unions to challenge industry over human needs. All industry and production should be organised to meet the needs of people, for which is more important, machines and profits, or people? We must all get our priorities in order. Until trade union officialdom accepts the responsibility of fighting for human needs, then they will continue to play games at our expense while ripping off the benefits accorded to them by virtue of their power positions.

## 22

The topic appeared just as concrete [?] ... which appeared just as concrete. Chairs [?] ... [illegible faded text at top]

I WAS BEGINNING TO HAEMORRHAGE. It's a much nicer word than bleed. Although the bleeding was slight, it continued month after month and I accepted this bleeding as being due to my age. Like most women, I had been told on many occasions that periods and any other internal "discomforts" are the lot of woman and only neurotics complain. Not only do women accept the "discomforts" as being normal, but some women who are fortunate enough to be free from these problems condemn or question women who speak of their suffering. Men also adopt this condemnatory attitude and eventually the sufferers begin to think they may be neurotic and cease to say anything. Again, it is women who must remain silent.

Recent research conducted in England revealed that many women do suffer fatigue, depression and uterine cramps and this problem is associated with hormonal factors. One of the reasons why insufficient medical research is being performed on women's specific problems is because the vast majority of doctors are men, and they do not feel our pain.

On one occasion I was feeling extremely ill and, on arrival at work, was put to doing very strenuous work. The hostility of the men towards women receiving equal pay prevented me from requesting lighter duties and I found myself again doing heavy lifting and pushing tasks after the meal break. I began to bleed profusely and I felt as if my back was going to break. I went to the ladies room and sank into a chair. I was unaware of the time until a woman ran in and said I was being paged over the loud speaker. I had been absent for fifteen minutes and my overseer had reported me to the supervisor.

The supervisor was a most uncouth and ill-mannered man and, when I approached him, he roared, "Where have you been?" I told him I wasn't well and had been resting in the ladies' room. "What's wrong with you?" he bellowed. I hesitated for a moment and thought, well if he wants to know all about it then he's going to get it. I looked him in the eye and said, "I'm haemorrhaging and after doing heavy work all day I felt very ill and had to sit down." He was abashed for only a moment and gruffly asked why I hadn't reported to the first-aid sister. I told him there was nothing she could do for all I needed was to sit down. His aggression came to the fore again and he said I could have been reported on paper for what I had done. I told him to go ahead and do so and walked off. I returned to continue the heavy work.

It was almost eighteen months since my previous holiday and I was feeling as if all my energy was drained. I ceased going to any meetings in the hope that more rest would restore my energy.

I was rostered on to a team which I had in the past always managed to change but, on this occasion, I was out of luck. I started my fortnightly stint in this section and, as usual, the regulars on the team had commandeered the easiest work for themselves. In this case it was a matter of selecting the machines with the least volume of mail. I, together with a man, had to share the work on the busiest machine in the section. We were on our feet all day and constantly on the move.

Because of the qualified and unqualified roster system, the sorters sat at the machines for almost all of the roster. Some yawned when they became weary of sitting, while others went for little walks to reactivate themselves.

I went to see one of the senior men and spoke to him of this terrible system where some people sat on their backsides almost all day and yawned while others were run off their feet. He said he would have the matter investigated and sent a man in authority to make inquiries.

The investigator didn't appear to be concerned with the

system which prevailed and the results therefrom, but confined his investigation to consulting the regulars in the section. I observed the proceedings from where I worked and was soon informed of what transpired. I could see the women laughing. "We've worked here for ages," they said, "What's she complaining about?" The same women had of course taken the easiest machines for themselves. I tried to talk to them but they were adamant about leaving things as they were. They didn't want anything changed.

I later learnt that each of these women had a lover in this section. They didn't want the system altered for fear of the work being reorganised. This change would have meant a more equitable distribution of the work-load which could have resulted in more women seeking roster teams in this section. The regulars were obviously insecure in the relationships with their lovers and felt the need to stand guard over their men. I felt desperately sorry for these women.

I decided to visit the doctor and discovered the reason for my illness. My blood pressure was extremely low. The doctor checked my heart twice and I was fortunate for my heart was unaffected. He put me off work immediately and told me to rest. I was to return to visit him in two weeks. When returning, I then told him of the constant bleeding and he was most concerned. He recommended that tests be performed to ascertain the cause of the bleeding. I was going away for four months holiday and asked if it was possible to delay the tests until my return. He agreed, and said that the rest may be sufficient to restore my health.

I went off to Western Australia and within three weeks the bleeding had ceased. I couldn't believe it. I thought maybe next month it would start again, but no, the bleeding had ceased and I was gradually beginning to come good.

There was no one about the house I was staying in when I decided to pay a visit to the Perth Botanic Gardens, so I couldn't ask for directions. There I stood, dressed for the occasion and waiting at the bus stop when a young woman pulled up on her motor bike. She asked if I could direct her to a particular street and, after explaining my visit to her city,

I asked if she could direct me to the Botanic Gardens. She was unable to help me and approached a group of road workers who were also unable to assist. She had a spare crash helmet and offered me a lift into the bus depot.

Thirty years had elapsed since my last venture on a motor bike and I thought why not, it would be like a new experience. As I proceeded to place the helmet on my head, the road workers ceased working, leant on their shovels and observed the scene. I climbed on to the back of the bike, gripped the young woman around the waist and gave the road workers a mighty thumb-up sign as the bike roared off. They almost fell off their shovels and I laughed at their dismay.

Public gardens always gave me a great deal of pleasure. People are so busy working in their own domestic gardens that they rarely have the time to enjoy them. It was Bertrand Russell who wrote that the most lasting happiness experienced is that which is associated with the earth. This was so in my case for our present society deprives most people from any sort of lasting happiness within human relationships. I often wondered if people employed in public parks and gardens were ever made aware of the joy they gave others through their labour.

Back home, when feeling that I needed to escape from the city and all of the world's problems, I would take myself off to the gardens or for a drive through the countryside. I would travel on the outback roads and, as I drove, I sang all the beautiful songs which came to mind and succumbed to the tranquillity of the surroundings.

As I wandered about the gardens, I envisaged the environment of other lands from which the various trees and shrubs originated. Australia was isolated from other lands, yet here I was able to get a tiny glimpse of our planet.

After strolling around the park for some time, the sun was beginning to make its descent and I knew it was time to leave. I found myself walking through the Avenue of Honour and on either side of the road were the enormous trees. I approached one tree and read the inscription on the plaque. His name, age and place of death were recorded and

I proceeded from tree to tree. All these men were very young and their lives were destroyed while, they in turn, were destroying other lives. I thought of their mothers and the sacrifices made in order to rear their sons and the anguish and pain they must have suffered when hearing of their deaths. Faces of young men began to appear before me . . . Fools, you fools, I wanted to scream, all you can do is fight and kill. Violence, violence is all you know and nothing changes. Tears began to pour down my cheeks and, as I hurried away, I kept on repeating, you have no solutions. You have no solutions.

It will take many years of the women's struggle before men will reach the solutions for they are reared to competition rather than co-operation.

The last few weeks of my holiday were spent in North Queensland where the climate was warm. I delighted in the beauty of our country, it's ruggedness, it's vast structures of mountains and surrounding seas. The sunshine was glorious and for three weeks I wore only shorts and a light top. I felt marvellous. Before returning, I had my blood pressure checked at a local hospital and it was normal. Hoorah, I felt on top of the world. It was with reluctance that I prepared for the journey home. I had a deep inner feeling that I was coming home to trouble.

Melbourne greeted me with grey skies and fine rain. "Zelda, you've hit the headlines again," was my welcome back. It took me several minutes to orientate my thinking. Several young women seemed to be talking to me at once. After getting my brain into gear and asking some pertinent questions it appeared that some sort of an ASIO document was leaked to the press and the *Age* newspaper featured an article on the document. I was the only woman named on the document. I was completely stunned. The women assembled didn't have a copy of the article so I hastened over to Leanne's home knowing she would have kept the paper.

There it was before me in bold headlines: "Memo tells of wire taps – ASIO man's secret report is circulated." The article went on to quote the secret report but because the

journalist was unable to contact me in person, my name was deleted and "(woman's name)" was inserted. The article referred to me as "a Women's Liberation leader" and went on to say, "The woman mail officer named had been based at the PMG's mail exchange branch in Spencer Street since September 1971. She was on three months leave yesterday and could not be contacted."[1] Why did the *Age* refer to me as a "Women's Liberation leader" when there was no reference to my being involved in the Women's Movement in the ASIO document? Was the newspaper insinuating that the Women's Liberation Movement was subversive?

I was both shocked and stunned when reading the reference to me in the document. Why me, I kept asking myself? Why this particular document? There must be vast numbers of these particular "minute papers" so why was this one selected to be leaked to the press? I knew that I must have had an ASIO record, for anyone who challenges the status quo or attacks the right-wing in our supposedly democratic society has a record, but why me? I was most upset and, on my first night home, I wrote to the Attorney General of Australia stating why I had only just become acquainted with the information published from the document. I went on to say that I considered this to be an infringement of my privacy and requested the right as an Australian citizen to view all reports and documents that ASIO had written about me. My letter was not acknowledged.

Several days later, I was to receive a photostat copy of the original document which was circulated to various newspapers around Australia.

I was initially afraid to publish the document in this book for fear of infringing some law or other in our statute books but *Rupert*, a new publication, has since published the entire document and I now feel more confident to do so. The following is the exact wording of the paper.

---

1.  Ben Hills, "Memo tells of wire taps", *Age*, 14 May 1974.

## ASIO
## MINUTE PAPER[2]

Subject:   Liaison: Attorney-General    (19 October 1971).
First Assistant Director-General (Int.)

Copies to: Deputy Director-General
             Assistant Director-General, B.
             P.A. to Director-General.

The Attorney-General asked to be advised on the following.
1.  He read the Log of W.855 (Cassidy, John Michael) up
     to 16/17 September 1971 and asked that he be given,
     (*before 22nd October 1971*) an up-to-date report to cover
     intercept material (and anything else we had) from 17
     September 1971 to 21 October 1971.
2.  Re "Jack Mundey" (Secretary, Builder Labourers?)
     He asked is this his correct name? If not, what *is* his
     correct name?
     What is his security record?
3.  Re "R.J. Wellard" – office bearer of ACOA at Darwin
     is he still a member?
4.  Re Mr Alan Parry (ph.) – a teacher of Templestow?
     High School – have we any record?
5.  Briefly, what record has ASIO of –
     (a) J. Halfpenny
     (b) G. Crawford
        (of the Labor Party)
6.  Is ASIO aware that "Zelda D'Aprano" has been
     employed at the Melbourne mail exchange? I said she
     would not come into a vetting category. (The Attorney-
     General believed she could cause similar damage there
     – as has been caused at the Sydney mail exchange by
     agitators. The Attorney-General suggested PMG Depart-
     ment should be advised of Zelda D'Aprano's record, if
     her employment is confirmed; he thought that she should
     be got rid of even by promotion (!) to some minor Post
     Office.)
                         signature
                         C.I.O.

---

2.   *Rupert*, April 1976.

When reading the document I observed the brief references made to the men, but it went into great detail about my job situation. Thoughts went on and on, and round and round in my head.

With the great revelations and exposures being published almost daily in our press of the American CIA activities, of their interference in people's employment, and of their interference in the internal affairs of other countries, it became obvious that some unknown person leaked this document to expose our ASIO activities and its interference in areas outside of its supposed realm.

Everyone knows that telephone tapping exists. Even the phones of Labor Party politicians are tapped and the reference to this practice being used (and anything else we had) in the document does not come as a surprise. I knew, going back many years, that my home phone was being tapped and was aware that private mail was intercepted. These revelations were not new. Why then was this document selected? Could the decision have been made to show that union officials are under suspicion and surveillance?

The union officials named hold mighty powerful positions and no one would dare touch them. The trade union movement would not tolerate any interference with their officials and any threat would result in an Australia-wide stoppage. The other two men named had responsible positions and, although references were made to them, there was no obvious threat made to their job situation.

I don't think I could be accused of being paranoid when claiming that the document was, in the main, chosen because of its reference to me. It served a two-fold purpose. While it exposed the interference of ASIO in people's job situations, it also could have cast doubts in the minds of some women concerning the activities of the Women's Liberation Movement. No one could convince me that I was the only person in Australia that ASIO had selected to meddle with job-wise. I knew there must be other left-wing people employed in government services and, on further reflection, I realised that they would almost all be men. And there was the answer

. . . It was necessary to safeguard men from being inconvenienced, embarrassed or threatened and I was the perfect scapegoat — what better victim can you have than a woman, a woman without a man (no husband), a worker at the lowest level, and who, in someone's opinion, had nothing to lose. No one will defend women in this situation for men do not care what happens to women and women have no power to protect themselves.

When one of Frank Sinatra's thugs punched a newspaper photographer in Sydney, the trade unions almost closed Mascot Airport. Even Bob Hawke the president of the ACTU intervened in the dispute. But who would rally to the defence of a middle-aged woman? I knew that had I been transferred to "some minor post office" in "woop woop north", only a handful of my old left-wing male trade union colleagues would have protested. The others may have written a letter. I realised how vulnerable I was and how vulnerable all women are who stop seeking male approval.

This is the reality facing all women especially when reaching middle age. For a woman to deny the reality of her own experience is to live a lie, yet to face the reality of her situation is extremely painful. All women engaging in men's politics have this decision to face and many choose the easy way out for it is difficult to negate years of dedication and devotion to political parties . . . even though their politics deny our very existence and pain. To deny that the personal is political is to deny our very being and all men's politics refuse to accept that the personal is political. I became very depressed.

The time had arrived for me to return to work and I was afraid. I knew that the vast majority of men and women at work would be curious and interested to know why the ASIO document said what it did about me, but there was a handful of men working there who hated my guts. Not only was I a Jew and a woman but they were so warped and fanatical in their views that they were capable of thinking and believing that I was a communist spy. I feared these men for I knew they were capable of violence. It was bad enough when working the late shifts to walk the two blocks through the

darkness of night to fetch my car but, in these new circumstances, I was more fearful than ever. Men may scoff at my fears, but all women are aware of male footsteps behind them when walking through the streets at night. Women are not paranoid when being afraid to enter a train carriage at night when no other women are present. We are not afraid of women but we are afraid of men . . . for it is men who are violent.

My fears about returning to work were justified. There were, in my absence, accusations made about me being a communist spy and, added to this malignment, there would have been the continual wisecracks. I could never and would never see this situation as being funny. I was desolate. Some of my women friends said I should be flattered to be the only woman named on the document, the only woman that the government feared, but I was unable to accept this backhanded flattery. For the first time in my life I knew fear, and I knew what male violence was capable of doing. Our daily press was full of it.

The media is but a reflection of our present society and one only has to read the press, read the mass of paperbacks written by men, visit the cinemas or watch television to be convinced of the inability of men to refrain from violence and destruction. In almost every case the woman is the victim, the person who is degraded for men's pleasure. She is the one who is battered, is slain or, at best, is left lamenting the loss of a man upon whom she has bestowed her love and care.

# 23

ON MY RETURN FROM THE NORTH and being confronted with the ASIO business, I decided to stay with mum. She was now old and glad of my company. She knew I wasn't well but she didn't know the depth of my feelings nor the extent of my suffering. There was no point worrying her. My body was tired and my mind was tired and I felt that I had taken all the kicking it was possible to endure.

Mum was still the same, she wanted to know the reason for the fighting in Ireland, the Middle East and everywhere else. Her yearning for a healthy world enabled her now, in her aged confusion, to imagine that all the male killing was for the revolutionary cause to establish a beautiful socialism. She became more confused when I enlightened her on the reasons for the continual slaughter.

After all the years of male violence, I had now reached the stage where I was no longer concerned about men killing men. What I was concerned about was the women and children caught up in the carnage of men's making; caught up in hatreds where men had created the enemies.

The National Feminist Socialist Conference was approaching and, although I wasn't attending any meetings, I thought I should try and write a paper for this conference. It was difficult for me to get my thoughts together but I knew that some papers would be presented by the small group of young dogmatic left-wing evangelistic women, as well as some from the few young airy-fairy "theoreticians", so I just had to make an effort.

Yes, we too had our young "Ted Mills" who sat on high and lectured us on what the working-class women should or

shouldn't be doing, or what "we" should be doing for the working-class women. There were vast numbers of genuine left-wing women in and around the Movement, but there was a small minority of vocal "greats"; the "leaders" who gave me the horrors. I don't for one moment question their sincerity, but life had yet to teach them a great deal and, in the meantime, I found them hard to tolerate. I had endured enough of this type of lecturing during my childhood and twenty-one years of membership in the Communist Party.

People could talk to me and with me, but no longer would I tolerate people talking at or down to me. My attitude had become, and would always now be, if you can't put your own theories into practice, then for Christ's sake, don't tell other people to carry them out.

I prepared a short paper for the conference but decided not to attend. The final session on Sunday afternoon was the section which interested me the most and there I was. I dragged my sick and aching body there. As usual I was menstruating and felt desperately ill.

All the women presenting papers at this final session were called to the platform and I joined them. I approached the chairwoman and requested the possibility of being the final speaker. She said that another woman had already sought this position. I asked if this other woman was from the working-class and she replied, "No." "Well I am, and seeing this session concerns us, I want to go last." I obtained this privilege and, when my turn came to speak, I told the women assembled what I had done. "Never," I said, "did I think I would ever be able to pull rank as a member of the industrial working class, but I have now," and I explained the circumstances.

On the day following the conference, my body was racked with pain. Mum wanted to call the doctor but I decided to wait. I writhed about in bed until I could bear it no longer. It was as if I were going through child-birth all over again. I forced my body to bear down and all of a sudden I could feel the clots oozing away and, like child-birth, the pain eased as the clots of blood came away. Oh what a relief!

Two weeks later I was again suffering extreme pain. I could

not straighten my back and realised that something was abnormally wrong with my reproductive organs. I attended the Queen Victoria Hospital and the male doctor, after examining me, said that I had fibroids and would have to undergo a hysterectomy. He was more interested in discussing me with the young male medical student in attendance than he was in communicating with me. I asked what caused fibroids and his reply was, "If I knew the answer to that question I would be a rich man." He again spoke to the student. I asked how prevalent fibroids were in women and he replied one in four women have fibroids. He made the appointment for me to enter hospital during the following week and there was no further communication between us. I was dismissed.

I thought about the need to have my uterus removed and was somewhat relieved to think that all my troubles and discomfort would be over. Won't it be wonderful, I thought, to be completely free of all this pain? I thought of all the years of trouble I'd had because I was a woman; as a child when I had the swellings prior to getting my periods, the pain and discomfort of the periods, the failed contraception and the resulting abortions, the intra-uterine devices which began to fall out, the sterilisation operation . . . and now it was all to end. And yet I was still to learn about the politics of my body; the politics of women's bodies and private property.

I entered hospital and was bedded beside a migrant woman who was also booked for a hysterectomy. The pre-operative tests were completed. Maria was wheeled off to the operating theatre and I was next.

There I lay in extreme pain and the drip slowly oozing into my body. I was in the "gyno" ward and, hour after hour, I witnessed the results of problems associated with the procreative organs of women. Some women were slowly attempting to visit the toilet, others were walking in hesitant steps up and down the ward in order to exercise their bodies. They clutched at their bodies to relieve the pain as they shuffled along. The nurses assisted the women in their early efforts to become mobile and one could not but realise how women were the nurses of life. How concerned they were for

the patients and how they did all in their power to comfort the women.

Three days after my operation the specialist and a group of medical students approached my bed and asked after my well-being. I was making good progress and asked if all else inside was in good order and if the uterus was all that required removing. The pages of my case history were rapidly gone through and I was shocked when told that both my ovaries had been removed. I asked why this was done and was told that one had cysts and the other had adhesions – "But at your age (forty-six) the ovaries are ceasing to function and should you suffer any side-effects, such as hot flushes, your local doctor will treat you." How conveniently we are disposed of! I felt as if I was an old boot being cast away.

I wasn't well enough and nor did I have sufficient knowledge at this stage to pursue the matter on the possible effects of my oophorectomy (ovary removal) but I was determined, when well enough, to follow this through. I was angry, so angry to think that there was no prior mention or discussion of the possibility of the need to perform an oophorectomy. It was my body, yet I had absolutely no control over it. Not only are we kept in ignorance of the internal functions of our bodies, but the vast majority of doctors consider that we are their property to do with as they choose . . . our lives are in their keeping. This was another lesson in the politics of private property and our bodies. After questioning the doctor, Maria was also told that her ovaries had been removed. She was fifty years old.

My later research revealed that, not only does this happen in other public hospitals, but women also have unknown oophorectomies when operated on privately, for the decision depends entirely on the doctor performing the operation. Almost fifty per cent of women I questioned who had undergone hysterectomies were unaware if they still had their ovaries.

As I lay in bed, I decided to write an article for the *Women's Liberation Newsletter*. The sister pulled the screen around the bed to prevent the light from disturbing the other patients.

It is now 10.30 p.m. and the ward has been in darkness for an hour. Saturday is a quiet day and only two emergencies were brought in. This is the "gyno" ward at the Queen Victoria Hospital; the ward where women come who only have "women's troubles". The continual stream of women entering and leaving the ward arouses all that I feel within me.

Seven women told me they had hysterectomies, the older women like myself also had their ovaries removed. Others came in suffering from miscarriages and a multitude of other women's troubles. At one stage, the ward resembled Myer's bargain basement: a young woman was brought in during the evening, the blood was flowing from her body and there was a great deal of running about and emergency treatment by the nursing staff and doctors. All of the patients woke up, despite the sleeping pills dispensed to all, how could we sleep when, within each of us, we knew that a woman's life was at stake? We were all silent and our thoughts were with our sister.

What can a woman say that would be fitting to describe the attention, care and concern shown to us by the nursing staff? It is impossible for me to put into words what and how I feel towards them.

One thought comes through all of the suffering witnessed. No woman should have to undergo this suffering alone. Should any woman be involved in a relationship with a man and this woman requires medical attention for her woman's troubles, then the man should be there to witness the operation performed and whenever possible assist in the nursing. For men to just turn up at visiting hours and see the women lying in the beds as if they are free from pain and discomfort is to release men from any responsibility towards women and our specific problems.

By coincidence, while here, I am reading *Freedom for Priscilla*, which resulted from the research done by the author into the history of the Queen Victoria Hospital. What a struggle our earlier women doctors went through to establish the right to operate when necessary. All hospitals at the time prevented women doctors from practising their profession when operations were necessary. But what has happened since then? Yes women doctors are

equal to the best that men have to offer, but is this good enough? It is not men who are having breasts, a uterus and ovaries removed. This is our specific problem and can we be satisfied to have our bodies mutilated by experts in order to survive? If men were losing a testicle as often as a woman is losing a breast, uterus or ovaries, would men be spending countless millions of dollars sending men to the moon, or constructing telescopes to gaze at the stars? We all know what the answer to that question would be!

It was so heartening to read the article in the last newsletter by the medical student. So much of the alleviation of our pain and suffering is up to the young women now doing medicine. Our medical sisters of the past had such a struggle to assert their rights to practise. That they were too busy doing this to then question the male medical standards established on women's bodies. Far more research is required and this needs money. Prevention is preferable to surgery. I was surprised at the questions put to me by several migrant women. One woman cried this morning when it was explained to her that her uterus had been removed. She does not understand any English. Another woman of her own nationality interpreted for the doctor. She must have been told prior to the operation, but she didn't know what was involved. She didn't want any more children but she, like several other women, thought their sexuality would now cease. I patiently explained their fears away.

The need to answer their questions is a vital matter, and one way of overcoming this problem is for women who have undergone these types of operations to be gathered together in the ward and a woman with this knowledge should conduct a discussion group to allay any fears the women may have.

Sisters, we need so much more money spent on research to do away with our pain and suffering. We must scream more loudly.

How conveniently men look after their own interests. Almost every woman who entered this ward was relating to a man, but where were they? The men who added to and were also

responsible for the conditions these women were enduring. They only called in for a brief visit, with or without a bunch of flowers and a kiss. They were not there when their women emerged unconscious from the operating theatre, they were not there when their women were racked with pain. It was the nurses, other women, who washed and assisted them to toilet. It's the old, old story . . . out of sight out of mind! "She'll be OK mate, the hospital will look after her."

Men don't want to witness the disagreeable results of what, to them, is considered to be their right; their conjugal right. Their pleasures must not be blighted and the hospital structure has been devised to enable men to evade their responsibilities to humanity, yet this is accepted as both "normal" and "natural". Our private enterprise system with its mania for profit welcomes the alienation of our hospital system for it is more important for men to produce profits for the capitalists than to be attending to their sick women and children.

It is interesting to note that the medical profession and hospitals show quite different attitudes towards pregnant women, as compared with women "only" suffering from "women's troubles". Pregnant women are in production; they are producing the next generation of wage-slaves for the business interests. In a society which is geared to production and profit only, pregnant women in this context are very important. They are, during pregnancy, encouraged to attend lectures where they can ask questions and are shown films to familiarise themselves with their productive situation. In contrast to this is the attitude adopted to women with "troubles". There are no lectures or films and there is no time for questions. In other words, you are not in production so you are of no value or importance. How ruthless the structures are which men, through the patriarchal capitalist system, have created. The tragedy is that men themselves often become destroyed by their own structures and can't even see it.

The time to leave hospital had arrived. We were not given any instructions on the post-operative care of our bodies, and we were not at any stage asked if there were any questions

we wanted answered. We were chopped open, closed up and sent home. It was a good feeling to get out of my bed attire and put clothes on.

I was suddenly amused by the trinket suspended from the chain around my neck. It was an ornamental fish, the sign of fertility, and all the patients enjoyed the joke as I said my farewells.

Almost immediately after leaving hospital, my head began to ache non-stop. It was some time before I learnt that this problem was due to the lack of hormones . . . the loss of my ovaries. I had visions of myself gradually becoming my old self again yet my head would not stop aching. I was becoming desperate and went to the Women's Health Collective. On arrival, I was delighted to see Bonnie, my dear friend who devoted her time to the collective. She embraced me and cried, "Zelda, why did they do this to you? You of all people. Why did they remove your ovaries?" She was overcome with emotion. I clung to her and also cried. "I didn't know. I didn't know they were going to do this. I didn't know they did this sort of thing to women," and I just cried.

Men, through the patriarchal capitalist society, have raped my labour. In the personal, they have raped my body and, through their institutions and structures, they have raped my mind. Despite all this suffering, and although my mind and body are now tired, only death will destroy my spirit.

More and more women are becoming aware of their own identity as people and, as they become so, they become aware of the violence of our male dominated society and its effects on humanity. We refuse to sit back and allow this lunacy to continue at our expense. Men have a choice to make and there are only two alternatives. One choice is to continue as they are already doing which can only lead to the death of our planet; either through war, pollution and/or a dearth of mineral resources. The other choice is to support women in our efforts to reconstruct our entire society.

We want a society free from all power structures and institutions. A society based on co-operation, not competition, and where all people are responsible for making the decisions

governing every aspect of their very existence. It is only within this type of society that human fulfilment, human dignity and human liberation can become a reality.

# *Afterword*

## INTRODUCTION

WRITING THIS BOOK was a feat in itself. For humans to survive in our society, we overcome our pain by different means but, in the main, we tend as time goes by to bury our hurt. When writing this book I had to bring forth the experiences of my past and relive them to enable me to describe the incidents in detail. It took over four months of writing, over four months of tears to complete the draft. My mother, who was still living at the time, kept on asking me why I was writing this book when it caused me so much pain. How could I explain it? I tried to make her understand why I had to do it, why I felt it was necessary for women to write truthfully of their experiences so that young women of the future will know the truth of their mothers' experiences.

I can understand why some women bury their experiences to the degree that it is almost as if they didn't occur but, unfortunately when this happens, we never learn from our experiences and tend to go on making the same mistakes or deny that they actually occurred.

When faced with the daunting task of writing the book, my feeling of inadequacy with written English, grammar and punctuation scared me. It was only when Barbara and Adriana, both university graduates, offered to advise and correct the work where necessary that I ventured forth. Both women questioned aspects of my work, forcing me to expand the writing in given areas. They assured me that my English wasn't as bad as I thought it was. Beata, too, gave many

hours of skilful typing.

After having written and rewritten the book, I reached the time when I would have to record the most difficult experiences I had to acknowledge – I had put it off until there could be no further delay: this was my experience of rape. It is interesting to note that when writing of the painful experiences of my life, rape proved to be the most painful to write about.

When deciding to publish the book myself, I was fortunate to have two Movement women experienced in publishing advise me on every step required. Initially I took the manuscript to two publishers but they thought the book would not be a seller or that it didn't fit into any particular category. It wasn't purely sociological, it was a combination of the lot.

As proof reader, I made over eighty corrections but, because the release date for the book had been announced, the woman who organised the printer was running behind time and, unbeknown to me, went ahead and printed the book without any of the corrections. Being very anxious to see the finished product, I felt ill when I saw all the errors. Now, after all these years, I feel that the errors were part of the learning process of my life and experience. In this new edition the errors have been corrected.

I started writing this book in 1974 and, after writing and rewriting in long hand for over two years, the manuscript was ready for publishing in 1977; the final touches being added in my hospital bed the evening before surgery – another operation.

I moved out of my flat for two weeks when the book was released. I was very aware of the power of men and was afraid. After some time, a friend told me that Geo intended taking action against me but nothing transpired.

Feeling extremely vulnerable, I was awaiting the reactions of the readers. When returning to my flat I began to receive phone calls from total strangers, women who rang to thank me and from others who opened up and told me of their painful experiences, I even got two phone calls from unknown men thanking me for my honesty.

Letters began arriving, some at great length, written as if to an old friend, some were extremely personal and all were supportive.

Now, after all these years, I am writing again and this time I have no more fears nor am I apologetic about my written English.

# 1. WOMEN'S ACTION COMMITTEE. BEGINNINGS OF WOMEN'S LIBERATION MOVEMENT. OPENING OF WOMEN'S LIBERATION CENTRE. CONSCIOUSNESS RAISING. *NEWSLETTER & VASHTI*.

> "*Vashti's Voice* published my first piece of fiction, I'm proud of that. What I owe to the Women's Movement, to the women in it (especially the older ones, whose courage, wisdom, humour and honesty still astonish me) is a debt I can never repay."
>
> – Helen Garner[1]

Twenty-five years have passed since chaining myself to the Commonwealth Building in Melbourne and a new generation of girls have grown into womanhood. What do young women know of women's history? What sort of a society are these young women experiencing today? How different was it twenty-five years ago? What brought about the changes?

In lieu of an in-depth history of the period from 1969 to 1976, I can only outline some of the events and activities which took place and try to capture the dynamic atmosphere which prevailed during the seventies, ultimately creating a change in the culture, a change which was enhanced by International Women's Year and beyond. A change whereby women, instead of being on the periphery of society, are beginning gradually to move into decision-making structures in almost all areas of endeavour.

This advancement has not been automatic nor without resistance, but with the encouragement, inspiration and painstaking persistency of women determined to make the changes. Men have at last been forced, coerced, cajoled and even convinced to make way for some women to enter the spheres of influence, even though this number is far from ideal and the going is still tough.

The Women's Action Committee, in one of our early actions,

---

1. From the Preface, *Voices of Vashti Anthology*, Vashti Collective, 1986.

defied the power of the Education Department. I was told of a young, single, pregnant teacher who was intimidated by the male principal of her school and resigned from her job. I brought this issue to the Women's Action Committee and we decided, after discussing the desperate need of women to have suitable employment when in this situation, to demonstrate outside the Education Department offices. We notified both the Education Department and the media of our intentions and our reason for the demonstration.

The Victorian Liberal Government Minister of Education at the time was Mr Lindsay Thompson who, in light of the publicity, made a statement to the press explaining that he would not grant confinement leave to single, pregnant teachers because "the government was anxious not to do anything to undermine the sanctity of married life."[2]

This statement caused an upsurge of opposition to the government, resulting in a spokesperson from the Education Department contacting me with the news that they were going to inform all school principals that single, pregnant teachers would be entitled to confinement leave. Having said this, he asked if we would go ahead with our protest. I explained that we would go ahead as planned because we wanted the Education Department to make this information available to the press so that all teachers would know of their rights.

Just prior to the demonstration, I received a phone call from a journalist saying his newspaper had obtained notification from the Education Department that approval for confinement leave for single, pregnant teachers had been granted and they were publishing this information. Our protest was called off.

Would the young women of today employed in the Education Department or elsewhere consider our behaviour at the time as being extremist or over the top? Would they think the action was justified? Most teachers would be unaware of how this change to the rules took place. We are never taught about the methods used to change the rules. This type of

---

2.  "Unmarried teachers get baby leave", *Sun*, 13 February 1971.

history could encourage the empowerment of people and make us a threat to those in power.

Despite what some people might now say, the press, and those from the whole political spectrum, looked upon me and the women of the WAC as a group of way-out extremists and expected us to be a seven-day wonder, something that would disappear overnight. How wrong they were.

Prior to the establishment of the Women's Liberation Centre early in 1972, several small Women's Liberation (WL) groups were already meeting in universities and around the inner suburbs of Melbourne during 1970 and 1971.

On 20 November 1971, the first pro-abortion rally saw a unification of these groups. The Women's Action Committee – which was developing with the various WL groups into a larger WL Movement – together with the newly formed Abortion Law Repeal Association (ALRA), organised the demonstration. Other women's organisations were invited to participate.

A later *Women's Liberation Newsletter* when reporting this demonstration noted that the speakers were Beatrice Faust (committee member ALRA), Sheila Wynn (secretary ALRA) and Jill Jolliffe (Carlton Women's Liberation). Sheila Wynn was also a member of the Women's Action Committee.

We were all excited when 500 women attended the rally and headed off on our historic march through the streets of Melbourne. As mentioned earlier in this book, the Melbourne *Herald* of that Saturday evening covered our demonstration with only sixteen words, one inch in a rear page.

The Abortion Law Repeal Association opened a centre in St Kilda, called Problem Pregnancy to help and advise women with unwanted pregnancies. The centre was open every week-night and was staffed by voluntary helpers.

With all of the activities taking place, it was impossible to cope with the demands made on Bon Hull and myself. The need for a WL centre became paramount. We were organising to open the Centre when Germaine Greer visited Melbourne

in January 1972 to promote her book, *The Female Eunuch*. I recall her attendance at our public meeting held at the Assembly Hall on 2 February 1972. Germaine, who had declined to speak, expressed her pleasure with the evening, commenting that she never believed she would see the development of Women's Liberation in Melbourne. She relieved a mother in the audience of her crying baby and, holding the infant in her arms, she walked up and down the entrance passage rocking the child until pacified.

Germaine's visit added to the interest already shown in the Women's Liberation Movement (WLM) and our Centre, which opened within weeks, was a place of joy as well as activity. Women came from everywhere and a roster of volunteers was organised to cope with the requests for advice on everything from marriage problems, eviction threats, violent husbands, the need for sympathetic doctors and abortion services, to speakers needed for schools and organisations.

This constant request for speakers had its own difficulties. Some women were already doing research into the various areas affecting women but, in one instance, we had a woman who undertook speaking engagements on all topics assuming she knew it all. We just didn't have the information available which women have today.

Consciousness Raising (CR) groups began to flourish all over Melbourne and our roster women had the responsibility of putting women in touch with their nearest group.

Requests were coming in for written material and we rapidly ran off numerous copies of various papers, some written by ourselves while others were copies of overseas publications. There was always so much to do and, with most Movement women being students, housewives or fully employed, some of us were flat out.

Consciousness Raising was the source of so much of our politicisation in the Women's Liberation Movement; a process we had already started in the Women's Action Committee. It was in CR that we discussed the reasons for getting married and having children. It was where we discussed why we wore make-up and what we felt about ourselves without make-up.

It was where we talked about our relationships with men. We discussed our sexuality, extra-marital affairs and if these helped or hindered our marriages. We talked about our relationships with parents and siblings. In CR a woman spoke of her businessman husband who, when wanting a quick divorce, sent his mate around to molest her. This was done in the hope that he would not only get a quick divorce on the grounds of adultery, but so that he could also retain the whole business, the home and the money to start afresh with his mistress.

In CR a woman talked of being forced, when young, to forgo her university scholarship and do nursing so that her two young brothers could continue their education at Geelong Grammar. We heard about a world famous male comedian whose sister was made, as a child, to polish his shoes every morning and see that his shirts were ironed. He became world famous, she became a housewife. We heard of the sixty-year-old woman who, having been married for forty years, had never experienced orgasm.

While most of the women were ready to speak of their intimate painful experiences, it took two years for some women to reveal their pain. We discussed all topics in depth and avoided simplistic or superficial answers. There were women who couldn't cope with the unravelling of barriers and, feeling too threatened by the revelations of truth, rapidly withdrew, however, the vast majority of women remained in CR. These women were no longer prepared to pretend that all was well. We were seeking change, real changes, not just a few extra crumbs on our plate. We had to acknowledge all the shit we carried around in our heads and hearts and, in doing this through CR, we were able to come to life.

The difference between CR, as practised then, and what most counsellors practise today is that in CR we politicised the process. We were opposed to the continuance of privatising women's suffering and we organised CR differently to ensure this didn't happen. We did it in groups; we discussed our personal experiences; we discussed reasons for problems, bringing in the role of the state, church and culture; we discussed what we could do to change the institutions and society to stop this

suffering. We wanted real change, no more band-aids.

Through doing CR, we realised that our pain was not a personal problem but a social problem and therefore political; we realised this could only be changed when working together. It was our sharing of intimate experiences which bonded us together. For me, apart from feeling wonderfully free, CR gave me the courage to confront patriarchy in all its forms, even when promoted by women.

I can recall reading, "The Myth of Vaginal Orgasm", an article which appeared in the *Second Year Notes*.[3] This article caused a great deal of discussion among women who had been silent about their sexuality for too long and we came to realise that our sexuality had been determined for us by men to suit themselves and we had been silent for fear of being considered abnormal.

When we were established in the new Centre, it was necessary to get as much written material as possible for distribution to meet the continuous demand and Liz Elliott, a young medical student, and I wrote a booklet called, *What do you really know about sex?*. Liz did all the diagrams and we sold several thousand copies. While writing of the need for a good relationship, this booklet spelt it all out. It explained the importance of the clitoris to a woman's sexuality. We gave explicit instructions on techniques emphasising that women's needs vary but, even knowing this information, it was necessary for women to articulate their needs to their partner.

A man called into our Centre after it had opened. He was trying to trace the previous occupant who had hired his services to erect partitions and who had never paid for them. We were unable to help. He asked if we were interested in buying the partitions and then browsed around looking at our reading material. He wished to buy the booklet on sexuality and went away with a copy.

This man called in a few weeks later and was effusive in his praise of the booklet. It appeared that his wife had been under

3.   Anne Koedt, Ellen Levine & Anita Rapone (eds), *Radical Feminism*, Quadrangle/The New York Times Book Co., New York, 1973.

psychiatrists as well as their local doctor for some years and all to no avail. Speaking on behalf of himself and his wife, he thanked us for the booklet and offered the partitions for free.

While women were busily engaged in CR, group activities, individual actions and attending meetings at the Centre, our newsletter helped keep it all together. Getting the monthly newsletters, and *Vashti's Voice: A Women's Liberation Newspaper* (*Vashti*) our quarterly magazine, out on time took a great deal of effort and commitment on the part of the women involved.[4]

The newsletter was a vital part of the Movement, being the vehicle for notifying women of all that was going on and what was forthcoming. Women depended on the newsletter to keep informed, particularly if they were unable to attend regular meetings. Obtaining the newsletter strengthened our feeling of belonging, our feeling of our togetherness, and enhanced our bond with one another.

The late Kath Gleeson who was involved in the *Vashti* Collective wrote the following to the *Newsletter* Collective in 1974:

> Dear sisters,
> I have read very carefully the newsletters over the past six months and I want to say thank you for the unflagging persistence, energy, enthusiasm and honesty. I understand how hard it is to use your time, your mind, your tolerance, over and over again in consistent effort. You have not at any time let the Movement down. To work as a collective as you do, to make collective decisions, which must at times have transcended personal views held, is to me a practical example of translating the personal into the political, the theory into action.
> (*Women's Liberation Newsletter*, July 1974, p. 9.)

*Vashti*, while being a forum for writings of our women, also published articles pertaining to feminist culture, poetry and information from overseas.

---

4.  Contact Jean Taylor, Women's Liberation and Lesbian Archives, PO Box 168, Brunswick East, 3057, Tel. 387 6610 for access to copies of the *Women's Liberation Newsletter* and *Vashti's Voice*.

These two publications were of the utmost importance to our movement for where else could our voices be heard? Where else could we have expressed our thoughts, our feelings, our concerns or our anger?

Where can we turn today when wanting to write of our very being, our innermost thoughts and feelings?

## 2. EQUAL PAY CASE. REVIVAL OF INTERNATIONAL WOMEN'S DAY MARCH.

The struggle for pay justice for women continues today just as it did in years gone by.

Muriel Heagney and Kath Williams spent years of their lives trying to get equal pay for women. I remember Kath Williams constantly speaking about equal pay during the 50s and the men paid as much attention to her then as they did to me in the 60s.

My initial chain-up in 1969 was over the issue of pay justice. It seems such a long time ago since I approached the Union of Australian Women (UAW) for support during my chain-up. Betty Olle turned up, as did Yvonne Smith, a UAW member and co-worker at the Meat Industry Union office. Val Ogden also came to give me moral support while they displayed posters advocating equal pay for work of equal value and an equal minimum wage.

Dianne Sonnenberg, with whom the possibility of the chain-up was first considered, and the woman JP who attended the chain-up in case of my arrest, all played a part in the action I took and, although I had the courage to do what I did, I could never have done it without the support of those women. Individuals alone do not make history.

The young women of today are unaware of the tremendous campaigns we held and the constant energy we spent in order to obtain a wage for women to live in dignity.

At that time (1972), I was living alone in a flat. I had to pay the same electricity bill as a single man, the same gas bill, the same weekly payment for the flat, the same rates, the same registration for my car, the same price for food etc., so why should I not get the same pay for doing the same work? Or work of equal value? There are no discounts given for being a woman.

The WLM and the UAW were both placing submissions before the Equal Pay Case and women were asked to attend

each day of the hearing to show the male-dominated establishment that our opinion had considerable weight.

It was suggested that groups might like to accept projects on particular issues at given times with all groups working on the same project at the one time, thus giving cohesion to the Movement. Projects suggested were: July/August – equal pay; September/October – community controlled child care. Other proposed projects included actions against sexist advertising and actions in support of abortion on demand.

The following paragraphs come from various issues of the *Women's Liberation Newsletter (WLN)* in 1972. They indicate the commitment needed at the time, especially when most of us were fully employed, students or housewives living in the suburbs.

> WLM Equal Pay Group in conjunction with UAW will issue a pamphlet in Italian, Greek and English which will be distributed at factories. Representatives of the Women's Movement will *march* with the Unions on the opening day of the case.
>
> (July 1972, p. 3.)

> The Equal Pay Case is expected to be held in the last week of July. Folders were distributed to groups to give to women, preferably those who are poorly paid and working in factories. Groups should contact the Centre for further supplies of folders.

> **Saturday 8th July.** A workshop was held at the Centre to make posters on equal pay.

> **Saturday 15th July.** In conjunction with the UAW, we met at 10.00 a.m. at the City Square with posters. About 40 women displayed equal pay posters and distributed pamphlets.

> **Saturday 22nd July.** The day of the tram ride.
>
> (August 1972, p. 2.)

This was my second venture on tram rides where we paid a percentage of the fare to the conductors but, this time, because there were far more women, we occupied two trams.

The tram ride on July 22 was a great success.

About 50 women met at 10.00 a.m. in the City Square and, as on the previous Saturday, distributed leaflets around the central shopping area. Response to the leaflets and the issue of equal pay generally was most favourable.   (August 1972, p. 4.)

**Equal Pay case day.** (Date unknown)

There will be a march to the court. Please come if possible. The unions may be joining us in this action. Women are needed to sit in the court throughout the case. A good way of bringing attention to the issue is for those women in attendance to wear T-shirts (white) with Women's Liberation or our symbol or something similar written in Texta-Colour as posters and placards will not be allowed in the court.

Women are needed to help fold leaflets on equal pay between 10.00 a.m. and 3.00 p.m. Tuesday to Friday at the UAW ...

**Finance**

We have to find $100, our share of the cost of the equal pay leaflets.                                               (August 1972, p. 2.)

**Equal Pay Action**

... The following are some suggestions from the equal pay committee. Groups can take the following actions.

1. Give out equal pay pamphlets (which are at the Centre) to women in factories. We suggest before work as women might talk about it when they are at work.

2. Interview the management of local places where women work – ask them what wages women get and what positions they hold. Give them your views. Do the same at government institutions where women work.

3. Write an article on working conditions, with special reference to local conditions if possible, and try to get it published in your local paper.

4. Interview local councillors and MPs to get their ideas and add them to your article.

5. Hold a demonstration in your local shopping centre – speakers?

6. Write to the main papers.                              (August 1972, p. 4.)

In 1972, Sylvie Shaw, with the assistance of Bon Hull, Alva Geikie and Libby Brook, produced our submission on behalf

of the Women's Liberation Movement. Sylvie presented it to the Arbitration Commission in two parts: one in support of equal pay for work of equal value and the other in support of an equal minimum wage. The UAW also presented a submission. I am unaware if any other women's organisations presented submissions.

We succeeded in obtaining equal pay for work of equal value but missed out on an equal minimum wage. To have succeeded in one without the other was (as described earlier) almost useless. Nevertheless, we had laid the foundations for an equal minimum wage and women were determined that this would be achieved; this was the next step.

When dealing with the judgement of equal pay for work of equal value, *how on earth do you prove equal value*, when it is automatically assumed that whatever women do is of little value?

As a result of the equal pay decision, the trade unions were in a situation where they would have to lodge a separate case in each award and argue a case of comparison with an area of men's work in order to establish equal value.

This resulted in very little being done. Fighting such a case did prove to be extremely costly as the nurses' case of 1985–86 indicated. In this case Justice Maddern finally ruled, "The Commission affirms the 1972 equal pay principles but rejects the idea of comparable worth." It took from 1972, when the decision was made, to 1986, when really put to the test, for the "idea of comparable worth" to be tossed out.

Referring back to the newsletter of 1972, after the completion of the Equal Pay Case, Sylvie organised a series of lectures on comparative political systems and basic economics. There was always plenty to do if you were interested. Summing up her views in the newsletter, Sylvie wrote:

> We've done so much this year. It's been a year of learning and educating, finding our way and consolidating; and building a powerful national movement. It's been a time of developing confidence and acquiring the courage to stand by our conviction against ridicule and criticism. It has been rewarding!

The Movement seemed to get right off the ground with the visit of Germaine Greer and the publicity surrounding *The Female Eunuch*. Who remembers the meeting in February? – torrential rain outside, sisterhood developing inside. Then the March 11 International Women's Day (IWD) expressing our solidarity for sisters the whole world over . . .

But what came out of 1972 was not the action or demonstrations, although these were memorable, it was the feeling of being part of a growing awareness, of a developing movement, and of knowing the real significance of sisterhood!

(December 1972, p. 3.)

The UAW had traditionally celebrated IWD with a luncheon. The IWD march, mentioned above by Sylvie, really was a memorable event. It was organised by our enthusiastic WL women to celebrate our day and it reignited the spark IWD had lost over the past decades. There we were: 3,000 women marching, singing and dancing through the streets of Melbourne, rejoicing in being together. I found myself marching beside an elderly woman of the left, Bertha Laidlaw, and I held her hand and asked if she'd ever thought she would see an IWD march like this. She expressed her joy at being part of the experience. International Women's Day had come to life again.

With all demonstrations and protests there is a certain amount of tension and anxiety involved, particularly for those who have organised the event, but we always attempted to make our protests a source of fun and pleasure and, most of the time, we succeeded in doing so.

The Women's Electoral Lobby (WEL) was also established in 1972. When attending the second meeting at Beatrice Faust's home, I was very aware that it would be a middle-class organisation and, although there was an important role for such an organisation, I knew it wasn't for me.

In April 1974 we were gearing up for the Minimum Wage Case campaign. This campaign was essential if we were to be successful. Our newsletter printed the following:

**Equal Minimum Wage**
This is $60.50 for men only.
Lots of women in factories get only $40.50.
Demo. Wednesday 10 April 2.00 p.m. GPO steps.
Saturday 20 April 10.00 a.m. City Square.
Equal minimum wage demonstration.          (April 1974, p. 12.)

In a lengthy article I made several suggestions which I felt were needed to begin changing the structures, two of which were:

a. One rate of pay for the job performed (not equal pay for equal work). This would break down the present Arbitration Court and ACTU policy of the wage structure being based on the male bread-winner family unit and enable women to be less dependent for their livelihood on men. There are other beneficial factors too numerous to mention in detail.
b. Equal minimum wage for men and women.
                              (attachment to *WLN*, June 1974, p. 4.)

During 1974, The ACTU claim before the Arbitration Commission for an equal minimum wage was heard with the Australian Council of Salaried and Professional Associations (ACSPA) supporting the ACTU claim. The WLM campaign for an equal minimum wage had started two years previously when presented to the Arbitration Commission in 1972. On this occasion, the National Council of Women in Australia, the UAW and WEL presented submissions. This was the first time for WEL and Edna Ryan spoke for the submission on behalf of WEL.

This time we were successful – the continuum; the combination of forces at work; the process of the changing culture. Over the past sixty years, many courageous women had fought for wage justice but it was only when women were more plentiful in the paid work-force and were marching the streets, handing out leaflets, demonstrating outside the Arbitration Commission, bringing up the issues at union meetings, and doing this all over Australia, that we succeeded. Yes we changed the culture and this is how we did it.

Will this unity of purpose become fragmented by enterprise bargaining? We must be alert and watch out, for the wheelers and dealers are very experienced at using methods which divide and conquer.

On examining differences in the present day pay rates (1994) between men and women, we find that, although the gap has been closing over a number of years, the average take-home pay for women is still far behind. This is due, in the main, to the extra payments men earn in overtime and penalty rates, and the lower take-home pay of huge numbers of women in part-time jobs.

Most of the jobs I had during my years of paid employment were in small businesses. This is where the vast majority of women work and this factor makes it difficult for women in the current wage-fixing system. Without the safeguards of the trade unions in enterprise bargaining and the award system, these women find their conditions and salaries being gradually eroded; the poor getting poorer. In remote areas where unemployment is rife, many women, not knowing what they are entitled to, are working below the award rates of pay and have been doing so for many years.

# 3. WOMEN'S LIBERATION MANIFESTO. WOMEN'S COURAGE.

By March 1973 we had decided on a manifesto for the Women's Liberation Movement (*see Appendix 1*). When reading through the manifesto now, parts of it seem so ordinary, so everyday, yet at the time when it was written, only twenty-two years ago, it was extremely radical. We made it even more radical by our continual public protests which drew attention to the injustices we endured.

The impetus for action and the sisterhood which bonded us together gave women the encouragement and courage to become active on behalf of all women wherever they happened to be; whether it be in their workplace, union, local school committee or church.

The power to act had to come from within ourselves and, because there was never any compulsion in the Movement, women came to a stage of empowerment through sisterhood. Many women, as individuals, undertook courageous actions, most of which we will never know, but the following two experiences indicate the type of commitment and courage which occurred at that time.

The late Kath Gleeson was a working-class woman who grew up in a left-wing family and became a communist of many years standing. As manager of the International Bookshop, Kath was able to transform the shop from a purely sectarian Communist Party bookshop to one which held stock covering all aspects of radical material, including the largest selection of feminist books in Melbourne.

Kath's reason for not initially joining the Women's Action Committee was that the Party wouldn't approve because of her position at the bookshop: there was also the possible reaction of the customers.

Kath was a great support to me during the early part of WAC and, being friends, we shared our thoughts and concerns.

As time went by and the Women's Liberation Centre opened, Kath became involved in the Women's Movement and believed she could have some positive influence on the Communist Party. She became a member of the state committee and was asked to give a report to them on the Women's Movement.

Putting a great deal of work into this report, Kath anguished over its content and was determined to enlighten the Communist Party on the authenticity and radicalism of the Women's Movement. The importance of this document was more than just a report to Kath, it was a guide to the future.

Being aware of Kath's feelings, I was eager to hear the result and met her after work over a drink. When asking her what had happened, she remained silent; just drawing on her cigarette. Kath, who normally sparkled, sat there silently. She never did tell me what happened.

Kath resigned not only from the state committee but from her membership in the Communist Party. She also resigned from her job at the International Bookshop. This was the price some women were prepared to pay for their commitment to the Women's Movement. Women from the whole political spectrum were moving.

Marjorie was a petite woman, the mother of two children, and with a husband who was an upwardly mobile executive going places in the corporate world.

Christmas was approaching and the annual break-up dinner organised by one of the Chambers (industry or commerce) was being held for men only.

Marjorie was angry. She felt that the work done by wives towards the maintenance of their executive husbands' health, appearance, home and children was totally ignored and she made her views clear to her husband. Although agreeing with her, he said he had no control over the organisation or the event. (He wasn't prepared to challenge the rules.)

As the night wore on and Marjorie sat at home alone with the children, she seethed over the injustice of being ignored. She knew of the effort wives made to assist their husbands'

careers while often sacrificing their own and, having given the matter some serious consideration, she decided to act. She hastily made a pair of sandwich boards out of cardboard and on these she expressed her views. Ensuring that the children were asleep, she made her way to the venue and, when arriving there, she donned her sandwich boards and entered just as the stripper was performing. Marjorie walked on to the floor and turned around slowly to make sure all the men could read what she had to say about their men-only dinner.

The stripper stopped her performance. The proceedings came to a halt. When approached by some of the officials, Marjorie stood her ground and, speaking for all wives, she voiced her opinion on the role of wives in their husbands' careers; their sacrifices and lack of recognition. More men began to gather around and her husband was forced into joining them. Their only excuse was tradition; this is how it had always been. They had never thought of changing the rules.

Only one man had brought his wife to the function and, congratulating Marjorie on her courage, he told her that, having only one ticket, he and his wife had agreed that if she was prevented from entering the hall she was going to stay while he returned home. That too would have taken courage.

## 4. WOMEN'S LIBERATION GROUPS.
## SHE CONCERT.

Jan Harper, one of the members of the Women's Action Committee, became a member of the Box Hill Consciousness Raising Group when the Women's Liberation Movement got under way.

The women of this CR group consisted mainly of mothers who were very concerned about the sexism in children's literature. After discussing this problem, they decided to investigate the possibility of producing and publishing non-sexist children's books.

Jan was a driving force within the group and encouraged the women who enthusiastically researched the material required and went ahead and published *The Witch Of Grange Grove*.[1] The book proved to be so popular that further editions were printed.

They established themselves as the Women's Movement Children's Literature Co-operative and applied for and obtained a grant of $13,000 from the Schools' Commission which financed the publishing of four more books. The women, better known under the name of Sugar and Snails Press, illustrated, edited, published and distributed their own books. Over a period of some years, they went on to publish more than fifty books.

These women were the first publishers of non-sexist books in Australia. Most quality children's books now available are non-sexist. To have been able to successfully perform this venture indicates the ability, the skills and potential women in the suburbs possess when given the opportunity and support needed.

Many different groups developed within the WL Movement to deal with numerous issues affecting women. A teachers'

---

1.  Judy Bathie, *The Witch Of Grange Grove*, Sugar & Snails Press, 1974.

group decided to work in two main areas: within the class-room i.e. teacher–student attitudes, student–student attitudes, and subject material; and dealing with conditions which affect female teachers of all divisions.

At Monash University, women wanted a women's studies course. They already had a course which was being held with-in the Sociology Department, but they wanted a course that was open to all women and provided a creche for children.

All universities had active WL groups; the women were not only involved within the university but also as individuals in the various activities organised from the Women's Liberation Centre.

The St Kilda WL Group went to the state council meeting of the Liberal Party and demonstrated for the repeal of all laws concerning prostitution. This protest received a great deal of publicity for the Movement and the issue.

In the area of sport, a 1973 newsletter reported that several squash centres would not let women past the front door. The Monash Squash Club was asked to boycott these clubs and refuse to play in the championships with them. Are there any squash clubs today which close their doors to women?

A nurses' group also formed to deal with problems associ-ated with their work and how shift work affected their lives.

Early in 1973, the South Yarra WL Group organised a "Speak Out" at the Assembly Hall, where Melbourne women were invited to attend and speak if they wished to do so on issues affecting them. One never knew when organising this type of activity how well the women would respond.

There was no need for concern about attendance at the Speak Out, the hall was packed and women from all walks of life not only attended but many also stood on the stage in front of an audience and spoke of their frustration, pain and anger: the feelings and thoughts they spoke of covered a vast area of women's experience, from the home, employment, and the medical profession, to general and psychiatric hospi-tal treatment.

Many women were stunned by the revelations; revelations

which were confirmed by nurses and doctors in attendance who were prepared to go on the stage and speak.

It may be difficult for young women today to grasp the enormous courage it took for women, only twenty-two years ago, to stand up in public and make themselves vulnerable by revealing intimate details of their lives in public. These women, by doing what they did, were making their experiences political. When enough women openly acknowledge their pain and suffering, society is forced to do something about it. Women's magazines of the time did not print articles about women's sexuality, abortions, contraception or the exploitation or oppression of women. Times certainly have changed.

Apart from the serious side of the Women's Liberation Movement, we also had a lighter side. Many socials and parties were held which helped to raise badly needed funds. Apart from all the work we did, we also had to pay all the expenses. Women's dances were organised which were great fun and most enjoyable; I loved dancing then and still do. We introduced dancing for the pleasure of it and partners were not necessary, we could each do our own thing or even join up with others in larger groups.

I recall going out to a very conventional "couple" function with a group of women and we decided that, when the music started, we would all get up as individuals and do our own thing, establishing a free and spontaneous atmosphere. We had a great time and it wasn't long before other women whose husbands couldn't dance joined in with us. Before the night was over, even some of the men overcame their inhibitions and joined in the fun.

It was around this time that I had the following experience; one that was very telling as well as humorous. It occurred while I was working at the mail exchange and I feel that I can now write of this incident without fear (I hope) of getting the young woman concerned into trouble.

On this particular evening when visiting the John Curtin Hotel after work, three Russians – two men accompanied by their young woman interpreter – who were guests of a trade

union were also socialising there. The secretary of the host union introduced me to the guests as a member of the Postal Workers' Union then departed.

Although speaking of my membership in the union, I told the young woman about the Women's Movement in Australia and of our interest in the conditions of women in other countries. After telling her officials the details of my conversation back and forth from English into Russian, one man smiled and spoke. He understood what we were on about and, through the interpreter, said that your struggle for women's liberation would also lead to the liberation of men and children.

The other man, very stern and glum, began to speak and I waited for the interpreter to translate. She started off in her very concise English and it went something like this. "Our women in the Soviet Union have equality in every way. They have equal pay, they get the highest jobs, they are treated as equals in every area." The interpreter went on and on with all of these wonderful claims this man was making and finished up with, "and that is not true." She said this in the same tone of voice. I thought I was hearing things and desperately wanted to laugh but couldn't. I had to control my feelings as if nothing untoward had happened.

We decided to run a concert – a concert with a difference. The She Concert was held in the large Melbourne Town Hall and organised to take a broad view of women's history in song, from the early ballads to current demands for equality, from the lovelorn victim of the male seducer's charms or the woman dying for love, to Helen Reddy's "I am Woman". Glen Tomasetti, Margret Roadknight, Jeannie Lewis, Sue McCullock and the One and Future group were the performers. It was a memorable evening.

Jo Phillips wrote of her thoughts and feelings about the She Concert in the newsletter:

> It was all too much to take in at once; not only the songs, the poetry, the apparent ease with which everything flowed, the beautiful voices, the message which became clearer as the

evening climaxed with the Freedom Song . . .

"Oh freedom – Oh freedom – Oh freedom over me!" which brought almost everyone to their feet, clapping, singing, moving with the rhythm and the force of it; and kept them up for the finale – "I AM WOMAN" . . . Congratulations.

The success of the whole night created a euphoria, not only in the women who worked so long and hard to put this real happening together, but in all of us fortunates there to see it, hear it all "happen".

The Movement got it together. The Movement made it happen. It was our public "coming of age". It was an historic demonstration of our solidarity – our togetherness – and our effectiveness, particularly in this medium. The effective use of talent, and the freedom to use it this way (our way) both collectively and individually as women; and the effective contribution to culture by and for women (but undoubtedly enjoyed also by men and non-feminist females!).

This concert showed how delicately, but also pointedly, we can give out the message of our freedom . . .

That the message was effective was evident from the *Age* review next day. The spontaneous response of the audience was evident to us there on the night. (August 1973, p. 5.)

I too felt like Jo on this wonderful evening. The concert made our efforts seem worthwhile. As with all our public events, we had a feminist book and magazine stand where our literature was on sale and we took turns watching the stand so we could all enjoy the great performance going on in the hall. Towards the end of the night, when the books were packed away, I entered the hall where I stood at the back holding a bag of cash in each hand – the night's takings, and, with tears in my eyes, I gloried in the joyousness of the women in the grand finale.

## 5. PROBLEMS WITHIN THE WOMEN'S LIBERATION MOVEMENT. THE SPARTACISTS.

I don't want to give the impression that all was love and light in the Women's Liberation Movement. On the contrary, when you have an open door policy and no formal structure, you can finish up with the tyranny of structurelessness which leads to a lot of frustration and anger.

Alva Geikie in *Vashti* of March 1973, wrote of her frustration at the poor attendance of women at committee meetings. She mentioned the great attendance at the abortion rally and the rally to support Lamb and McKenzie in their bid to have a private Members' Bill to decriminalise abortion but she pointed out that, during the week, committees were often poorly attended. Alva was a member of both the WLM and WEL and, being impressed by the amount of organisation in WEL, she suggested that more organisation was required in the Women's Liberation Movement. I wrote the following article in 1973 which explained my feelings at the time.

For some time now, I have been feeling a growing anger and resentment to women within and without our movement who refer to our movement as middle class.

This continual use of the term middle class makes me feel as if I don't exist. Many other women like myself who work in industry (as apart from housewives or professionals) must also feel like I do.

We have time and time again heard the expressions like "How are we going to reach working-class women?" or "What can we do for the working-class women?" There are women who are not industrial workers who proceed to tell all of us so-called "middle-class" women what working-class women want. In my anger, I have asked myself why am I ignored even though all the women know I am an industrial worker? It is just as it was in the male political scene. Why are all of the women in the Movement who work in offices, shops etc. being told they are middle class? It suddenly hit me this morning like an explosion

and this is why I am writing down my thoughts today.

Men and women who ignore members of the working class do so because they consider the working class to be inferior human beings. To their way of thinking, the industrial working class, whether male or female, are considered to be ignorant, stupid, inarticulate and not interested enough to be involved or present at any sort of meeting or organisation.

So when we, the industrial working-class women in our movement come to our meetings, because we are not stupid or afraid to speak our mind, we are not seen as working class and, in the minds of our sisters, have achieved middle-class thinking status as we no longer fit in with their concept of the ignorant worker. These women cannot accept the fact that industrial working-class women are intelligent and able to express themselves in a manner understood by working-class women. What we say concerning our women in the work-force is ignored or, even worse, our judgements are rejected.

As more and more working women enter the Movement and become aware and articulate, they cease to be seen as working class and the cry continues, "Where are the working-class women?"

The psychology of this middle class or politico thinking shows, in fact, a conscious or unconscious contempt of industrial working-class women, and sees us as unable on our terms to organise and evaluate our own struggles; in other words, we need to be led and taught. "Take notice, we know more than you, we are politically and/or formally educated." Just the type of thinking that men feel towards women (second-class citizens).

It is now argued that all women (all women work: housework etc.) should be part of the recently established Working Women's Coalition. However, it was, and rightly so, accepted without any debate or objections that teachers and nurses have individual groups where they can discuss and assist each other with their own specific problems.

As an industrial working woman who resents being considered middle class, I felt that if we, the non-professional working women got together in a group, we could do the same as the teachers and nurses. But NO! We must accept all interested women.

Is it because we are considered to be too unintelligent to deal with our own specific problems? Are teachers and nurses considered to be more intelligent and capable of dealing with

their own problems, or does the WWC afford an opportunity for do-gooders and politicos to have an ego trip (our leaders, teachers and guides)?

What a contradiction – and who makes the standards when questioning our ability?

On the one hand we are all "middle class", but when industrial working women want to get together to discuss our own specific problems, we are incapable of doing it. Why? Who places upon us the standard of tertiary education or party political nous as a necessary prerequisite?

Already in our movement one working women's group has become defunct. The group was originally mooted by non-industrial working women. The few working-class women involved soon withdrew feeling that the group was artificial. Now, in attempting to involve industrial women workers for a second time, we are told we must accept all women.

Our movement could not survive without the continuous and valuable contributions of our intellectual sisters. We, the industrial working women recognise this contribution and would never consider ourselves to be judges of their specific situation, nor would we underestimate their ability to deal with their specific problems.

If we wish to involve working-class women in our movement, then we must be given the right to deal with our own specific problems, a right that you already have.

Sisters, our movement embraces all women, giving women the opportunity to develop into knowledgeable self-confident women. Only by ridding ourselves from male thinking will we cease to underestimate the ability of [all] women.

(*WLN*, November 1973, pp. 5–6.)

When the Movement finally "permitted" us, the working-class women, to have our own group, we actually began to meet.

One young middle-class, professional lefty also attended. Everything was fine and, at our second meeting when we got around to discussing our job problems, she was silent. When asked what her job problems were, she said she didn't have any. Have you ever known of anyone without any problems at work? By saying that she didn't have any problems at work, she indicated that she wasn't prepared to either jeopardise her job by discussing anything openly or she didn't think we

working-class women had anything to offer.

I was dumbfounded for a moment and then let fly. I asked why was she at the meeting if she didn't have any problems at work? I went on to ask if she had come to help us poor ignorant workers with our problems and if she thought we were incapable of dealing with our own problems? How patronising can you get? Perhaps she was there to further her political party line?

The class structure does not in itself denote intelligence, just as wealth or poverty do not necessarily indicate intelligence; people in all classes, educated or uneducated (formal), may be intelligent or extremely ignorant – I have met them all.

As time went by, many working-class women in the Movement soon began to develop a greater feeling of self-worth and were then able to take advantage of the Whitlam Government's free university policy. They eventually got their degrees and moved into better paying jobs and ultimately became part of the middle class, a position most people aspire to, including most of the radicals.

The open door policy of the WLM proved to be very trying at times. Several women began attending our meetings at the Centre (not CR) who belonged to an extreme left-wing sect called the Spartacists. My experience of them in the WLM led me to believe they were a sect, as all they ever did was attend our meetings for the purpose of evangelising.

It didn't seem to matter what topic was under discussion, whether it be our relationships with parents and siblings or the role of women in novels, they never entered the discussion on the topic but always made another contribution; something Marx had written or some great pronouncement about capitalism. To make their contribution more effective, when breaking into small groups they would see that as many groups as possible had one of them in attendance, so it was almost impossible to get away from them, and when they had the floor, they went on and on in their endeavour to convert us.

Despite participating in some of our marches, they never attended any of our other functions and their mettle was put to the test when we decided to confront the Russell Street Police Headquarters with our affidavits stating we had undergone illegal abortions. We did this to challenge the abortion laws and presented ourselves as law breakers in order to be charged. I approached one of the fervent Spartacists with an affidavit form and asked her to fill it in and come along with us. She withdrew in fear and spluttered that she had never had an abortion. I assured her that it didn't really matter because the police couldn't prove anything against those of us who had undergone illegal abortions, but she wasn't interested in challenging the system; they were only into evangelising.

It was usual for three or more Sparts to attend our meetings so they could each take turns presenting their text for the day. Their preaching reached the point where women who had patiently listened to them month after month were at breaking point and presented the meeting with an ultimatum: either the Spartacists are barred from meetings or we stop coming. After more months of discussion, more preaching and futile attempts to get closer to these women, the vote was unanimous to debar the Spartacists from the Women's Liberation Centre. They were the only women barred from the WLM. Unlike the Sydney WLM, we prevented our movement from being split by these extremist left-wing women.

I had, over the years, witnessed groups of young "radicals" who used other people's organisations, work and money, to come in, take over and quite often become the kiss of death. Most of these people are now in well-paid jobs and part of the establishment; only a handful have gone on to continue their inner organisational work elsewhere.

## 6. WOMEN'S REFUGES.

When writing about the first women's refuge in Melbourne, I can do no better than quote excerpts from *Vashti* and the *Women's Liberation Newsletter*.

> A Halfway House Committee has formed within the women's movement. The aim of this group is to provide help and accommodation for women if and when they require it . . .
>
> The halfway house committee is endeavouring to establish houses in the inner suburbs to be used as refuges by women. We have approached various organisations in the hope of being given certain houses which are vacant.
>
> (*Vashti*, June/July 1974, p. 3.)

> Due to personal experiences, we as individuals were conscious of the large numbers of women living in an intolerable situation simply because they had no alternative . . .
>
> Most women in a trouble situation feel that theirs is an isolated and individual problem that requires an individual solution. But we feel and can see that this is an overall social problem that requires a solution on a widespread scale . . .
>
> We offer more than the conventional shelter because we are not going to try to sedate or tranquillise women into a state of acceptance or treat them as causes deserving charity . . .
>
> We intend not only to offer food and shelter, but help and encouragement that is required for a woman to establish a new lifestyle . . .
>
> We hope to provide women with the space to start helping themselves.
>
> (*WLN*, August 1974, pp. 8–9.)

No houses were forthcoming. By September, a house was established at Kew.

> The house which has been acquired will be forced to function on donations only for some time – we need individuals and groups to give reliable pledges of specific amounts per month or week, so that we can budget efficiently.
>
> The group also needs women who can be present at the

house on a roster basis – one CR group has offered to take at least one shift a month and to send two or three of its members to the house on that night . . .

In order to reduce the size of grocery bills, can groups get together and agree to buy a few extra items when doing their weekly shopping? If enough groups did this, a large amount of groceries could be collected at little cost to the individual. We suggest staple items such as coffee, tea, sugar, soap, toilet paper, canned food etc. (*WLN*, September 1974, p. 8.)

The Women's Movement Halfway House which opened in late September . . . is functioning extremely well and has already provided accommodation and emotional support for a large number of women and children in desperate circumstances.

The house is still operating entirely on voluntary donations and has received no financial help at all from government sources – more donations are urgently needed if the house is to remain open. More women are also required to attend the house on roster (particularly over the holidays) and women prepared to take one or more children at the house for a day or even a few hours . . .

A group of women in the eastern suburbs of Melbourne is already working towards setting up another house in their own area. The impetus for this move came initially from . . . the Nunawading Free Legal Service . . .

This group – called the Maroondah Halfway House Group – is now starting to look for a property where it can establish a halfway house. (*Vashti*, Summer 74–75, p. 3.)

Most of the women who worked so ardently for the first women's refuge to become a reality and function successfully were lesbians: lesbian women caring for and about heterosexual women and their children.

Welfare workers and the police were always referring women with children to these refuges only to find there was a limit. The demand far outweighed the facilities available.

Eventually, after a great deal of pressure and agitation by the WLM all over Australia, governments came around to accept some responsibility and women's refuges are now, in the main, funded, although insufficiently.

337

## 7.   HEALTH COLLECTIVE. RAPE CRISIS CENTRE.

When the Women's Liberation Centre opened, women called in or phoned, desperate in their need for advice on contraception, abortion and other health matters. Some of the women seeking abortions were very poor and/or unwilling to let their husband or lover know of their condition for fear of being forced to carry an unwanted child. Time and time again we were confronted with poverty and the misery it caused, so a group of women decided to establish an Abortion Trust Fund which was to be used to fund these women; the idea being that they could repay the loan for as little as one dollar per week.

Over a period of time we realised that some women, particularly those with religious backgrounds, while prepared to undergo abortions chose to overcome their guilt by forgetting about them. Some made irregular payments while some stopped paying at all. The trust fund ceased to exist. The fund had never been seen as a permanent solution but as a way of helping desperate women until such time as abortions could be carried out under the health scheme.

The news of the Melbourne Speak Out held in March 1973 rapidly travelled to Sydney and at the Sydney Conference held by the NSW Women's Commission two weeks later, there was a similar Speak Out.

> The dominant feature arising at both of these meetings was that health care for women was damned as often being demeaning, discriminatory, judgemental and of poor quality. Out of these two meetings, the movement for women's health collectives began and the Leichhardt Women's Community Health Centre opened in Sydney early in 1974 with funding from Canberra.
>
> Here in Melbourne we began with four hundred and ninety dollars donated from the defunct Abortion Trust Fund and, like Constance Stone back in 1896 with her two pound donation

from a grateful patient, we paid the rent for the first month at 85 Johnston Street, Collingwood.

The Melbourne Women's Health Collective was born on 12 October 1974. It had one young doctor who had been with the group through its trials and tribulations since 1973. She was the late Dr Janet Bacon. While she taught us, she also learnt new things, and as we learnt, we passed on our information. We must have been making waves somewhere, because Professor Carl Wood had us talking to his fifth and sixth year medical students and the Women's and Queen Victoria hospitals were sending us women with whom they said they couldn't communicate. Before five months had passed we had another four doctors, three more nursing sisters, a naturopath and a dietitian. All people working at the collective, including the professionals, were volunteers.

The day before we opened, an examination table arrived from an unknown retired doctor and his wife called in to wish us well. A loan from a member of the collective paid for the phone and switchboard installation. Collingwood council donated two thousand dollars and, during 1975, the International Women's Year Committee and twenty-two affiliated groups donated $1,300 from the sale of T-shirts and badges. With gifts from many women, we accumulated chairs, cupboards, tables, filing cabinets, stationery supplies and, finally, disposable sheets and towels (which saved us doing laundry). With the help of the unions, we soon had a toilet and hot-water service installed so that women who came from the country and interstate could have a shower.

The microbiology unit at the University of Melbourne did all our swabs and smear tests at no cost and a couple of pathology laboratories did our pregnancy tests. They also taught me how to do various other tests in their labs.

When Medibank began in mid-1975, we were able to bulk bill. Before that we had to depend on women who carried private medical insurance to help defray the costs for those who had none. Many women who could afford private treatment gratefully gave donations. Because we were a totally voluntary collective, all members had outside work to survive. Even so we had three sessions per week over a period of fourteen months and registered three thousand primary visits by women. The two evening sessions which began at 6.00 p.m. provided for

339

vaginal infections, cervical swabs and smears, and contraceptive information etc.

The women who attended these sessions at the collective were encouraged to exchange information on their health problems and their medical experiences in discussion groups. All women working at the collective, both lay and professional would also take part in these groups. It was not unusual to see the wife of a Collins Street doctor and perhaps a young woman from a biscuit factory exchanging experiences and information. These sessions often went on until midnight, after which specimens had to be checked and delivered to the university. Friday morning was the session for pregnancy testing, information and counselling on abortion. No women ever went to have an abortion unescorted. Women were encouraged to write their own medical histories which, though kept at the collective, were always the property of the women.

Because 1975 was International Women's Year, we decided to apply for funding as most other states had done. After much discussion and many two-way visits with Canberra, we were finally granted $178,000 on rather less than our terms, but further negotiation would have been possible.

In Victoria, then as now, we had a Liberal Government and funding had to come through the then Hospital and Charities Commission of Victoria, which immediately began placing fumbling bureaucratic restrictions on the collective. The restrictions were:

1. that we allow men to join the collective.
2. insistence that we treat men as well as women.
3. that doctors be paid on a fee-for-service basis, rather than salaries.
4. that only professional staff be employed.

Remember this was 1975 and, knowing full well what had happened to the Queen Victoria Hospital over the past fifteen years, we said NO. We felt exactly as did Dame Ella McKnight, one of the old obstetric/gynaecology specialists from Queen Victoria Hospital when she said, "the founding doctors would have been horrified had they known that women coming for help and treatment from a woman, were faced with a man."[1]

Some women thought we should compromise but eventually

---

1. Ella McKnight said this to Bon Hull.

we requested that the funding, which the Hospital and Charities Commission was withholding from us, be returned to Canberra and, tired but without debts, on 14 December 1975, we closed the door on the Melbourne Women's Health Collective.[2]

The first rape crisis service in Victoria was initiated from our Women's Liberation Centre and conducted at the Women's Health Collective premises at Collingwood. The women involved in the Rape Crisis Collective volunteered their services five nights per week in supporting, counselling and accompanying victims to police stations when required. As the demand for services became greater, our women began to apply pressure for the establishment of rape crisis centres with paid staff. Having the right kind of woman staff in any service for women was essential.

Over the years, with more women becoming aware of the politics of our being, we were becoming less competitive and more supportive of each other. This facilitated the availability and selection of suitable staff to deal with women in problem areas.

Child sexual assault was never spoken of in the past. Incest was totally unacknowledged, that is, to everyone but the victim, even though it occurred then just as it does today. It was through our CR groups that women, after privatising their painful experiences over many years, broke the silence and let it all come out. I was shocked when hearing of such an incident which involved a priest and punishment from the nuns to ensure the victim's silence.

It didn't take long before we realised that these cases were not isolated incidents and that, for some children, the family home was a very dangerous place.

The Women's Movement all over Australia began to bring the entire issue out into the public arena and, with pressure and persistency over the years, women in the community were able to convince governments to establish child sexual assault clinics in every state in Australia.

---

2. This material was prepared by Bon Hull for this publication. It also deals with issues published in her book, *In Our Own Hands*, Hyland House, Melbourne, 1980.

## 8.  INTERNATIONAL WOMEN'S YEAR.

It was 1975, International Women's Year (IWY) had arrived and I was too ill to march on International Women's Day. I went to the Exhibition Gardens where I sat and waited for the marchers to arrive. I was still overcoming complications which stemmed from the hysterectomy four months previously and was just skin and bones. My poor body wasn't doing too well and I was advised by a doctor friend to change my way of life. How can one do this after living a vital existence? I was too afraid to return to work at the mail exchange following the release of the ASIO document and was very depressed over my situation. I learnt just how vulnerable women are and was ultimately superannuated from my job. The postal department had at last got rid of this "dangerous woman".

There was so much happening in International Women's Year and it was great being part of the Australia-wide surge in women's activities; not that I personally was able to do very much. During one of our Women's Liberation meetings, I heard my name being called. At the time I was engaged in a conversation and hastily turned in the direction of the caller. I was told that the meeting wanted me to represent the WL Movement on the United Nations Association of Australia International Women's Year Committee. I laughed at this dubious honour being bestowed upon me and let them know that the only reason they wanted me to be their delegate was because they didn't want this "honour" for themselves. They all laughed. This task was something I could do, as it didn't entail any pressured activity, so I became the Women's Liberation delegate on the committee.

This IWY Committee was made up of representatives from national women's organisations from around Australia and was responsible for the participation of these organisations in IWY; the one year allotted to more than half the world's population by the United Nations.

Women, whether as individuals, groups or organisations,

were able to apply for grants to fund their activities. The Whitlam Federal Labor Government had given two million dollars for the year's activities and Elizabeth Reid, the woman responsible to the Prime Minister for Women's Affairs, had the unenviable task of coping with the flack when nine million dollars worth of requests for funding was lodged.

By the time I was appointed to this committee, two or three meetings had already transpired. It was so alienating to return to this rigid type of structure. Our WL meetings were very casual with women sitting on whatever chairs were available, while the rest sat or lay about on the carpeted floor. At IWY meetings, we sat upright in our chairs like school children, all facing our chairwoman. Each delegate was expected to report on the activities of their organisation and enter the discussion on how we could best encourage more women into IWY involvement.

The chair was an older woman who, having been a leader for several years in a national women's organisation, came from the entrenched establishment and used her position as chairwoman to do most of the talking; a situation common in hierarchical organisations. Most of the women in attendance had very little to say.

On one occasion, a woman attending as proxy for her absent delegate and ignorant of the situation, showed tremendous courage or naivety, when she got to her feet and expressed, in subdued and lady-like tones, her views which did not conform with those of our lady-chair. The chairwoman immediately rose to her feet, interrupted the speaker when recognising her dissent and, in brusque terms, told her that she was only at the meeting as a proxy and, being a proxy, she wasn't allowed to vote so had no right to express an opinion. The woman sat down, red-faced with embarrassment. There was a strained silence until the meeting resumed, that is, until the chairwoman again took over. This incident took me back many years to my experiences in the Hospital Employees' Union.

One of the delegates told me that, prior to my attendance, the chairwoman had made several disparaging remarks about the WLM but nothing was said after my arrival.

I rarely had anything to say at the meetings but was pleased to learn of the activities taking place all over our country. I reported back to our WL meetings on events taking place. Towards the end of the year, when activities were coming to an end and very little was left of the funds allotted to our committee, madam chair suggested that we use the last of our funds to invite three guests, three men – all members of the Liberal state government – to a luncheon. This was the government that had appointed a man as head of the Women's Advisory Office in Victoria.

I could no longer remain quiet. I told the meeting that I was totally opposed to the last of our IWY funds being used to dine men but, if they insisted, then surely the guests should be the men who had made the funding for IWY possible. Madam chair was on her feet; she interrupted me and tried to prevent me from speaking but I stood my ground and talked her down. I told her that I had attended these meetings for months and had continually listened to her talking, had never interrupted and that I expected her to extend the same courtesy to me. She remained silent. I went on to say that being IWY, what better purpose could the last of our funds be put to than to spend them on three women guests, three women who had made an exceptional contribution to our country?

My comments really set the cat among the pigeons. I had never seen the women so animated or vocal. Anyone would have thought I had suggested inviting three strippers . . . All the women who spoke agreed with the chairwoman, they wanted to dine three men for International Women's Year. Perhaps the women who disagreed were too intimidated to have their say.

An old pensioner delegate who came down in the lift with me said she was very pleased I had stood up to Ada, no one else, she said, would do it. She also said she couldn't afford to go to the dinner. I too did not go to the dinner, so I never knew what the final decision was regarding the guests.

With women all over our country being involved in IWY, they were, in most cases unbeknown to themselves, becoming a part of the overall Australian Women's Movement and,

when examining the current situation, we can see the great changes which have occurred in women's attitudes and lives. I feel quite certain that women today would not spend the last of their funds wining and dining men in just the one year allotted to us.

## 9. THE ARTS.

International Women's Year didn't just pop up out of the blue. Women around the world had been active in all spheres for some years and IWY was, for many, a plateau where we gathered to unleash our joyful energy across the globe.

Women around Australia flourished in their various artistic endeavours and this chapter is devoted to highlighting some of those projects and the opinions of the women involved. It is important to note that almost all of the women involved in the various art forms of that time were in some way connected to and part of the Women's Liberation Movement, even though this is rarely mentioned.

"One Hundred Years of Women's Art" was the heading of an article in the Spring issue of *Vashti* 1975. It began with:

> Just in case anyone imagines Australian women were absent from the annals of art as they have been from government, the exhibition "Australian Women Artists: 100 Years 1840–1940", puts the record straight. Not that the small scale of the show, permitting only thirty-six out of about four hundred notable painters and sculptors, does justice to our women artists – it's only a start.
>
> But a very good start indeed, and those of us who have been waiting for years for a historical survey like this are elated that the initiative came from Victoria and proud of the really professional job that Janine Burke and the team at the Ewing Gallery, Melbourne University, have done.

Merren Ricketson[1] wrote:

> Battles and discussions in the 70s and early 80s concentrated on redefining the hi(s)story of art, the recognition of women's diverse artforms and questions of female sensibility. The debate

1. Merren Ricketson, "The Women's Art Scene in Australia", in *Australia For Women: Travel & Culture*, eds Susan Hawthorne and Renate Klein, Spinifex Press, Melbourne, 1994, pp. 196–203.

was fuelled by the publication of surveys on women artists through the centuries, texts addressing the inequitable situation in galleries, and new "ways of seeing".

A new form of women's theatre originated in Melbourne in the early seventies with a burst of excitement which still sends a glow of nostalgia to the cheeks and a sparkle to the eyes of those who were involved, whether as audience or participant.

A form of radical alternative theatre had evolved in the sixties, and it was appropriate and inevitable that when feminism hit town, women working in theatre would use their work to express their politics.

Frustrated with the stereotypical roles available to female actors, lack of scripts written by women (or even for women), lack of opportunity to become involved in direction or to develop skills in technical work, and with the hierarchical structures in general, women got up and did their own thing with spontaneity, enthusiasm and optimism.

In the beginning there was street theatre – initiated by women in Melbourne from the Australian Performing Group (APG), but open to all interested women, skilled or unskilled. A sketch involving a "baby machine" was used at an abortion demonstration in 1971.

In 1972 Kerry Dwyer directed *Betty Can Jump* at the Pram Factory (home to the Australian Performing Group). "The audacity of women working alone and developing a play without a writer was staggering . . . the APG was primarily a theatre whose aim was to develop new Australian writers and as those writers were men with particularly masculine and male perspectives, the attempt was seen as a dangerously divisive one." (Kerry Dwyer).

Two years later, a separate group, the Women's Theatre Group (WTG) was formed and eighteen women were involved in a group-developed revue, satirising advertising and media images of women, using scripted scenes and songs and lots of comedy. The mix of experienced and inexperienced women worked well. Performances of *Women's Weekly Shows* (Vol. I and Vol. II) in the back theatre of the Pram Factory were packed out, with more than a hundred turned away each night.[2]

---

2.  Merrilee Moss, "Puppets to Playwrights: Girls on Stage", in *Australia For Women: Travel & Culture*, pp. 142–7.

Australian women had been active in all forms of filmmaking since the early 1970s – in production, distribution, training, education and in making films. Women had formed their own film groups, begun to teach themselves the skills of filmmaking, and had held conferences and weekend workshops on the media. Women's film groups were established in virtually all of the Australian states with the largest groups in Sydney and Melbourne. The establishment of the Women's Film Fund provided crucial financial assistance and support but without the fund, women, no doubt, would still have continued to make films about women's issues.

In the early 70s women's films were marked by a desire to put into practice the aims of the feminist movement, to document women's lives and to explain the basis of feminist thinking to the community. From the beginning, the women's film movement in Australia set itself up in opposition to the practices of mainstream commercial cinema. Women favoured a collective process and co-operative model of film production. Films were exhibited to community and women's groups and discussion was considered an essential part of any screening.

A landmark in Australian filmmaking, *For Love Or Money*, explores issues such as female transportation to the new colony, the treatment of Aboriginal women, unequal pay for women, family and motherhood, abortion, Aboriginal land rights, the environment, peace, immigration.

Along with films currently being made by women, the earlier films continue to be hired by community, educational and women's groups. Women's filmmaking constitutes a dominant aspect of feminist culture in Australia and the films produced are now integral to the running of the large number of women's studies courses that proliferate throughout the educational institutions and universities.

Since the early 70s a number of women have either learnt the necessary skills and/or graduated from the various Australian film schools and become internationally known professional feature filmmakers. These include Gillian Armstrong (*My Brilliant Career, High Tide, The Last Days of Chez Nous*); Ann Turner (*Celia, Dallas Doll*); Jocelyn Moorehouse (*Proof*); Jackie McKimmie (*Waiting*); Tracey Moffat (*Bedevil*) and Jane Campion (*Sweetie, Angel at My Table, The Piano*). It needs to

be noted, however, that working in what remains an essentially male-dominated industry is not easy and a number of these directors have spoken out in interviews about the sexist structures with which they have had to contend in the course of their careers. Nevertheless Australian women directors have in the last decade produced a number of feature and short films which have achieved acclaim both at home and internationally.[3]

Since the 1970s there has been a huge literary output by Australian women writers and in this time we have seen the emergence of fiction and poetry by Aboriginal writers, migrant writers from diverse backgrounds, and by lesbian writers.
. . . In 1975 the Australian Women's Broadcasting Collective established "The Coming Out Show" and it has been running weekly at 5 o'clock on Saturdays since then. A large audience hungry for information about women's lives, women's culture, women's events and women's politics. Primarily national in focus, the programmes have ranged hugely across an enormous variety of topics.[4]

In the 1990s it is very easy to forget that, in 1971, the Women's Movement was a fledgling movement with a lot of dreams that had no material parallel. In 1971, there were no women's health centres; there were no women's bookshops, and certainly no publishing companies, galleries or theatre groups owned and controlled by women; abortion was difficult to obtain without entering the criminal arena; there were no refuges for women and no sexual assault centres; no one believed that women would soon be holding conferences to discuss women's liberation; there was no paid maternity leave; there was no such discipline as "Women's Studies", and few tertiary education courses included any information about women at all; there were no lesbian festivals and few places for lesbians to meet. None of this could have happened without a political movement committed to changing the shape of the culture.
There are several false views of the Women's Movement

---

3.  Barbara Creed, "Women's Cinema in Australia", in *Australia for Women: Travel & Culture*, pp. 185–7.
4.  Susan Hawthorne and Renate Klein, "Cultural Life", in *Australia for Women: Travel & Culture*, pp. 110–4.

that tend to be presented by the media. One is that the entire movement is made up of lesbians; another is that it is made up of middle-class, highly educated white women; yet another view is that it is made up of women who have had bad experiences with men. All these women are in the Women's Movement. Indeed, without the lesbian presence we would not have progressed as far as we have ...Women have not always agreed on every aspect of feminist theory and action, but a diversity of voices is what has made the Women's Movement in Australia, and internationally, a vigorous and everchanging pool of thought.[5]

Some day research will reveal all the wonderful initiatives which stemmed from IWY all over Australia. To add to those already mentioned, the following events were published in our newsletter and *Vashti*: the YWCA held a photographic exhibition of women, the Council of Adult Education started women's studies courses with eleven different areas of interest being presented. Even the trade unions started training courses for women covering various areas pertaining to women at work, and teaching skills required within trade union structures.

5.  Susan Hawthorne, "A History of the Contemporary Women's Movement", in *Australia For Women: Travel and Culture*, pp. 92–7.

## 10. FIRST AUSTRALIAN WOMEN'S INTERNATIONAL FILM FESTIVAL. FIRST WOMEN'S NATIONAL HEALTH CONFERENCE (BRISBANE).

I have selected excerpts from Suzanne Spunner's contribution to *Don't Shoot Darling*[1] as an example of the atmosphere which prevailed during 1975 and the initiatives undertaken by women at that time.

> Thinking about it ten years later, it is impossible to separate the Women's Film Festival from the atmosphere of 1975 and the heady days of International Women's Year, when everything you ever dreamed of seemed to come about in a succession of extraordinary and, to date, unparalleled women's events – both cultural and political . . .
>
> In August 1974, a group of some twenty women presented a submission to the Film and Television Board of the Australian Council for the Arts:
>
> > We feel a Women's Film Festival is necessary for the following reasons:
> > - to provide an historical and cultural context of women's cinema
> > - to explore our own creativity through films
> > - to counteract the reluctance of distributors to release women's films in Australia
> > - to break down Australia's insularity in this field
> > - to explore women's cinematic language and iconography
> > - to examine to what extent there is a female culture and to produce a feminist critique of women's films and style of filmmaking. (from the Introduction to the Submission.)

---

1. "With Audacity, Passion and a Certain Naivety: the 1975 International Film Festival", in *Don't Shoot Darling!: Women's Independent Filmmaking in Australia*, eds Annette Blonski, Barbara Creed and Freda Freiberg, Greenhouse Publications, Richmond, 1987, pp. 93–8.

The Submission netted a loan of $20,000 . . . In March 1975, the National Advisory Committee for International Women's Year agreed to guarantee the festival against a loss of up to $35,000.

The Festival was held from August to October in every state capital city and in Canberra. Sydney and Melbourne held the largest festivals, running for nine days . . . Child care was provided for evening screenings and, in each state, venues were made available after the screenings for coffee and informal discussions . . .

The sheer volume of work involved in putting on such an ambitious event, and the complexities and problems that arose internally and externally were so staggering that if I, for one, had known beforehand, I would never have dreamt of taking it on. Fortunately, we didn't know, so we all just went ahead step by step, day by day, for nine solid months.

So the work continued: in a non-hierarchical way, sharing major decision-making while taking individual responsibility for specific tasks, as fitted our various abilities . . .

Working in an all woman group on an event dealing with the expansion of our female self-image certainly feels different from any other work situation. If the festival sets up interactions that are also different, then our efforts will have been worthwhile (from "How We Happened", in Women's International Film Festival 75 programme).

The scale of the event was at times startling. The Palais, then the home of the Melbourne Film Festival and hence the only venue geared for a festival, seats three thousand and I remember a sense of horror when I saw all those thousands of numbered squares on the floor plan. We sold over a thousand subscriptions and were delighted, considering that we had organised the Melbourne end of the festival from a minute back kitchen in my house. Nevertheless that kitchen came into its own when Christine Johnston and I boiled up great pots of flour-and-water glue for our late night poster-pasting raids all over the city. We were always being rung up by agencies in control of the big billboards claiming we had pasted over them; in fact, we were the only bunnies with our address and phone number on our posters . . .[2]

_____

2.   Suzanne Spunner, "With Audacity, Passion and a Certain Naivety", pp. 93–7.

The overall quality of the films was remarkable and the response of the audience was exciting. During the festival a feeling of solidarity and discovery arose among the stayers and it became apparent how politicising an effect cinema can have. The festival provided ample intellectual and emotional fuel to refute the still remaining prejudices concerning women and film. The pre-publicity tried not to alienate men, but the unfamiliarity of a "women's film festival" kept many people away. Sixty to seventy per cent of the audiences were women and it is obvious that many men were deterred because of their preconceptions . . .

Now that a context for viewing women's films has been established it is essential to look closely and in detail at selected areas of interest. To make the festival an annual event will require government finance and support. The festival has established its credibility, the films were good and those who saw them should question why they were not previously available.[3]

I had, for some time, been doing research into primate sexuality. I wasn't deterred when learning that the only information available at that time was researched on primates in captivity, because we humans also exist in captivity. None of us are free. I made a concerted effort to have a twelve page, foolscap document completed for presentation at the National Health Conference being held in Brisbane, but the committee rejected it on the grounds of it being too late for acceptance. I couldn't help feeling that the paper was rejected because it was too radical and also because I wasn't an academic.

When rereading this paper some years later, there was only one section which I would refer to as a conclusion reached through reasoning (hypothesis), the rest was based on research.

Having my paper rejected didn't stop me. I went ahead and had seventy-five copies printed at my own expense and took them with me on the plane. Do women of today think we were crazy for the commitment we felt just twenty to twenty-five years ago? For those of us who paid our own air or train fares to attend this conference and who weren't

3.  Suzanne Spunner, Christine Johnston, Pat Longmore, Sue Johnston. from *Cinema Papers*, Nov/Dec 1975, p. 210.

academics or business representatives, there were no concessions or free flights; we couldn't even claim expenses off our taxation.

After distributing my paper among the women assembled, I was approached by many women seeking a copy. There was a great deal of interest shown in the document and I was later to be invited on numerous occasions to speak to women on sexuality, using this paper as a basis for discussion.

This national conference of women was the first time women had come together from around Australia for the sole purpose of discussing all aspects of our health. Papers were presented on all health matters, both physical and psychological. After the papers were presented, we broke up into small groups to participate in discussion. There were several workshops dealing with different topics simultaneously which proved to be frustrating; it was difficult to choose. I often wanted to be in two places at once.

It was evident from all the discussion that very little research was being conducted into women's health and what little research was being done was carried out by the drug companies, interested only in furthering the sales of their tablets etc. for more profits.

What we needed to know then and still need to know is how we can prevent breast cancer, fibroids, endometriosis, adenomyosis, ovarian cysts and the many other conditions endured by women.

I arrived at one of the conference venues well before time and struck up a conversation with a grey-haired matronly woman. She asked of my interest in attending the conference and, after briefly mentioning my involvement in the WLM, I went on to talk of my paper on sexuality and of its rejection. She proceeded to tell me that, when young, her mother when discussing sexuality with her explained each method of obtaining sexual satisfaction without penetration. I was flabbergasted. What an enlightened mother! And especially for those days.

This woman telling me of her experiences was a doctor who was presenting a paper at the conference but was, because of

her profession, unable to express what she really thought; to do so would have unleashed the venom of the conservative medical profession as well as the churches. What a pity she couldn't tell us all at the conference about her wonderful mother and of the advice given.

Life is so strange, here I was at a health conference swallowing antibiotics. I had badly infected kidneys and, although knowing of this before leaving Melbourne, I wasn't going to miss out on the gratifying experience of the conference. It was great just being among intelligent and caring women. I find this to be one of the most satisfying experiences, satisfying to both my heart and head.

## 11. THE WOMEN'S LIBERATION MOVEMENT AND LESBIANISM.

Working in the psychiatric hospital in my twenties was like being thrown into the deep-end of life; the total experience of people. It was rumoured among the staff that several of the nurses employed there were lesbians and, although they were considered to be "abnormal", they did their work well and were tolerated and nothing was ever said.

The prevailing philosophy at the hospital was that hospitalised lesbian patients were there because of their lesbianism and I, being totally ignorant about this area of life, accepted this diagnosis unquestioningly. I never at any stage thought that heterosexuals were hospitalised because of their heterosexuality; a perfect example of double standards.

This was my entire understanding of lesbianism and it was with these prevailing views and attitudes that I was to meet and become associated with lesbians entering the WLM in the early seventies. I wasn't the only woman in this situation, I think most of the women in the early part of the Movement knew as much about lesbianism as I did. After several years of lesbian involvement in the WLM, I wrote a lengthy article in the April 1976 newsletter which reflected my concern and distress, as well as my confusion.

When thinking back over this article, written nineteen years ago, one of my most serious omissions was the lack of perception concerning the age of most of the lesbians who came to the WL meetings; they were very young.

*Vashti* featured a paragraph informing young lesbians of a group which had been formed to discuss women's sexuality, lifestyles, and their oppression as women and lesbians. The group met at the Women's Liberation Centre. Apart from some of these young women rebelling against the older generation of women at our WL general meetings (anyone five years older than them), there were other problems stemming from the involvement of lesbians in the Movement.

356

When young, I remember the intensity and insecurity, the desperate need to be loved and the need to give love plus all the emotional trauma associated with this period of life. At the Centre we had young women attending the meetings who were heavily involved in relationships and, two or three months later, they would see their beloved just as involved with another; a new lover. Is it any wonder feelings ran high?

Part of this youthful rebellion was expressed in anti-male discussion which seemed to go on forever. This was only brought to an end when more and more women objected to most of their time being spent on men. This discussion resulted in hetero women feeling guilty because of their association with men. Discussion also took place on children and the effect children had on women. Women in CR groups discussed all these topics in a personal and supportive atmosphere but, at large meetings, these areas of deep and intimate concern became objective discussions – discussions of the head.

As explained previously, Consciousness Raising (CR) groups were the life-blood of the Movement. Hetero women in CR were able to openly discuss their present as well as past relationships in confidentiality, with trust and with every support given. When lesbian women began doing CR, it soon became impossible for them to open up because, in most cases, their partners were in the same group or, if absent, the other women present would learn of their attitudes or behaviour towards each other. This posed a great threat to their relationships. Due to this dynamic, very few lesbian women were able to do CR and, if they did, they never discussed their personal relationships. So while hetero women felt close and warm with each other because of our shared experiences, we rarely got to know the heart of our lesbian sisters, only their heads – and that took place at meetings.

I have no doubt that some of the young lesbians thought the hetero women were cool towards them, and this may have occurred on the part of some women who were unused to associating with lesbians. However, I am more inclined to believe that the different dynamic created through the inter-relationships of the lesbians plus the bonding of hetero women

through CR was a potent factor in causing the schism.

Ageism was an added problem. While the young women admired the older women, they also resented us. The young women, although rebellious, had an abundance of energy which they willingly gave, making the establishment of women's refuges, the Rape Crisis Centre and the Child Sexual Abuse Centre possible. When looking back, we needed each other; the young needed the experience and wisdom of the older women and we needed their great energy, but we could all have done without the aggression and "political soundness" displayed by some of the women.

These early years in the WLM gave lesbians the opportunity to gain the confidence and support to participate in the marches as lesbians and proclaim their strength. This opening to the public inspired them and assisted in developing their feeling of self worth.

I agree with Barbara Wishart who, when referring to the WLM, writes, "The enthusiastic rejection of stereotype femininity threw the baby (and the mother) out with the dirty bathwater."[1] However, I would question Barbara when she writes, "we entered into an anti-motherhood phase which seems to have lasted some seven or eight years."[2] I estimate this period, while starting in 1973, gradually worsened until 1976.

When Barbara states, "For those women who were 'unlucky' enough to already have children, they had to cope as best they could with all the conflicting feelings about their own mothering raised by the critique of women's traditional roles."[3]

Having my daughter was something I never regretted and, although some women in difficult circumstances expressed other points of view, most of the hetero women, including myself, remained silent when these topics were discussed at

---

1.  "Motherhood within Patriarchy", in *Embroidery the Framework – All her Labours*, Hale & Iremonger, Sydney, 1984, p. 85.

2.  ibid, p. 85.

3.  ibid, p. 86.

the Centre; we preferred discussing intimate topics in the supportive atmosphere of our CR groups.

Barbara continued, "needless to say, most of these women left the Women's Movement at this time although they may well have remained feminists."[4] As time went by, most hetero women gradually withdrew from the Centre, remained in their CR groups, joined WEL or just did their own thing. During this difficult period, many lesbian women also withdrew from the constant conflict and those remaining became divided, not only on age lines but also on issues of class and separatism. In 1976 the Women's Liberation Centre ceased to exist.

While knowing that everything has a beginning and an end, this didn't detract from the sadness felt when the Centre closed. I have no doubt that, with changes taking place in society, the WLM as was earlier established would, by necessity, have reached a stage where changes would have needed to be made. Unfortunately, the methods by which the Women's Liberation Centre ceased to function didn't leave sufficient goodwill to maintain a newsletter – a contact point for women.

Vera Ray said, "Women have many opinions and many views and sometimes we get locked into these views and we start feeling alone or we start feeling that, you know, we can only trust one or two others. And I do have an overview of feminism as a very strong, potentially revolutionary movement that can actually change things quite significantly – but not while we are not able to communicate. And to me, another old-fashioned word is sisterhood which I really quite believe in. I don't mean that I want to feel sisterly towards every woman who wants to be one but doesn't know how to do it, but I do feel that most feminists have enough in common to develop that kind of feeling. There has not been a venue for that sort of thing in Melbourne since the old days when the old Women's Liberation House actually functioned properly. That was a long time ago."[5]

---

4.  Barbara Wishart, "Motherhood Within Patriarchy", p. 86.
5.  Virginia Fraser, "Renaissance of the Salon", in *Australia For Women: Travel and Culture*, eds. Susan Hawthorne & Renate Klein, Spinifex Press, 1994, pp. 106–9.

The Women's Action Committee was established in 1970, the Women's Liberation Centre opened early in 1972 and closed in 1976. When thinking of all the activities, eventual gains and changes inspired in these few short years, it makes one realise how ready society was for change: all it required was women who had the guts to make it happen.

## 12. THE MEDIA.

When looking through the archival material over the past twenty-five years, one can see the vast changes that have occurred during this period; nevertheless, there can be no room for complacency for there is yet a great deal that needs to be changed.

The following is a good illustration of what it was like when the Women's Movement first began in Australia. Commenting on the WAC in the Melbourne *Herald* on 16 March 1970, John Sorell wrote, "It's another one of these tiresome female suffragette bodies – this time called Women's Action." He concluded his article with, "I've seen this sort of organisation before. They generally peter out after some enthusiasm at the start, and the reason they peter out – the apathy of women themselves. They realise they've never had it so good." This was typical of the publicity we received from the media in those days.

Twenty-five years ago, major daily newspapers devoted half a page to women, once per week only. Much of this space was taken up with fashion, or Lady Bloggs and her daughter and what they had worn to the races or to the tea party given in the honour of Lady Biggles who had just returned from overseas.

Apart from the women's page, women journalists' names seldom, if ever, appeared in the newspapers. These papers were devoted to male journalists who wrote about topics pertaining to men and their interests; it was then considered that women would not be interested in worldly matters and nor would they have anything to offer of any importance.

As the Women's Movement developed, women like the late Nancy Dexter of the *Age*, Pat Jarret of the *Sun* and the late Claudia Wright, gave us support on the women's page of their newspapers and the stronger we became, the area of space allotted to women expanded. I recall women journalists in the past criticising the lack of opportunities available to

them and the difficulties associated with becoming sub-editors. The male sub-editors used to put sneering headings on their articles in the press. I doubt if there were any female sub-editors at that time. How many female sub-editors do we have today? Michelle Grattan, the first female journalist to interview me (1969), became the first woman editor of a major daily newspaper in Australia, the *Canberra Times*, in 1993.

Due to the pressure by women and the resulting change in our culture, our reputable daily newspapers have changed dramatically with female journalists being featured in all sections of the paper, even sport.

Women journalists have been responsible for altering the method used in reporting wars. Prior to women's coverage, war reports always recorded the number of soldiers killed or wounded, or the number of miles or kilometres gained or lost; no mention was made of civilian deaths or suffering. Women journalists introduced a complete picture of the effects of war on people, while the USA, through their total control of the news, reduced their war news in the Panama and Iraq to a video-game technology skirmish; people didn't matter.

Television – the industry geared to making money out of advertising – came to Australia in 1956 and was able to cover the Melbourne Olympic Games. Over all the years of radio and television, we became totally familiar with men's voices and faces, and whatever topics, films or sports they were interested in. We accepted the situation as normal and very little was ever done to question the state of affairs. This industry offered women the usual type of employment; positions as telephonists, clerks, typists, or the choice of being the tea-lady or cleaner. The only time Australian women appeared on the screen was in advertisements where women were needed to sell products and, again, they were always cast in the housewife–mother role. The excuse given for not featuring women as presenters on radio and television was – and it is still being used today – that women's voices are disliked and not popular.

This excuse for practising discrimination is more likely to be used by the commercial stations on both radio and TV, and these stations still strongly project the "dolly" image which caters for men. The ABC features women on TV and radio who have proven to be intelligent, competent and extremely popular with viewers and listeners. Unfortunately, the ABC proved to be sexist and ageist during the 1980s when terminating the positions of three women TV presenters. No official reason was given.

The three women concerned were considered to be attractive (a requisite for the job) by the man or men who appointed them and, over a period of time, they displayed their competence and popularity, so why were they dumped? Rumour has it that, when interviewing "important" men, one was considered to be too brutal, one was too tenacious and the last was too old (early forties) and tenacious. It would seem that these women were removed because they wouldn't play any of the games expected of women when dealing with the fragile egos of powerful men.

While women now appear in what could be seen as equal roles as news readers on TV stations, they still have to look like "dollies", heavily made up with coloured, starched hair, while the men are suitable as they are, with grey hair or no hair.

The changing culture, brought about by the continual pressure of the Women's Liberation Movement and the on-going effects of women who have become aware of their own strengths and moved into all areas, has enabled the acceptance of women presenters on TV and radio. We welcome their perspective, their objectivity, their intuition, their faces and their voices.

It is not enough to claim that being represented on the media is, in itself, sufficient for women. While it is essential for girls and young women to have successful role models in all spheres, it is also essential to know that when we've achieved representation we haven't done it alone; someone cleared the track for us. There may be an isolated case where a woman is first in a virtually untapped field but how many

women would fit this category? In this rare situation, one may say that she did it alone but, for the majority of women who have made it into the media, the struggle to get there was forged by other women.

In the main, all areas of the media are competitive because that's the way patriarchy functions and it will become more so as the ownership of the various facilities becomes concentrated into fewer and fewer hands until such time when there will be so few owners that they can come to an arrangement.

It is of great concern that, in Australia, the commercial media, which controls almost all of the incoming news of the world, is owned or controlled by three or four men. They decide what information will be given to us, and this is how public opinion is manipulated.

Patriarchy is very clever in how it operates!

## 13. EDUCATION. TELEVISION. BEAUTY.

In the field of education, we now find that girls are no longer discriminated against and can choose from all the subjects available in schools, however, very few girls apply for apprenticeships in non-traditional areas.

Recently much publicity has been given to a select group of girls who have proved to be equal to or perhaps better than boys in maths or science: "only one group of girls obtained the same high levels of performance as males and these girls were from professional backgrounds [however] ... boys from professional backgrounds were still much more likely than girls to achieve at that level."[1] Little has been said about the fact that, in the main, these girls come from professional families where the mother is the role model and encouragement is always forthcoming. For the majority of girls in secondary education, maths and science is still less desirable.

It is interesting to note that, because there has been much ado about this small group of girls doing well in maths and science, some educationists are claiming that enough has been done to redress the imbalance in education and boys now need more attention at school to overcome "learning disabilities, behavioural disorders [and] a high rate of suicide."[2]

When examining education, we find it is geared to masculinity; maths and science are held up as the peak of all learning by our patriarchal society and all other areas of learning are considered to be of secondary importance. Girls are traditionally and culturally discouraged in these subjects, yet girls are seen as the problem. This insidious conditioning permeates the young girls to the extent that, while they may not be attracted to maths and science, the skills that were in the past looked upon as traditional female skills, such as

---

1. *Sydney Morning Herald*, "Battle of the Genders", 12 July 1994.
2. ibid.

knitting, sewing etc. are seen as old hat and of little value in the age of technology.

It would seem to me that the emphasis placed on maths and science is part of the de-humanising process of the young and perhaps subjects which develop warm and caring behaviour modes should be our first priority, followed by maths and science.

How can educational structures prevent boys from becoming macho and encourage them to be more co-operative? Among the various suggestions made to remedy this situation, support is given to co-education yet research has shown that girls do far better when segregated from boys in the senior years. Why should girls have their education jeopardised for the benefit of boys? This is a male problem and means must be found to eradicate the problem without sacrificing the educational future of girls. Another reason for boys' lack of interest in higher education may well stem from the current unemployment situation which can easily destroy the initiative and motivation of people.

Perhaps we need to look again to our culture when seeking to understand the male problem. Clancy Sigal in the Metro section of the *Sydney Morning Herald* reported that Hollywood has now "upgraded designer brutality into box office and critical acceptance", even "true romance is marked by relentless violence." The heroes "pepper the narrative with bloody killings, Hollywood's substitute for resolving difficult plot points."[3]

With films like *Natural Born Killers* and *Clockwork Orange* the film director Oliver Stone was reported as saying, "Americans have a schizophrenic attachment to violence. One part is aversion and condemnation. The other part is a sleazy attraction to it. And the media is part of it."[4]

It has taken the "experts" all this time to acknowledge that people, young and old, are influenced by television. If

---

3. *Sydney Morning Herald*, 11 February 1994.
4. Bernard Weintraub, *Sydney Morning Herald*, 25 August 1994.

this was not so, why would business invest billions of dollars on advertising?

Television, the seven days and seven nights per week university of killing and violence, is sacrosanct in our society and when criticising this violence one is made to feel as if you are attacking something extremely sacred. We need look no further for most of the causal factors than the competition depicted by Stallone, Eastwood, Schwarzenegger and the other men who profit from this culture. Most boys and girls are fed on this diet day after day and the boys unfortunately adopt these men and their behaviour as role models; why must role models for males be involved with violence of some sort?

Unlike the "open learning university" which is always telecast in the early mornings, the "killing and violence university" on commercial channels is telecast during prime-time to suit the advertisers for whom the industry exists. It's this very culture which promotes violence in the home and society. How can schools counter this instruction?

To counter the classes in aggression constantly viewed on TV, should we introduce conflict resolution courses in all schools and should these courses be compulsory for all students? Would this, if introduced, be sufficient to counter the violence instilled in children almost since birth? Wouldn't it be much more economical and humane to do away with all promotion of violence in our culture?

How often do we see males or females who work in factories, shops, banks, on the roads or wharves; or people who are painters, carpenters, landscapers, or machinists in garment or shoe factories featured on TV or in films? Our children almost never see people like their parents in the media. Almost all people in film or on TV are depicted not only as white-collar workers but as very successful white-collar workers who never seem to do very much yet possess huge houses and huge cars. Is it any wonder that so many young people in our society look upon their parents as failures?

This scenario has become part of our culture, just one more feature of patriarchy, and remains so because the media is

owned and controlled by patriarchs hell-bent on preserving their entrenched power, their control over people's minds and their desire to remain extremely wealthy at the same time.

Gone are the days of the Whitlam era and free university education. During this period, it was possible for the young who had abandoned education to resume at a later time when more mature. These mature-age students, having experienced something of life, applied themselves very seriously and are now in responsible positions in society. We all know that people mature at different stages; what is to become of the young today who, for whatever reason, drop out? Are economic rationalism and the International Monetary Fund all that matter? Are people of secondary importance?

Before the advent of TV, women, like myself, who were extremely thin were full of complexes because of our skeletal appearance; we very rarely, if ever, saw skinny females featured in our weekly visits to the cinema. Today, we are continually confronted with long, narrow, gaunt youngsters depicted as models of beauty who appear regularly in magazines and on TV. Unfortunately, these same skinny young women are projected as being healthy and how every young woman should look. In the USA alone, 150,000 women die each year of anorexia. What are our statistics?

Nutritionists are very critical of the diet industry and weight-loss centres, especially as ninety-eight per cent of dieters regain the weight lost. The media assists their advertisers in undermining the self-esteem of women in order to further promote the need for the products of the advertisers. We've all seen feature articles like these, "The Eight Fashion Classics You Can't Do Without", "Born Again Blonde", "Get Ready To Parade Peroxide".

One can be very critical of our media which is owned and controlled by men, but can we be less critical when the purveyors of this poison are women? One only has to look at the magazines and films which cater for teenagers to see how

many of the old ideas are still being perpetuated under the guise of sophistication. Many of these lies are promoted by women employed by the media; women who, for a salary, are prepared to play the games as set down by the male owners. Is this how we regard the successful woman to be? Loyal to the advertisers?

The cosmetics industry (part of the beauty machine) is very powerful and depends entirely on ensuring that we continue to buy its products; this can only be done by making us feel displeased with our appearance.

Despite the invasiveness of the cosmetic and fashion industry, more young women are staying at school longer and prefer to be casual in their appearance, wear less make-up and accept themselves as they are. Much depends on whether young women value themselves as individuals or feel the need to emulate the models in magazines and/or compete with each other in order to get a "boyfriend": the "boyfriend" then giving them a feeling of worth, status or success; a very doubtful basis on which to build self-worth, status or success.

It is interesting to note that Vivienne Wynter, after interviewing fifty women in paid work from around Australia, wrote, "The majority were alienated by images that concentrated on physical appearance, or suggested that diet, exercise or beauty tips were needed to make women more worthwhile or attractive ... Women were more interested in character, personal style and good grooming than they were in glamour or beauty."[5]

Noela Quadrio, when referring to the TV show "Melrose Place", wrote, "It reminded me of just what powerful educators these popular programs are. While we busily monitor the media through advertising, print, and radio, these programs laugh at our efforts and busily go about shaping the attitudes of girls and boys, women and men ... In fact they rigidly reinforce mythical moralities which imprison women under the guise of wealth, beauty and emotional independence."[6]

5. *Media Matters*, 5 August 1994.
6. ibid.

The "beauty" industry makes its owners very wealthy; it has an annual turnover of twenty billion dollars worldwide, 1.1 billion dollars Australia-wide, with an approximate fifty per cent profit margin, and the "beauty" parlours of Australia make 110 million dollars per year.

Is it any wonder that the media advertisers need to keep you feeling unhappy about your appearance; their wealth depends on it!

## 14. HOW IT USED TO BE. YOUNG WOMEN.

Who of us twenty-five years ago would have envisaged young-sters with plastic cards buying up large? Just these few short years ago, it was impossible for a married woman to purchase an expensive item in her own name; that is, if it was on credit terms.

I recall being in this situation after having worked in paid employment for some years. I'd already paid for two used cars in my husband's name but I insisted, when buying the third car, that it be in my name. It took a great deal of deter-mination and insistence to stand up to the salesman even though my husband agreed with me. Being single also had its drawbacks; male guarantors were necessary before you could make a purchase. One employed woman finding herself in this situation, got her pensioner father, who didn't have a cent, to go guarantor for her. The application was accepted because he was male.

I recall the lengthy campaign waged by women with the Tramways Board and Union when wanting to become tram-drivers, a struggle which eventually got the union on side but was not resolved until 1975. The leadership of the union was, at that time, communist but certainly not radical when it came to women; that is, until forced to be. The WLM gave the tramway women support by demonstrating through the city streets and drawing attention to their demands; this was the only way to achieve success and this they did.

The same type of campaign was conducted to enable women to become bank tellers and clerks. There was, at this stage, no possibility of women ever having the opportunity to under-take study and move up in the banking business – it was the typewriter, the switchboard or nothing; if you were lucky you could operate a calculating machine. While the union came around to supporting the women in their endeavours, the banks were determined to prevent women from moving up.

The WLM supported women in banks and their union in this campaign and, eventually, the bank culture too was changed.

When reading ACTU material of 1991 regarding the gains made in the banking industry (gains which enhanced the quality of life), one can see the general improvements in trade union policy taking shape.[1] Compassionate leave, maternity and paternity (in some awards) leave, recognition of de-facto partners, bereavement leave, job sharing, policies and action on sexual harassment are all examples of positive changes in attitudes within trade unions. Yet one needs to remain alert despite these positive attitudes, for example, while part-time and shared work for women in any industry is welcome, women need to watch that this is not used against them when wanting full-time jobs.

Women in the early seventies were always the losers. When shop assistants were due for an increase in pay, the men got three dollars per week extra and the women got nothing. This was not unusual for industries where women predominated in the traditional female occupations. The unions covering these industries were always male-controlled and women remained subservient due to their lack of industrial and political understanding; they brought their serving, housewife–mother roles with them to the job and into the union.

Recently our daily press reported of a Queensland woman who received an award for being Australia's top woman pilot. It was only in 1979, when Deborah Wardley went to the Victorian Equal Opportunity Board in her attempt to be accepted as a trainee pilot with Ansett, that women wanting to be pilots gained recognition. When Ansett was told they had to accept Ms Wardley as a trainee, they appealed the decision and went to court. Again Wardley won the case and

---

1. This material comes from the ACTU speech by Jennie George at the Women, Management & Industrial Relations Conference held 6 July 1994. Also refer to the Working Women's Policy, ACTU, 1991; Workers with Family Responsibilities Strategy, 1991.

went on to become a pilot. Nothing comes easily, not even today.

After the many years of effort to clear away the discriminatory clauses in the Apprenticeship Acts and Awards, women are now, despite the difficulties, accepted in all trades. There are women carpenters, electricians, fitters and turners, motor mechanics, printers; TV and radio service women, sign writers, technicians in TV production, technicians in film and theatre production as well as other trades. Yet it is still the case that few girls seek apprenticeships.

In some areas of professional expertise, women were totally absent or very few in numbers. Today, while the proportion of women entering most of the professions has markedly increased, women still predominate in the humanities, while men predominate in engineering and technical areas; however, the number of women entering engineering courses is gradually increasing. Women have a great deal to offer the trades and professions, bringing with them the woman's approach to solving problems and dealing with difficulties. Perhaps there will be fewer hernias to cope with when women apply their skills to overcoming problems within the workplace.

Young women who may know of the vast changes which have occurred in our society over the past twenty-odd years need to understand what was required to make these changes possible. It is important to emphasise that nothing changes without a great deal of effort, sacrifice and financial cost and, although some changes can be brought about by women in "high places", empowerment for the majority of women can only come from within themselves and through bonding with others to campaign for their common good. This campaign never ends . . . it's a continuum. As time passes, you will come up against problems, problems that other women will also be facing and, when this happens, it will be your turn to take up the campaign to make the changes necessary to overcome your problems.

Much has been written in recent times of young women who, while concerned and in favour of women's rights, don't see

themselves as feminists or identify as feminists. This is not difficult to understand. One of the major reasons why young women do not identify with feminists is that, from an early age, they soon learn where the power lies. Most girls become aware that men possess the power; they run the governments, the army, the police, the churches, big business and most of the families.

In a period of economic downturn when unemployment is rife, most young women being aware of their vulnerability may reject feminism for fear of losing male approval, whether it be from a father, brother, boyfriend or boss. Young women know they need to get a job and most businesses are controlled by men. A recent study of forty-two participating employers found that young women applying for apprenticeships faced several major obstacles including a selection process which relied on "word of mouth" knowledge which is usually passed from male to male.

According to research done by our newspapers, the majority of young women, whether or not they get a job or career, hope to marry and have children, and they are very aware that the vast majority of men do not approve of feminists or feminism. Young women have indicated that, as well as having families, they want satisfying jobs, equal partnerships and friendship from men. When statistics show that divorce is on the increase, it doesn't take long for young women to realise that most of their needs will not be met.

If young women are interested enough to research the newspapers of the early seventies, they will find very little information to attract them to feminism. Unfortunately, not much of the recorded historical data of the WLM between 1969–76 has been made available to schools and this accounts for the many myths still in circulation. Perhaps this attempt to record some of the details will redress the situation.

With the greater number of women journalists now appearing in our daily press and more accurate and supportive information being made available, it is very heartening and encouraging to all women to at last see ourselves being acknowledged. However, we have a small number of female

journalists who see feminism as an industry and have made a lucrative career out of playing the devil's advocate in the press and TV. These women are used by the powerful men in the media to do their bidding by constantly criticising women and feminists in a destructive manner.

When understanding the problems facing young women, experience has taught us that life will soon turn most women into feminists, even though some of them may deny this. It is learning from experience which makes us so, especially when boys are still being conditioned into being macho men. Experience is our main teacher – that doesn't necessarily mean that all older women have learnt – some women never learn and go on from one disastrous situation to another and/or identify with men through being constantly judgemental or condemnatory of women. This attitude is adopted in the hope of ingratiating themselves with men while making themselves feel superior to other women.

It is interesting to note that some young women, while having little experience of life, have by perception and observation come to understand what life has in store.

It has been said that young women of today feel that the feminist movement is controlled by older women. The feminist movement is all embracing and there is nothing to prevent young women from forming their own groups, if that's what they want to do, and doing whatever they feel is needed. All you need are young women who want to talk about life as you see and experience it and you are on your way; there are many suitable books to assist you.

Ché Stockley, a young woman, wrote the following in the *Southern Peninsula Feminist News*, 1994:

> Yes I am a feminist. Yes, I call myself feminist. Yes, I believe in feminism. The reason for this is because they are words which signify my belonging to a group. This group has branches world wide, and it is very old, and it continues. Without this group you may not have studied, and you would not have been pursuing a career. In the US at the moment members of this group are campaigning because the right to choose to have an abortion may be taken away. I call myself a

feminist because when it comes to ensuring our rights continue and expand, I want to be part of that. I want to help make sure you get paid equally to men. I want to make sure your friend has the right to legal and safe abortion. And I want to walk at night without fear. That is why I call myself a feminist.[2]

One of the more insidious aspects of our society is the ever-increasing individualism as promoted by some of our politicians, including Bronwyn Bishop. We've heard it all before; "It's all up to you; if you really want something you can get it." etc. What if you can't do it because you have a low self-image or you don't have the money? What if there are no jobs?

The adage, "I can deal with any problem" works for some but, for most young people, this thinking creates a feeling of personal failure. They feel that the lack of success on their part is their own fault, without really knowing why or how, and they can't see themselves as having any sort of a future. They have never been taught that where oppression exists, where you have those who possess wealth and/or power while others live in poverty and are powerless, where women subsidise our country's economy by their lower wages, where women endure rape and violence, that all these problems are social problems and are political. They can only be changed when we all get together to do so.

---

2.  Ché Stockley, "Advocacy of the Claims and Rights of Women", in *Southern Peninsula Feminist News*, Victoria, 1994.

## 15. WOMEN IN CAREERS AND BUSINESS.

When travelling by tram to the city during my last trip to Melbourne, two expensively groomed, perfectly made-up and perfectly spoken young women who oozed success, sat in the seat just inside the entrance to the compartment.

It wasn't long before a woman in her fifties entered the compartment; she had difficulty arranging her walking stick over her disabled arm while trying to keep her balance with a disabled leg. She desperately clung to the strap above the heads of these two very sophisticated and successful young women who completely ignored her and continued with their conversation in highly cultured modulated voices. My friend, in his seventies, gave the woman his seat.

I know I should have said a few "sweet words" to these women and regret that I didn't but, as it turned out, a similar thing happened on my return from the city when a very pregnant young woman got on the tram at the Women's Hospital and was left to strap-hang. I got up and gave her my seat and, in doing so, learnt that she had one week to go. I addressed the whole compartment on their attitudes while they all looked down at the floor.

Is that what is called looking after yourself? Is this plain individualism? Plain bloody selfishness! The "bugger you Betty, I'm OK" attitude.

Much publicity has been given in recent times to problems women in senior executive positions encounter with the glass ceiling. It was reported in the press that female executives earn twenty per cent less than their male counterparts and, while the most dominant positions are held by men, the odd woman who makes it into a senior executive position gets less pay. Women also get fewer bonuses and commissions and their superannuation is lower – even professional women are in the same situation. It is obvious by these disclosures that women in management do not get equal pay even though

equal pay was granted in 1969; they also miss out on cars and other perks.

Furthermore, approximately ninety per cent of all senior management positions are held by men yet, in clerical areas, women outnumber men four to one. What do women intend to do about these imbalances? Is there anything they can do?

Knowing full well how patriarchy works, will women in senior positions prove to be kinder, more caring, less acquisitive and less exploitative than their male counterparts or will the drive for profit by the company they serve put its shareholders first?

Like men, women have formed networks to support each other in seeking jobs, extra business or advantages in numerous areas, and this is fine but networking is not sisterhood. Networking is taking advantage of contacts to better oneself and this does not necessarily include benefits for other women or changes to what we already have. I have seen networking result in a group of women taking over after "disposing" of a warm, caring and efficient woman; just like the men do to each other.

Sisterhood embraces networking and is motivated by the heart and head, creating a bonding which endeavours to bring about benefits for all as well as ourselves. Networking, while useful, can never replace sisterhood. Sisterhood is more than just making it in the structures.

Women in all positions of power must tackle the structures in which they operate in order to bring about more humane methods of working and being. This can only be done if women have a social conscience and are genuinely concerned about people (as well as their children) and nature. I wouldn't for one moment say this is an easy task – on the contrary; men who have clawed their way up in the structures and have created their own little empires feel that this is what gives them self-worth and are very reluctant to see these structures criticised, let alone done away with. Women too when having these little empires can often act in the same way; power is very corrupting.

Unfortunately, not all women have a social conscience,

feminist or non-feminist, for there are many variations of women and feminists. If women in careers eventually reach the stage where, like men, they identify themselves by what they do and not by who they are, they will also be reluctant to let go for fear of feeling worthless when without the power or status of their paid work.

I remember the matron who retired from the psychiatric hospital where I worked many years ago. After working in the department for thirty-nine years she returned to live overseas; she had no close friends here. When learning of the Victorian Women's Trust with its one million dollar grant, given by the Cain Labor Government, and its subsequent success after assisting 1,400 women in business, I thought how wonderful this would have been if the women setting up the businesses introduced new methods in their operations rather than the old methods of alienation and authority; the normal pattern. Perhaps some of them did.

Some people are creating new methods in industry such as the Brazilian industrialist Ricardo Semler and his company Semco. A quarter of his staff now set their own salaries, dress code has been thrown out of the window, employees decide their own working hours and holidays and everyone has access to the company's accounts. When interviewed, Semler said, "We won't put a program forward because we don't make rules. The people at Semco decide who works there."[1] However in the same interview he said, "About 5% of managers are women . . . I think." – an obvious weakness. It is interesting to note that, since introducing the above conditions at Semco, the company has made tremendous gains both in production and profits.[2]

While the above example is not ideal, it is a beginning; a move in the right direction. There are instances in Australia where established businesses are already introducing methods to safeguard the environment as well as ensure humane business practices, however, for these changes to really take off,

1. *Sydney Morning Herald*, 30 August 1993.
2. Also refer to Richard Semler, *Maverick*, Arrow, 1994 for more information.

it requires a greater involvement and commitment by women; women who not only think of their own well-being but of all life.

Much of women's culture has changed in the past twenty-five years, and now men, who feel that in many ways their lives too are rat-shit, need to tackle their culture; the dominant culture in society. It will require great effort on their part to deal with their culture of sexuality, violence and pornography, to deal with their structures, particularly industry and labour relations, and to reassess the arts, although perhaps not in that order. All of these structures have been created by patriarchy. To tackle any one of these aspects of living in isolation from the others will fragment their very being and solve very little, if anything.

While older men who have made it in the structures may be content to live off their ego satisfaction, the majority of men, young or old, have very little to compensate for their feelings of emotional emptiness or failure. To overcome these negative feelings, many young men tend to place great expectations on a relationship with a young woman, hoping this will give them some hope, something to live for while working in jobs they dislike but, unfortunately, most young women working in boring jobs come into relationships with the same unreal expectations.

The Women's Liberation Movement has been accused of being too extreme in the past in seeking more than equal rights with men. I do not want equal rights with men; I want something different, something which is much better. I don't want to share in the responsibility for making all the wars and killing, I don't want any part in making armaments of death, I don't want to live off someone else's exploited labour, I don't want people to be homeless and I don't want women to have to work fifty or sixty hours a week as executives. I don't want women to be like the men who were ripping off the training levy introduced by the government by going to Hong Kong for the rugby, or taking a trip on the *Achille Lauro* or abseiling at Batemans Bay, or visiting Honolulu for a conference for political lobbyists.

I don't want women in any endeavour to be part of rorting the system. Men often rort the system feeling they are entitled to these perks but this doesn't mean that women should be "equal" in this regard. I expect women to be more accountable for their actions, even if this results in the men feeling threatened.

It is the people at the bottom of the pecking order who finally pay for all the perks for those above. Working-class women, because of our lack of worth in the networking systems, become valueless and of no help to those in power positions, and therefore totally unconsidered. Women working in shops or offices may not see themselves as working class and they may aspire to higher things but, as long as they have no control or say in their working environment and get taxation group certificates, they are of the working class.

I expect women in power to make every endeavour to change the structures – nothing is set in concrete. If we do not humanise all avenues of our existence and make our country a more concerned and caring place to live in, then women may question their support for women in business and government.

Our attitudes and life-styles govern what happens to our earth, sea and sky, and seeking success as a high flyer in a Porsche or a high flyer in a BMW is no guarantee against breathing in foul air, drinking chemicalised water, eating chemicalised food and seeing more and more of our children suffering from asthma or the ill-effects of modern society. We can, like men, pretend it's not happening while we pursue our careers with status and large salaries or go on playing our violins like Nero but, if we really love our children and grandchildren, shouldn't we be doing something to prevent them from suffering from our materialism and hedonism?

## 16. THE TRADE UNIONS.
## THE WORKING WOMEN'S CENTRE.
## POLITICS AND POLITICIANS.

In 1969 there were only three full-time women trade union officials in the eighty-one trade unions in Victoria.

When the Women's Action Committee requested, from the ACTU, a copy of the Charter on Women adopted by the ACTU at the 1969 congress, it took eleven months to get a reply – they couldn't find one.

> The year 1975 was declared International Women's Year (IWY) by the United Nations, but still the trade union movement could be described as male-oriented and male-dominated. This was evidenced by the lack of policies on women, lack of women in senior positions and even under-representation of women in unions at rank-and-file level. This was exemplified by, for example, the 1977 ACTU Congress, where the ACTU Working Women's Charter was first debated, and less than five per cent of all delegates were women and there were no women on the Executive of the ACTU.
>
> The Australian Council of Salaried and Professional Associations, (ACSPA), however, could boast of several women Executive members, including one female vice-president. Not long after its inception in 1956, ACSPA developed policies on women's issues. During the period 1966 to 1974 policies on women included decisions relating to Maternity Allowances (1966), Equal Pay (1966 and 1972), Working Mothers (1972), and Pre-School Education (1972 and 1974) . . . These issues were referred to a Women's Committee to make policy recommendations to the Federal Executive of ACSPA. The existence of a women's committee within ACSPA in 1977 was also quite significant.[1]

---

1. Anna Pha, "Working Women's Centre: Its First Five Years", submitted for an MA Degree, 1982, p. 3.

In contrast, "the ACTU and most of its affiliates did not have such Committees. (The ACTU set up a Women's Committee in 1977. Several teachers' unions did have women's or sexism committees.)"[2]

The ACSPA Working Women's Charter illustrates the extent of the rising feminism of the time (*see Appendix 2 for the charter*). The formal title for the women's committee was the ACSPA Committee of Women's Affairs (ACWA).

> [ACWA] had been established on the initiative of Bill Richardson shortly after he became Federal Secretary of ACSPA in November 1973 . . . The objectives of the Committee were to recommend policy and action for consideration at National Conferences of ACSPA and report regularly to the Federal Executive. The Committee of eight had two male members including Richardson himself. It met fortnightly and one of its initial requests to the ACSPA Executive was for a women's resource centre to be established on ACSPA's premises, which would operate on a part-time basis.[3]

With Sylvie Shaw's instigation and Bill Richardson's commitment, ACSPA made a submission to the International Women's Year Secretariat for a grant to establish the trade union women's resource centre – to become known as the Working Women's Centre (WWC). ACWA was offered as a suitable body to direct the staff and work of the proposed Working Women's Centre. The $40,000 grant was to cover the cost of employing staff to run the resource group. ACSPA offered to provide accommodation, power, library facilities, files and general assistance and Richardson was to be responsible for the administration of finances.

> Under normal circumstances one might not have expected the Federal Government to provide $40,000 for such a trade union project. Several other factors could be seen as having

---

2. Anna Pha, "Working Women's Centre", p. 3.
3. ibid, pp. 3–4.

contributed to the possibility of such a grant: the aftermath of the Equal Pay Case; IWY; the Whitlam Government with its commitment to women's issues and to IWY; and, not unrelated to these, the general size, momentum and stage of development of the Women's Movement. It was in this climate that ACSPA was granted its request ... The initial grant was seen as sufficient only to establish the Working Women's Centre.[4]

It was realised that at the end of the 12-month period of the grant, further funding would be needed if the WWC were to continue on a long-term basis as envisaged and not just become a token gesture.

The grant was conditional upon trade union support for the Centre, and on the proposed Centre's services being available to all women, regardless of whether or not they were members of a trade union. This latter point, not normal trade union practice, was included in the original submission by ACSPA, as it was seen as important that women wishing to enter or return to the workforce should be able to receive assistance, and that working women who were not already members of a union could be encouraged to join the appropriate trade union. The exclusion of women who were non-union members from the services of the Centre would have negated a major purpose of its existence.[5]

To enable the WWC to be established, to support its activities and protect it from attacks, to support its staff and to ensure its continuance and high level of activities, Bill Richardson spent almost one-third of his working hours on women's issues. He believed that women's issues "are not normally seen by union officials, especially male, as important or prestigious activities warranting such extensive attention."[6] The massive nature of the task would also deter many people. When asked about this Richardson said, "I believe the amount of time was appropriate and desirable having regard to the

---

4. Anna Pha, "Working Women's Centre", p. 6.
5. ibid, p. 7.
6. ibid, p. 10.

fact that activity on women's issues has been largely ignored by the trade union movement."[7]

When receiving the grant, advertisements were placed in the media for the positions of Industrial Research Officer. Mary Owen and Sylvie Shaw were subsequently appointed. Mary with responsibility for union relationships and public relations, Sylvie with responsibility for research and the production of discussion papers on women in the workforce. Later two part-time migrant liaison officers were appointed, one Greek and one Spanish with a good knowledge of Italian as well as Spanish. In the early stages clerical assistance was provided by various women on a voluntary basis. Later a paid clerical assistant was employed, starting at five hours per week and gradually increasing to a full-time position.

> Richardson foresaw the contentious nature of some of the women's issues such as abortion or married women working and so quite deliberately was a member of the ACSPA women's committee. His membership meant that any attack on the committee would also be an attack on the Federal Secretary; an attack on a person of the status of Federal Secretary of the second largest peak council of trade unions which would not be entered into lightly by unionists or outside bodies, whereas an attack on a group of women would be a much easier proposition . . .[8]

The Whitlam Labor Government was dismissed in November 1975 and the new government was a Liberal National Country Party Coalition, led by Malcolm Fraser. The Fraser Government failed to renew the initial twelve month IWY grant when it expired. For the next three years, 1976–78, the Federal Government provided no funding for the running of the Centre. During this period the WWC had to rely on contributions from unions and individuals and the sale of publications. While funding for the two special projects continued, this money was ear-marked for these specific purposes and could not be used for the general work of the Centre.

---

7. Anna Pha, "Working Women's Centre", p. 11.
8. ibid, p. 8.

During its four years the Centre had received donations from seventy different unions, more than half of which were not affiliates of ACSPA. In fact one third of the Centre's expenditure had been met through union donations. By the end of 1978 the continuance of the Centre's work was under threat. Already cuts had been made in the services provided because of inadequate funds.[9]

The women involved in the establishment and running of WWC were the first Movement women outside of the public service to be paid a salary when working for the interests of women in Victoria. Because of the concern about funding, they did not take a salary increase for four years.

The achievements of the WWC over a short period of time revealed a new way of operating for the trade union movement. It is impossible to capture the atmosphere of the Centre or portray the energy and the work expended there in so few pages. Many women were involved with the WWC and I wish I had the space to bring their achievements to light. Their hard work on discussion papers which were presented on a monthly basis to the unions, their production of the WWC bi-monthly newspaper, *Women at Work*, which was written specifically in plain language for rank-and-file women, and their representation on numerous committees disseminated information and helped educate the unions and women in general on women's industrial issues. Their child care project saw the development of child care centres in the suburbs and workplaces, and their regular visits to schools continued the education process. This is only a sample of their achievements.

During this period, outside of the Working Women's Centre and no doubt due to the efforts of the WWC, unions were slowly becoming more supportive of women's issues. Several unions got together during 1975 and commenced educational training courses for women members. The subjects offered were, Trade Union Structures and the Arbitration System;

---

9.    Anna Pha, "Working Women's Centre", p. 29.

Sex Role Conditioning; Women, Health and Safety; Migrant Women Workers; Shop Stewards' Roles; and Job Grievances. In 1978 a special union conference was called by the ACTU to plan the implementation of the ACTU Working Women's Charter. This conference gave recognition to the work of the Working Women's Centre and called on the ACTU to provide support to ACSPA in its endeavour to ensure the continued operation of the WWC after the unification of ACSPA and the ACTU took place.

After lengthy negotiations, the Working Women's Charter became part of the ACTU in 1980.

Over the years the ACTU gradually changed its policies. "After an extremely heated and divisive debate, the 1981 Congress adopted, for inclusion in its Social Welfare Policy, the right to free, safe and legal abortion for those who choose it."[10]

> Since the 1981 Congress, the ACTU changed its policy on discrimination against women in the area of unemployment benefits. It has also made a number of amendments to the Working Women's Charter which indicated a clearer intention to combat discrimination against women in such areas as super-annuation, management, legislation, sexual harassment, etc. Thus, while there is still division on these issues, the ACTU's of ACSPA and the WWC.[11]

Since 1970 great improvements have been made with more women being employed in official positions within the trade unions and the ACTU. Jennie George, the first woman to get on to the executive of the ACTU in 1983, became vice president in 1987, then assistant secretary in 1991.

Jennie George was recently reported as saying, "I see signs of change everywhere, although obviously some unions have accelerated faster than others." She went on to say, "the affirmative action programs, combined with the ACTU's formal rule changes, which will see women in half its executive

---

10. Anna Pha, "Working Women's Centre", p. 37.
11. ibid, p. 38.

positions by 1999, means that unions are attracting talented women away from the Labor Party. It is heartening to see the depth of talent in women in the trade union movement. We are leaving the Labor Party for dead."[12]

With more women being involved in the ACTU, it is already noticeable that the trade union movement has developed beyond seeing the worker as a wage slave only and is now recognising that we have other needs as mentioned in this book. It is very pleasing to see issues such as maternity and paternity leave, compassionate leave, choice of shorter working hours introduced, and family sickness leave in the pipeline.

Unfortunately, while this is happening, Australia's largest company, which has made record profits and created four new millionaires through extra payments to its directors (1994), has delayed payment to women over job discrimination by litigating continually for fourteen years and has also delayed payment to the families of men killed in their mines. Will women in this company or in the trade unions be willing, or able, to make a company like this more humane?

Over the years, I have observed men coming into the trade unions with ideals and then gradually move into power positions within the trade union hierarchy. I have also seen how many of them eventually develop a contempt or total disregard for working people, women, the aged, and the unemployed. They find they have very little in common with these people and have difficulty communicating with them. When people rise in the ranks of any given structure, divisions occur and a pecking order is established.

Because the trade union movement was my area of involvement I am familiar with what happens in these structures, however, all commercial and government institutions have the same structures and function the same way.

The vast majority of men in power positions seem to have the need to impress others with their "success", position, knowledge, ability and presence and, if they find you are not

---

12. Sally Loane, "Unionists crash through the glass ceiling", *Sydney Morning Herald*, 17 March 1994.

impressed or are of no benefit to them, they decide you are not worth impressing and won't bother with you. They only want to associate with their peers, those who have risen above the ranks or the like, where associating with this or that person may be advantageous and where they can all feed each others' egos with their exploits, jargon and bullshit. This situation also applies to the public service, private industry and to the more recent phenomenon: consultants.

It has become very obvious that this behaviour is being dis-played by women already making it in the structures. Will this also happen to the women trade union leaders? Will having more women in the ACTU change the structure? Within a few months of Jennie George making her statement about more women coming on to the ACTU executive, Bill Kelty, the ACTU secretary, stated in the press that the ACTU was gearing down and more responsibilities would have to be undertaken by individual unions.

Why the change in direction? Does this have anything to do with the introduction of restructuring and enterprise bargaining?

Perhaps it also has something to do with the possibility of greater numbers of women becoming part of the ACTU leadership as stated by Jennie George? Do some of the learned men of the ACTU feel they will lose prestige in the eyes of their peers by having more women involved in the organisation which was for so long a "boys' club"? And where does all this leave the greater numbers of women now going to be involved in the ACTU? What powers will the "down-graded" ACTU have? Will this new situation open up opportunities for ambitious consultants with their egos in their pockets?

I am curious to know where the replaced men intend going when the ACTU is geared down. Will they be slotted into other areas with status? Perhaps as commissioners on the Industrial Relations Commission (which used to be the Arbitration Commission)? And, while we're at it, do these commissioners have to declare their financial interests? They could often be situated in a conflict of interests, depending

where their investments are!

Yes, I am very cynical due to past experience and, even though there may be women commissioners or Justices sitting on the bench, I ask all these questions because we need to know the answers.

A recent opinion poll revealed that, while Australians are chirpier than people in other countries, the majority believe the world has become a more dangerous place. Perhaps it is the 9.2 million capsules of the anti-depressant drug Prozac (16.6 million dollars) or other anti-depressant tablets swallowed which brought about our chirpiness during 1991–92.[13] I would imagine that, with Victorian women suffering the greatest loss in wages in any state due to the Kennett Government, more women as well as men will be consuming anti-depressant tablets.

With a scenario of thousands of homeless adults and children and 500,000 people suffering extreme poverty in Australia, what can we hope to expect from women in parliament?

Most young people are cynical about politics and politicians. I would like to think that perhaps most women politicians would be more accountable than men and bring a concern for the welfare of people back into politics.

What we need to ask ourselves is, what will happen to women politicians in all parties if they, for example, oppose the privatisation of hospitals, support Aborigines in their fight for land, support the unions in safeguarding the interests of the low-paid workers, oppose raising the retirement age of women, and support the right of choice to retire from sixty years old for both men and women?

I would like to think that, if all political parties had equal female/male politicians, we would see a more humane approach to the ills of society; however, my experience of life has shown that very few people are able to withstand the seduction and corruption that goes along with status, ego and

13. See Gareth Boreham – medical reporter, *Age*, 2 April 1994.

power. Will women in power be capable of, or interested in, withstanding the "gravy train"?

Some of our older women politicians who experienced the passion of the Women's Movement in the 70s and its ideals for a better future, have maintained most of their ideals and integrity. Are we to believe that, when more numerous, women will be able to humanise the parliamentary structures as well as society?

I am well aware of the power structures and the ambitious types who often seek career paths in search of power, so one would be foolish to imagine that all women seeking these positions will be caring people. Some of our present-day femocrats are as ruthless as the men and have been selected for the job because they are no threat; the structure is in no danger of being humanised. In the eyes of patriarchy, anything seen as a decrease of power in the master and slave situation devalues and demeans the structure and is therefore threatening.

While commenting on femocrats, it is necessary to state that some women in these positions are attempting to conduct proceedings with more humane and participatory methods and they need all the support they can get, whether it be within the public service or private enterprise; these women by the nature of their circumstances will be encountering a lot of flack and they need our support.

When leaving the Communist Party in the very early seventies, some of the Party women felt that, given time and more women joining the Party, the women would be able to get more control and influence the Party in a humane direction. I said that, this being the case, the patriarchs who undervalue women's participation would leave the organisation well before this happened. They would feel that it was no longer a Party of any significance and would take their allegiance elsewhere and this is what eventuated. It is precisely for this reason that the patriarchs in various churches oppose women entering their power structures; for example, the priesthood.

It is important to understand that, because women are undervalued, our contribution in whatever sense is very rarely assessed as being valuable in men's eyes, the eyes of patri-

archy, and, in my opinion, they will prevent women from gaining "too much" power in their political parties because of the same dynamic as mentioned above.

Should there be some sort of miraculous occurrence and women in large numbers do manage to penetrate the two major parties to the degree that male domination in our parliaments is threatened, then the patriarchy will alter the rules; they will take their bat and ball and go play elsewhere. They are very experienced in changing the goal posts and the least they will do is establish new political parties.

I don't want to come across as negative, but we need to understand patriarchy and its structures to know what we are up against. I really hope I am wrong – only time will tell.

It is necessary to form a critical mass of women holding political power. 40/60 or even 50/50: slogans like these are catchy and get us applause but what does it really mean? 50/50 of the same kind of politicians? I don't think we would like to have the same kind of politicians, only that they are women. This is not just about putting more women in public office, is it? This is about using power to bring about the transformation of structures.

The goal of women – and men, too, I might add – in politics should be nothing less than transformational politics . . . The editor of *Manushi*, an Indian feminist magazine, writes: "Today, we no longer say: give us more jobs, more rights, consider us your equals, or even allow us to compete with you better. But rather we say, Let us re-examine the whole question, all the questions. Let us take nothing for granted. Let us not only redefine ourselves, our role, our image . . . but also the kind of society we want to live in."[14]

When redefining the kind of society we live in, we need to redefine work and the nature of work.

---

14. Supatra Masdit, Women's Environment and Development Organisation, *News and Views*, Vol. 6, No. 1, June 1994.

## 17. WHERE TO NOW?

> "It's hard for young women today to understand the shocks,
> the explosions that the Women's Movement brought into our
> lives in the early 1970s, and harder still to believe how separate
> women were from each other before we woke up from our soli-
> tary dreams and had a good look around. We'd been asleep for
> so long!"
>
> – Helen Garner[1]

Much emphasis has been placed on women in the paid work-
force and the "pill" as indications of the success of the Women's
Liberation Movement. These claims are only part of the
picture.

Many women's organisations have existed during my life-
time but never have I seen a response such as the WLM was
able to generate. I have given this happening a great deal of
thought and, apart from the "pill" and women being in the
paid work-force, there was one other factor which I believe
accounted for much of the success of the WLM.

While examining all other women's organisations, the WLM
was the only one that dealt with every aspect of a woman's
life; there were no more divisions, no more taboo areas. For
the first time ever, all of a woman's experience had become
valid and here was an organisation which brought it all together
and out into the open. We were concerned about ourselves
as individuals, about our sexuality, our relationships at home,
and as mothers. We were concerned about the conditioning
we had undergone, our education, conditions in the work-
force, in the professions, in the media, in law, in our culture,
and in society; only a movement could have accommodated
these needs.

And this is why we had to become a movement, not an
organisation; an organisation where egos prevail and every-
one sits facing the chair with very few participating. This

---

1. From the Preface, *Voices of Vashti Anthology*, Vashti Collective, 1986.

would have defeated everything we were trying to achieve. All of the areas mentioned above were part and parcel of the WLM and to overlook any one area was to curtail our development and process towards liberation.

This opening up process liberated us from a past of pretence and shame, guilt and fear. We came to life; we reclaimed both our bodies and minds. This process unleashed our energy and we were prepared to fight for what we wanted; there was no turning back.

Criticism has been levelled at the WLM for not doing sufficient to involve Aboriginal or migrant women. It would be true to say that, although some migrant and Aboriginal women were involved, in the main, there were difficulties in this area.

One young migrant woman, a student, became involved in her national group which was controlled by men. After some time and much talk and talk and talk, the men finally agreed for the women to have their own group. This group proceeded while concentrating on their major priority: the economic plight of migrants. They would not venture into personal problems. The young student accepted an invitation to speak on community radio and, among other things, spoke of the need for free and safe abortions for women. Pressure was brought to bear following a phone call to the radio station by a priest and the men who had earlier dominated the group decided to take control over any further public announcements by the women's group.

Following this episode, the student left the migrant group disappointed at its narrow approach to women's issues.

My parents, ex-husband and in-laws were non-English speaking migrants and, having associated with migrants throughout most of my life, I was aware of the very privatisation of their personal lives. I had tried on several occasions to talk with my mother on intimate aspects of our lives and, although she opened up in some areas, there was a point she could not pass and I respected her privacy. There was no way that my mother with all her left rhetoric could have fully participated in the WLM.

After controlling my thoughts and feelings for so many years and coming to life through the WLM, there was no way I could return to working within a restricted area of my experience, pretending again that so many of my experiences didn't happen.

The WLM assisted our Aboriginal sisters when they asked for support but I cannot recall a request ever being made to the WLM by a migrant women's group for assistance, although there may have been such an incident. Those in our movement who were involved with Aboriginal women in the early days must speak for themselves about their experiences. This activity needs to be recorded and can only be done when a full history of the Women's Liberation Movement is carried out. What I am recording, apart from the many quotes in this afterword, are my views and experiences of the WLM; other women will have different views and different experiences.

I cannot speak for other women but, knowing how painful it would have been for me to move back into any organisation which was restrictive in its concerns, I can only presume that other WLM women may also have felt like I did. I know this applied to most of the migrant women in the Movement who told me of their frustrations when trying to communicate with women of their own nationality. As the years have passed, children of migrants have grown and many of the daughters have been educated and/or have worked in various areas and become financially independent. These same daughters have witnessed the lives of their grandmothers, mothers and aunts and have helped to enlighten their female relatives when sharing their experiences. Today, we not only see the daughters moving into positions of responsibility in all areas from academia to trade unions, but their mothers and grandmothers have now become visible.

These days, we have many Aboriginal and migrant women's organisations, which not only concern themselves about economic and political issues but also about the politics of personal lives. These organisations have established refuges for their women and children as well as self-help groups where women who have suffered, or are suffering, problems such

as domestic violence, rape, and incest can obtain assistance and support.

Since the WLM era, professional women's organisations have been established to look after their own interests. These professional women have also campaigned within their spheres of expertise to introduce new ways of looking at all aspects of their areas of concern; the woman's perspective. Women in the legal profession have actively campaigned for changes to laws which discriminated against women in many areas; from laws pertaining to ownership of the family home to sexual harassment and, although there is much to be done, a great deal has been achieved.

Over the years it has become obvious that the judiciary, when trying rape or sexual assault cases as they are now called, were, in the main, prejudiced because of their personal views gleaned from a misogynistic society. In 1992–93 the situation became heated after several anti-woman judgements and comments were made. This resulted in our learned judiciary being pressured into re-educating themselves on their attitude towards women.

Women farmers and women working together with their husbands on farms have formed organisations of their own, not only to press for recognition in their own right as women farmers but also to deal with the many problems facing country women living in remote and isolated areas. They have also become more involved in farmers' organisations and are playing a far greater role in the decision-making processes.

Women's organisations are still continuing to apply pressure on politicians, governments and their departments in order to improve the lot of women; the difference being that the Women's Liberation Movement, apart from bringing this type of pressure to bear, created, through CR, a movement of women bound together through the sharing of personal experience and a desire to free ourselves.

One could say, when looking back, that there were issues that we didn't discuss sufficiently such as racism, class, work or ecology. These very vital issues could only have been dis-cussed adequately in CR groups where we discussed matters

in great depth; general meetings became head only discussion areas and often led to confrontation.

I firmly believe that the Women's Liberation Movement, despite the difficulties from time to time and lack of strict organisational guidelines, appealed to women who were yearning to break the bonds and this we did.

How fortunate we were! If there was an Australia-wide *Women's Liberation Newsletter* today, this is what I would write:

Dear Sisters,

I ponder for a moment before writing . . .

I can see all your beautiful faces, the thousands of you who were fortunate to have been involved in the early part of our movement – the inspiration that we received from each other which enabled us to move into new areas of endeavour, prepared to take a risk with enough confidence to try something different. Where are you now?

When I read the press comments by Chrystos when attending the 6th International Feminist Book Fair, I wanted to embrace her. She said, "In my own country I am not considered a radical feminist because I am not an academic, which has become a criteria for a movement which is increasingly estranged from the grass-roots origins of feminism."[2]

I know exactly how she feels. I am not an academic, I am not middle class, I am not lesbian and I still talk to groups of women without having an agent or a fee but I have retained my passion. Does that make me an idealist, a radical feminist, an embarrassment or a threat?

I often read articles in the press about you, I read of interviews with you, I see wonderful women being interviewed on TV, I read your books, but rarely, oh, so very rarely do I see any mention of our wonderful movement which enabled it all to happen. Is it any wonder that young women of today have a distorted image of our movement when those who were there are silent about their involvement? What happened to your passion?

I see a different country where so much has changed but

---

2. *Sydney Morning Herald*, 1 August 1994.

almost no acknowledgement of the part you played in it while being involved in the WLM. Why are you letting this happen? Is this the price one has to pay for success? – making it in the structures?

Is something going on out there that I am unaware of or don't understand?

Will you be penalised in jobs, or when seeking jobs, if your involvement in the WLM is known?

I recall the first time I felt the obliteration of the Women's Liberation Movement and that was when attending the reception held by the IWD Committee in 1975 to honour pioneering women (yes, it didn't take long for this trend to appear). This function was held at the Old Customs House and was very grand – it was also very, very respectable with Mr Whitlam being the guest speaker. Not one word was mentioned of the Women's Liberation Movement which made it all possible. The refinement of our struggle was already in place!

I have, in these pages, recorded other women's experiences and, when requested, safeguarded their privacy. When unable to contact some women, or when my letters and phone-calls have remained unanswered, I have instead quoted from the *Women's Liberation Newsletters* or other material and have noted the source.

I am well aware that women must earn an income in order to live but so many of you had important experiences during those vital years which should be recorded. How and when will this happen?

Patriarchal history was created to show men in power as great men . . . to pander to the ego of individuals and safeguard their image. What this type of history really does is negate the role of people, the grass roots activists and this was carried out very effectively against women.

Now we are seeing women do this to women. We cannot afford to adopt these destructive methods.

There are women who are already distorting our history. If we allow these patriarchal methods to infiltrate our movement by glorifying individuals while ignoring the women both young and old who enabled it all to happen, there will be nothing for younger generations of women to identify with because their reality is not there. All they will see is a lot of written material about older women who have made it in the structures and/or

who were wheeling and dealing above and/or who made great speeches and attended great celebrations and dinners: a carbon copy of men's history and a gross distortion of our past. If this type of history persists it will just be more of the same!

Individuals alone did not and will not make our history and we must guard against the obliteration from history of the wonderful women all over Australia who had the courage to come out on to the streets and be counted. It was because of these women the world over that we began to see ourselves as people in our own right. True, we need women in all positions and with all sorts of skills, but it is fatal to lose contact with the life blood of the Movement . . . the grass roots.

To have been involved in the WLM is, in my opinion, a badge of honour; we have the highest reason for being proud of our achievements and the results of this period.

To be proud of our involvement and achievements is to give the young women of today good reason to continue the essential campaigns yet to be waged. I know that, for most of you, whatever field you're in, you will be assisting young women to be confident, capable, strong and caring women, with a true appreciation of their own worth but the invisibility of the Women's Liberation Movement from history and the tendency to work from the top has taken the feelings, the passion and the life force out of the struggle and left a feminism without a heart.

When we started the Women's Action Committee in 1970 there was very little to read on the oppression of women. Today we have a preponderance of books which have revealed every facet of the methods, techniques and stratagems used to "keep us in our place". What is lacking are books on what the structures are, how they function and how they prevent people from being liberated, both women and men, and information on what can be done to change these structures.

Sisters, very early on we gave women the courage to introduce the initial changes, we now need your passion, your heart and your head to continue the changes necessary to free us all from the patriarchal mess: we don't want more of the same!

# *Appendices*

## APPENDIX 1

### THE WOMEN'S LIBERATION MANIFESTO[1]

Women's Liberation believes that women in our society are oppressed.

We are economically oppressed: in jobs we do full work for half pay, in the home we do unpaid work full time.

We are commercially exploited by advertisements, television, and press: legally we often have only the status of children.

We are brought up to feel inadequate: educated to narrower horizons than men.

This is our specific oppression as women.

It is as women that we are, therefore, organising.

We demand:

#### 1.  *That Women Have Control Over Their Bodies*

We believe that this is denied us until we can decide whether to have children or not and when we have them.

#### 2.  *The Repeal of Abortion Laws: Abortion on Request*

Abortion is an essential part of birth control. Contraception without the right to abortion means that the State, in effect, controls our bodies if we become pregnant unwillingly. Women

---

1.  *Women's Liberation Newsletter*, March 1973, pp. 5–6.

should have the right to decide whether or not to have an abortion.

### 3. Freely Available Contraception

More education on contraception is needed at an early age and, for this to be effective, contraceptives should be easily available and free on social security. Doctors should not have the right to refuse contraceptives on their own moral grounds.

### 4. Free 24-hour Community Controlled Child Care

The government should provide full child care facilities throughout Australia. These should be free and staffed by qualified people – men and women. The centres must be under the control of those who use them, to prevent bureaucratic "baby-dumps".

Women should not have to bear individual responsibility for the care of children.

### 5. Equal Job Opportunities and an End to Low Pay

Employers have no right to pay women less than men, or to keep women in menial jobs. The government must act to correct this injustice by making it illegal for employers to discriminate against women.

Although, at first glance, the equal pay decision in 1972 seems favourable, the full effect of the decision will not become apparent until 1975. In other words, we have been "bought off" until then.

### 6. Equal Educational Opportunities

To enable women to have really equal opportunity, all schools must stop streaming women into "service" jobs which reflect the wife–mother role – cleaners, teachers, nurses, secretaries, social workers – essentially supporting roles.

Sexual bias in curricula should be eliminated. The education system must play a large part in undoing the conditioning of women to accept an inferior role, by encouraging women to assert themselves in all fields.

We believe that by united action we can achieve our aims.

Women's Liberation questions women's role and redefines the possibilities. It seeks to bring women to a full awareness of the meaning of their inferior status, and to devise methods to change it.

In society, women and girls relate primarily to men; any organisation duplicates this pattern; the men lead and dominate, the women follow and submit.

We close our meetings to men to try and break through this pattern, to establish our own leaderless groups and to meet each other over common experiences as women. If we admitted men, there would be a tendency for them, by virtue of their experience, vested interests and status in society, to dominate the organisation. We want eventually, to be, and help other women to be, in charge of our own lives: therefore, we must be in charge of our own movement, directly, not by remote control. This means that not only those with experience in politics, but all must learn to make their own decisions, both political and personal.

For this reason, groups small enough for all to take part in discussions and decisions are the basic units of our movement. We feel that the small group makes personal commitment a possibility and a necessity, and that it provides understanding and solidarity. Each small group is autonomous, holding different positions and engaging in different types of activity. As a federation of a number of different groups, Women's Liberation is essentially heterogeneous, incorporating within it a wide range of opinions and plans for action.

We believe that women must be guaranteed the right and the ability to make real choices about their lives.

Our goal is the total liberation of womankind so we can be free to determine our own futures and realise our potential.

ACSPA WORKING WOMEN'S CHARTER[2]

To campaign among women so that they may take an active part in trade unions and political life and may exercise influence commensurate with their numbers and to campaign among male trade unionists that they may work with women to achieve the following aims:

1. The right to work for everyone who wishes to do so.

2. The eliminating of all discrimination on the basis of sex, race, marital status or sexuality.

3. Equal pay for equal value – meaning the same total wage plus other benefits.

4. Equal opportunity of entry into occupations and of promotion, regardless of sex, sexuality or marital status or race.

5. Equal education opportunities for all.

6. Equal access to vocational guidance and training including on-the-job training, study and conference leave.

7. Introduction of 35-hour week, flexible working hours, part-time work and reasonable shift-work opportunities for all workers.

8. Working conditions – without deterioration of previous conditions – the same for women as men.

9. Removal of legal, bureaucratic and other impediments to equality of superannuation, social security benefits, credit, finance, taxation, tenancies, etc.

10. Special attention to the needs and requirements of women from ethnic communities – as they see them: e.g. Industry

2. Anna Pha, "Working Women's Centre", submitted for an MA Degree, 1982.

to provide English classes for migrants at work, in work time, at the boss' expense.

11. Establishment of community-based child care centres open 24 hours a day to cater for shift workers and emergency care.

12. Introduction of adequate, paid parental leave (maternity and paternity leave) without loss of job security, superannuation or promotion prospects.

13. Availability of family leave to enable time off to be taken in family emergencies, e.g. when children or elderly relatives are ill.

14. Sex education and birth control advice freely available to all workers.

15. Comprehensive research into health questions specific to women.

We believe that stronger unionization of women workers will increase the effectiveness of the national trade union movement and will ensure that women workers and the community both recognize the importance of trade union organization for women.

We wish to ensure that women workers have:

- Equal access to trade union training.

- Special union training courses which will concentrate on overcoming the diffidence to which women have been conditioned.

- Inclusion of women's problems in the general education programme of trade unions.

- Equal access to higher office in trade unions.

We seek to encourage women to participate more in trade unions and to encourage unions to take positive action to make this possible.

# Acknowledgements

To THE ATTORNEY GENERAL'S DEPARTMENT for permission to publish the transcript of my submission on behalf of the Women's Liberation Movement placed before the Arbitration Commission, National Wage Case 1973.

To *Rupert* for permission to quote the ASIO Minute Document published in their issue of April 1976.

To Longman Cheshire for permission to quote from *The Split: Australian Labor in the Fifties* by Robert Murray, Melbourne, 1970.

To the *Herald* and *Age* newspapers for permission to publish photographs.

To Greenhouse Publications for permission to publish excerpts from "With Audacity, Passion and a Certain Naivety: the 1975 International Women's Festival" by Suzanne Spunner in *Don't Shoot Darling!: Women's Independent Filmmaking in Australia*, editors, Annette Blonksi, Barbara Creed and Freda Freiberg, Richmond, 1987.

To Hale & Iremonger for permission to publish excerpts from "Motherhood within Patriarchy" by Barbara Wishart in *Embroidery the Framework: All her Labours*, Sydney, 1984.

To Spinifex Press for permission to publish excerpts from *Australia for Women: Travel & Culture*, editors, Susan Hawthorne and Renate Klein, Melbourne, 1994.

To Anna Pha for using excerpts from "Working Women's Centre – Its First Five Years" submitted for your MA degree (Industrial Relations), 1982.

To Clancy Sigal for permission to quote from "Generation Vexed", Metro section, *Sydney Morning Herald*, 11 February 1994.

To Sally Loane for permission to quote from "Unionists crash through the glass ceiling", *Sydney Morning Herald*.

To *Southern Peninsula Feminist News*, Victoria, 1994; Women's Environment & Development Organisation, *News & Views*, June 1994; Media Switch journal, *Media Matters*, August 1994.

And to the many wonderful women who wrote to the *Women's Liberation Newsletter* and *Vashti*, making the research for this addition possible.